Dec 25

May all of your dreams come true

Love
Gary

P9-CJS-137

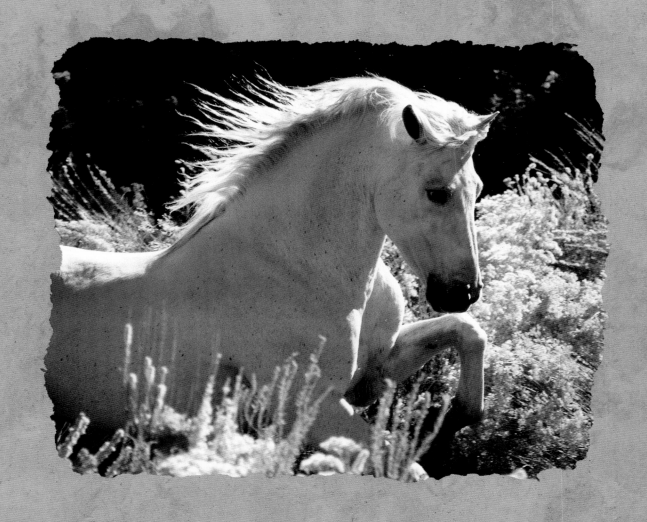

The sun's horse is a yellow stallion,
A blue stallion, a black stallion,
A red stallion, a white shell stallion,
The sun's horse is coming out to us.

Apache Ceremonial Song

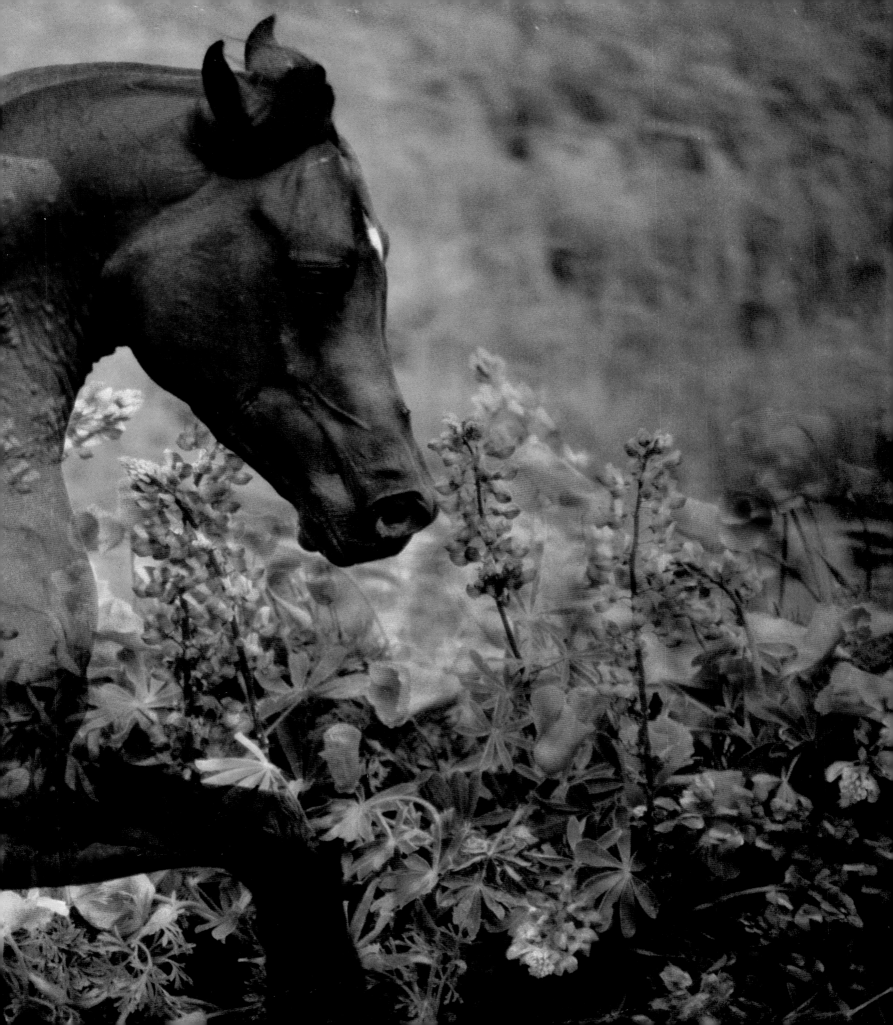

HORSES

William Morrow and Company, Inc.
New York

OF THE SUN

A Gallery of the World's Most Exquisite Equines

ROBERT VAVRA

foreword by WILLIAM SHATNER
drawings by Roger Bansemer

For Rafael, <u>Luz</u> Maritza, Rafael Alberto and Maritza Parra, whose family effort has been unsurpassed in bringing prominence to the Andalusian horse in this country. Mis queridos amigos, este libro, y un fuerte abrazo van para vosotros...

Copyright © 1995 by Robert Vavra

All rights reserved. No part of this book may be reproduced or utilized in any form or by any means, electronic or mechanical, including photocopying, recording, or by any information storage or retrieval system, without permission in writing from the Publisher. Inquiries should be addressed to Permissions Department, William Morrow and Company, Inc., 1350 Avenue of the Americas, New York, N.Y. 10019.

It is the policy of William Morrow and Company, Inc., and its imprints and affiliates, recognizing the importance of preserving what has been written, to print the books we publish on acid-free paper, and we exert our best efforts to that end.

Library of Congress Cataloging-in-Publication Data

Vavra, Robert.
 Horses of the sun / Robert Vavra.
 p. cm.
 ISBN 0-688-13864-0 (hard cover)
 1. Horses—Pictorial works. I. Title.
 SF303.V379 1995
 779' .32—dc20
 95-15544
 CIP

Printed in Hong Kong

First Edition
1 2 3 4 5 6 7 8 9 10

Designed by Robert Vavra
Photographic assistant: Kent Rump
Photographic laboratory: Rick Fabares
Drawings by Roger Bansemer
Literary research: Valerie Hemingway
Equine consultant: Jayne Parkinson
Dust cover image: Barexi
Title page image: Padrons Psyche
Digital imaging: Digital Imaging of So. Calif., Canoga Park

Colour Origination By United South Sea Graphic Art Co.,Ltd.
Printed and bound by South Sea International Press Ltd.
Address: 3/F., Yip Cheung Centre, 10 Fung Yip Street, Chaiwan Hong Kong.

More than ten years ago, when a film director friend arranged for me to have lunch with Robert Vavra, I was delighted, as would be anyone who loves horses. Over the years I had seen and admired Vavra's equine books, and I was eager to meet not only the artist behind the lens but the man who clearly feels as romantically about horses as I do.

In one of the four introductions that James A. Michener has written for Robert Vavra's books, he states: "In the history of photography no cameraman has recorded the horse with such excitement and personal style...these are interpretations of the horse as perceptive as those done by Stubbs and Remington." Peter Ustinov called Vavra "part magician, part alchemist" and referred to the "epic intimacy" of his vision. Other artists of great sensitivity, such as Princess Grace and Yehudi Menuhin, have directed their praise not toward the pictures but toward the words in Vavra's books.

Thus when Robert Vavra and I met face-to-face in Carlsbad, California, I was convinced, along with hundreds of thousands of readers, that here seemed to be the only man in the world able to capture the horse in images that represent all of our romantic feelings about equines. Equally astonishing, he was able to express these sentiments not only in his photographs, but also in the words that accompany them.

It was my pleasure that morning in Carlsbad to show Robert the first American Saddlebred horse that he had ever seen in the flesh. It was a five-gaited stallion called Time Machine, and as it broke into the rack, hooves pounding on the sand, Robert exclaimed, "What power! What beauty! I've never seen such a combination of both

in a horse!" Following those moments with Time Machine, Robert and I spent leisurely hours over a Mexican lunch, talking about what both of us love so much — horses. Happily, this was the beginning of our friendship. I told Robert that if he had been impressed by Time Machine, one day he had to see my black stallion, Sultan's Great Day, who to me is indeed Bucephalus reincarnated. Little did I know that Robert would not only see Sultan's Great Day in Kentucky, but that he would eventually photograph him there in a series of images that are as evocative as they are unique and stunningly beautiful.

Over the years, when Robert ventures forth from his ranch in Spain or his camp in the Kenyan highlands to visit California, we get together for lunch, dinner, or simply to be with horses. Once, as the moon rose from behind a cliff on the Pacific Coast, I rode Time Machine while Robert photographed us. From that experience, I had some insight into his success. Robert was as relentless in his scrutiny of every detail and search for perfection as I imagine had been one of his heroes, the incomparable film director, David Lean. Lean and Vavra were introduced in Spain by Robert's friend Peter O'Toole. After the director had seen some of the young Californian's work, he allowed him to photograph what he wished during the making of *Lawrence of Arabia*.

I find it difficult to describe the exhilaration of that evening ride on Time Machine. The only sounds were the faint clicking of Robert's camera, the cries of gulls and the crashing of the surf on the rocks below us. What a thrill it was to feel the power of that chestnut stallion beneath me, not in a show ring, but on equal terms with nature. The pounding of the stallion's hooves resounded off the rocky cliffs to join with the rhythm of the waves. It was a magical moment, but even more magical was the photographic image that Robert captured on film and that later appeared in his book *Equus Reined*.

Knowing Robert's feelings for horses and how he had been impressed by Time Machine, I invited him to the Los Angeles Equestrian Center to attend a show that I was helping to organize. However, I didn't summon him from San Diego simply to see another horse show, but to witness in action two living legends: Sky Watch and Imperator. There was wonder in the ring that night as there was in Robert's eyes following the exhibition of those grand old stallions. Robert and I hardly exchanged words, but merely a simple smile that came from having shared a very special equine moment.

On another occasion, Robert invited me to San Diego to share an experience with two equines that were important to him. At the San Diego Wild Animal Park, he introduced me to the Przewalski, the Mongolian wild horse which is the only truly wild horse that exists today, and to the Grévy's zebra.

Years before, Robert had done a study of primitive equine social behavior that eventually became the book *Such Is the Real Nature of Horses,* which was published in eight languages, featured in *Life* magazine, and is still in print today. While most of Robert's works have been accomplished with the wild horses of the Carmargue, which is in the Rhone delta in Southern France, he has also studied Przewalski's horses and the Grévy's zebra.

That afternoon provided some of the most unique of my equine experiences. As we sat in a Land Rover in the Przewalski enclosure, Robert described equine social behaviors exhibited by the stallion and mares in front of us. With us that day was Rich Messena who was in charge of large animals at the park. The Przewalski stallion with his rust color and upright black mane not only looked like a primeval equine directly off some prehistoric cave wall in France or Spain, but embodied the territorial aggressiveness that is the most necessary of attributes for the leader of a wild horse herd. Proof of the stallion's violent determination were the jagged scars on Rich's arm. Once, when attempting to remove an injured foal from the enclosure, Rich had been able to get the young animal into the back of a truck only to have the stallion attempt to leap in after him. The Przewalski then grabbed Rich by the arm and shook him like a cat shaking a mouse. Rich's arm was left dangling, shattered in six places.

During that day at the Animal Park, Robert also explained social differences between Common and Grévy's zebra. His eyes sparkled while he described his plans to continue his equine primitive behavior study, not only in the Carmargue but also in Kenya, where he had established his own permanent camp above the Maasai Mara. His premise is that if humans knew more about equine communication, man and domestic horses would enjoy a closer relationship in which the animals would receive better treatment. At that moment, I decided to join James Michener, Deedie Wrigley, Martha and Henry duPont, and other horse lovers who were patronizing Robert's study.

That evening over dinner at Robert's twin brother's home, I was given even more insight, not only into horses and their behavior, but into that of Robert Vavra. In a charming house of natural wood decorated with relics from far-off travels, I sat in front

9

of a fireplace with three generations of Vavras: Robert's nephews, his brother, Ronnie, and his sister-in-law, Gale, and his silver-haired, blue-eyed mother who was clearly the matriarch of the family. How refreshing it was to have a meal in front of a fireplace without the presence of a television set, while three generations of one family were totally engrossed in conversation. What would be a rare get-together for most families was a nightly occurrence for the Vavras.

At one point in the conversation, Robert mentioned his first trip to Spain. "I must have been crazy at the age of twenty-three to leave Glendale with three hundred dollars and a one-way ticket in my pocket. It took fourteen hours to get to New York on an old prop-plane, and another ten days by ship from there to Lisbon and then on to Algeciras. When I arrived in Spain I didn't know a soul."

More than crazy, Robert had been adventurous. We then reminded him that the previous year he had gone to Kenya, borrowed a couple of worn-out Thoroughbreds in Nairobi, become acquainted with half a dozen former Maasai warriors, and set out alone in the wilds of Africa.

It is that sort of adventurous spirit, along with his artistic eye, that in part is responsible for the success of Robert Vavra. He dares to go beyond the known and the normal. When he photographed my stallion, Sultan's Great Day (a feat he accomplished in less than an hour), not content to let the already dramatic and handsome images stand on their own, he montaged them to create compositions of a dream-like quality. In analyzing his success, I should also mention his natural manner which in itself has attracted to him creative men such as James Michener, Peter Beard, Wilfred Thesiger, Peter Ustinov, and Ernest Hemingway.

In this book, *Horses of the Sun*, Robert Vavra has again focused his camera on an entire gallery of gorgeous equines, representatives of six noble breeds. With his images, he not only demonstrates the "epic intimacy of his vision," but also the physical and inner beauty of an animal that has brought such wonder into all of our lives — the horse.

William Shatner

A Note on the Horses' Songs

The horses' songs that appear on the following pages came to this book from many voices. Some were carried on the wind and punctuated by the beat of hooves on stone. Others were written in the dust or reflected and held, waiting to be gathered from dew on the grass. Many of these words are those of men and women who have loved horses, from William Shakespeare to a Navajo Indian. The identities of these human contributors will remain as anonymous as were the identities of the individual stallions and mares who inspired their words. All join here in a hymn to horses everywhere.

Boticario De La Parra

The curve

of my neck

lit by

the fire

in my eye

was

the glorious

figurehead

from which

El Cid

shouted

his

Spanish

battle cry.

12

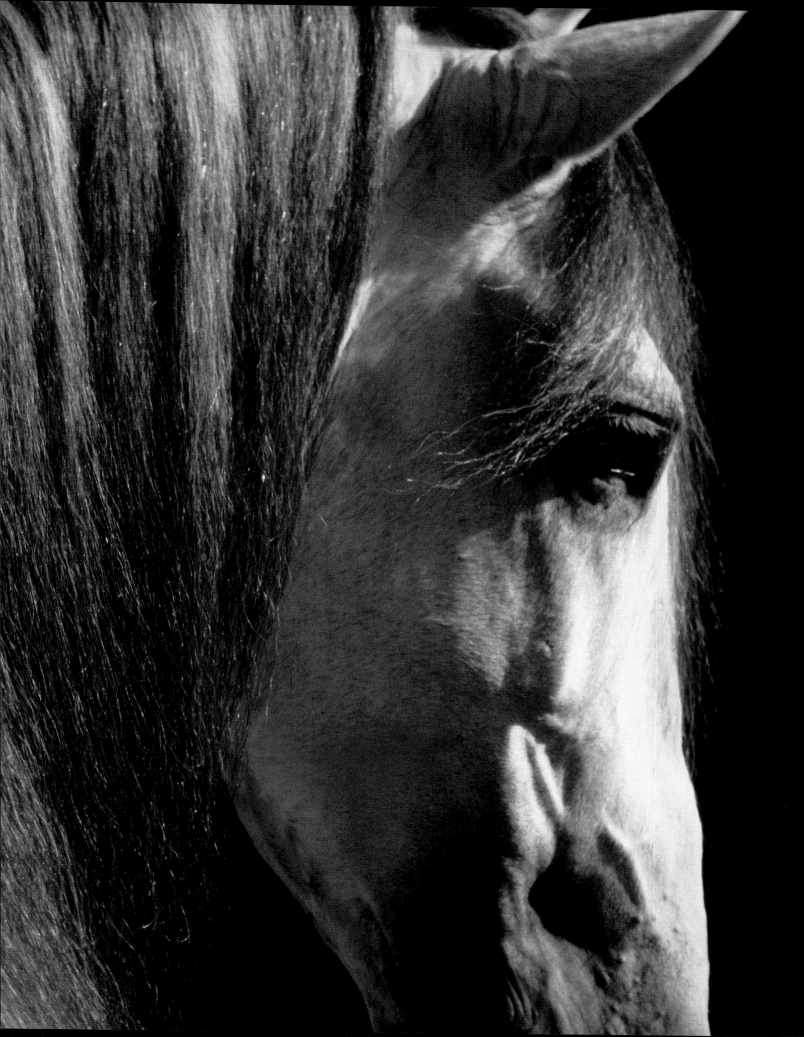

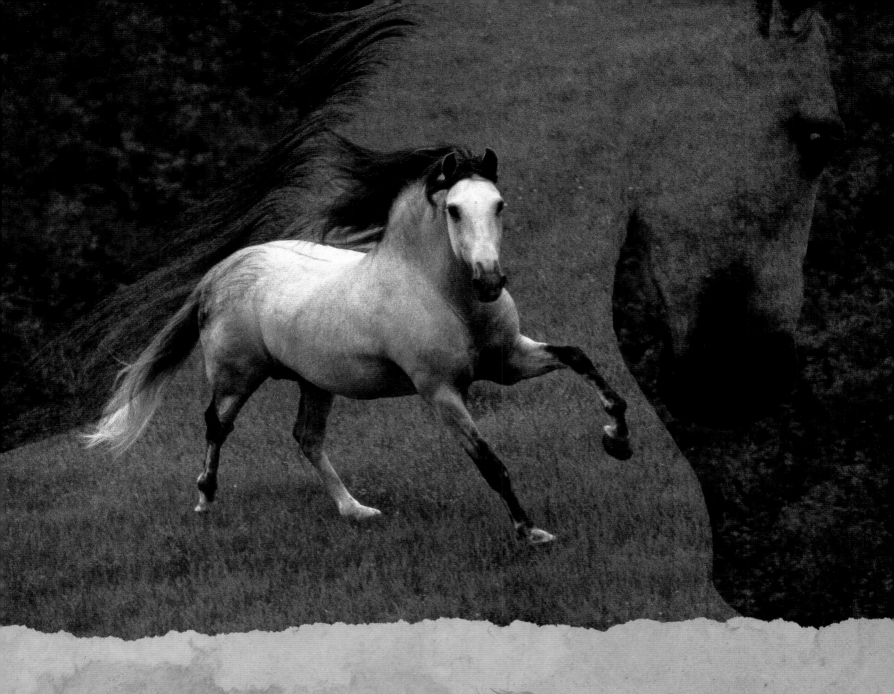

Movement
is
the primeval
element
of my being,
joyous

14

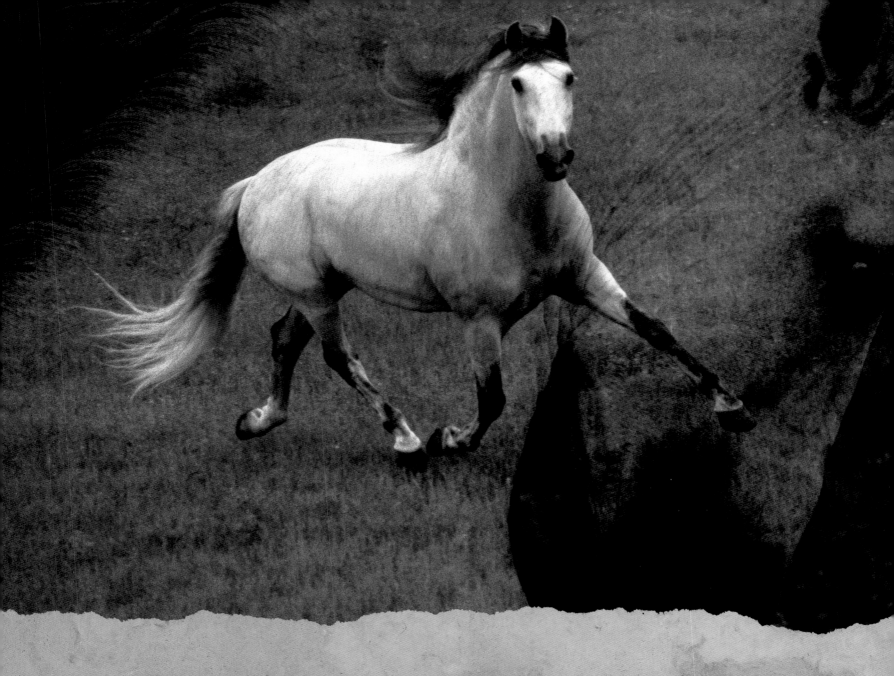

movement
in
the
wide
spaciousness
of freedom.

15

I am

as

wild

and

as

swift

and

as

buoyant

in my flight

through the fields

as any eagle

that ever

soared

into

the clouds.

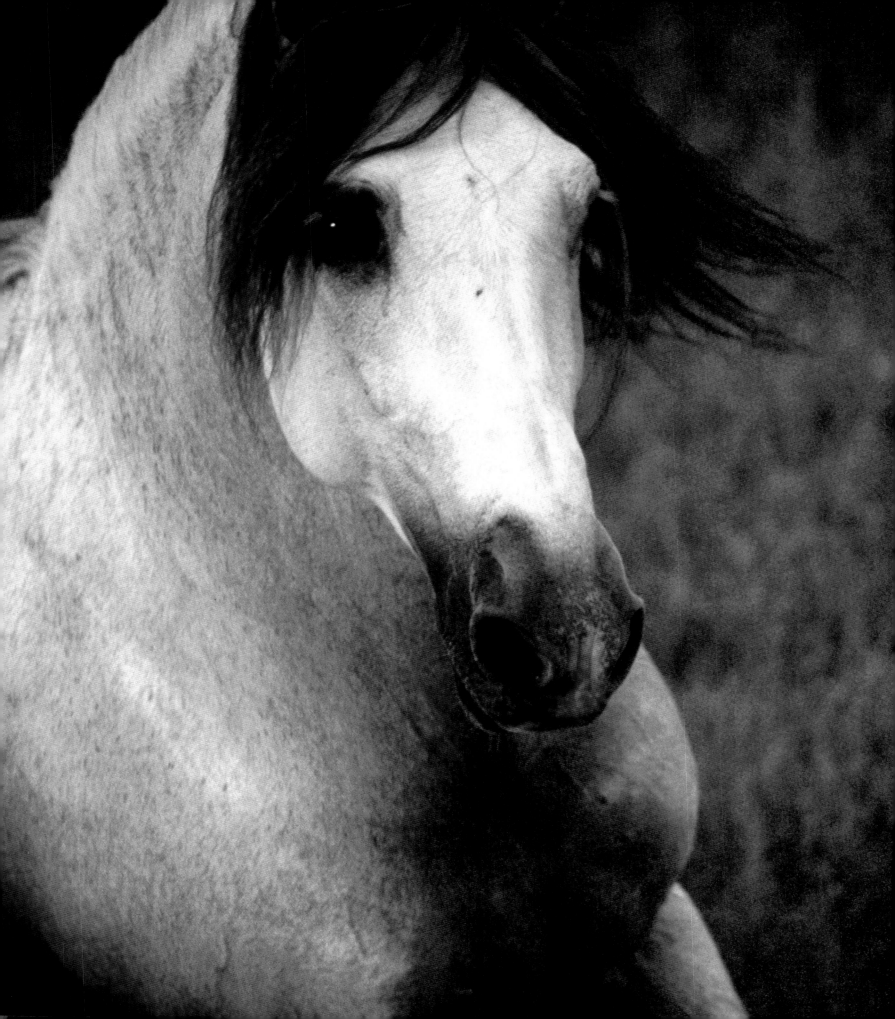

Azure
grapes
of
the Parra
in
my Spanish blood,
deep
draughted wines
of
memory brew.

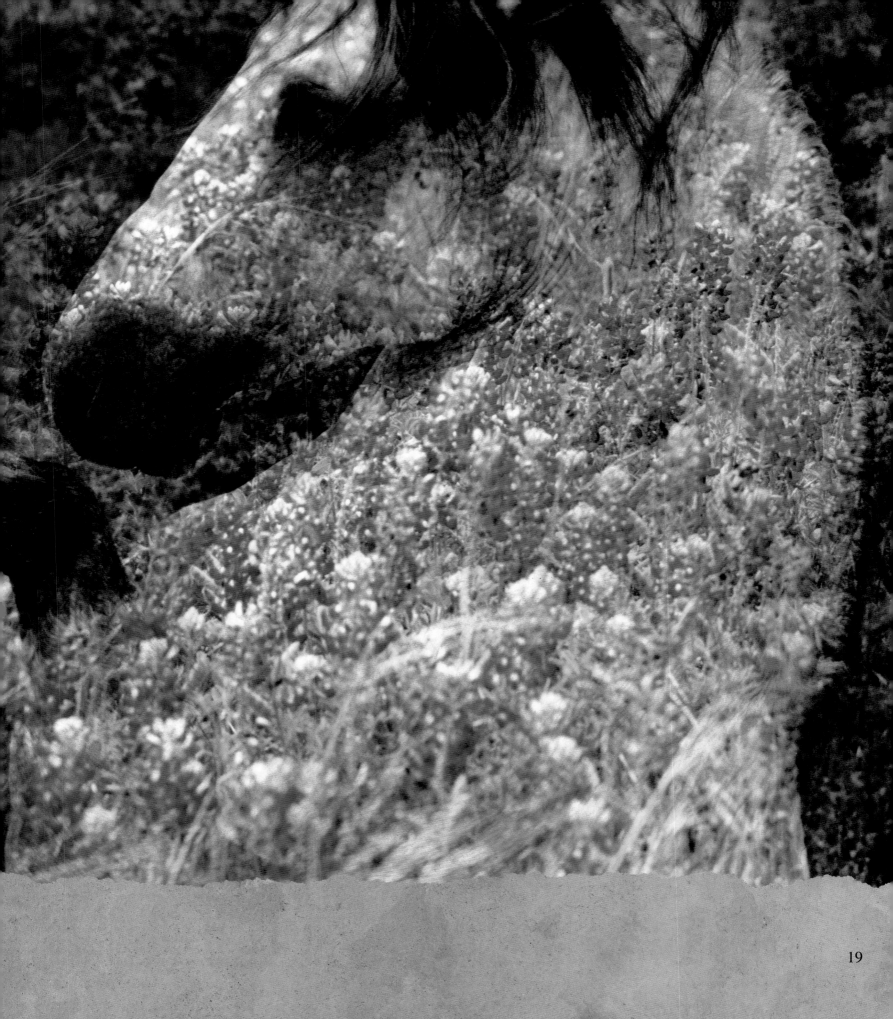

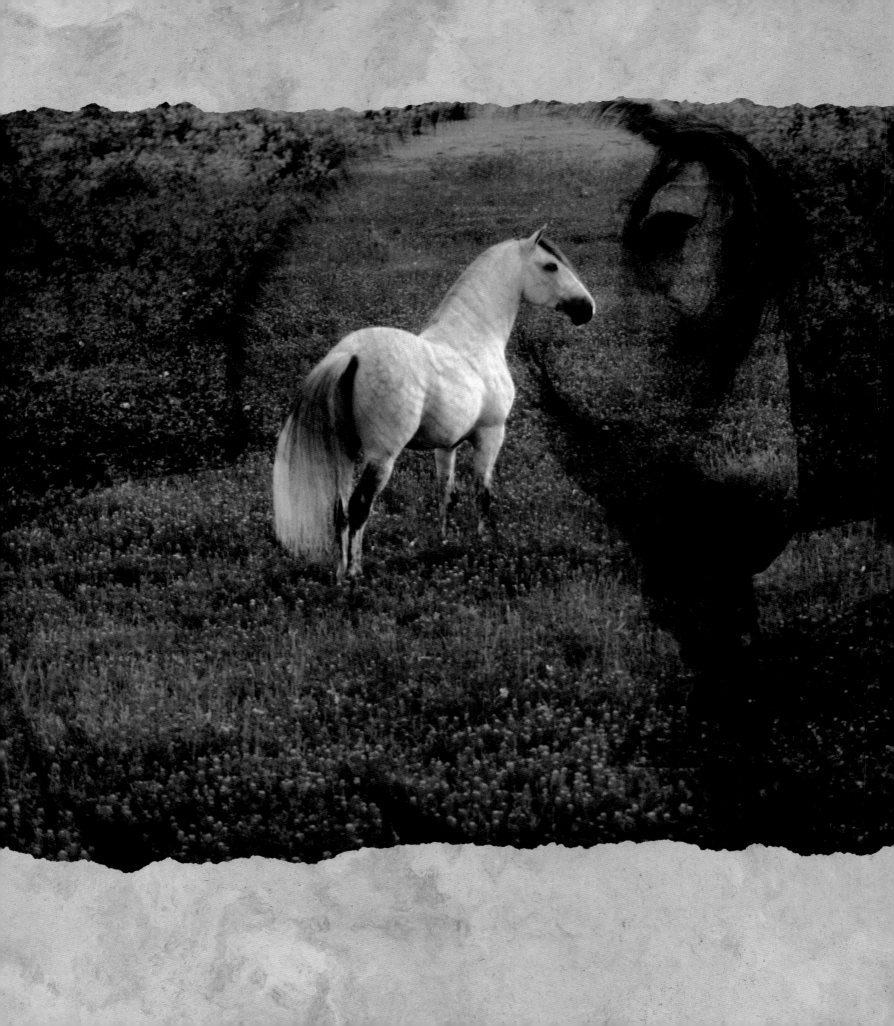

I,
El Noble Bruto,
extend
my
noble name
to thee
of
lesser form.
Thus become
—caballero—
gentleman
of
the horse.

Boticario's Song

CH Santana Lass

Far,
far
from
my glorious past,
far
from
the trumpet's call,
from
the rolling surf
at each pass,
long
will be remembered
my name,
Santana Lass.

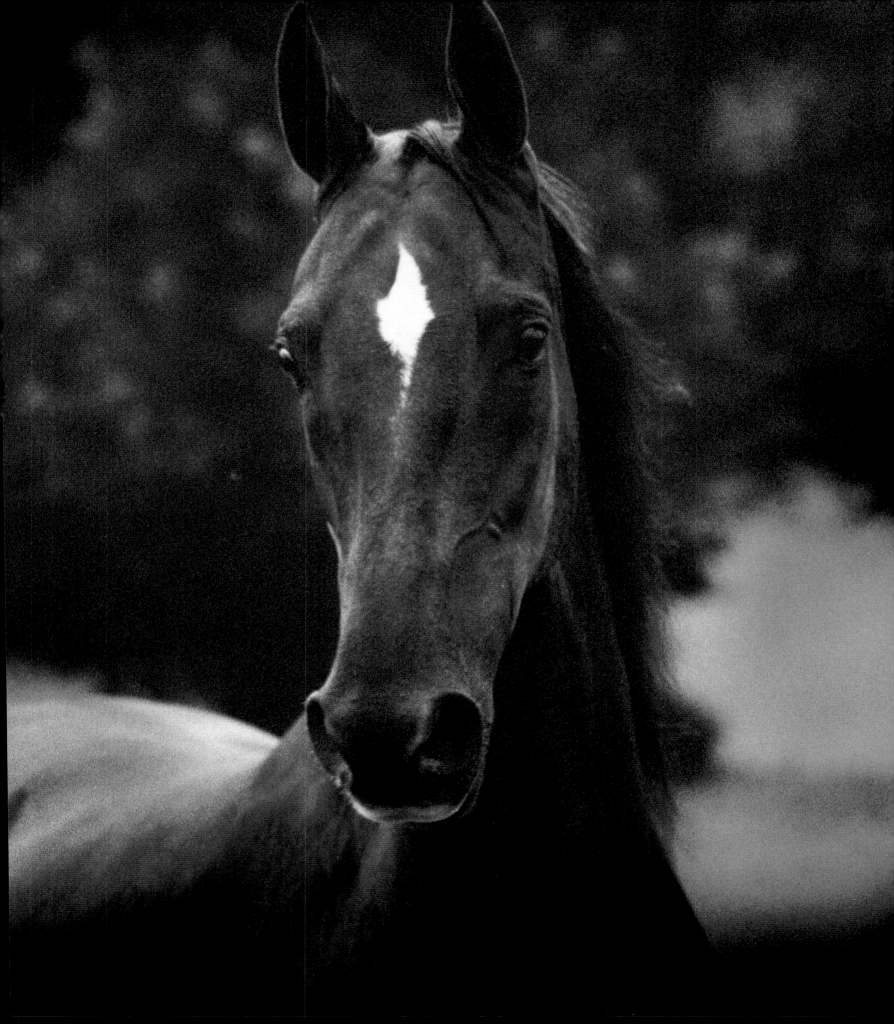

Now,
with this foal
at my side,
each high step
I take
is done
with
gentle dignity
and
modest pride.

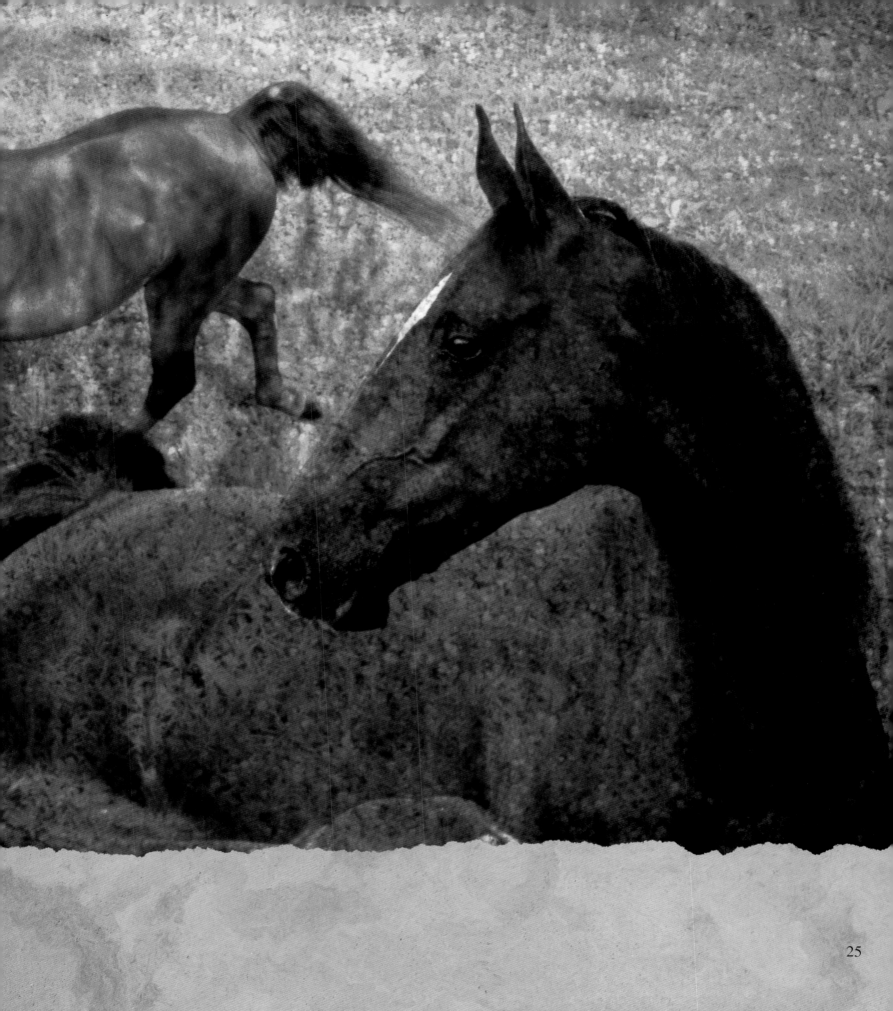

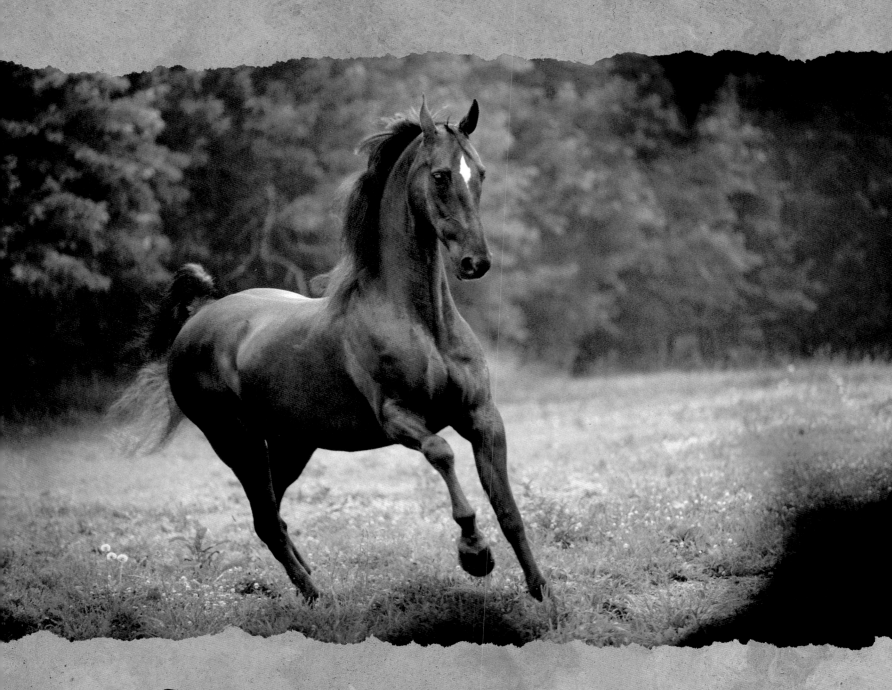

Few
stepped
higher
through five gaits,
rack-rack-rack,

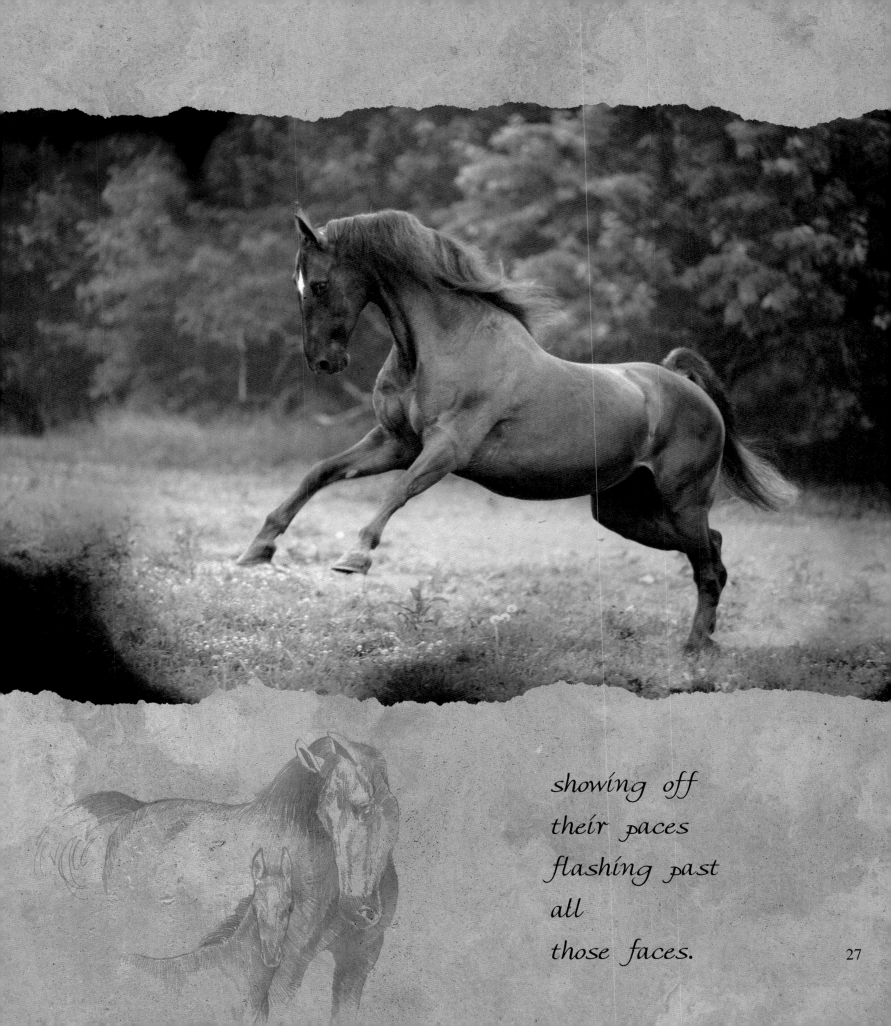

showing off
their paces
flashing past
all
those faces.

27

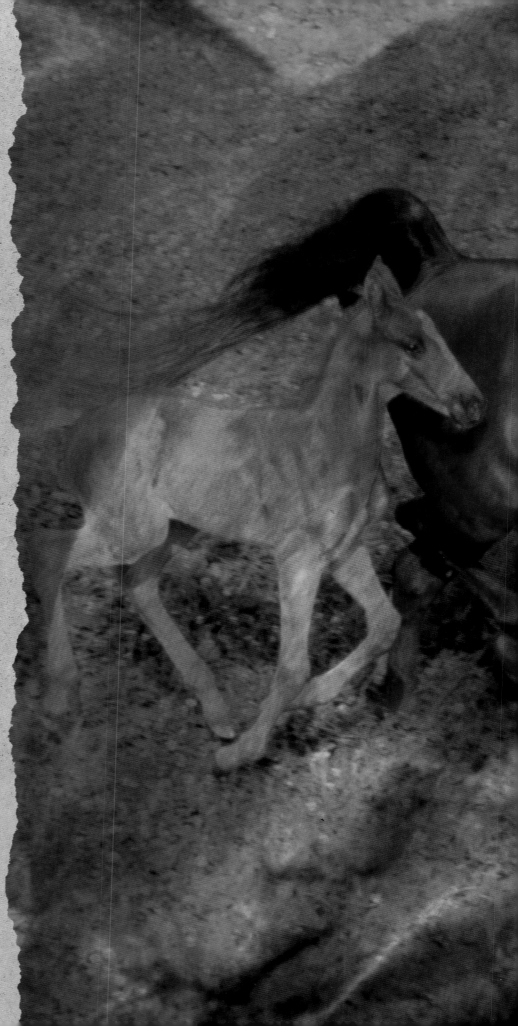

Right
from
the first
my foal,
which is
of
noble birth,
steps
higher
and
more lightly
treads
the ground.

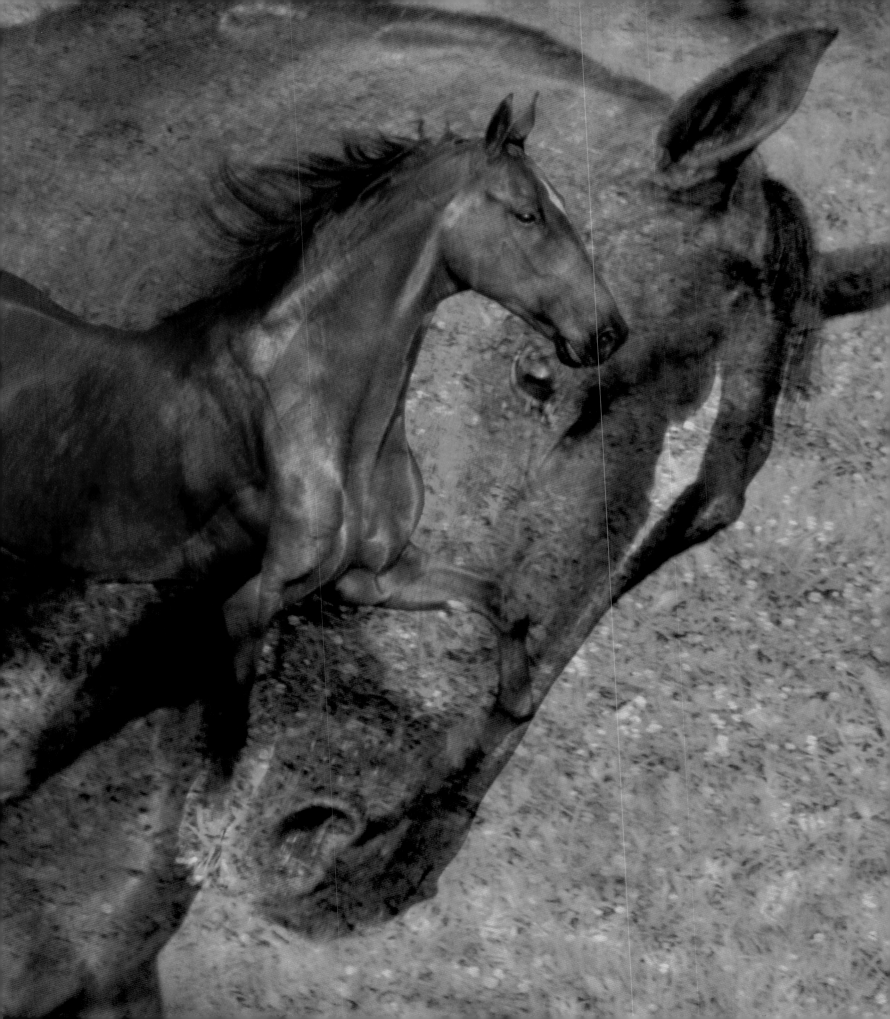

Today
in the pasture,
to passing eyes,
I'm
just another mare
with a foal
under
a
blue-blue-blue
Kentucky sky.
CH Santana Lass's Song

30

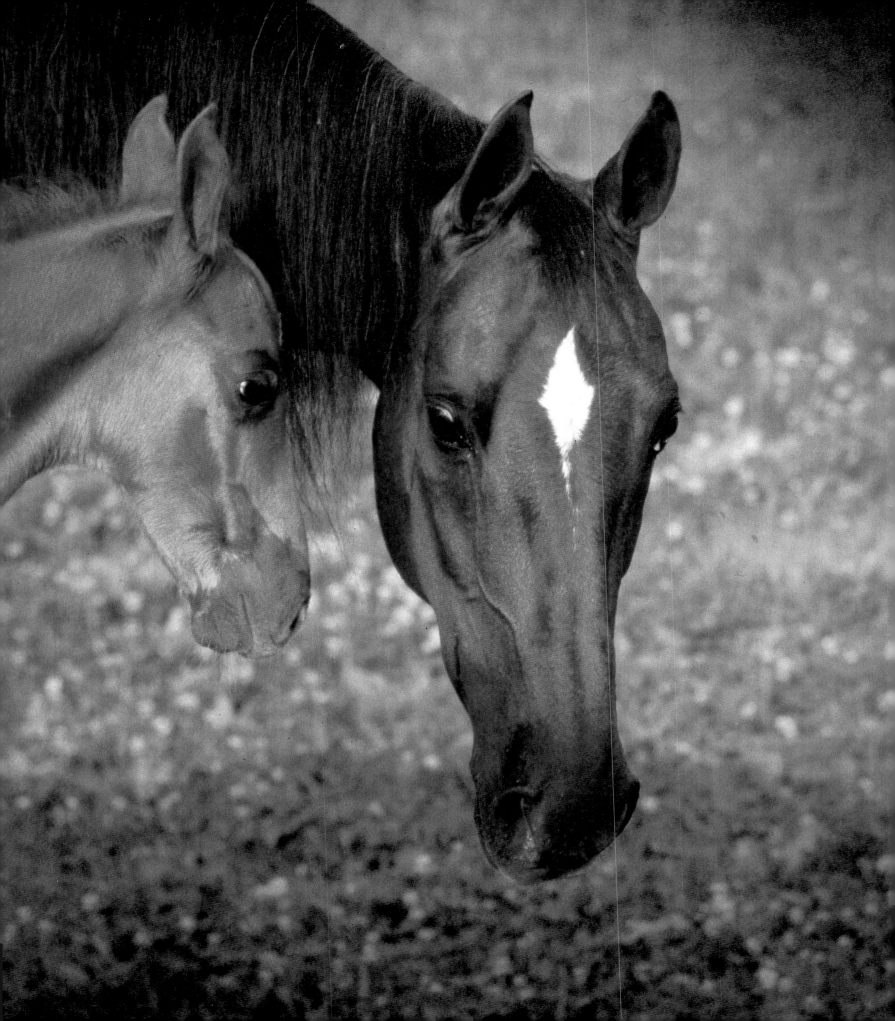

El ghazi

Treasure-laden
dhows,
few sailed
from
desert ports
with riches
such as mine
in
their prows.

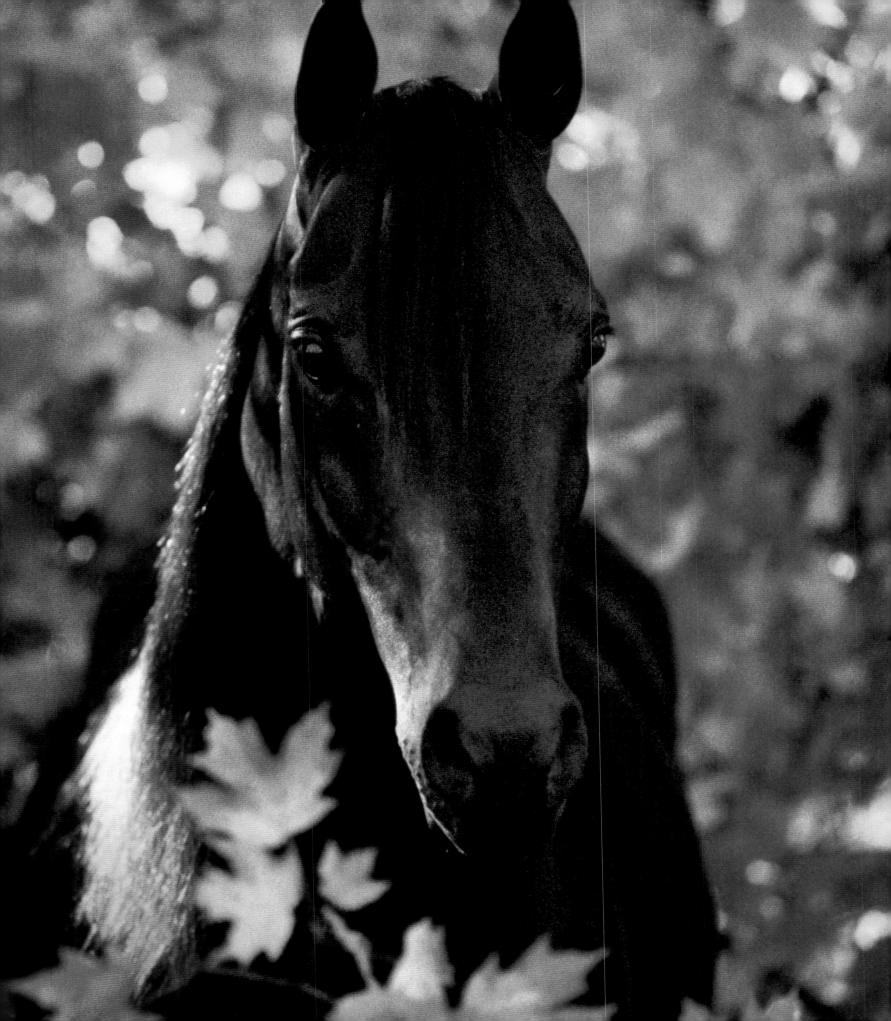

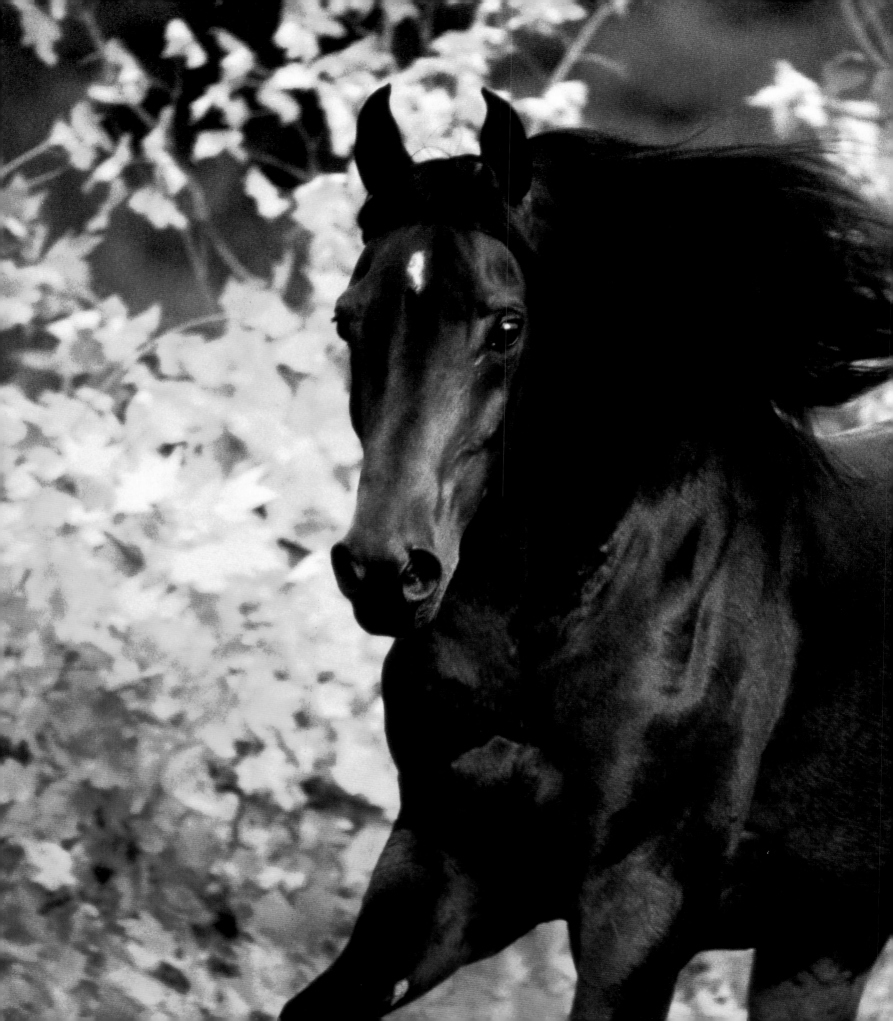

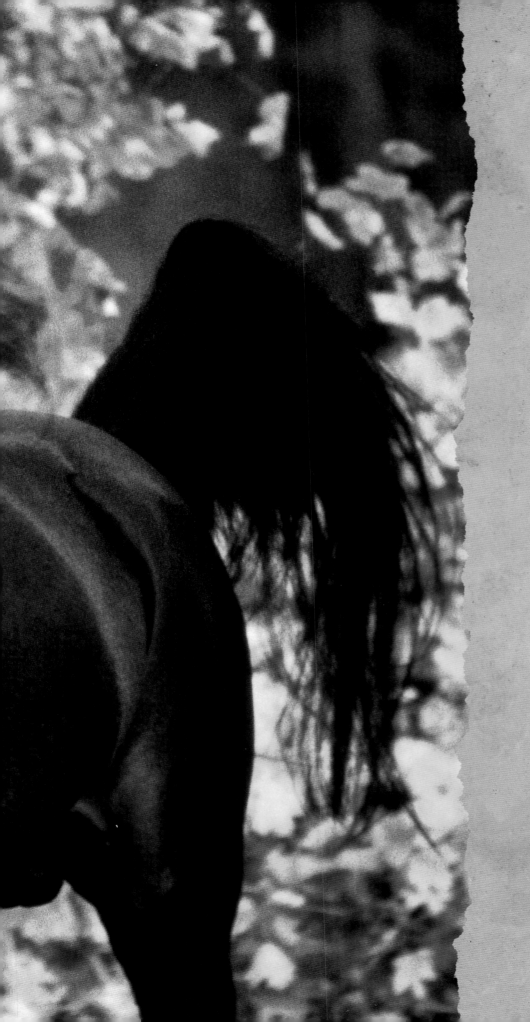

Given
the power
of
flight
without wings,
under
my hooves
the earth
to tambourines
of
Bedu
sings.

Drinker of the wind,
Raswan
would have
trembled
at my neigh,
this desert breath,
this zephyr
that blows
even
the sand
from
sandstorm skies
away.

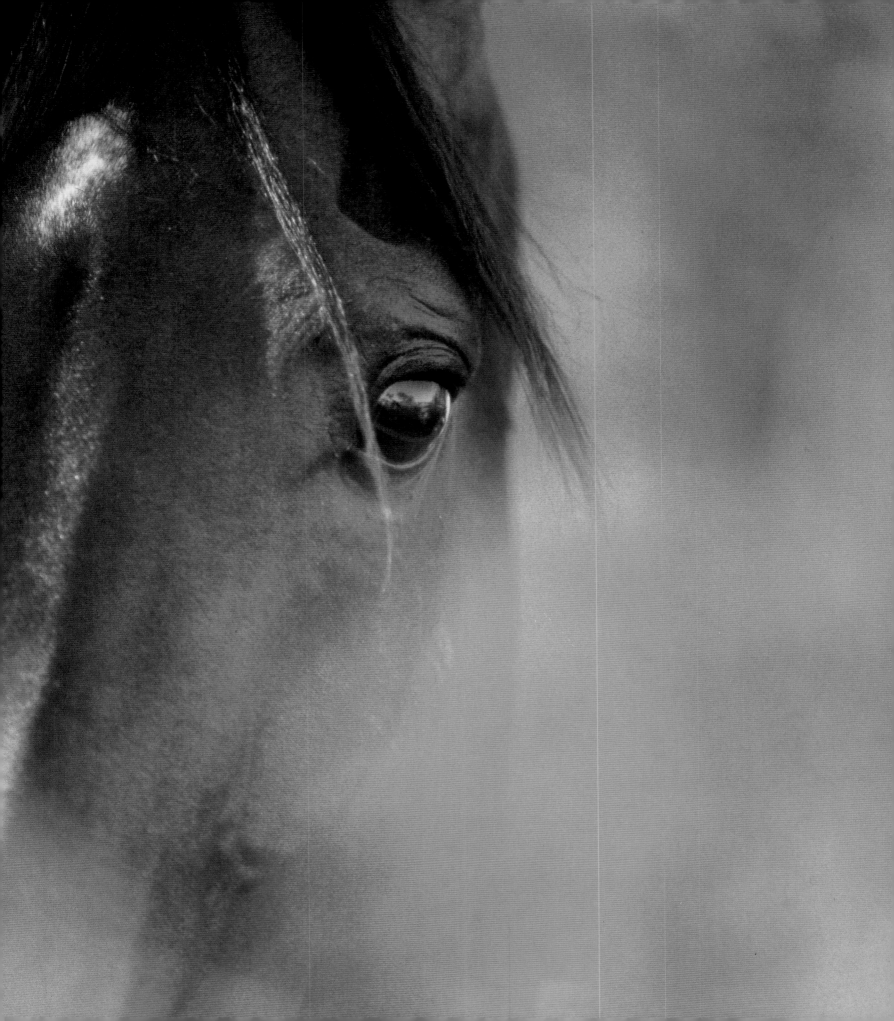

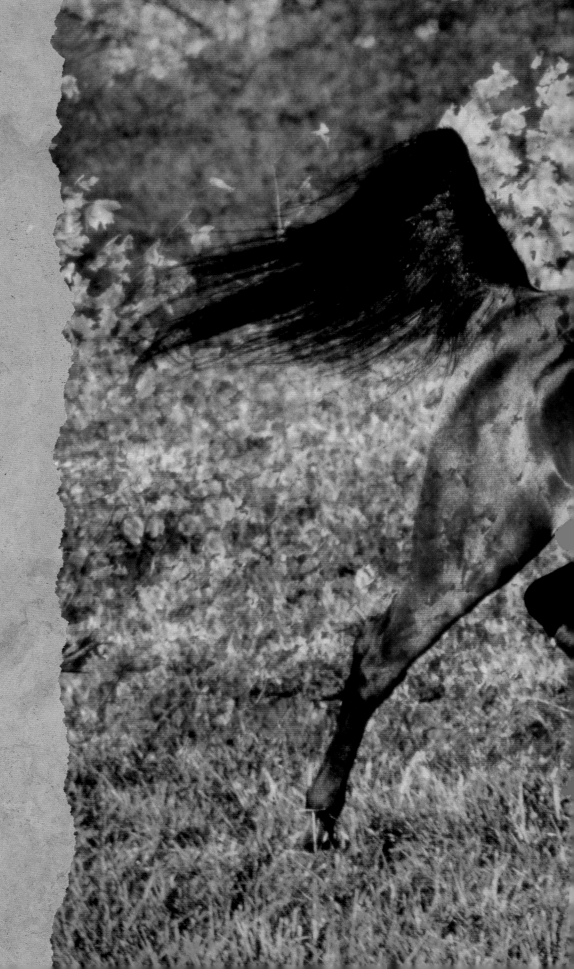

Like
a wave
off Lamu
this crest
proudly arches,
swells
and
gleams,
hurried on by
my
ebon
and
wind-combed
mane
against a sea
of sunset leaves.

38

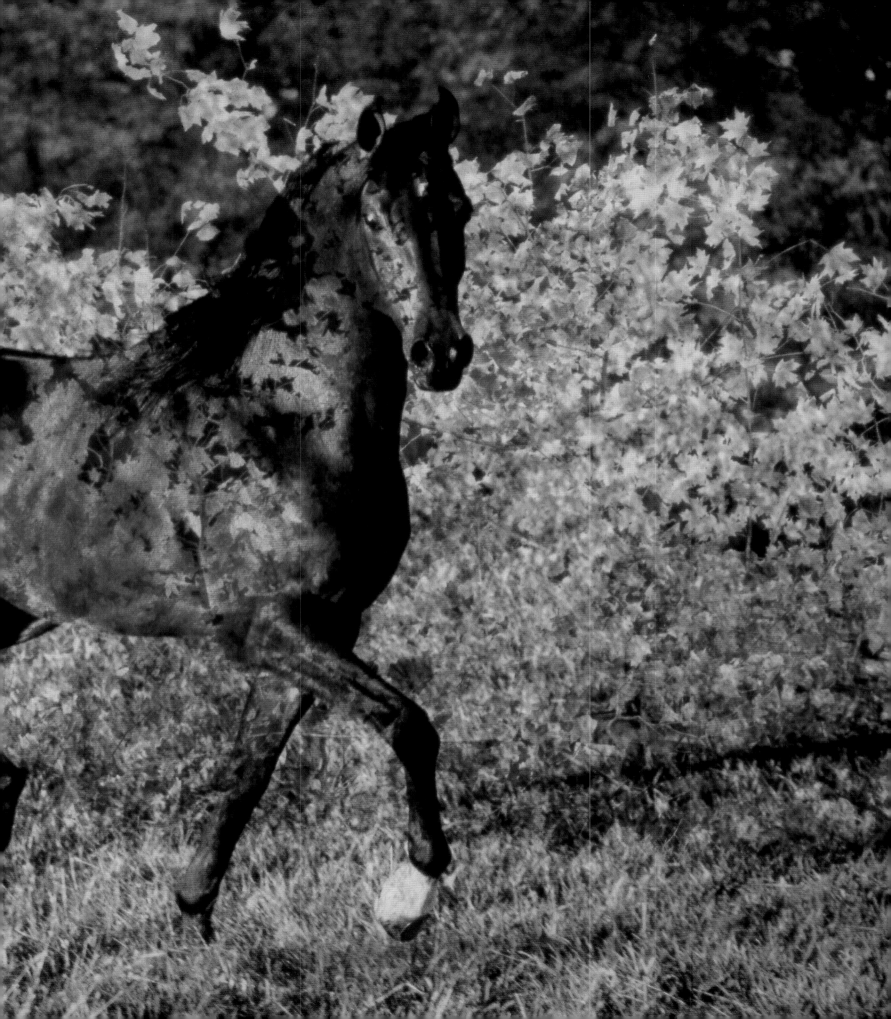

From

the prick

of

my ears

to

the flow

of

my tail,

the Bedu call

resounds

in my throat

and eyes.

Oh, marvelous

with

the drifting clouds,

I drift

40 the sun-flamed skies.

El Ghazi's Song

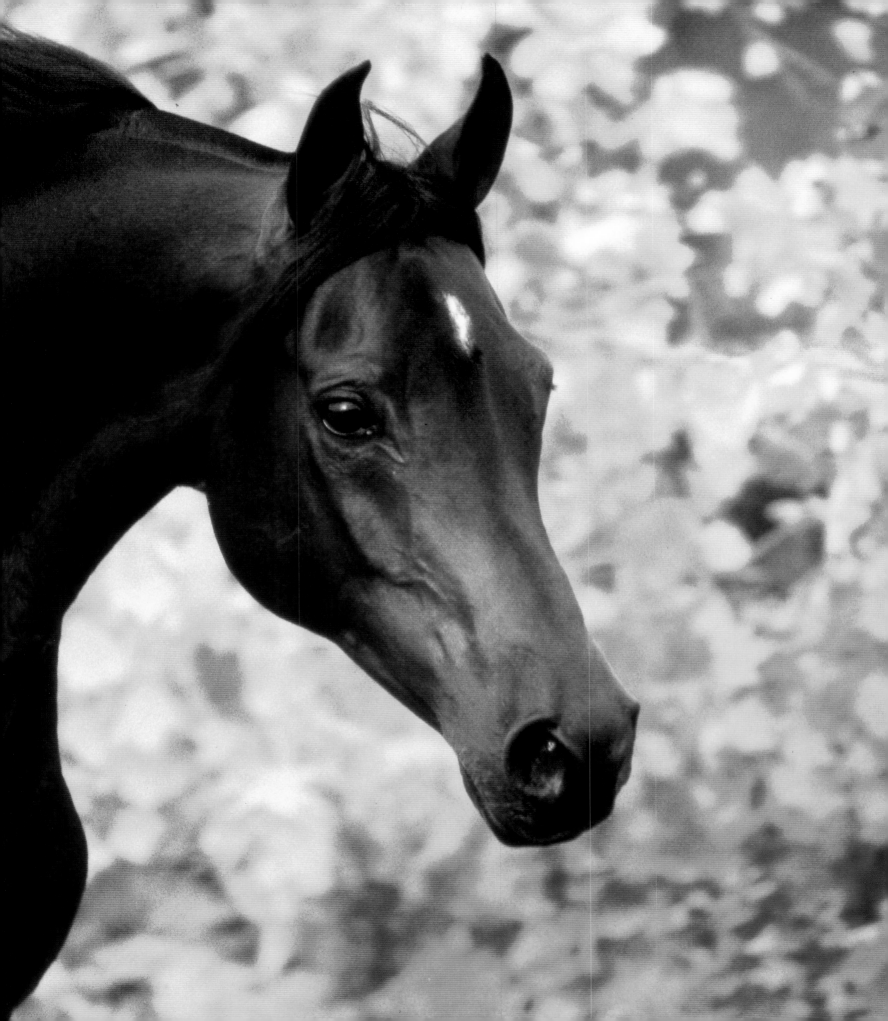

Alada Baskin

I am the dolphin
of the dunes,
the dhow of sunshine,
steed of fire.

42

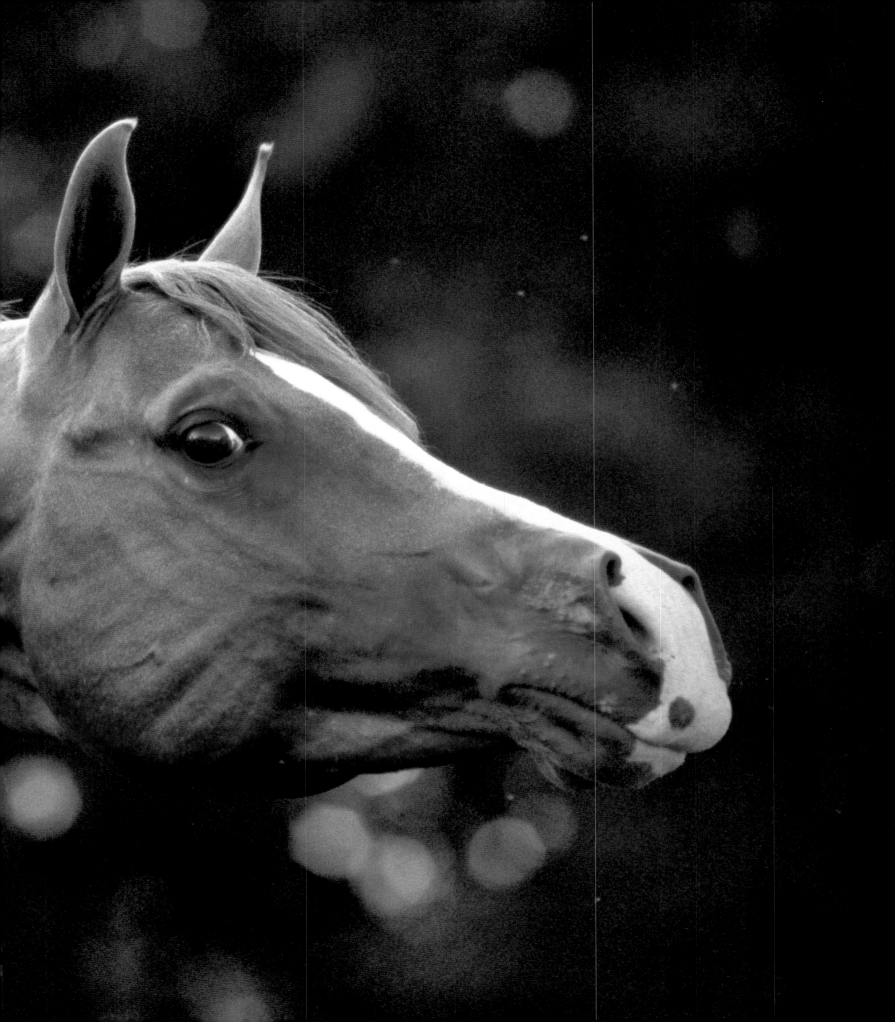

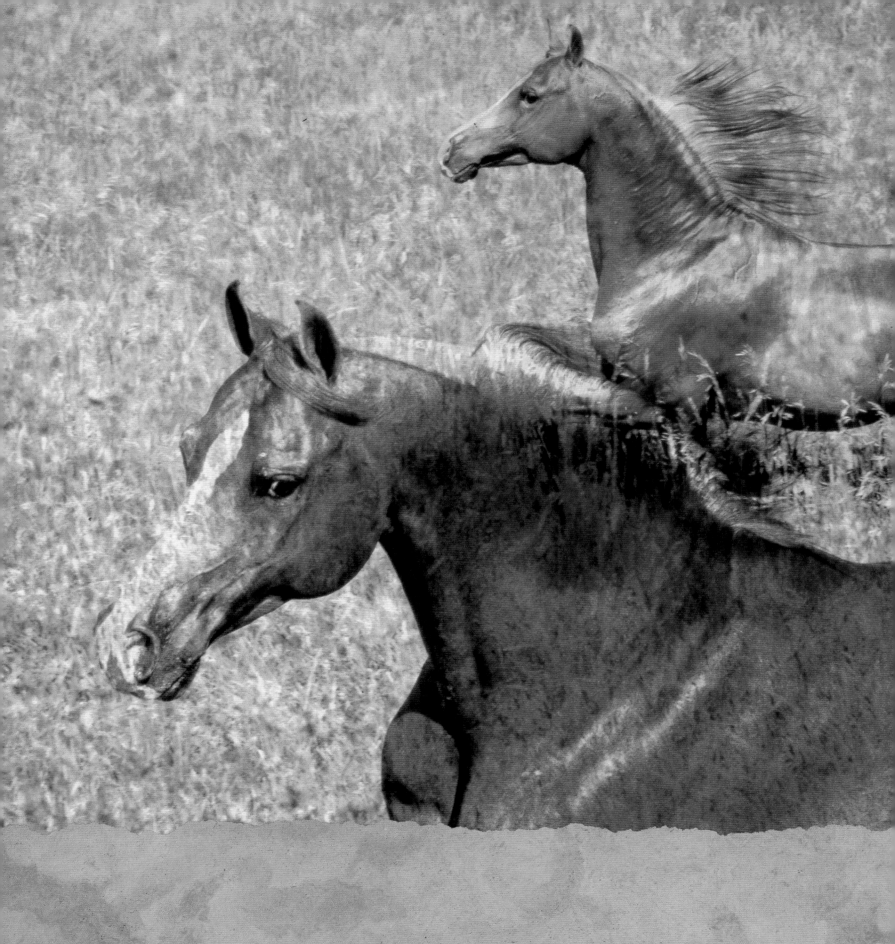

At once the courser
and the shallop,
the charger
who on each surge
of wind
will gallop.

With proudly arched
and copper neck
and dark
and fiery eye,
I long to roam
the desert now,
with all
my winged speed,
borne
with the swiftness
of Nasim,
for I'm
of
the Bedu breed.

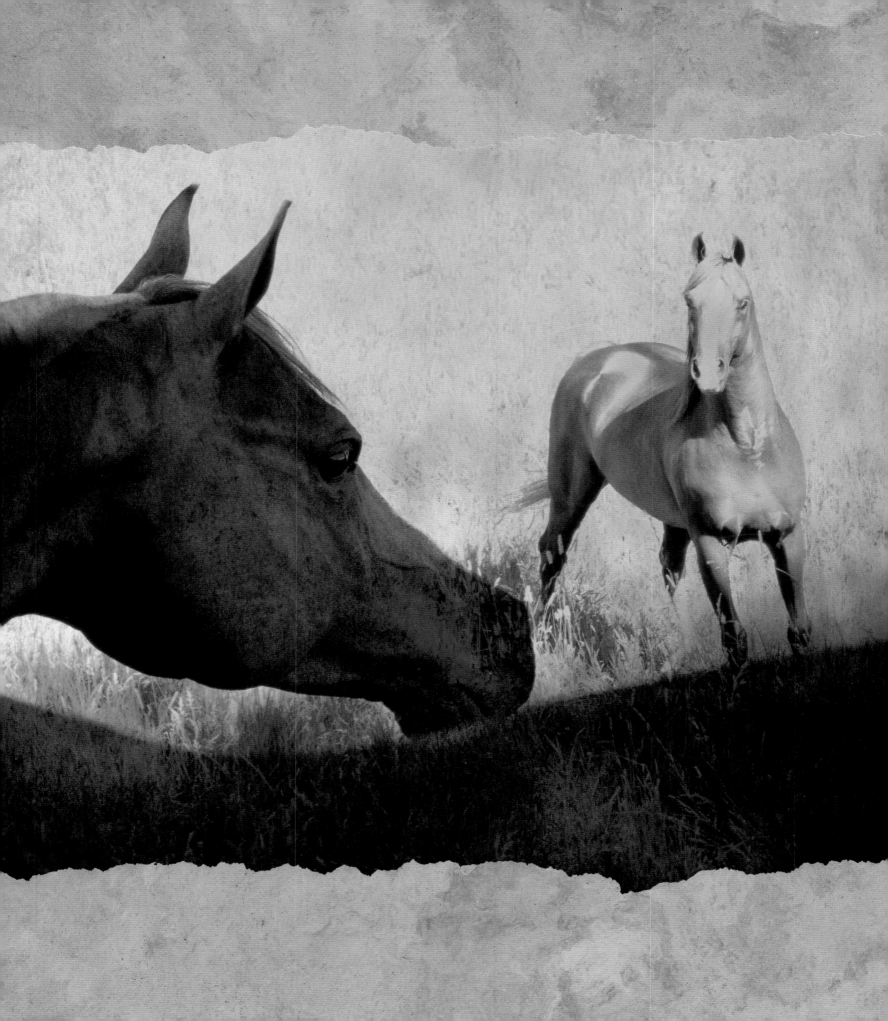

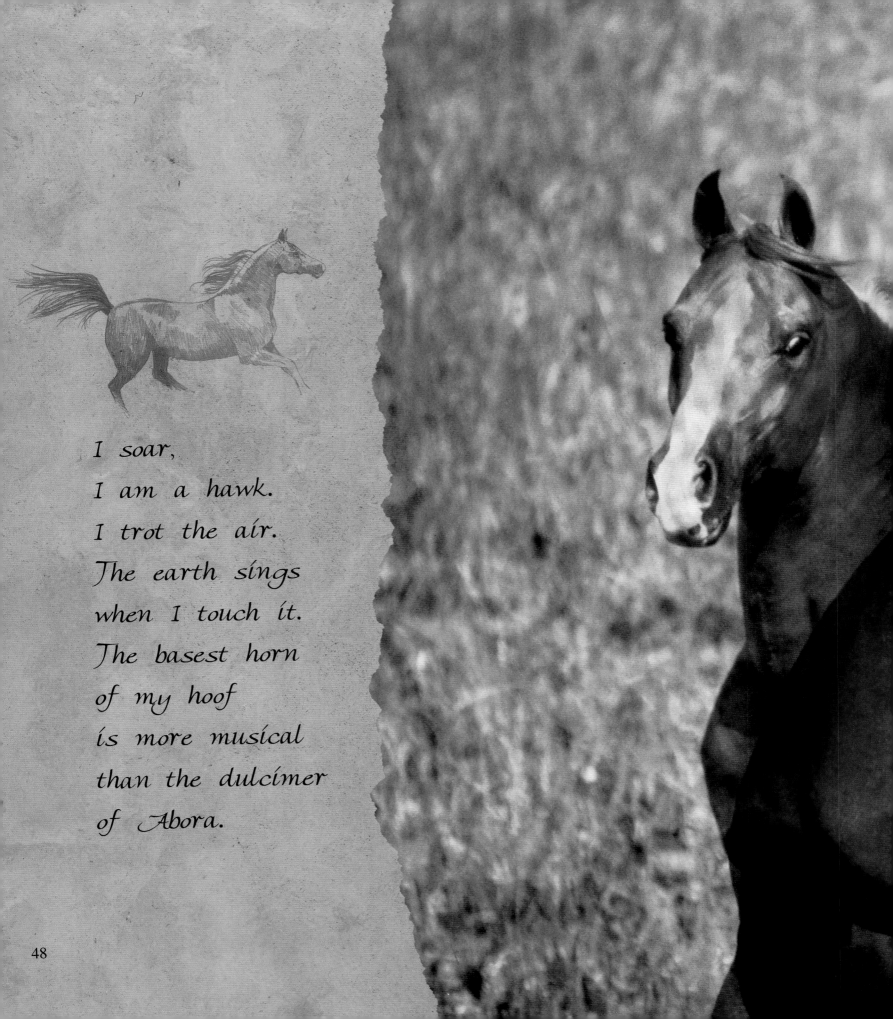

I soar,
I am a hawk.
I trot the air.
The earth sings
when I touch it.
The basest horn
of my hoof
is more musical
than the dulcimer
of Abora.

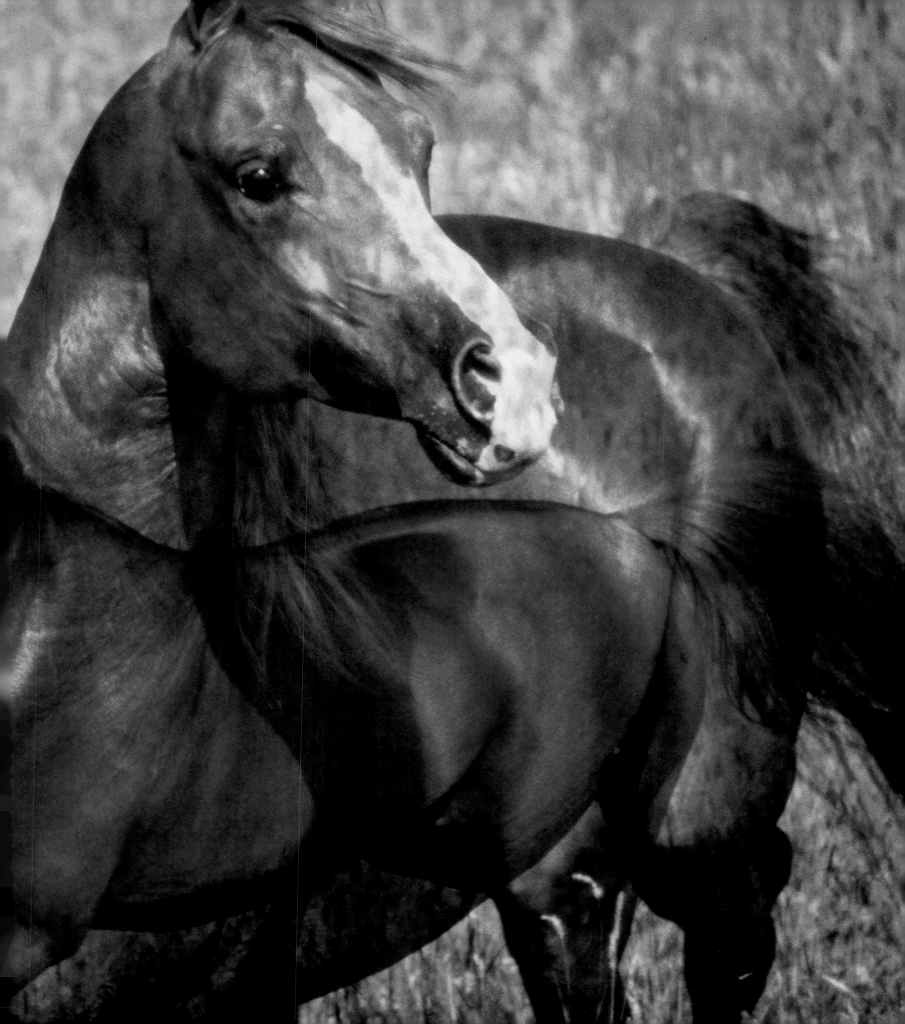

The falcon circles high,
a shadow in my desert eye.
What Meccan vision
halts my gliding dance
to catch me in
this Bedu trance?

Alada Baskin's Song

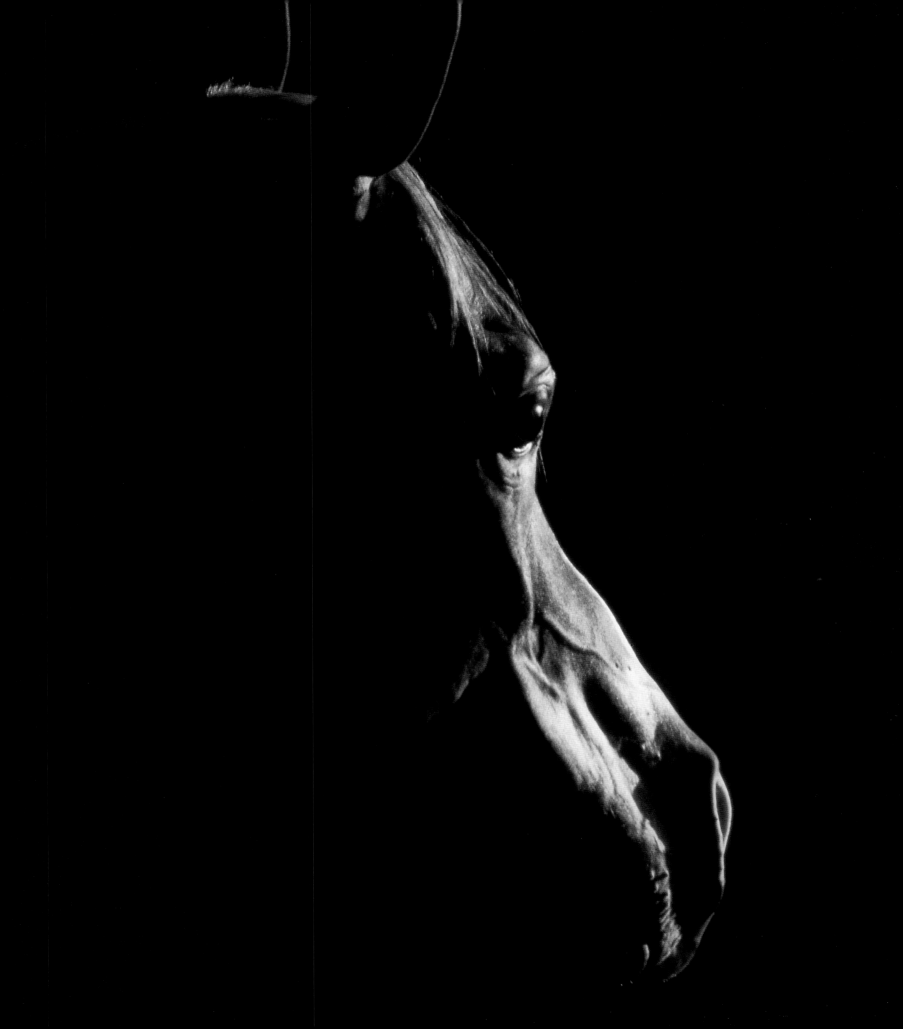

Normando

In
the dappled clouds
of
my stallion sky
Iberia's
golden history
flashes
by.

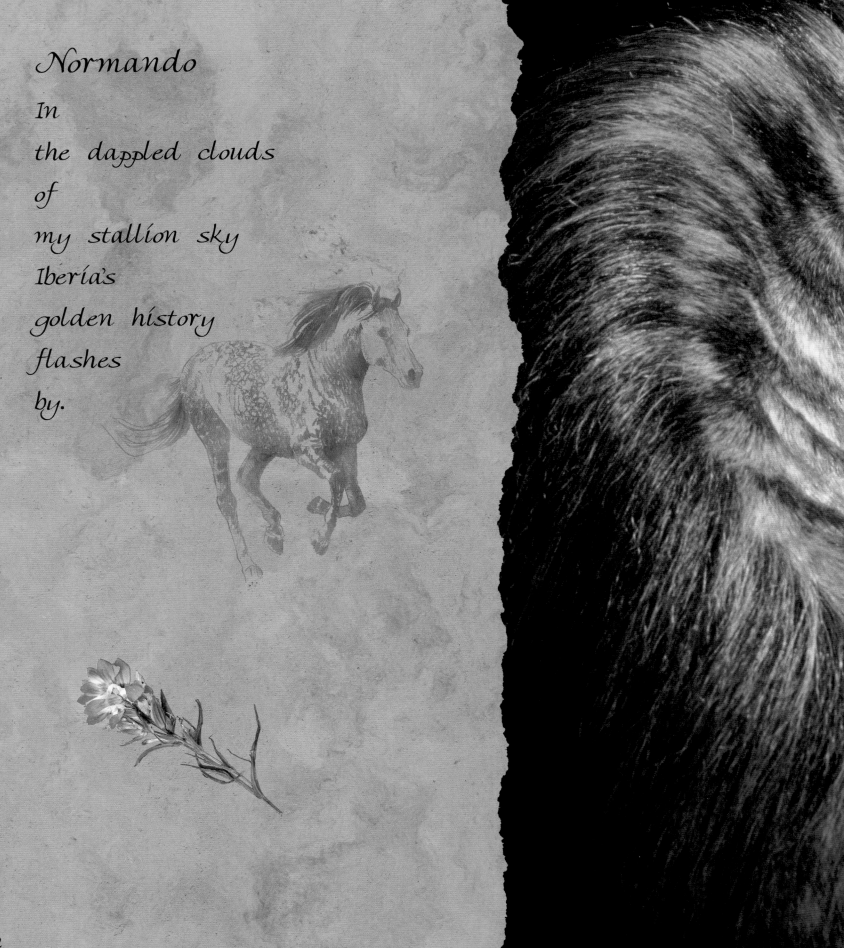

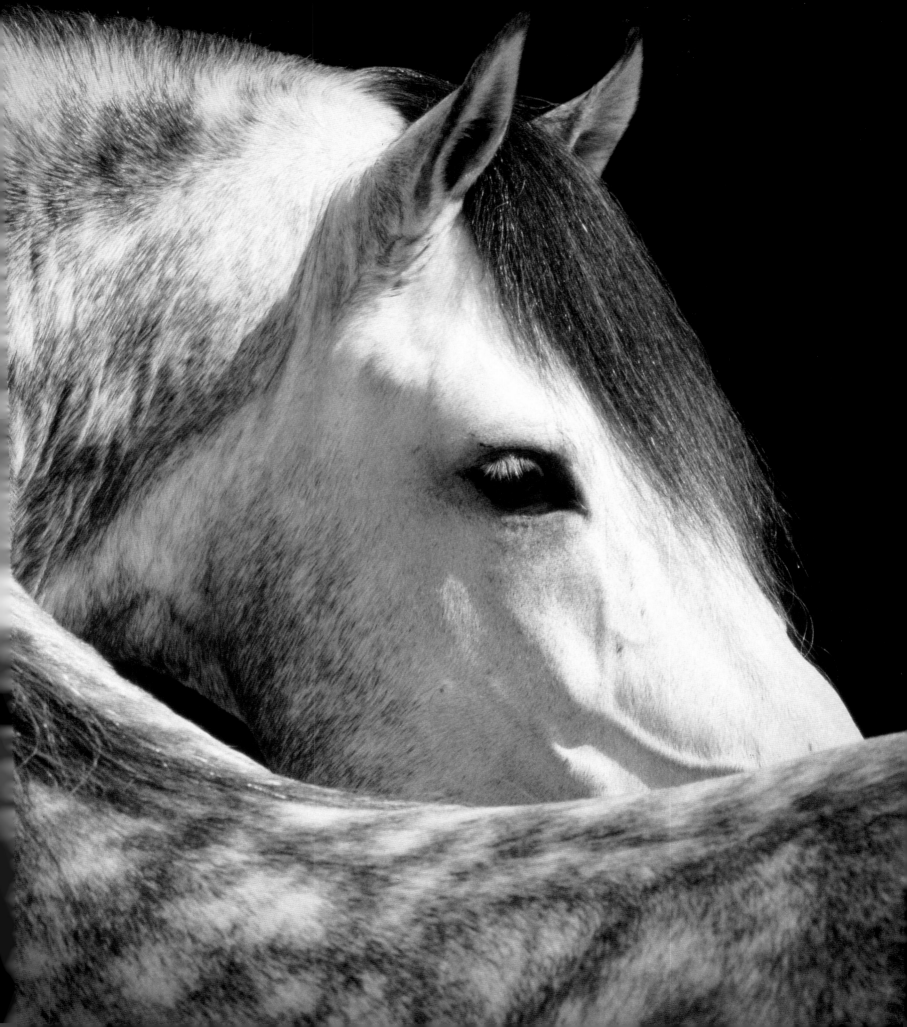

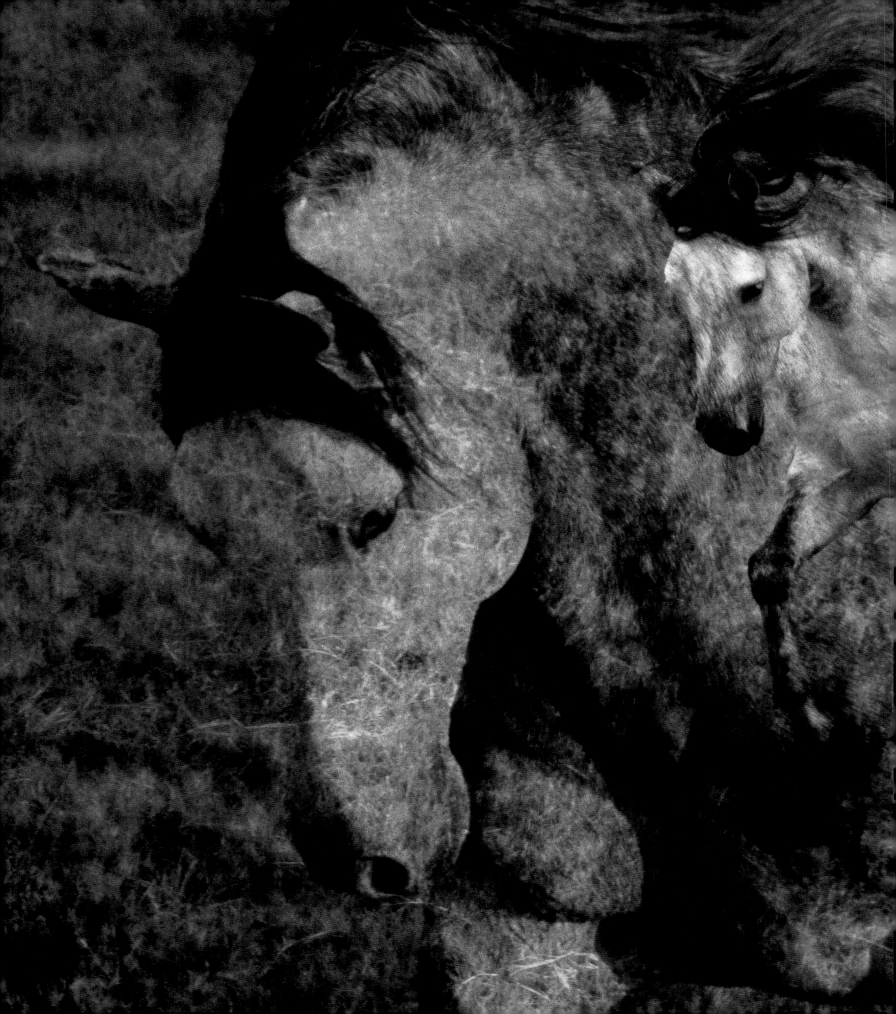

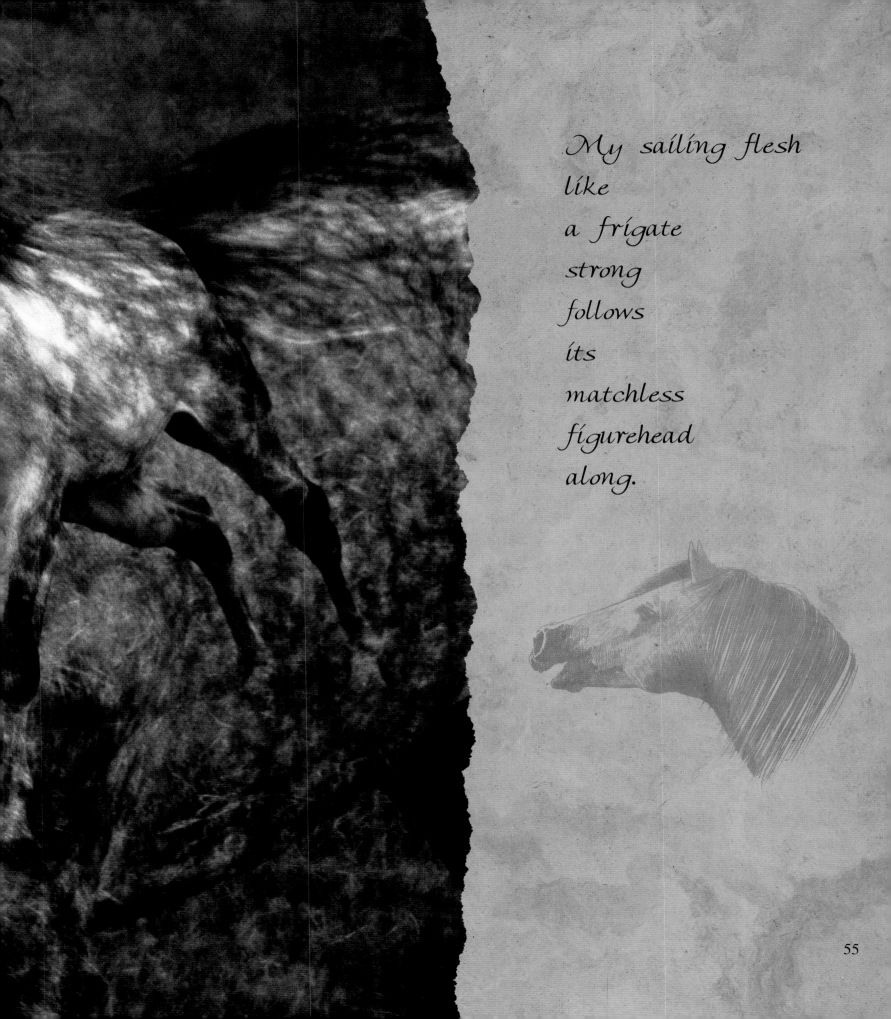

My sailing flesh
like
a frigate
strong
follows
its
matchless
figurehead
along.

55

And blossoms
spring
beneath me
all
the way
to shower
my sunset passage
with
a fragrant
wake of spray.

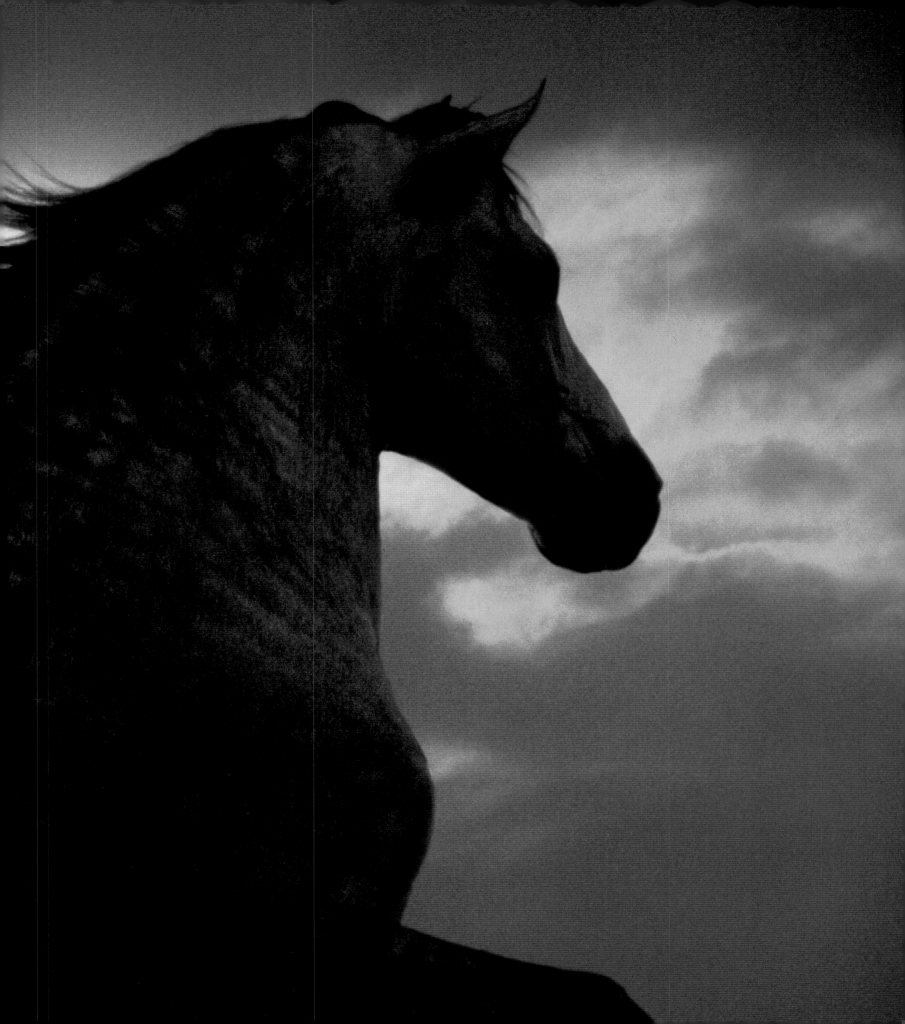

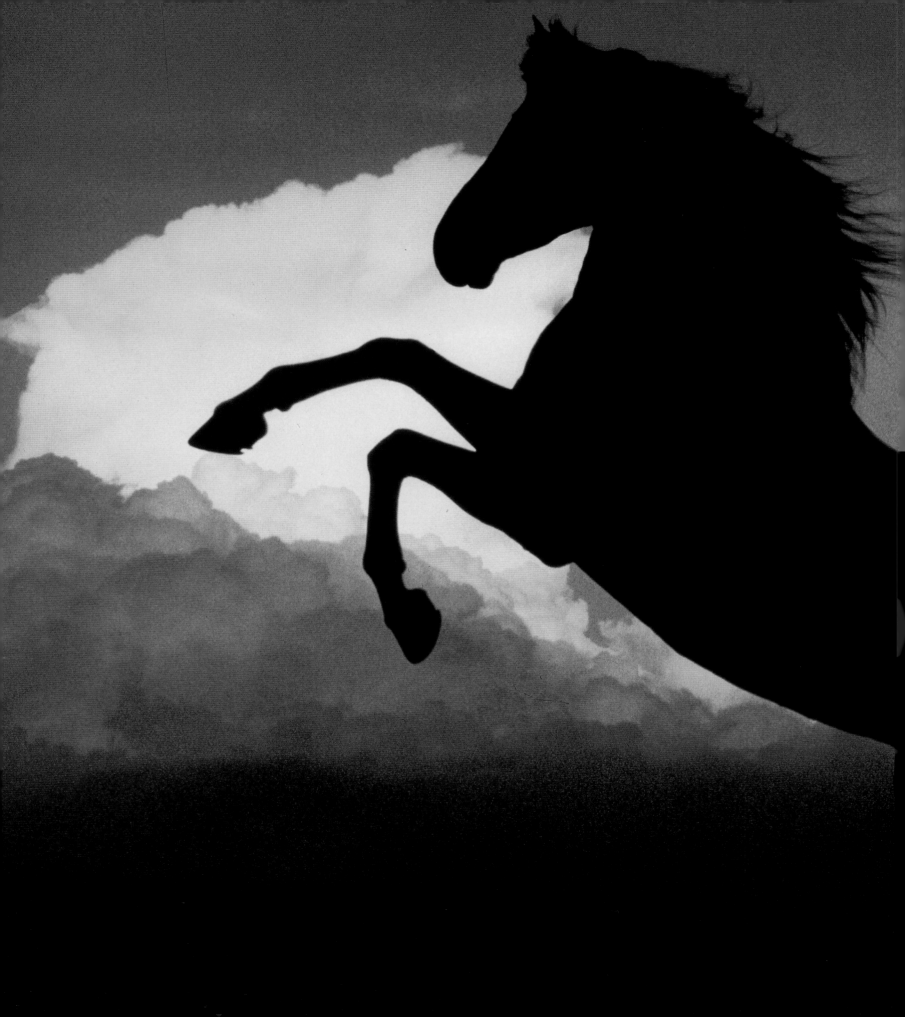

Upon raw pinions
of the wind
I speed
like a meteor
into the sky,
with lifted tail
and
cataracting mane.
Gloria to the fields
of
Andalusia
from whence
came my name.

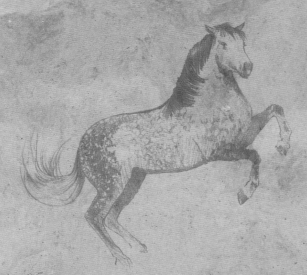

There was a slight breeze
that played through
my mane and tail,
bringing with it
the scents of
orange blossoms
of Sevilla,
sherry
of Jerez,
jasmine
of granada,
nardos
of Córdoba,
and salt
of Cádiz.

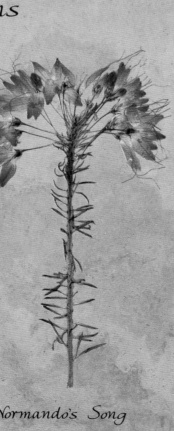

Normando's Song

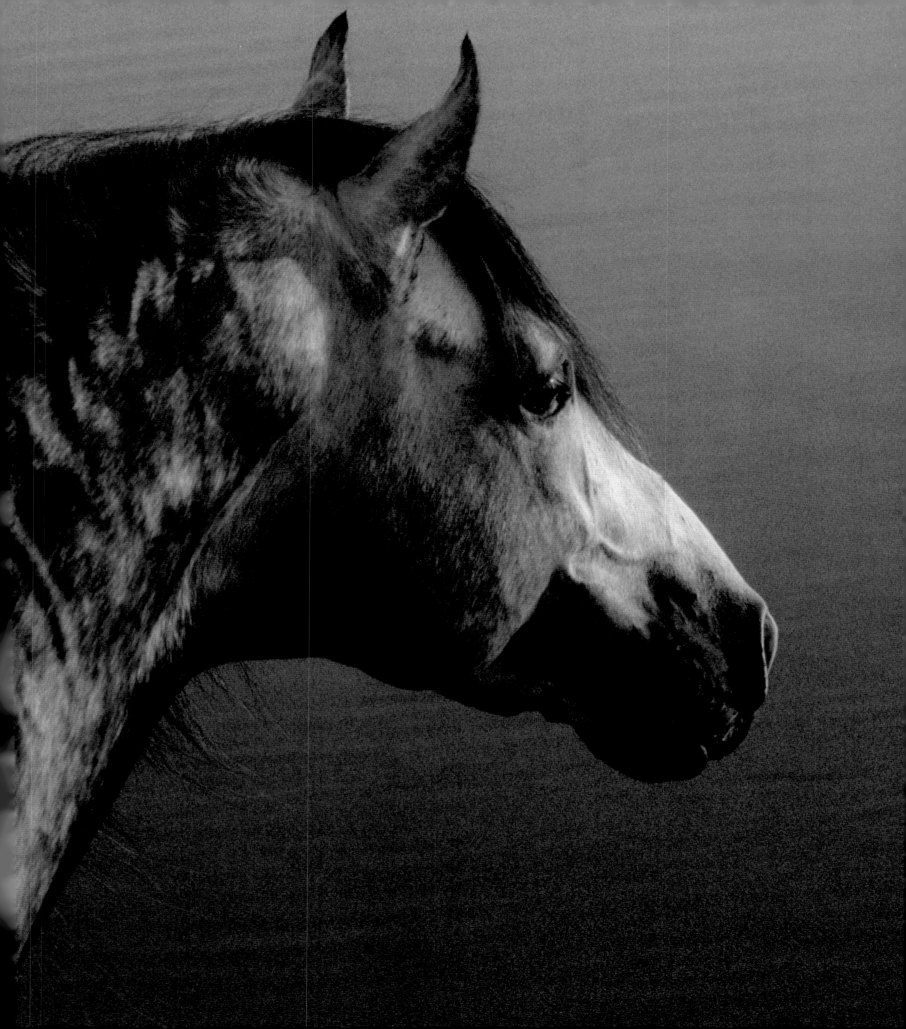

Callaway's Gold Rush

I am

pure

fire

and

the dull elements

of earth and water

never

appear

in

my being.

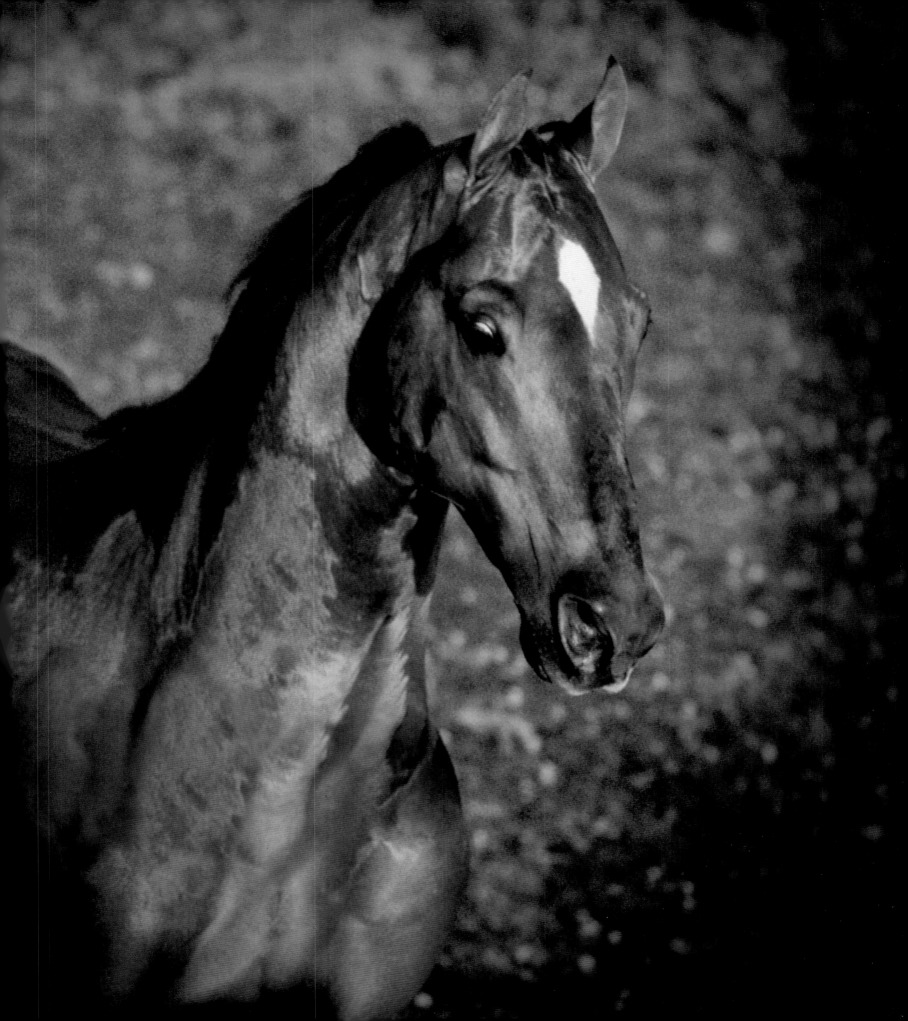

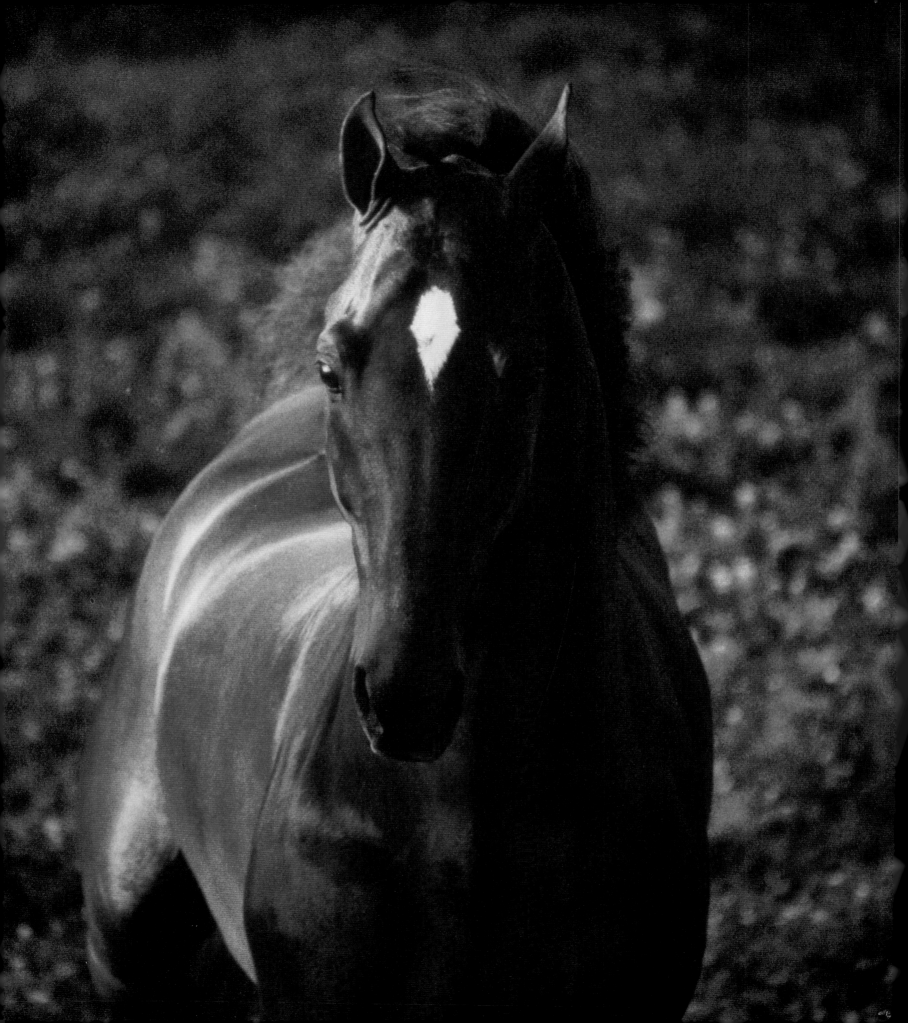

Like
a fiery plume
I lash my tail
to
step
so fiercely
high.
There is
nothing
so powerful,
nothing so quick,
nothing more
patient
under
this bluegrass sky.

Imperiously
I trot,
one gait
surges
into
another,
as
the bearing earth
my hard hoof
wounds.

66

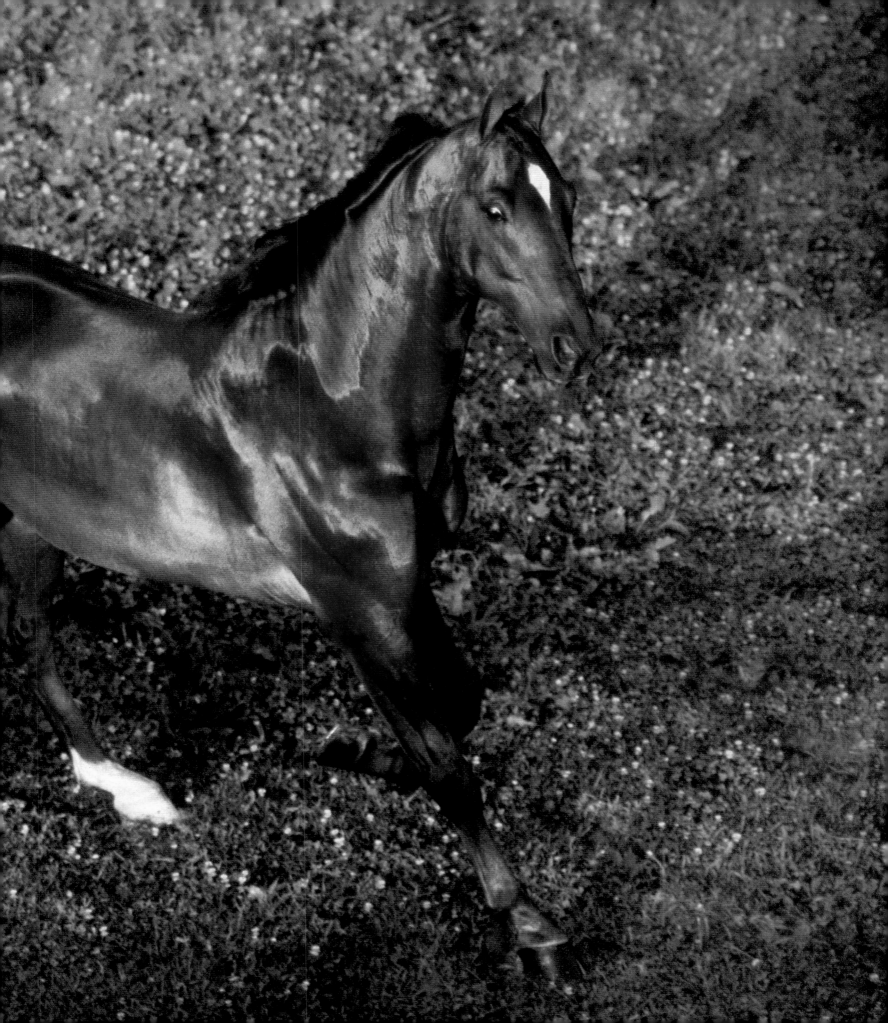

Where
on this brilliant morn
can be found
nobility without pride,
friendship without envy,
and
beauty without vanity?
Here,
where
grace
is laced
by
muscle
and strength
by
gentleness
confined.

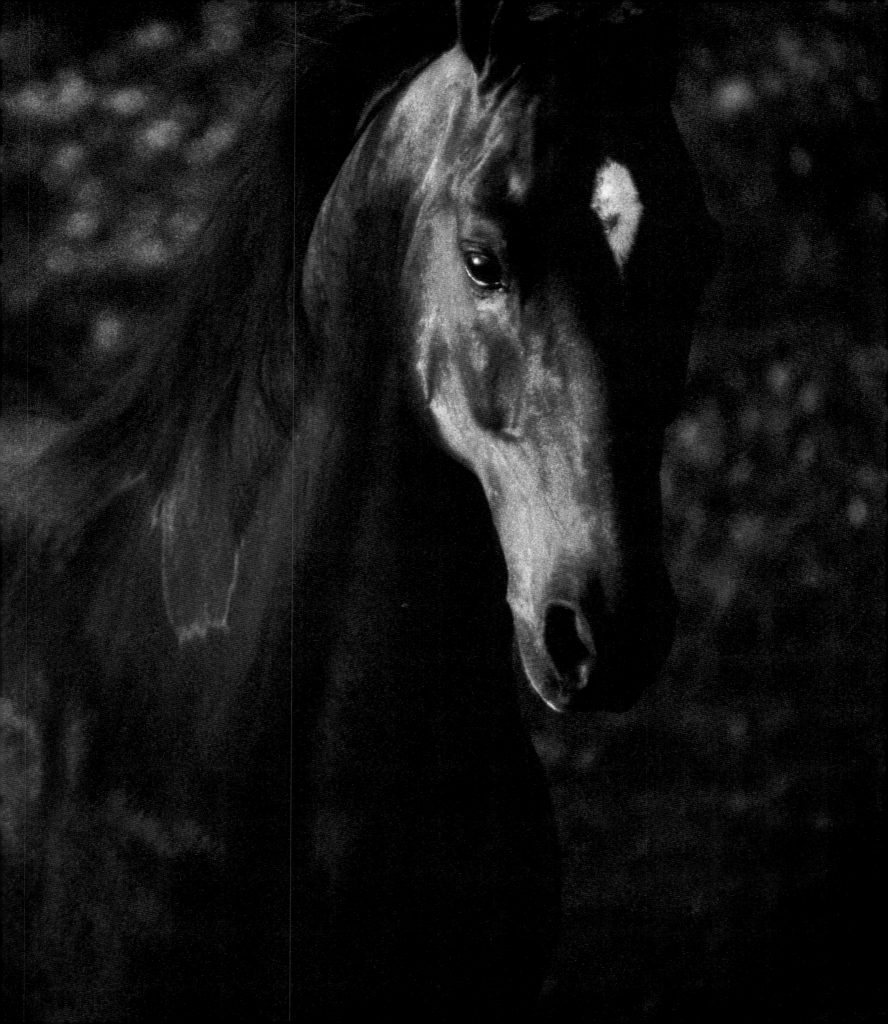

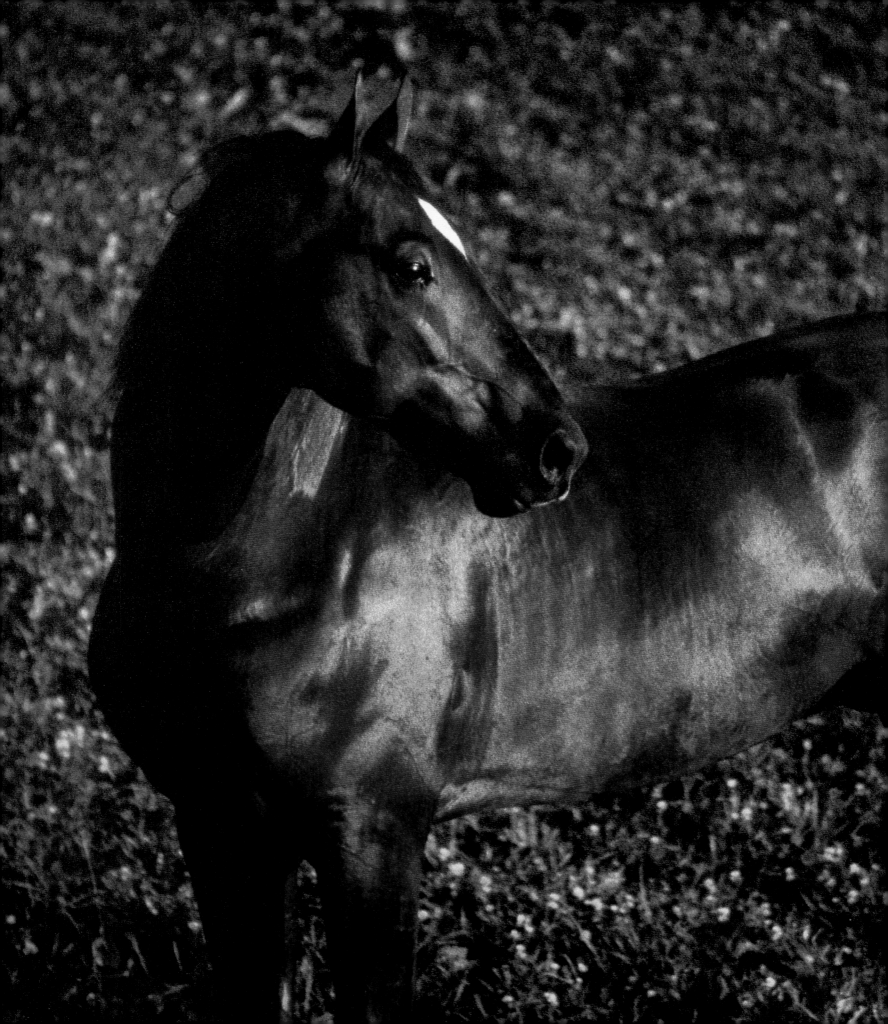

golden
memories
summon
dawning skies
to cast my
reflection
in
Will Shriver's
flashing
eyes.

Gold Rush's Song

Domecq

Atahualpa,
Pizarro
are names
as
noble
as is my
distinguished
nombre
Español.

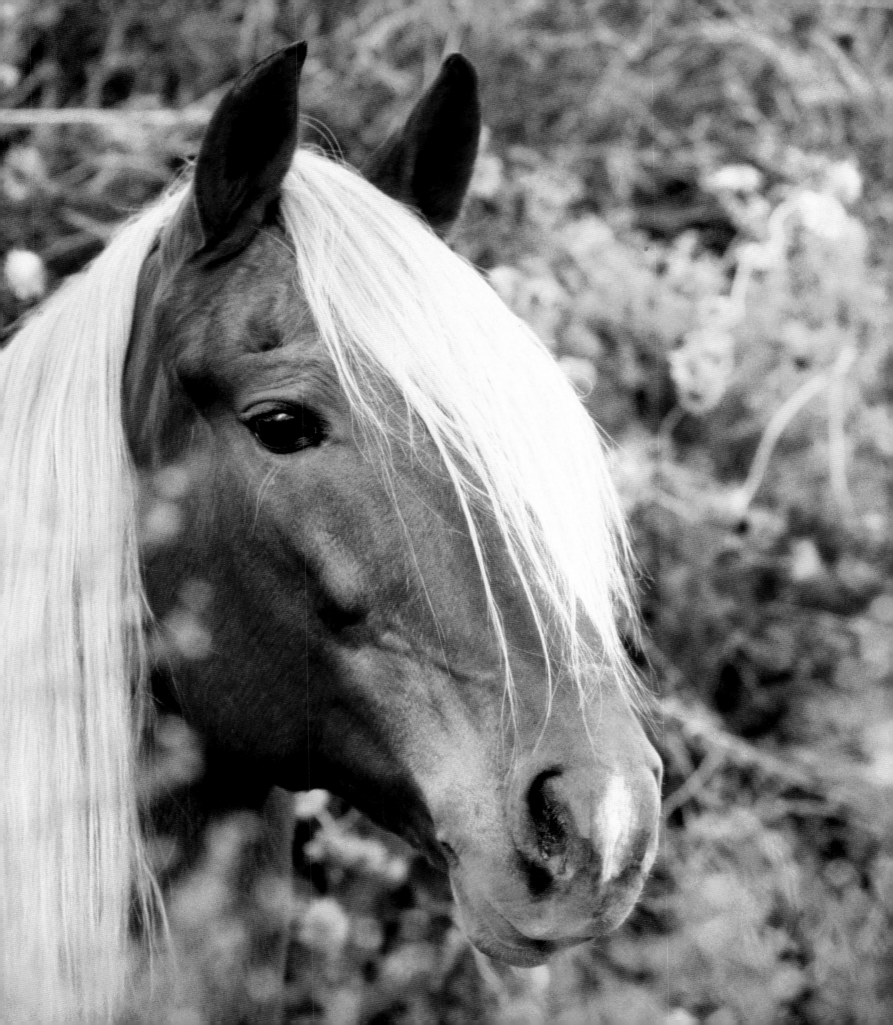

On
Andean thermals
I glide,
caressing
cumulus
with snow-tipped
condor wings
or
with merely
the flow
of
my mane.

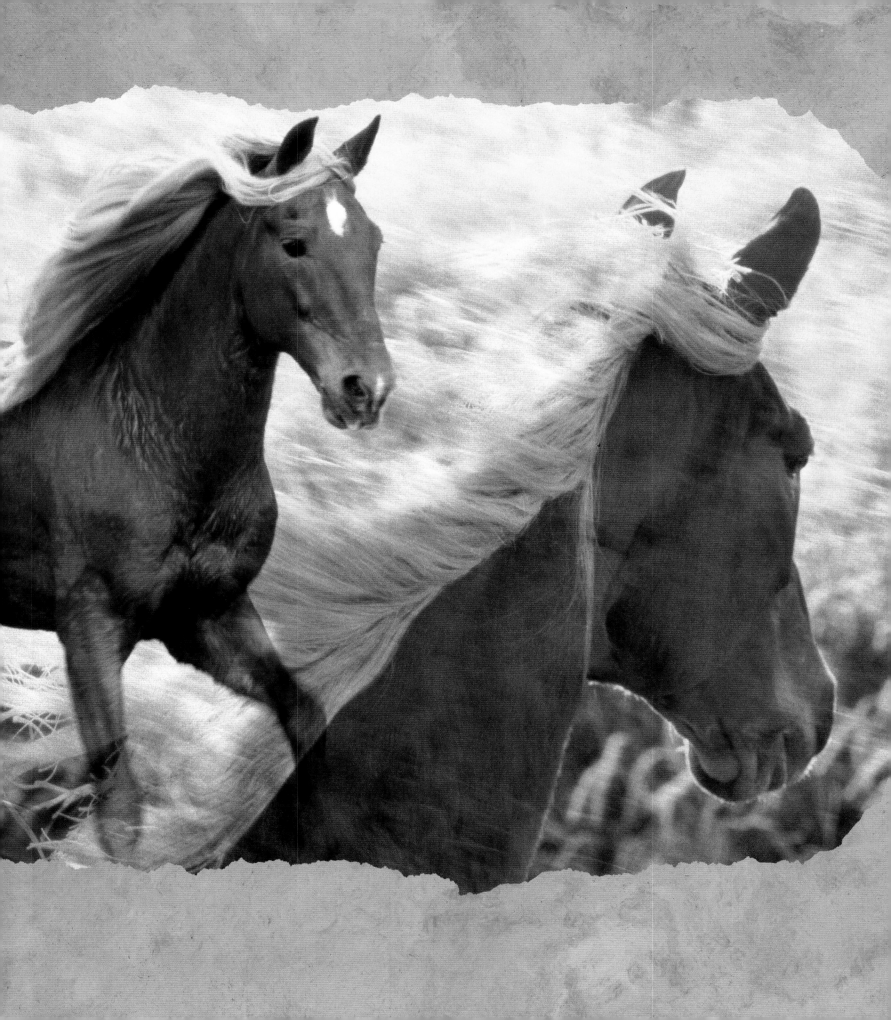

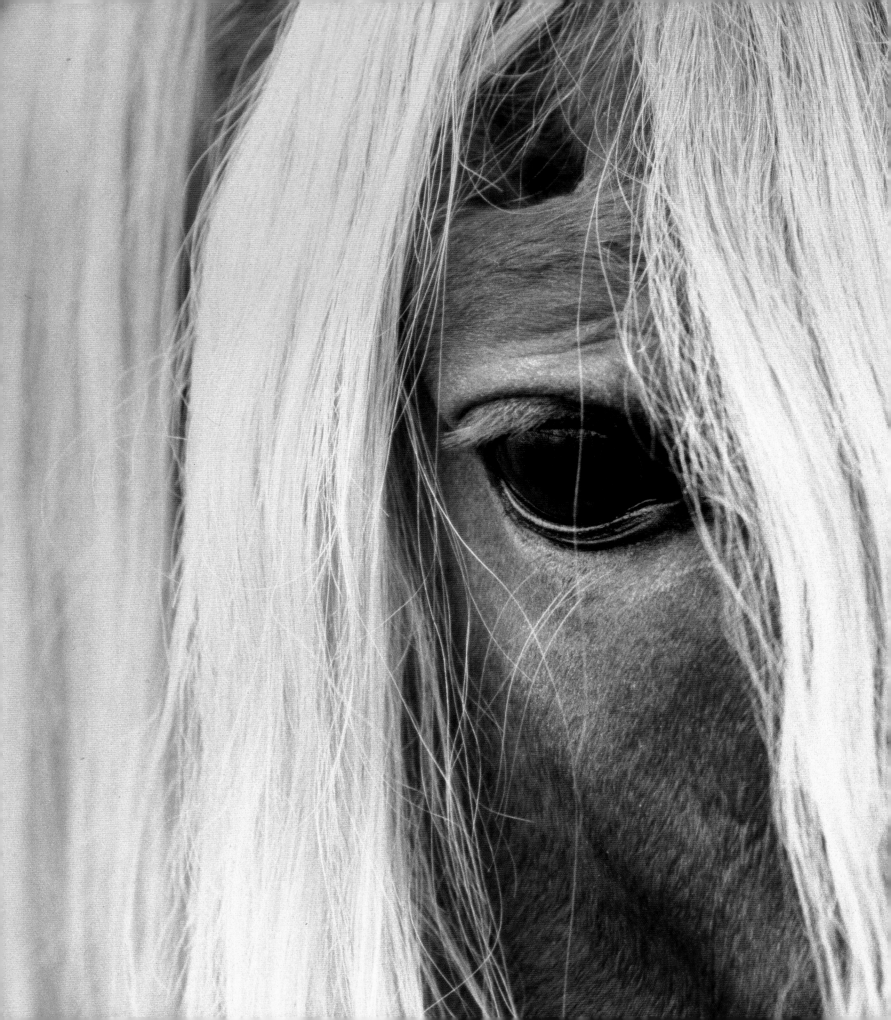

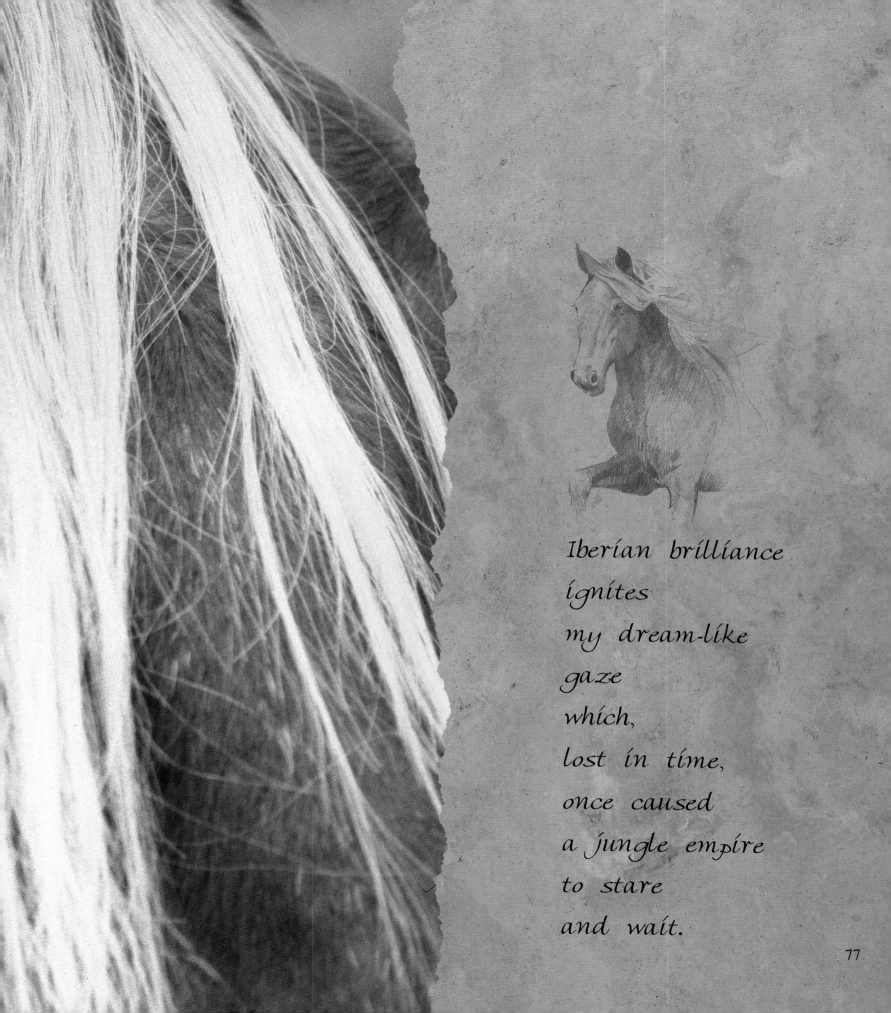

Iberian brilliance
ignites
my dream-like
gaze
which,
lost in time,
once caused
a jungle empire
to stare
and wait.

77

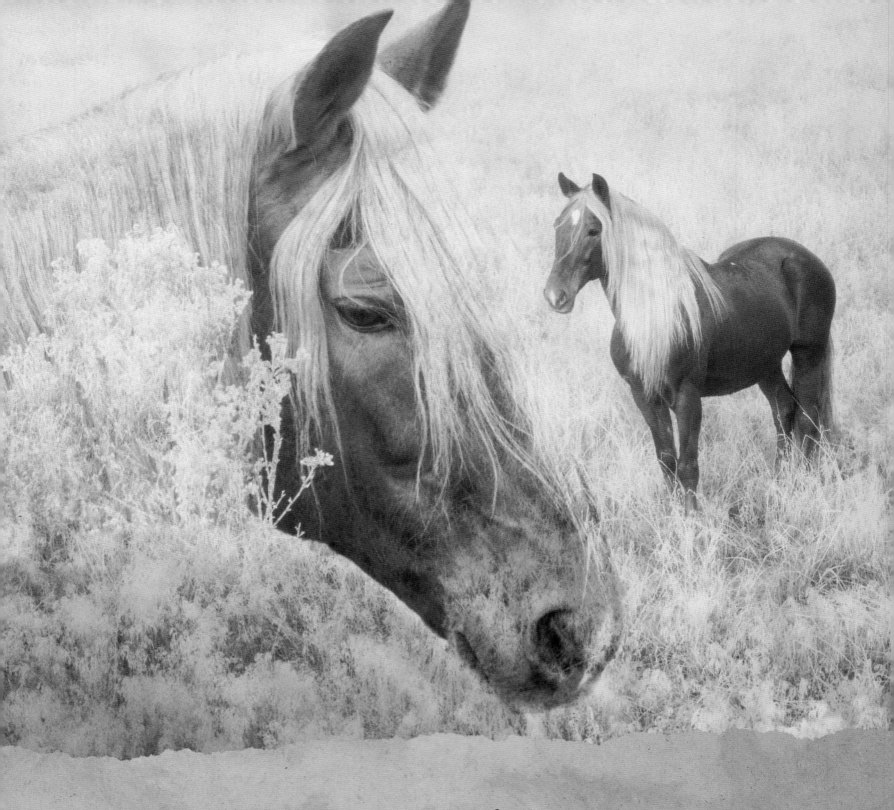

Wherever man has left
his footprints
from Barbarism
to Civilization,

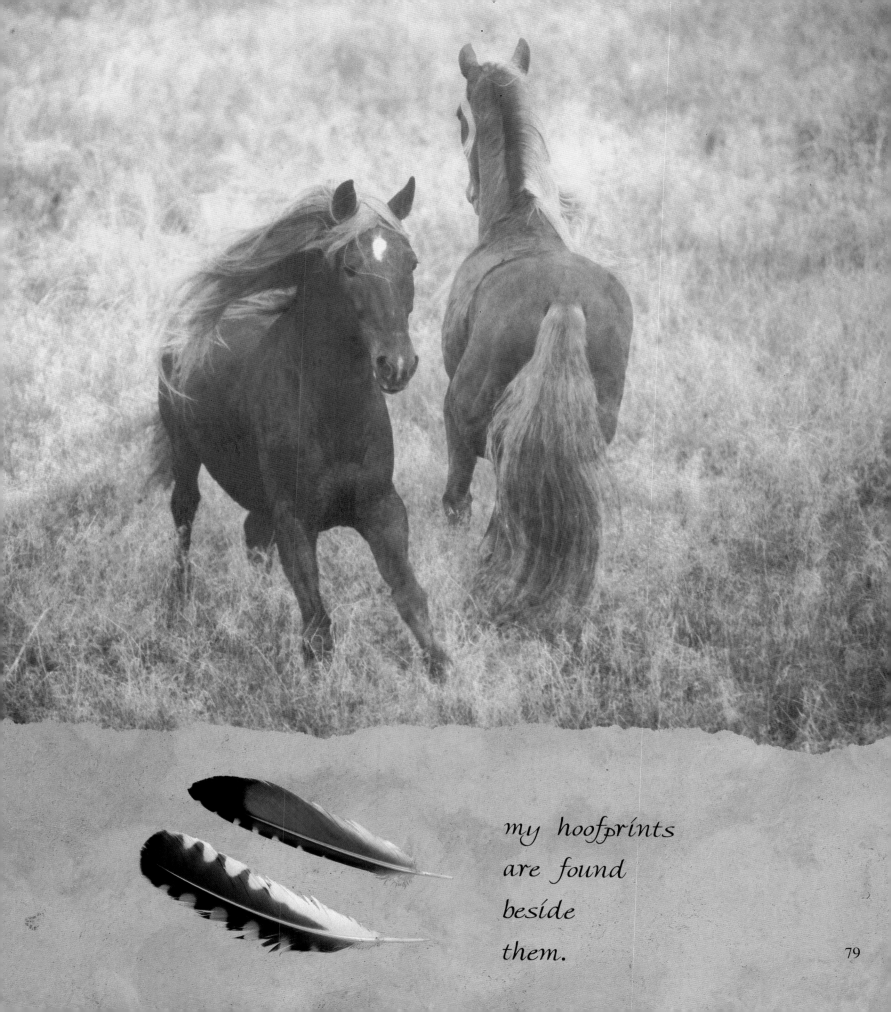

my hoofprints
are found
beside
them.

Molten Incan
gold-silver-copper
cast
my Peruvian elegance
in the sun's
last rays,
to remind the world
of more glorious
days.

Domecq's Song

80

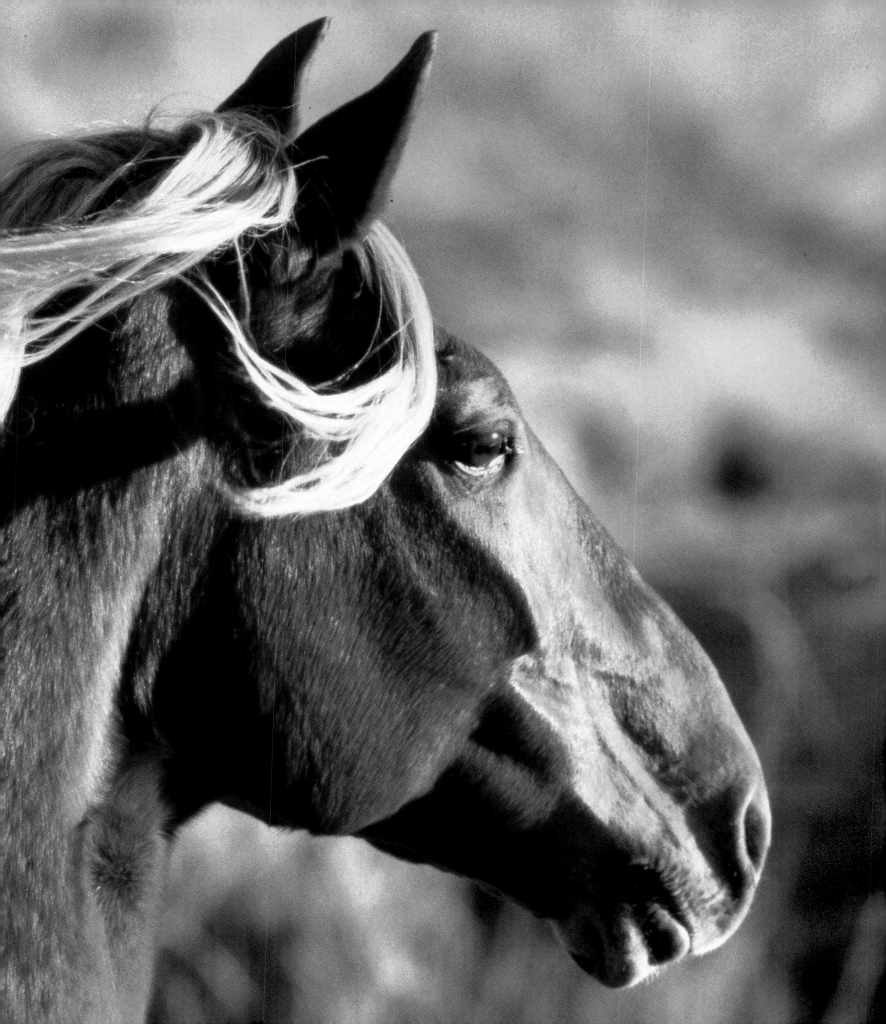

Padrons Mahogany

In the swiftness
of my darkness
I
whisper to thunder.
I am as
patient
as stone,
as wild
as lightning —
the very symbol
of surging potency,
and
the power of movement.

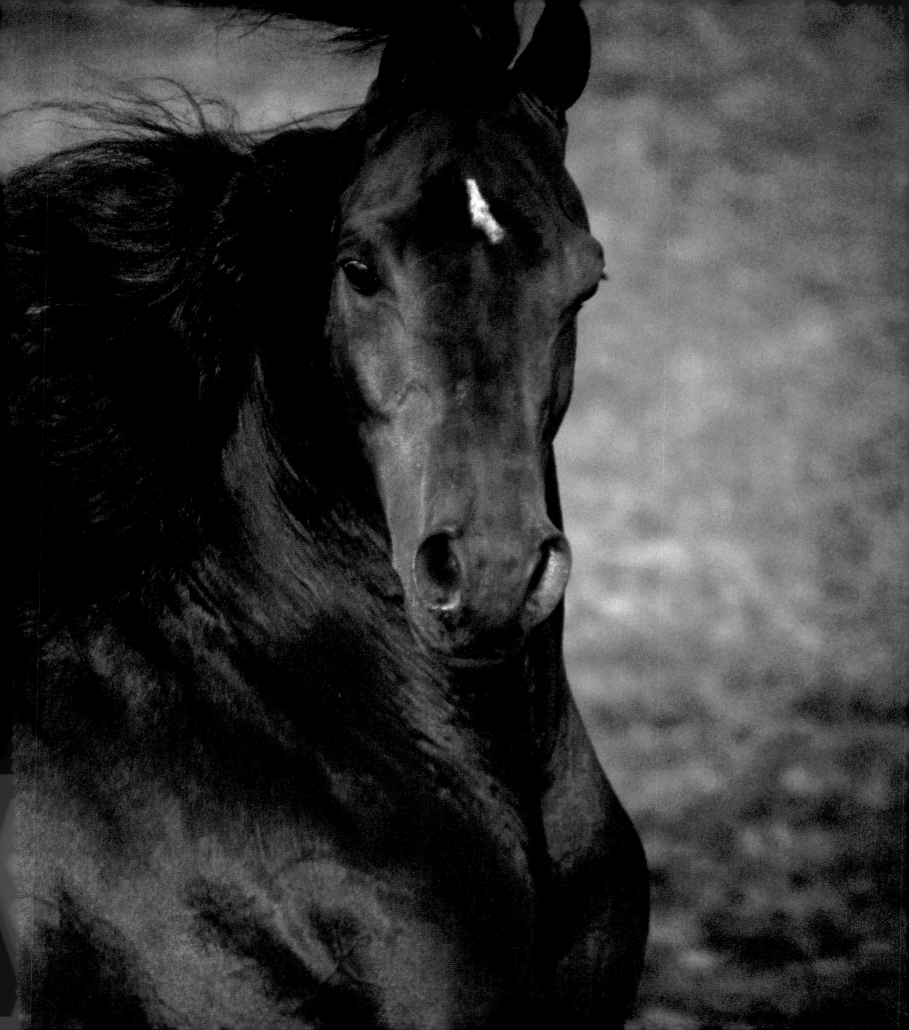

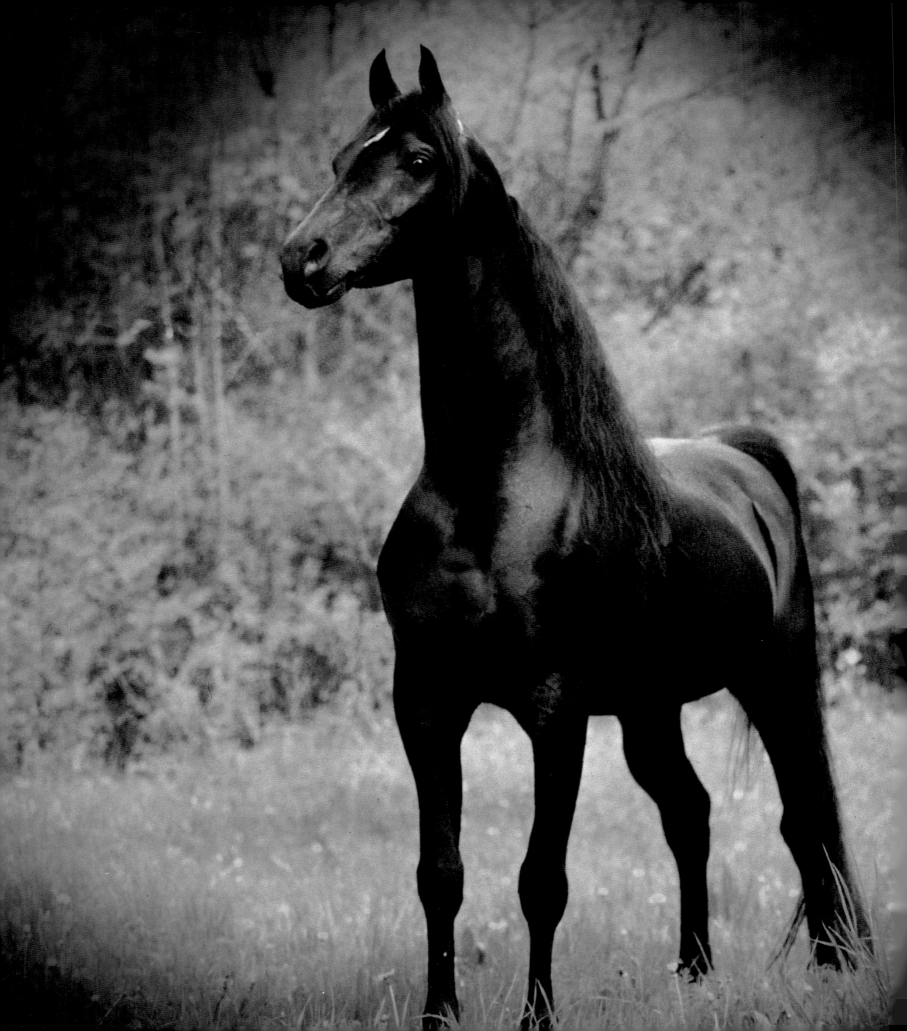

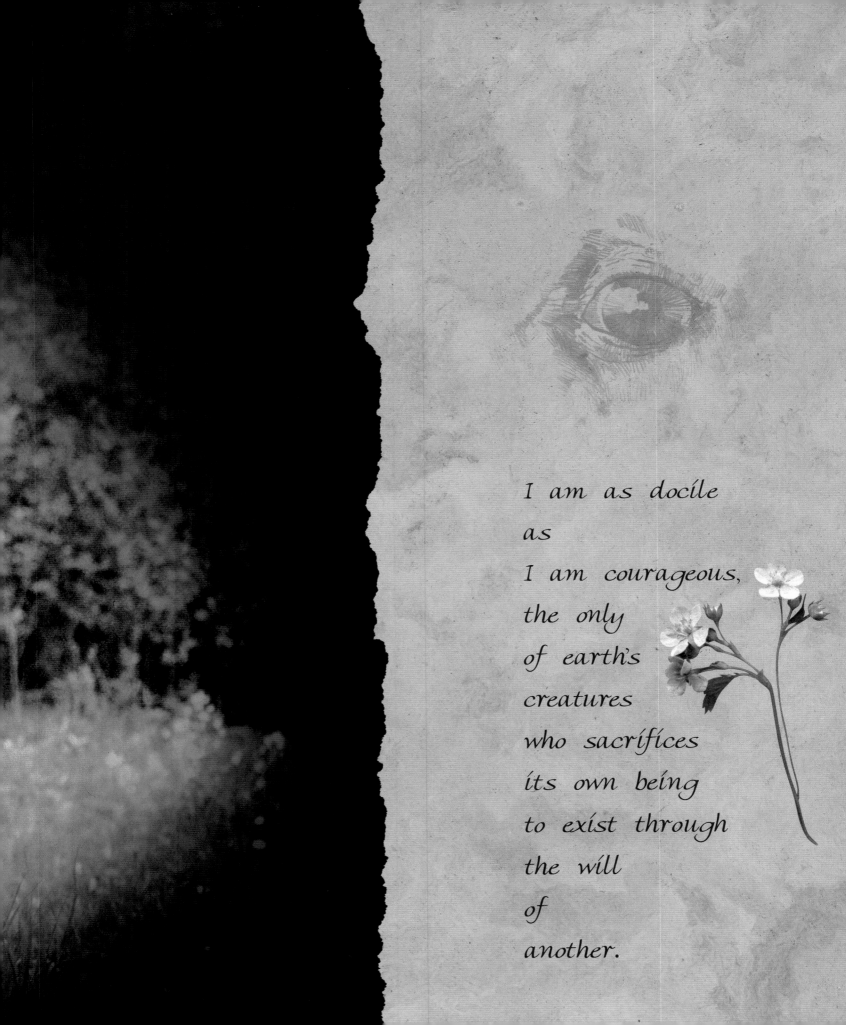

I am as docile

as

I am courageous,

the only

of earth's

creatures

who sacrifices

its own being

to exist through

the will

of

another.

85

A strange stillness
dwells
in my eye,
a composure
that appears
to regard the world
from
a measured
distance.
It is the gaze
from the depths
of
a desert dream.

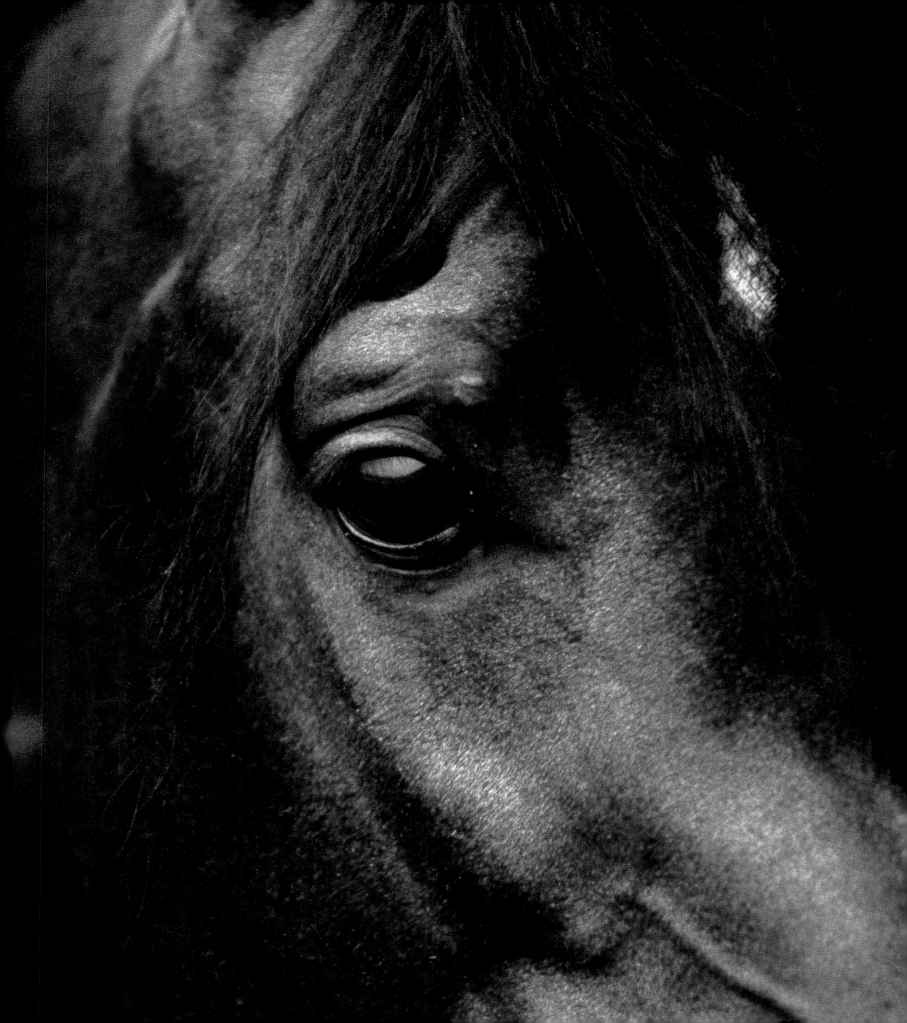

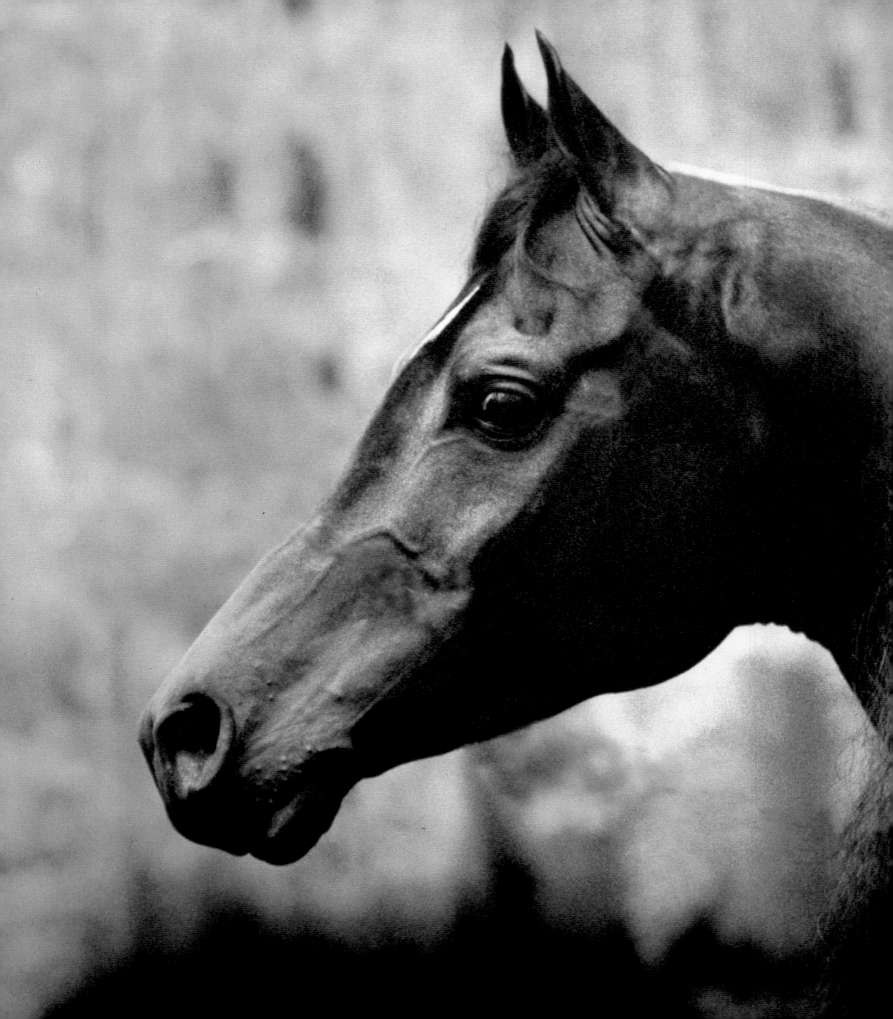

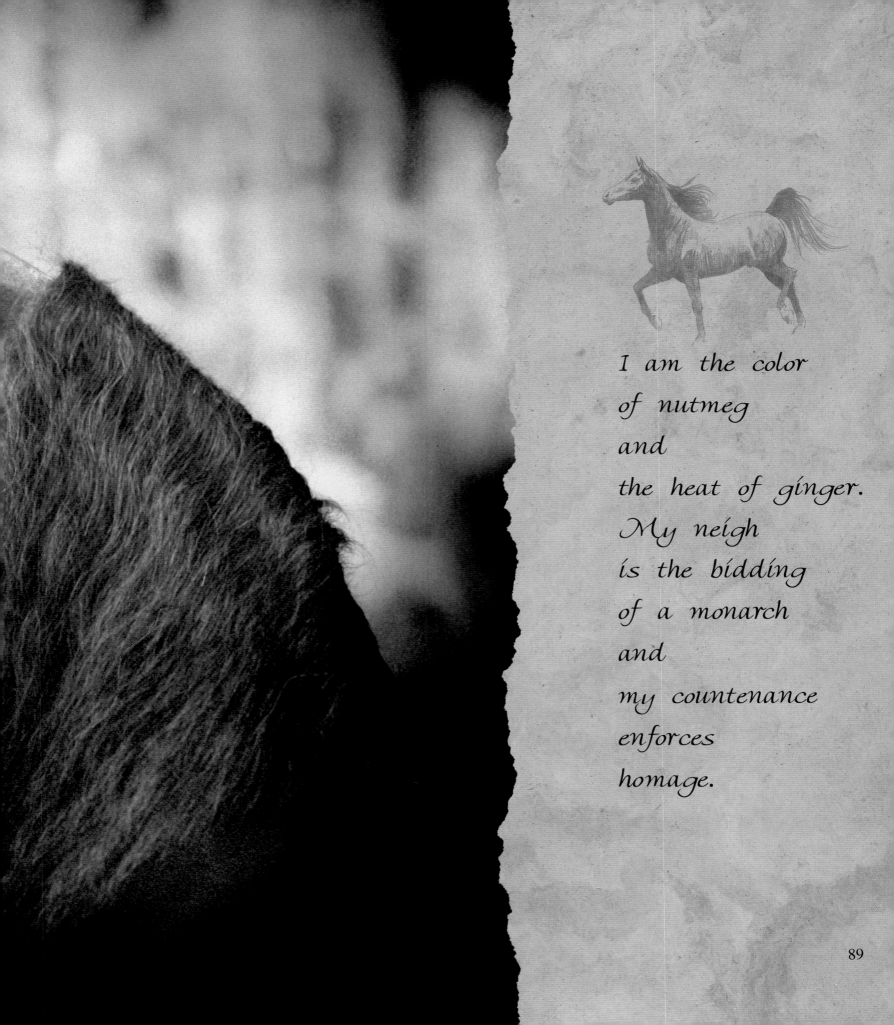

I am the color
of nutmeg
and
the heat of ginger.
My neigh
is the bidding
of a monarch
and
my countenance
enforces
homage.

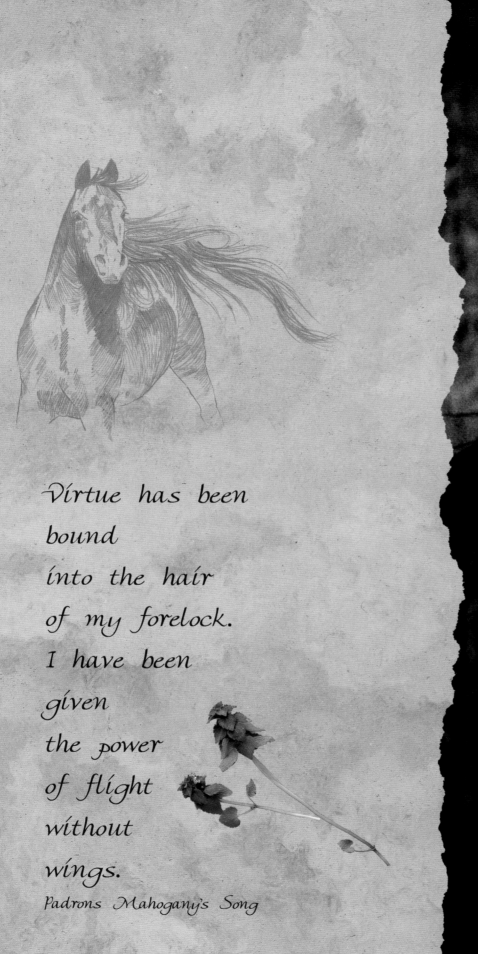

Virtue has been
bound
into the hair
of my forelock.
I have been
given
the power
of flight
without
wings.

Padrons Mahogany's Song

90

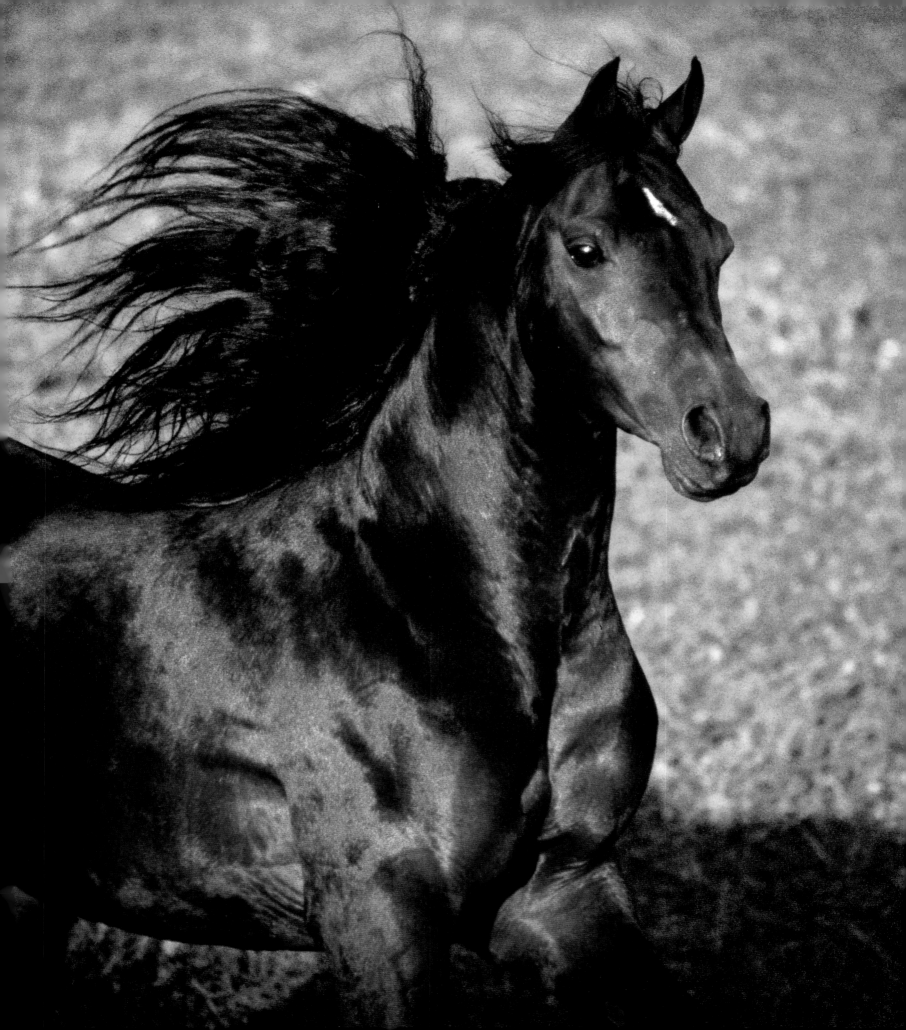

Caleyndar

Under
the first golden rays
I grazed.
Instead of grass
I ate ambrosia,
browsing quietly
at the tide line,
in readiness
to stampede
the skies of dawn.

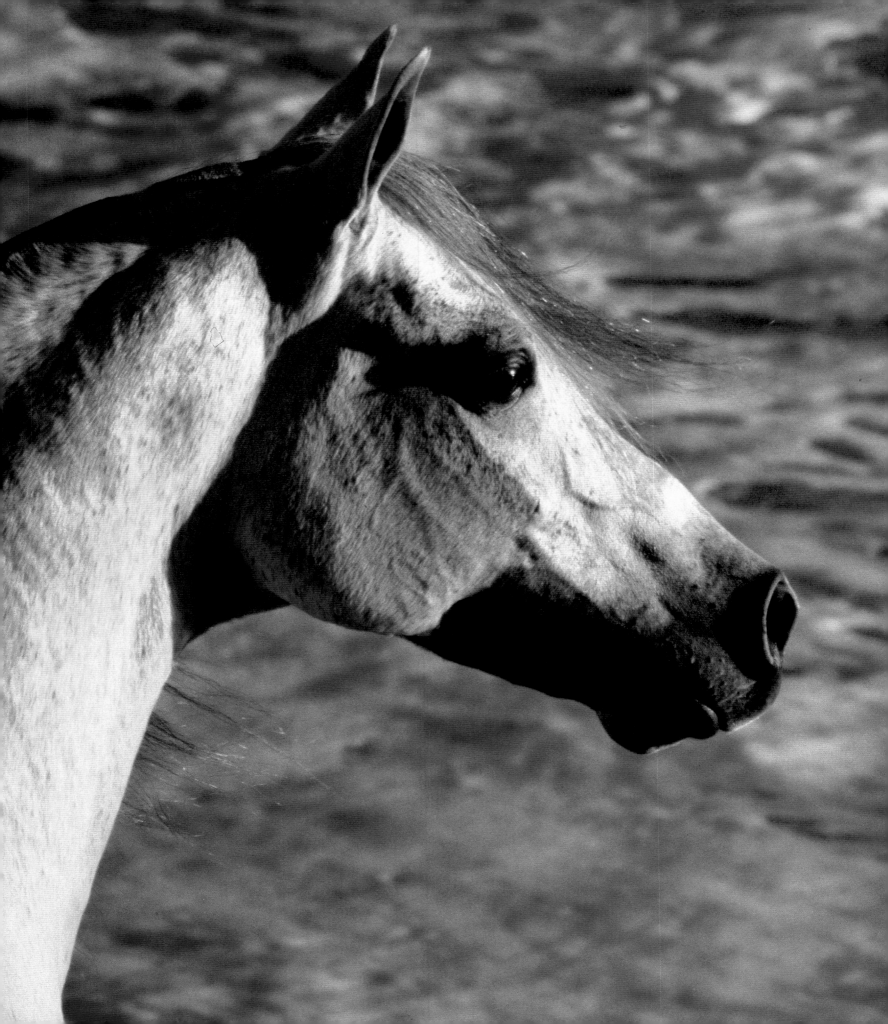

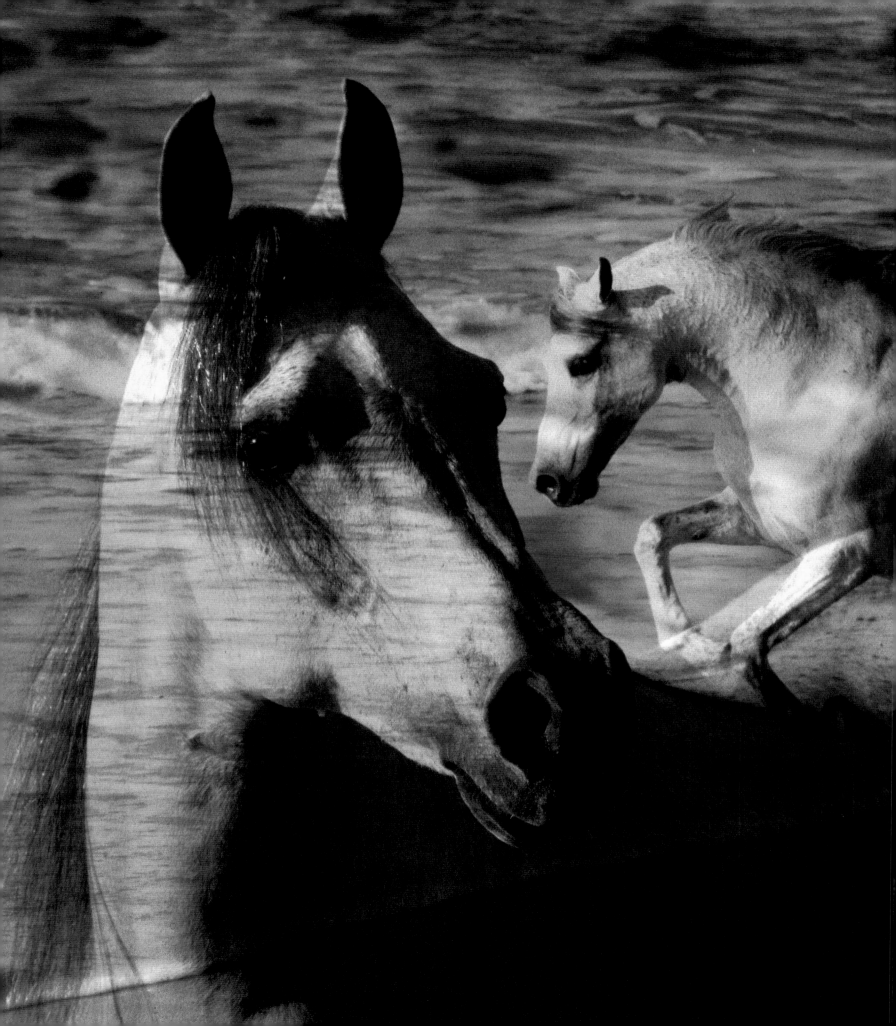

On I surge,
my eyes open
against the spray,
a wall of steely flesh
broadside
to the waves,
a stallion
that even
the sea
shall
not conquer.

95

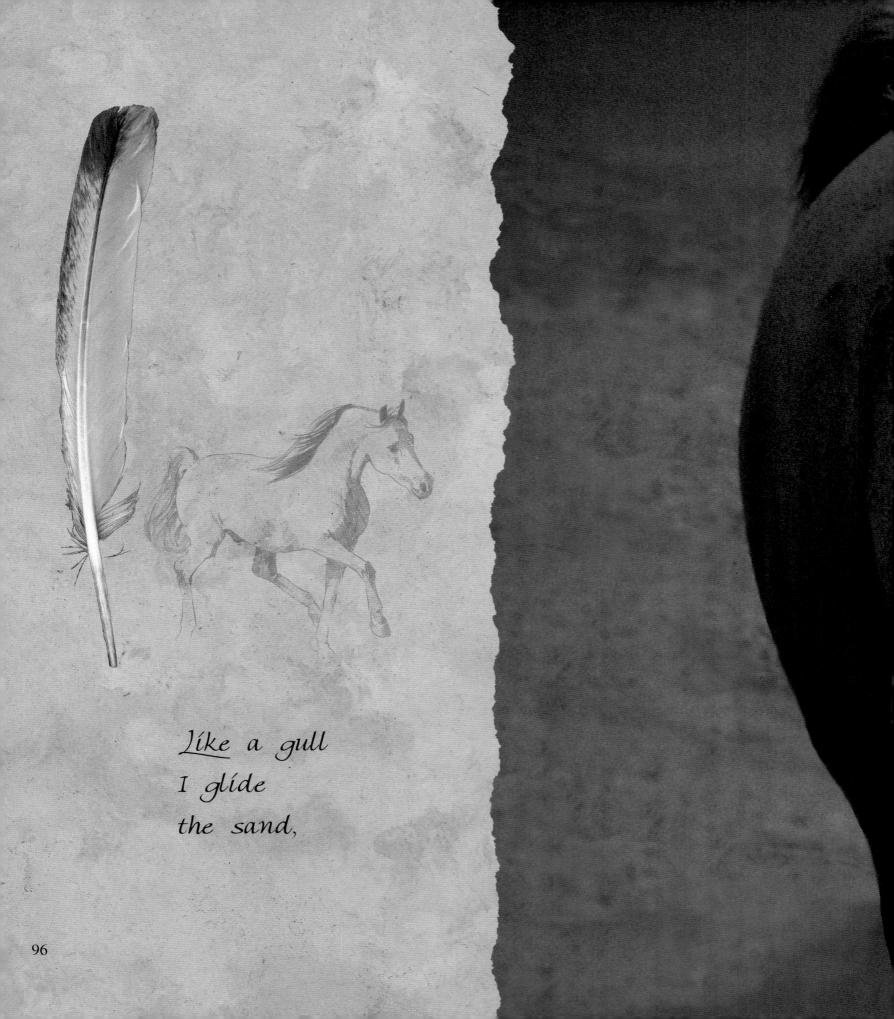

Like a gull
I glide
the sand,

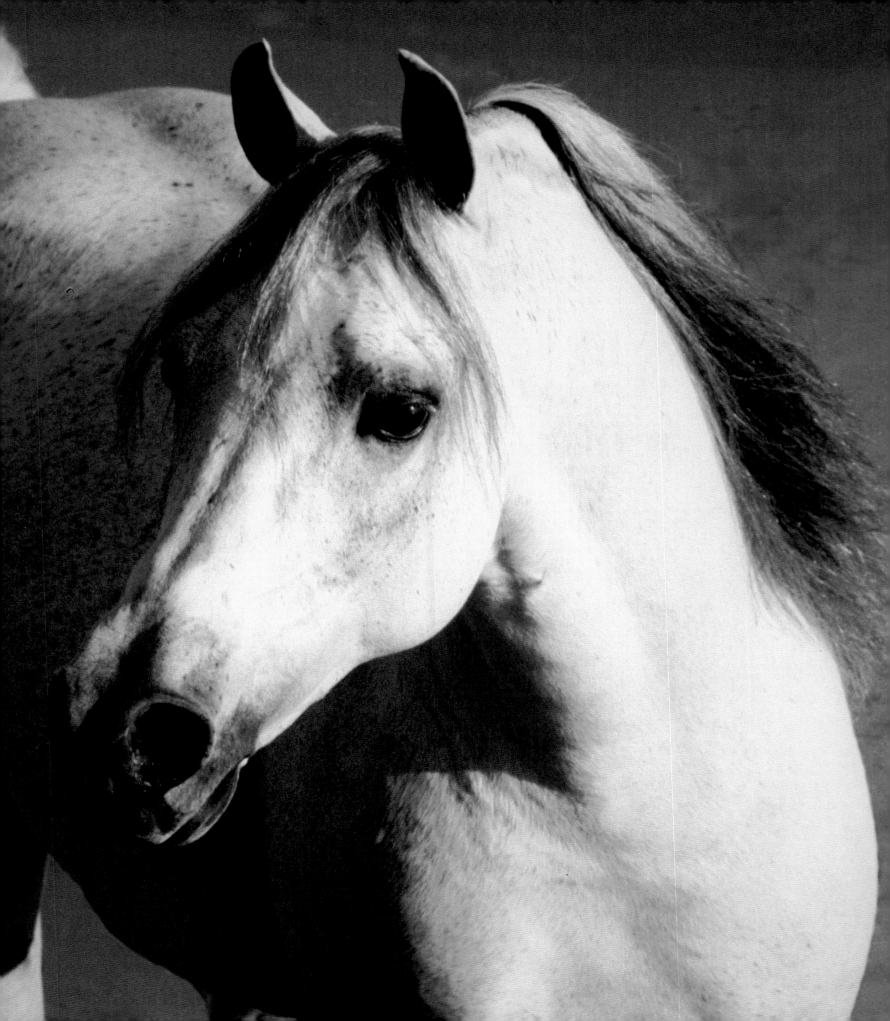

for
there are
wings
on
these hooves,
the speed
and power
of
foam-capped waves.

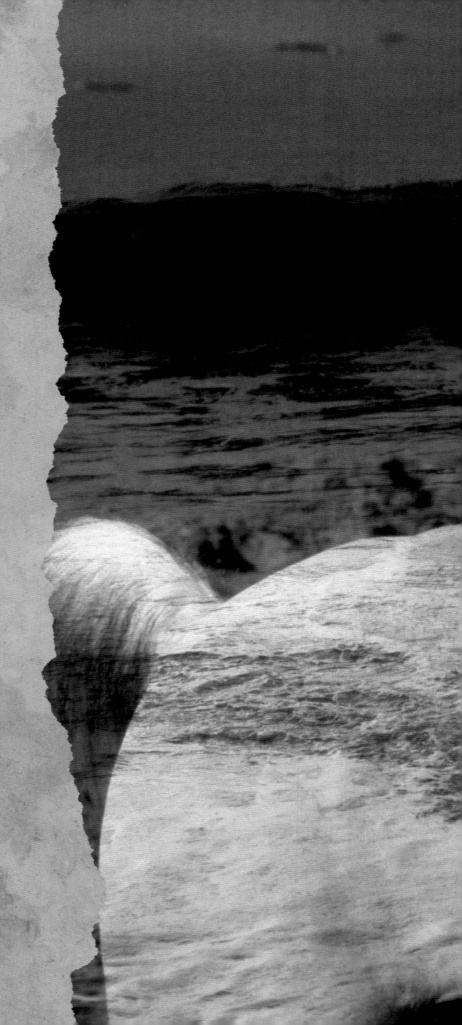

I must gallop
through
the sea
again,
for
the call
of
the rising tide
is
a wild call
and
a clear call
that cannot
be denied.

Caleyndar's Song

Elessar

America
the beautiful.
Oh, beautiful
American horse.
Oh, pounding hooves
from
shore
to
shore.

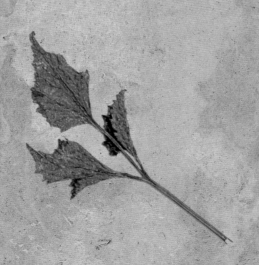

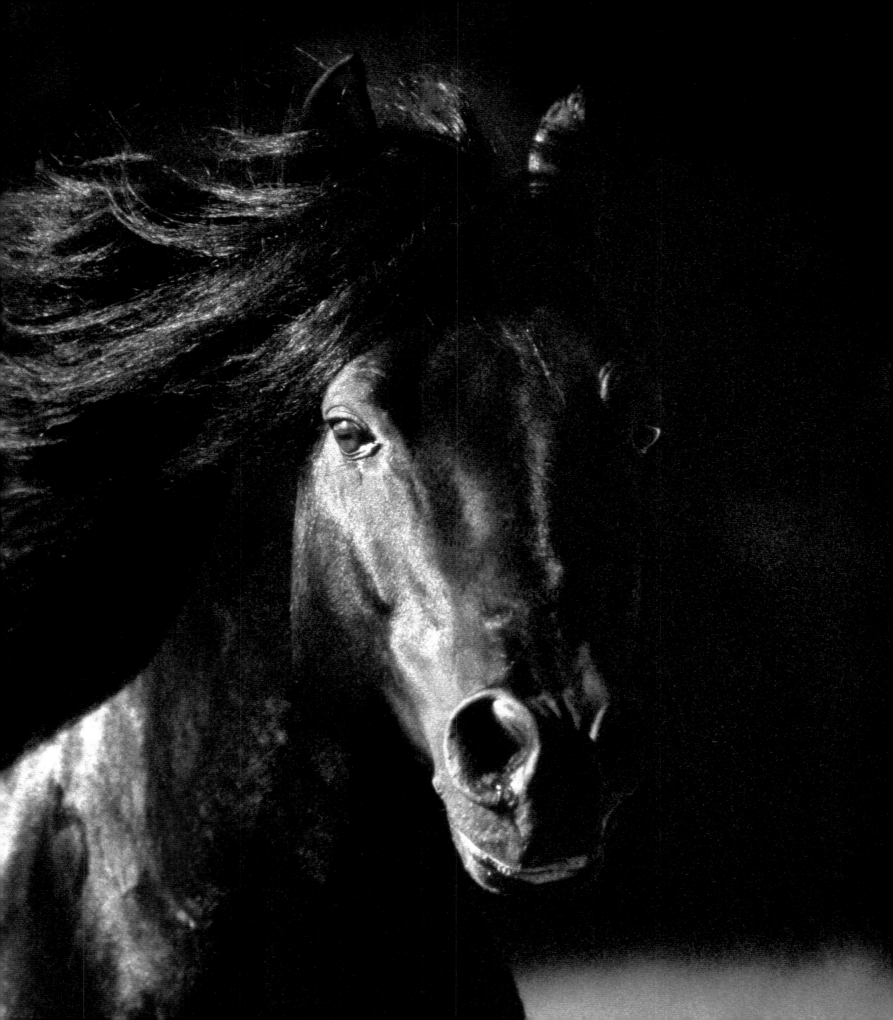

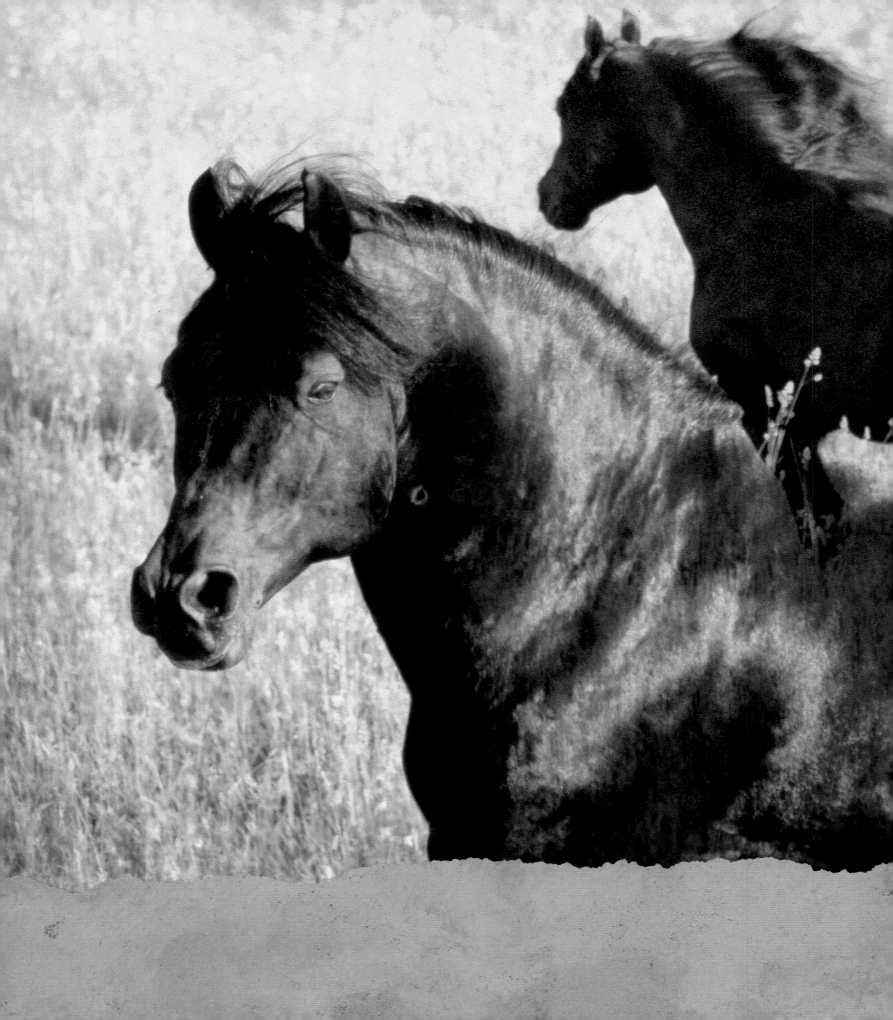

My gallant
heart
knows not
retreat,
only gallop on,
gallop more,
gallop to
the drum's
last beat.

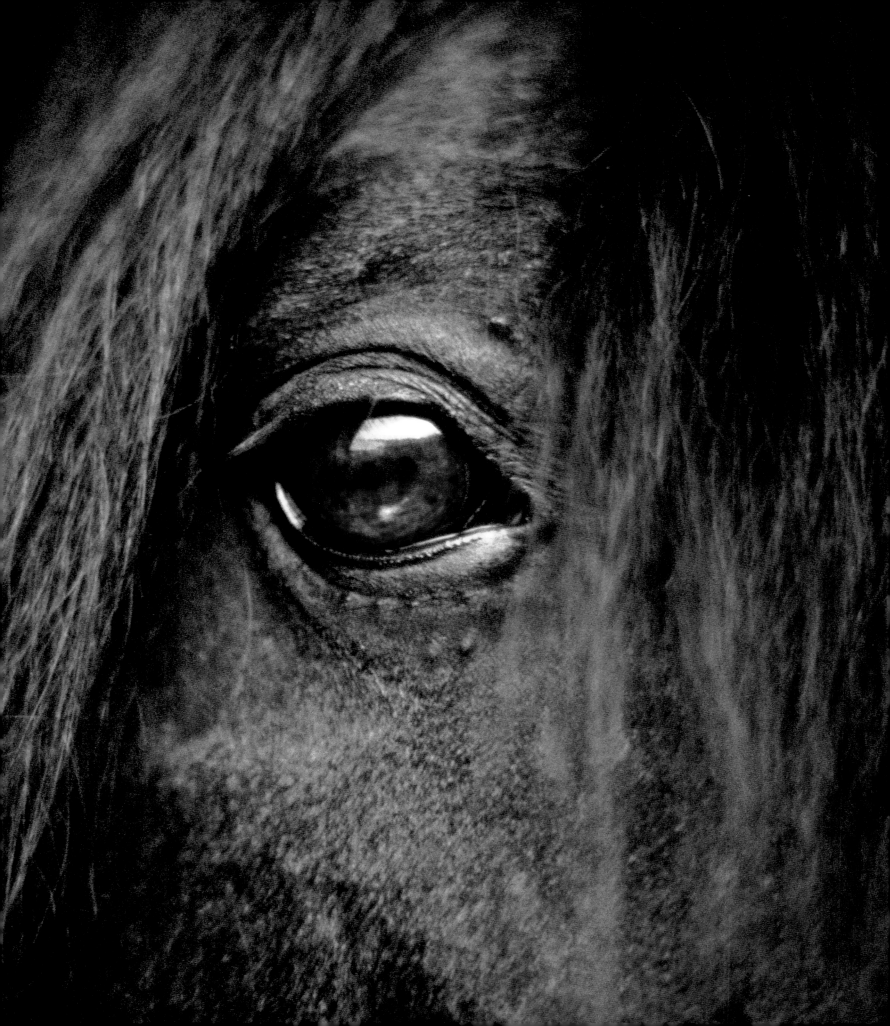

Only lit by moonlight
and the brilliance
of my eye,
that midnight ride
of Paul Revere's
was under
a black,
black sky.
Black as my mane,
black as the wind.
From New England
sprang my fame,
and
from Justin Morgan
came my name.

Even
without
a rider
I will always be
a charger
of the gods,
but a man
without
a horse
will only be
a man.

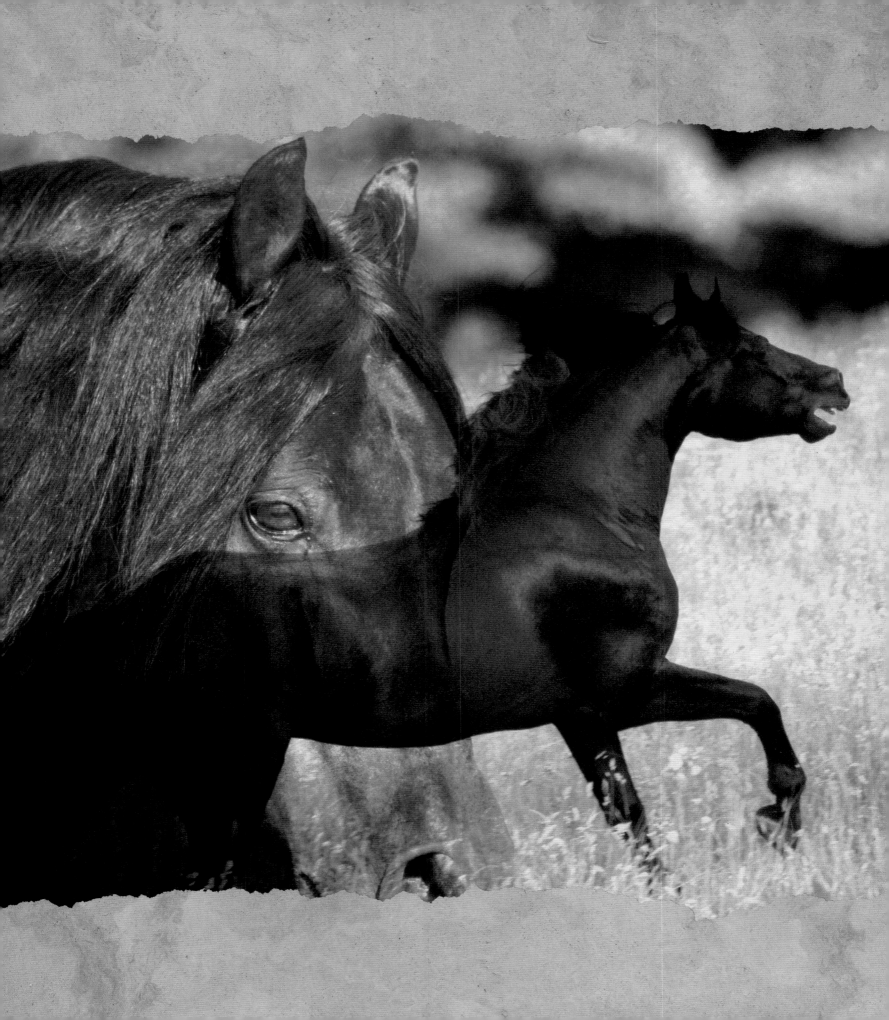

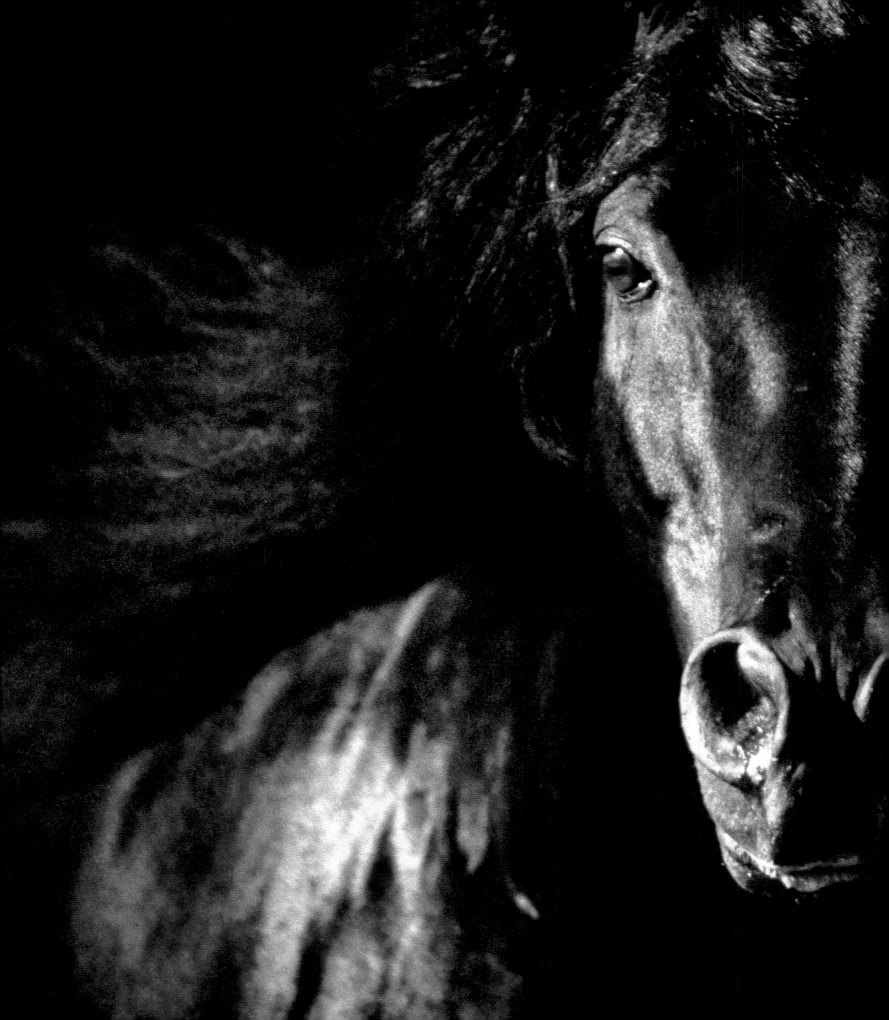

Surging crest
of tidal night,
with
raven's wings
lash the stars,
evermore,

evermore,

evermore.

Elessar's Song

Mark of Fame

All
the treasures
of this earth
lie
between
these eyes
which sparkle
with
your child's touch,
your
laughter
and
surprise.

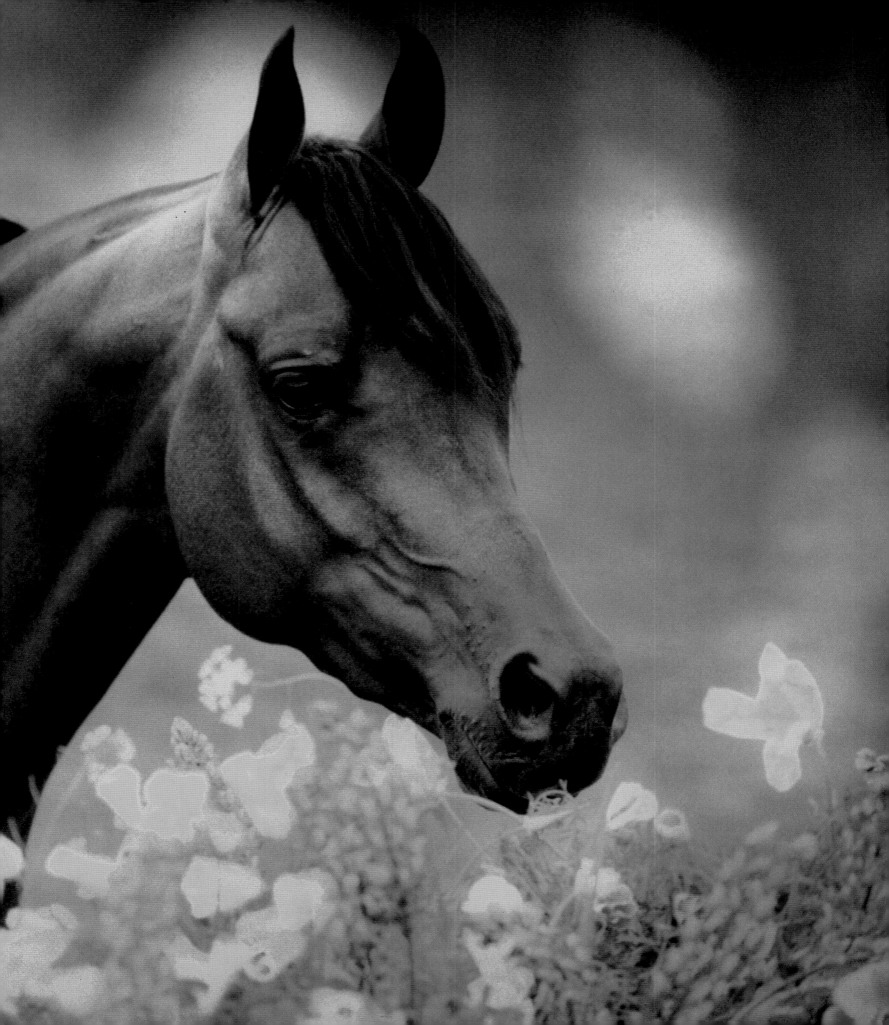

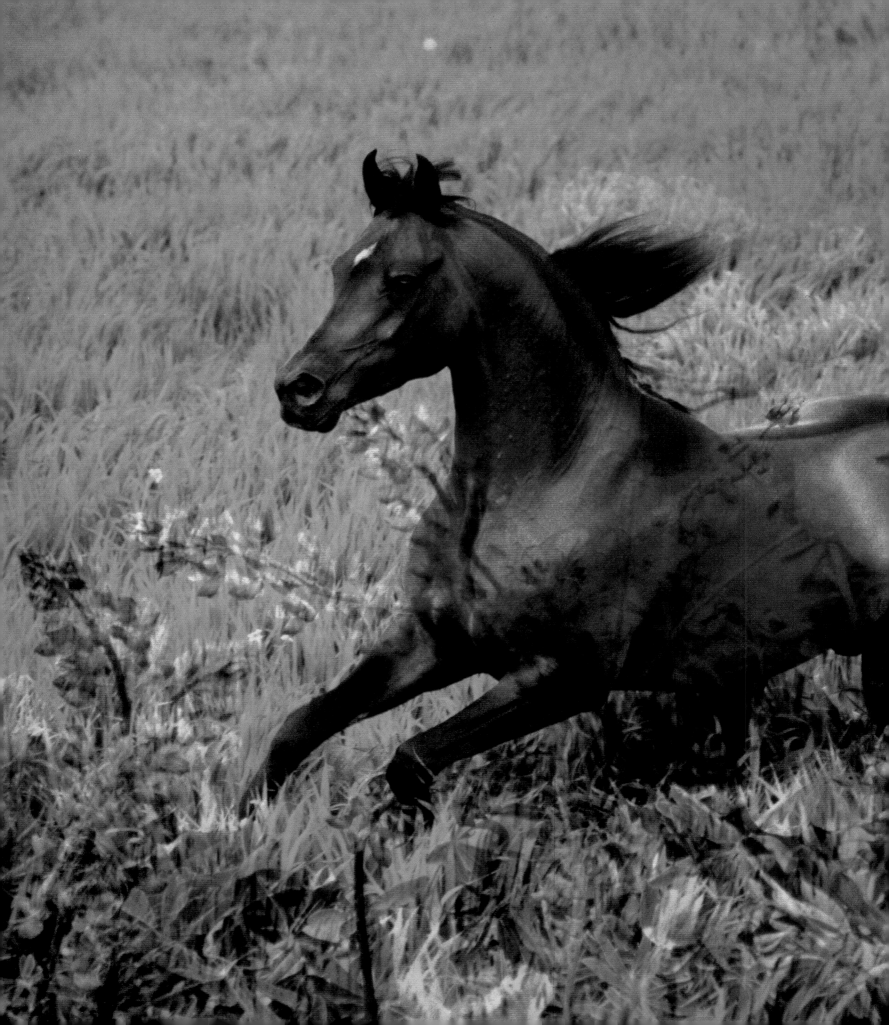

Nothing
in the world
is
single;
all things
by
a law divine
in
one
spirit
meet
and mingle.
Why not
I
with
Thine?

115

The earth's
pollen rises.
The shining dust
of your being
covers
my dark countenance
as you become
one
with me.

116

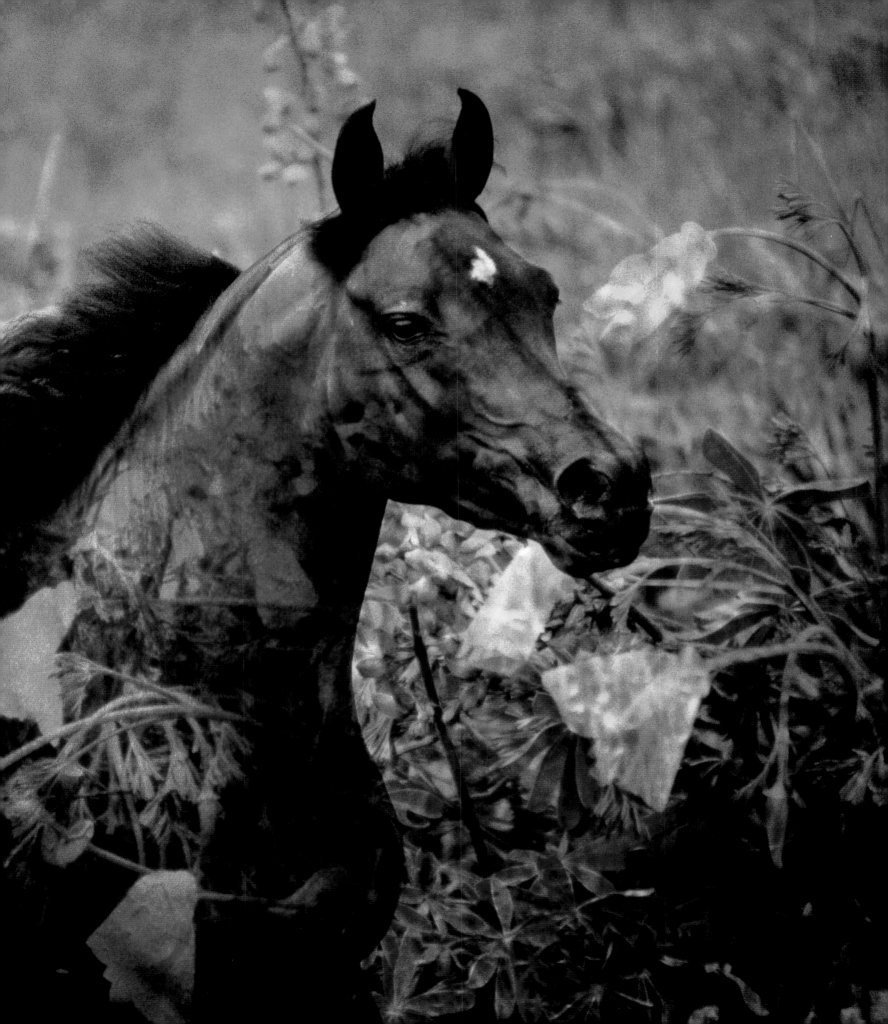

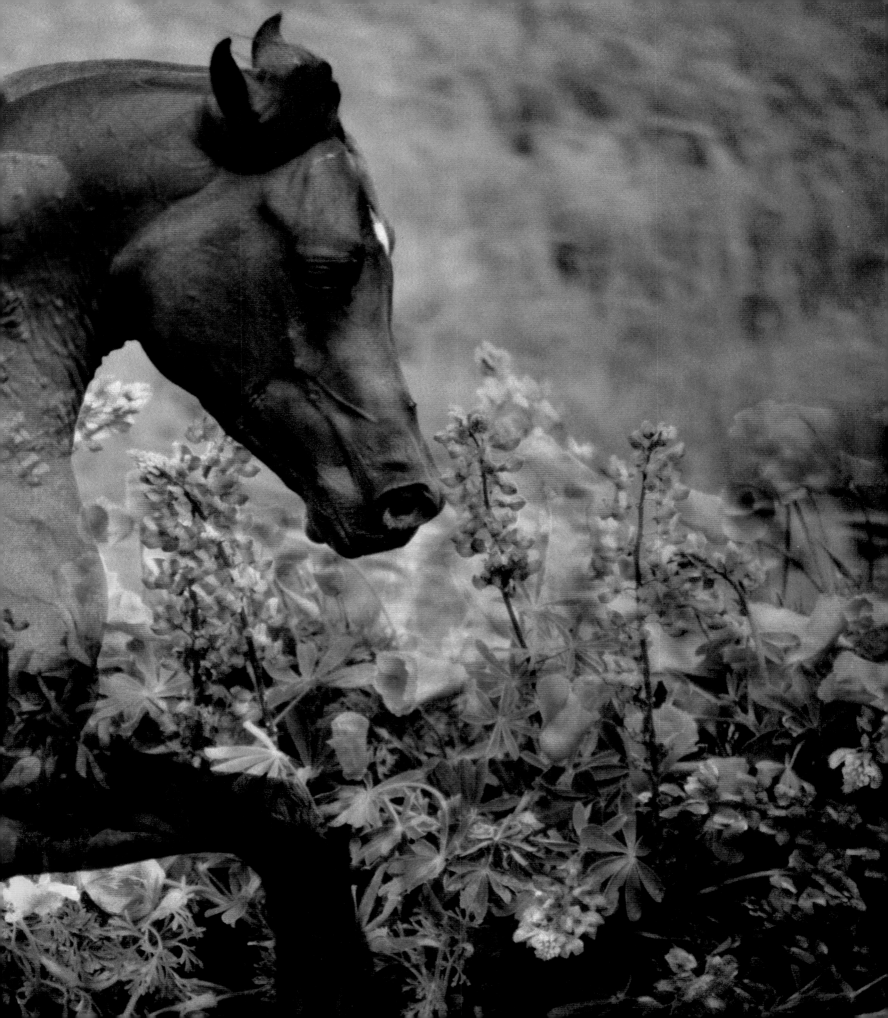

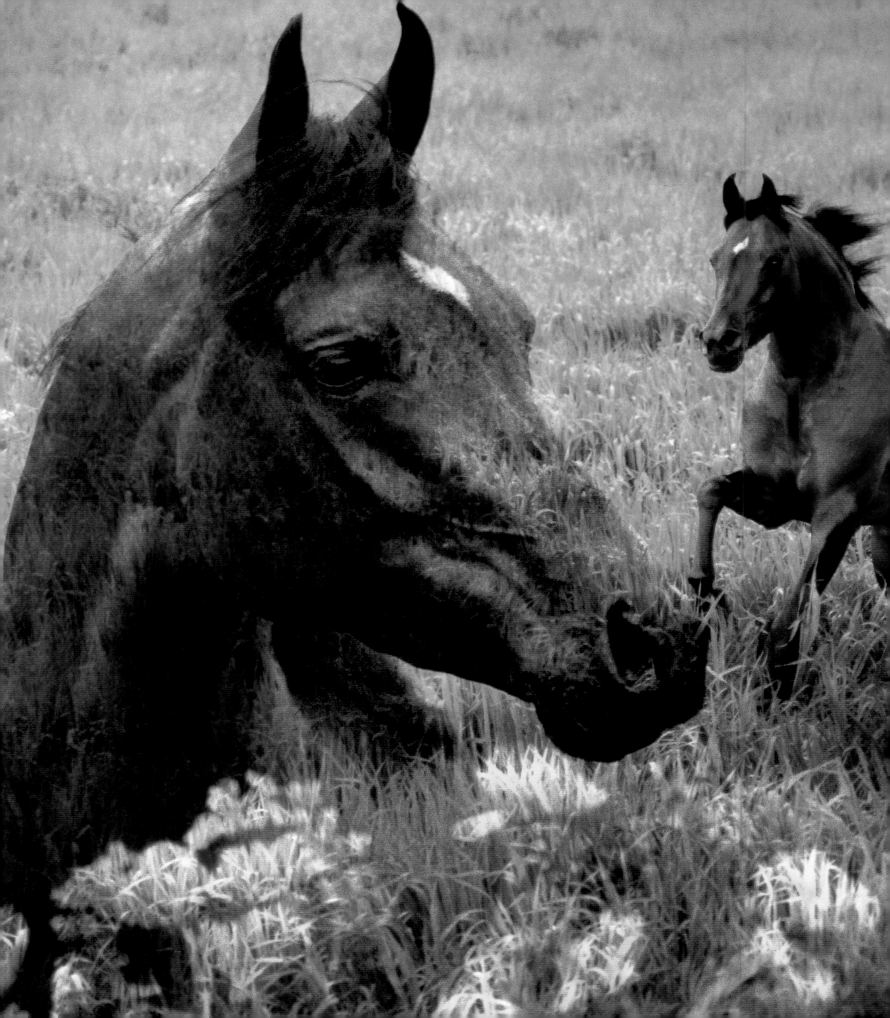

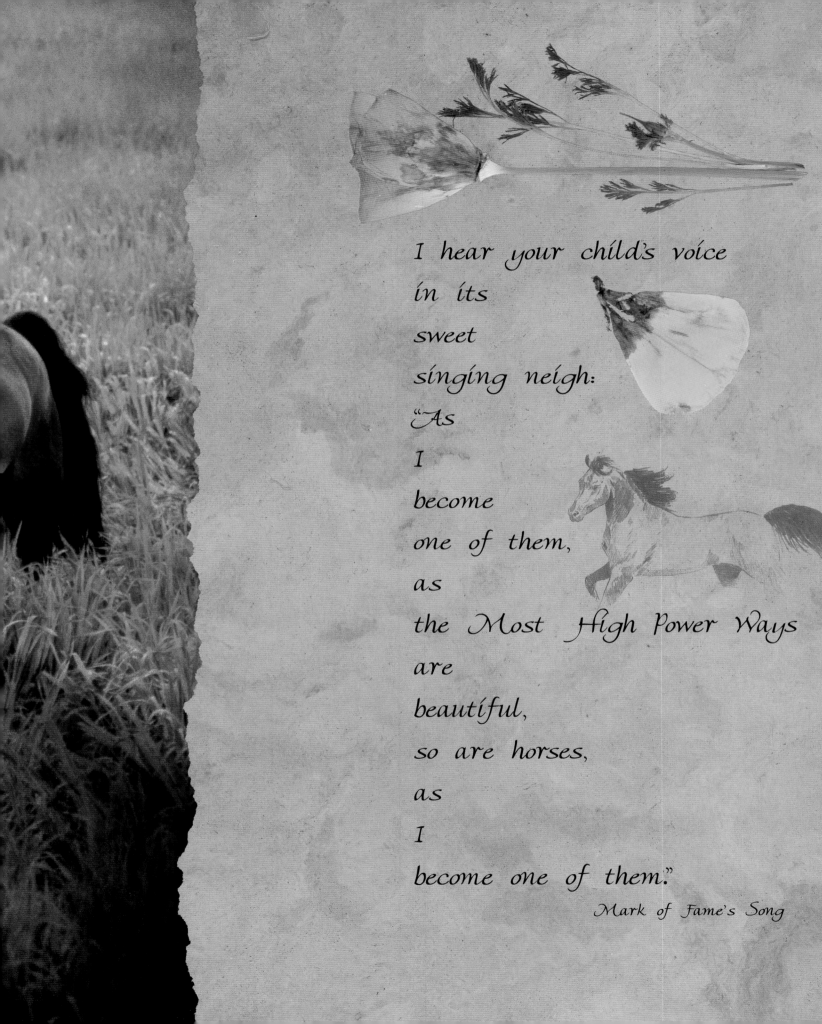

I hear your child's voice
in its
sweet
singing neigh:
"As
I
become
one of them,
as
the Most High Power Ways
are
beautiful,
so are horses,
as
I
become one of them."

Mark of Fame's Song

121

Negatraz

"Salaam,
Salaam,"
passing caravans
drift along
in search of
shade
where none
is found.

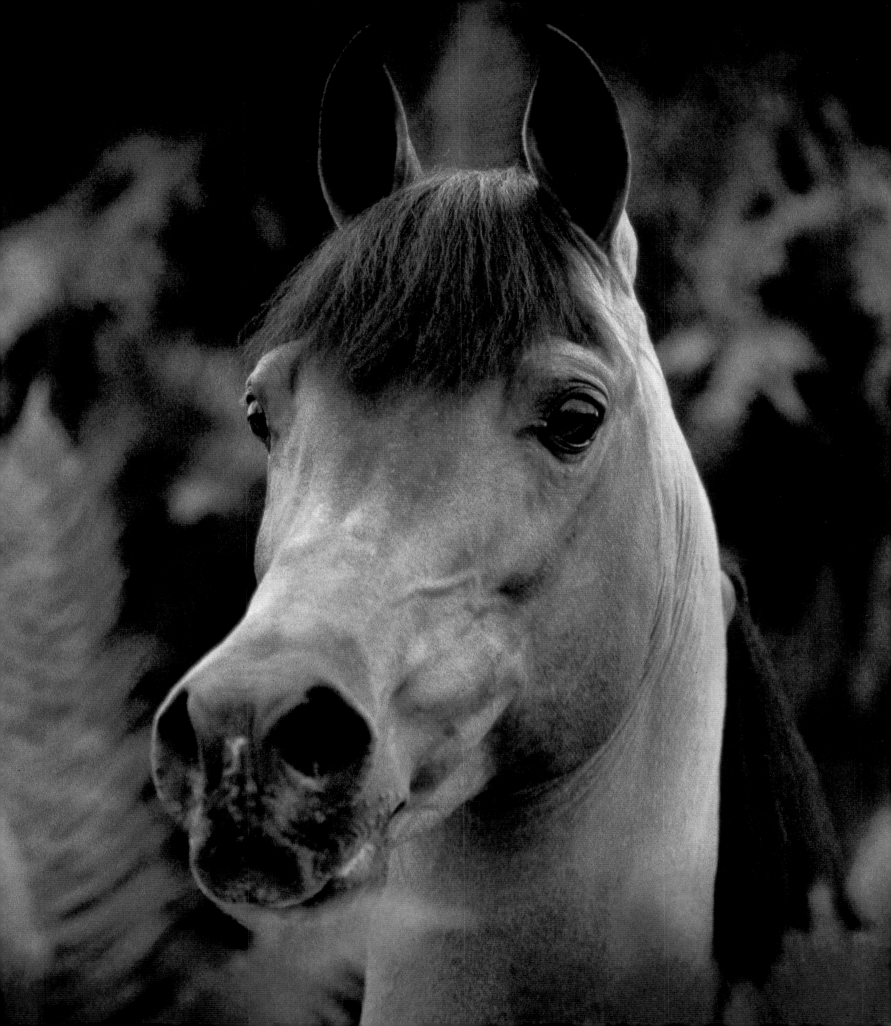

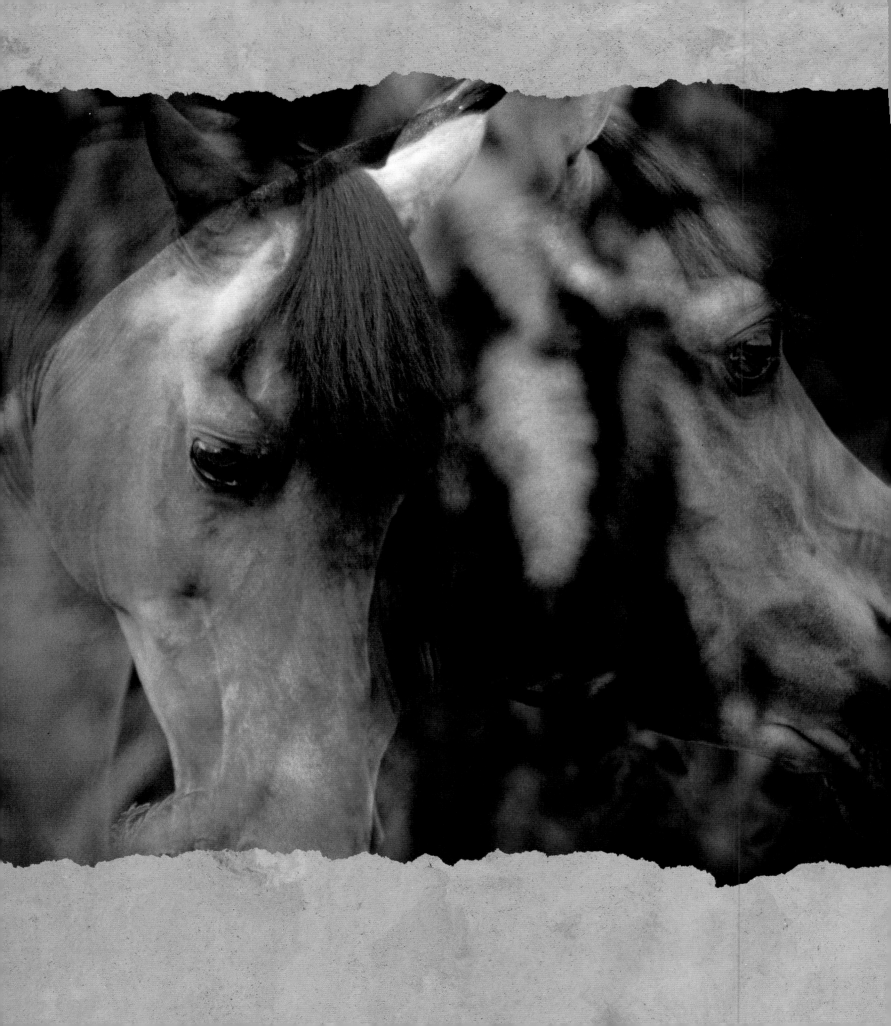

Behold,
beyond,
oasis green,
preening palms,
shielding fronds
from Helios' blaze.
I dream
of the honey,
the dates
and
the camel milk
that answered
a foal's
plaintive
cry.

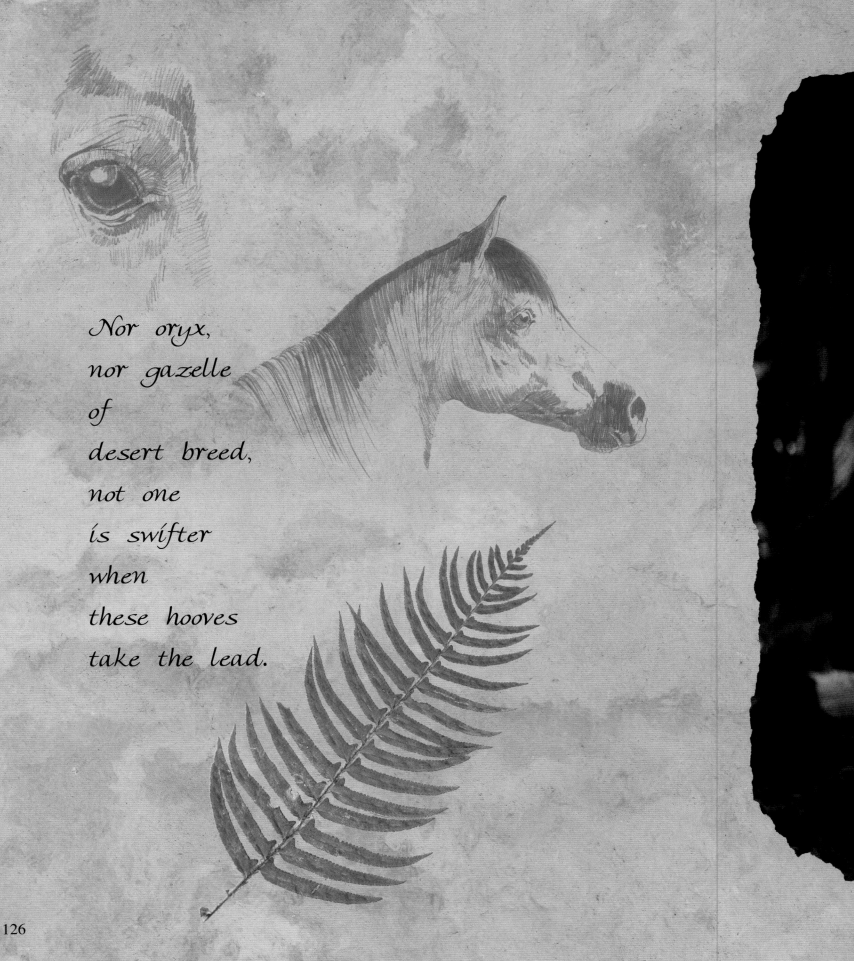

Nor oryx,
nor gazelle
of
desert breed,
not one
is swifter
when
these hooves
take the lead.

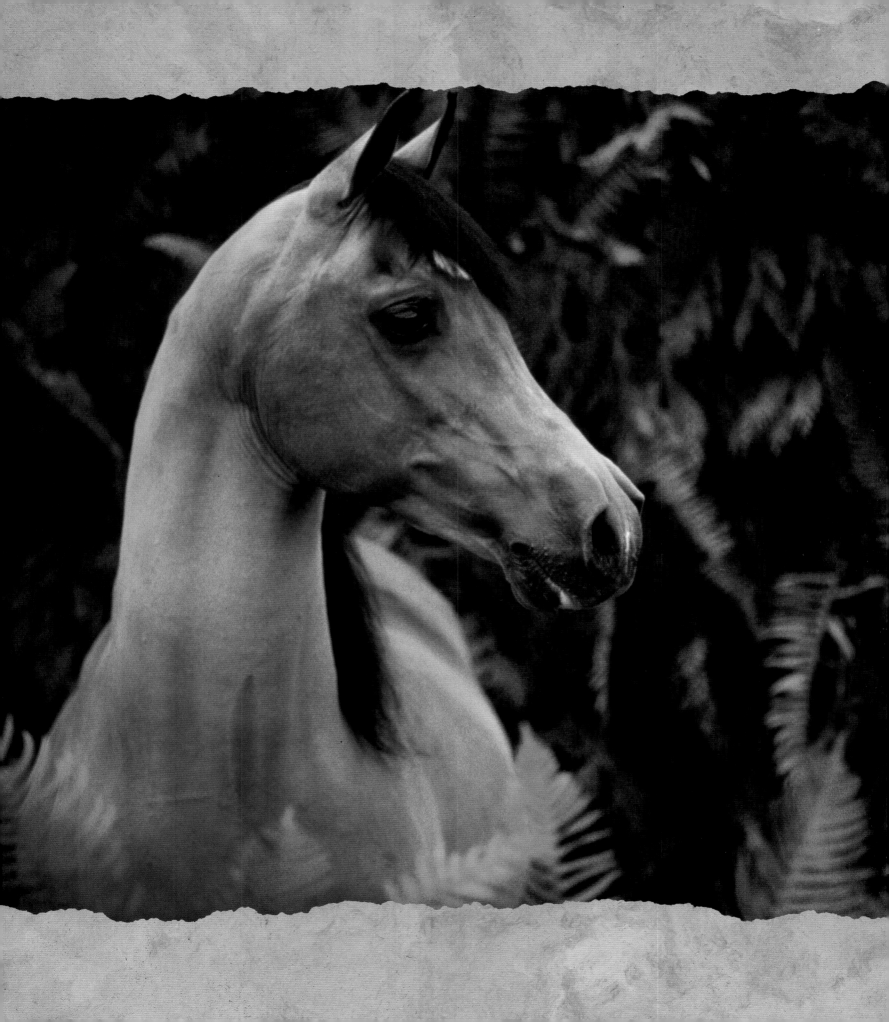

Oh, what
emerald fronds
shade this wadi,
silent,
except for
tinkling camel bells.
Ahead lies
the devil's anvil,
and a searing path
to hell.
Undaunted,
my spirits soar
for
I have breathed
the salt-scented wind
of Aqaba.

128

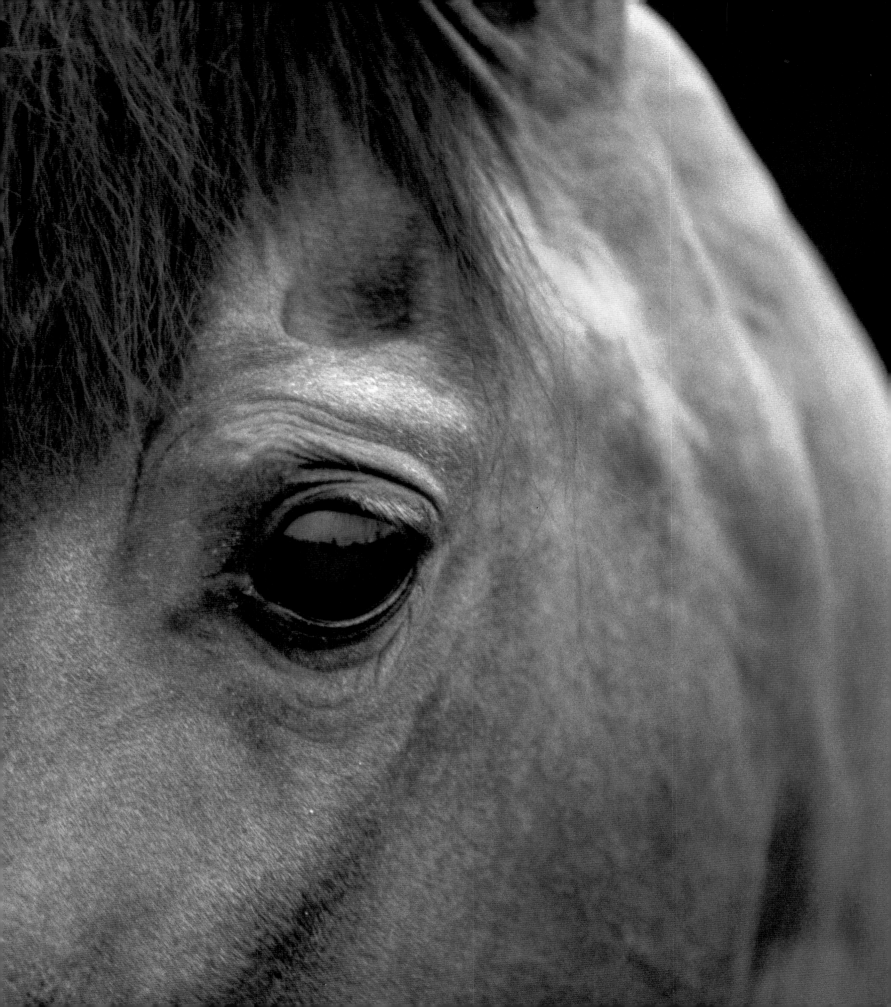

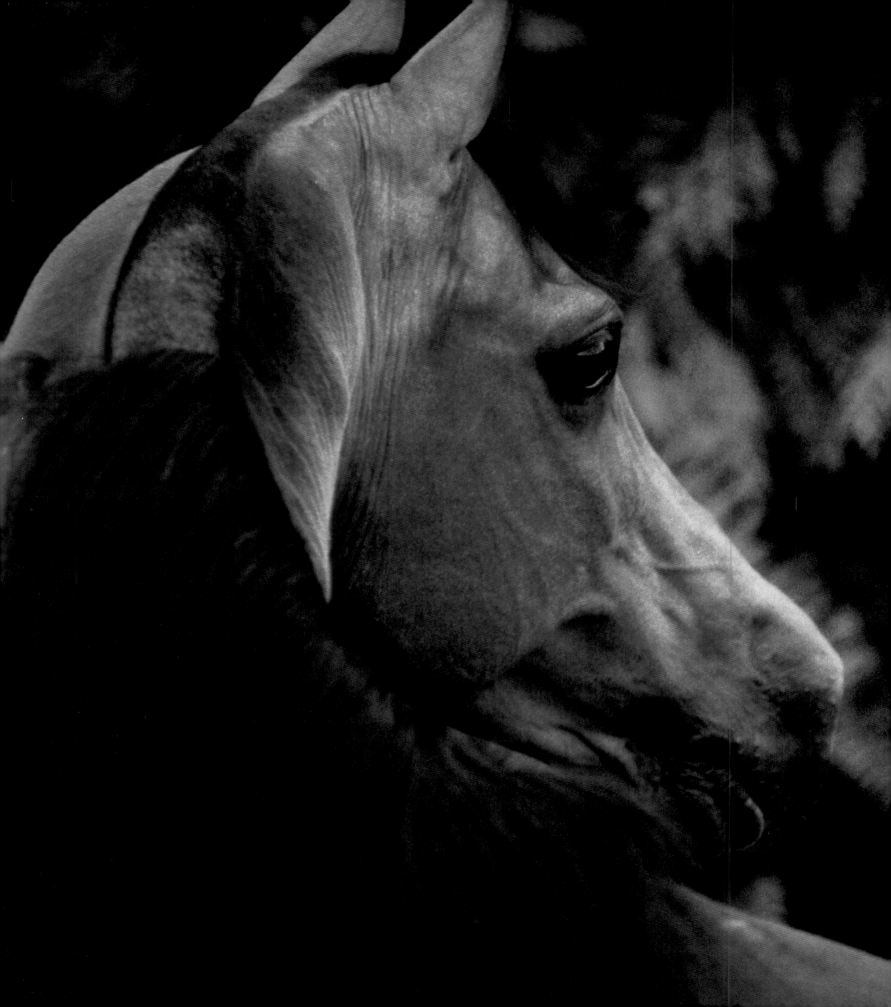

My fell is
of the desert dye
compact
of living sands,
my eye,
black luminary
soft and mild,
with its dark luster
cools the wild.

<div align="right">Negatraz's Song</div>

Bravo

Olé!
Olé!
Velázquez
would have
painted
me
this
day.

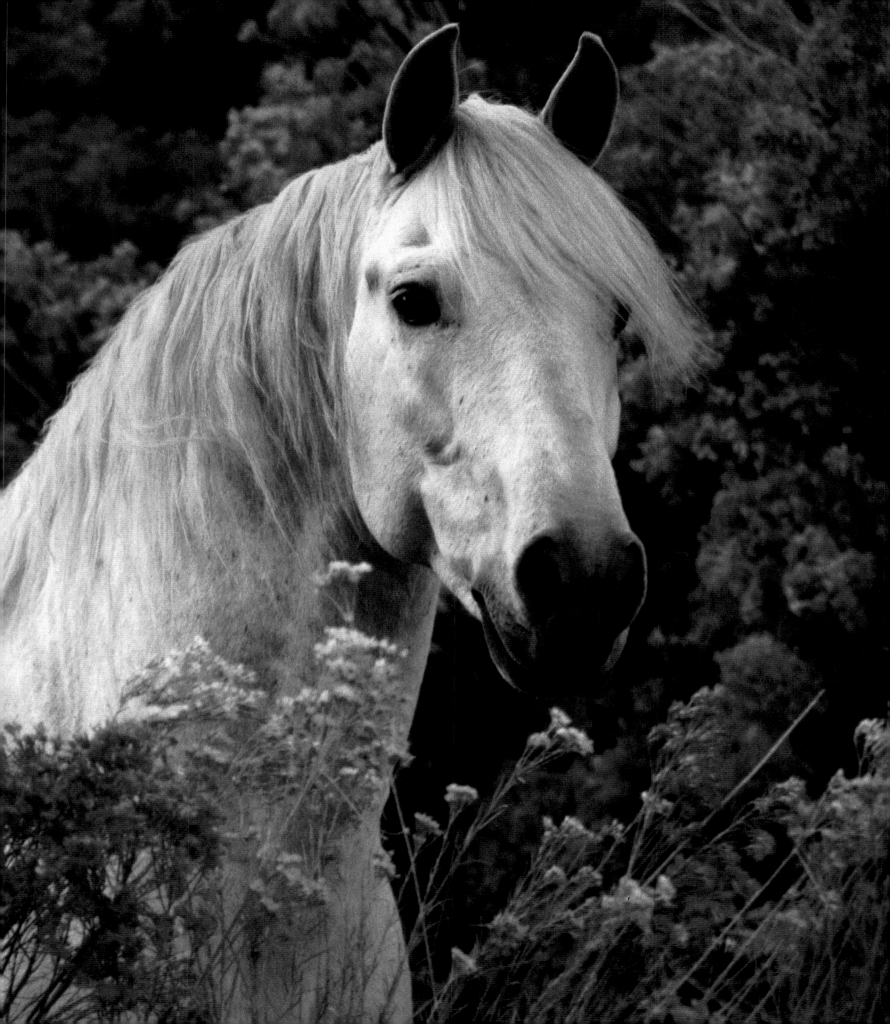

Rudolf II
of
Austria
claimed
my
Andalusian
prance
for
his Viennese
equine dance.

134

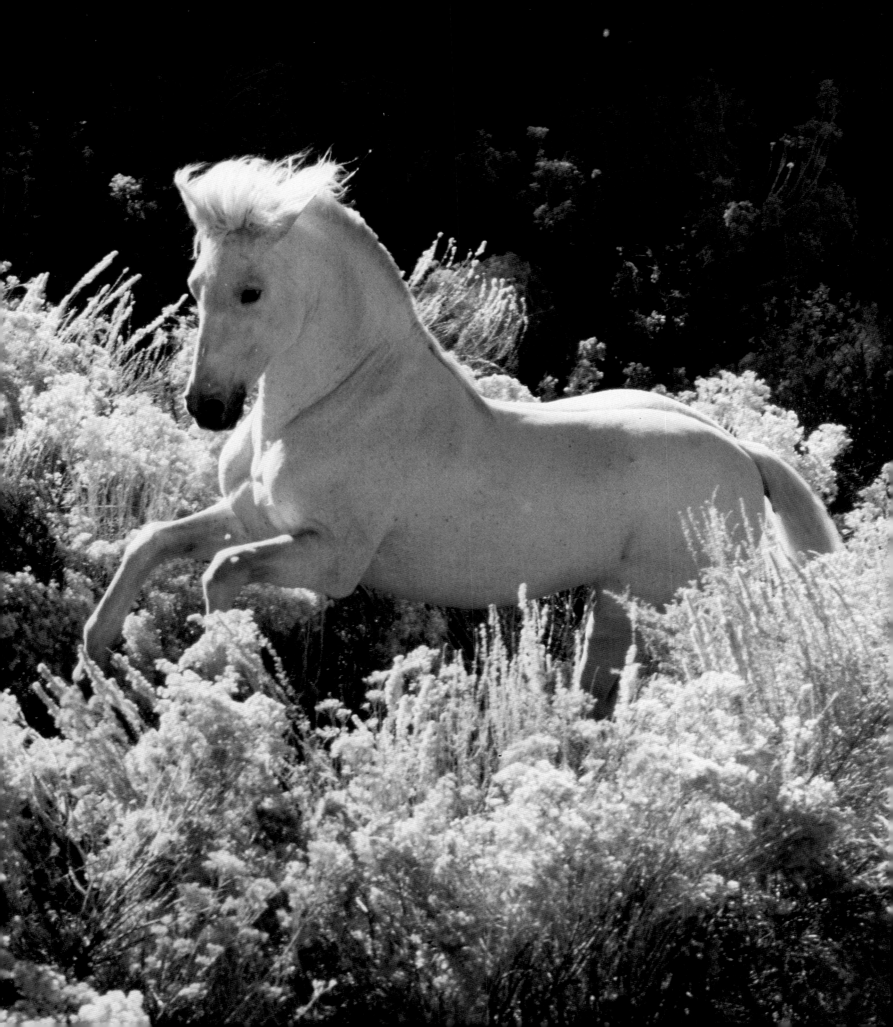

Golden airs
of Andalusian Rome
circle my head
and gild it.
In all Sevilla
there has not lived
a prince so royal
Nor any heart
so staunch and loyal.

136

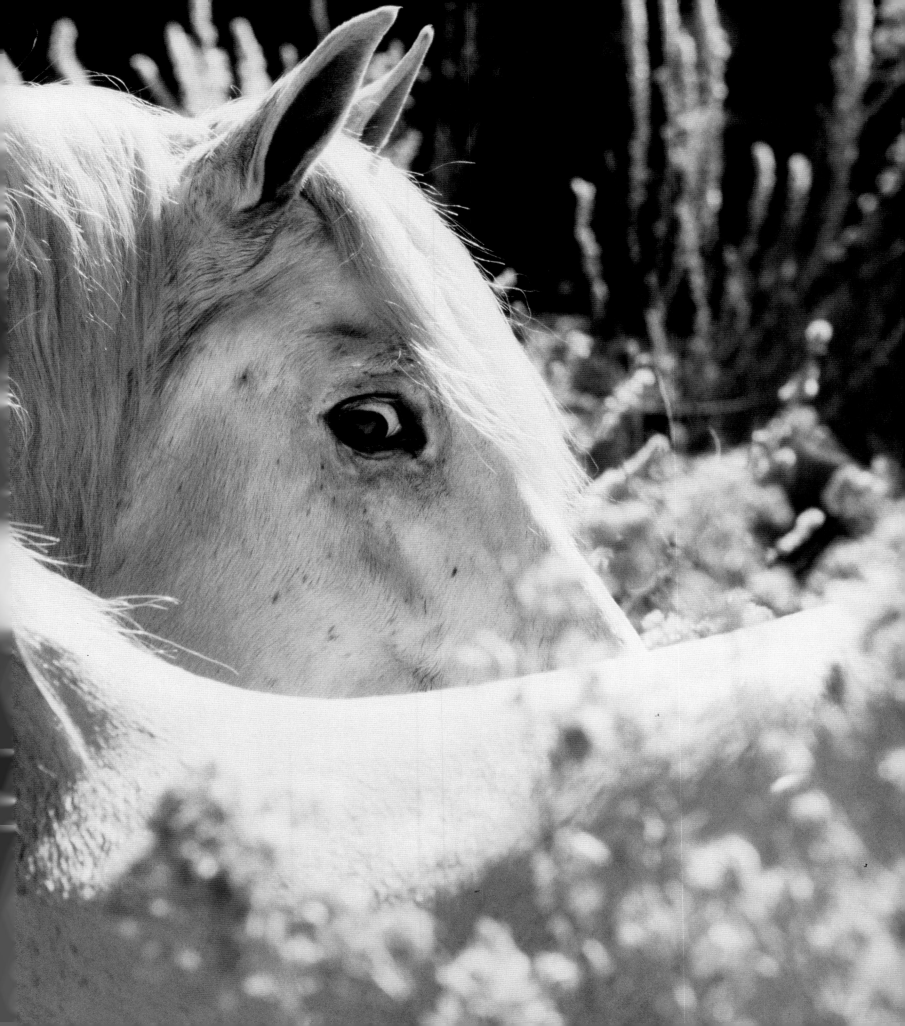

Lorca
would have written
my whiteness
against
his
Andalusian
green.
Verde,
· que te quiero
verde.
Verde viento,
verdes ramas,
y el caballo
en la montaña.

138

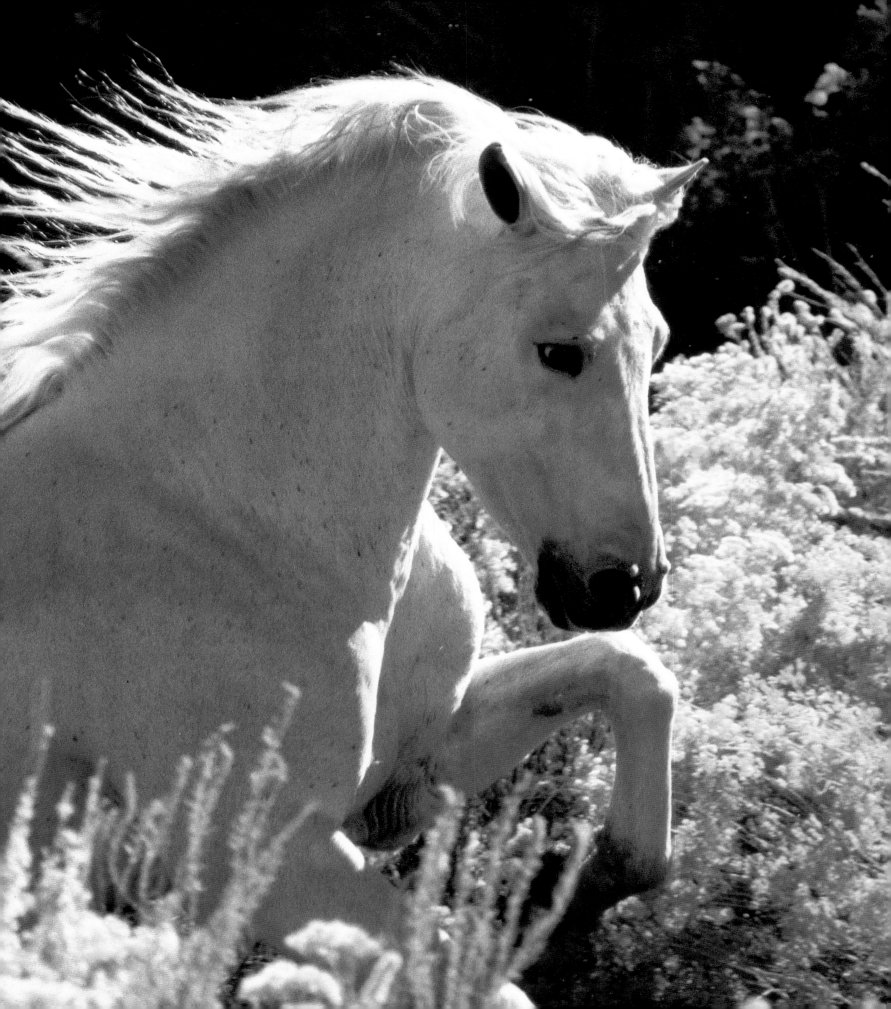

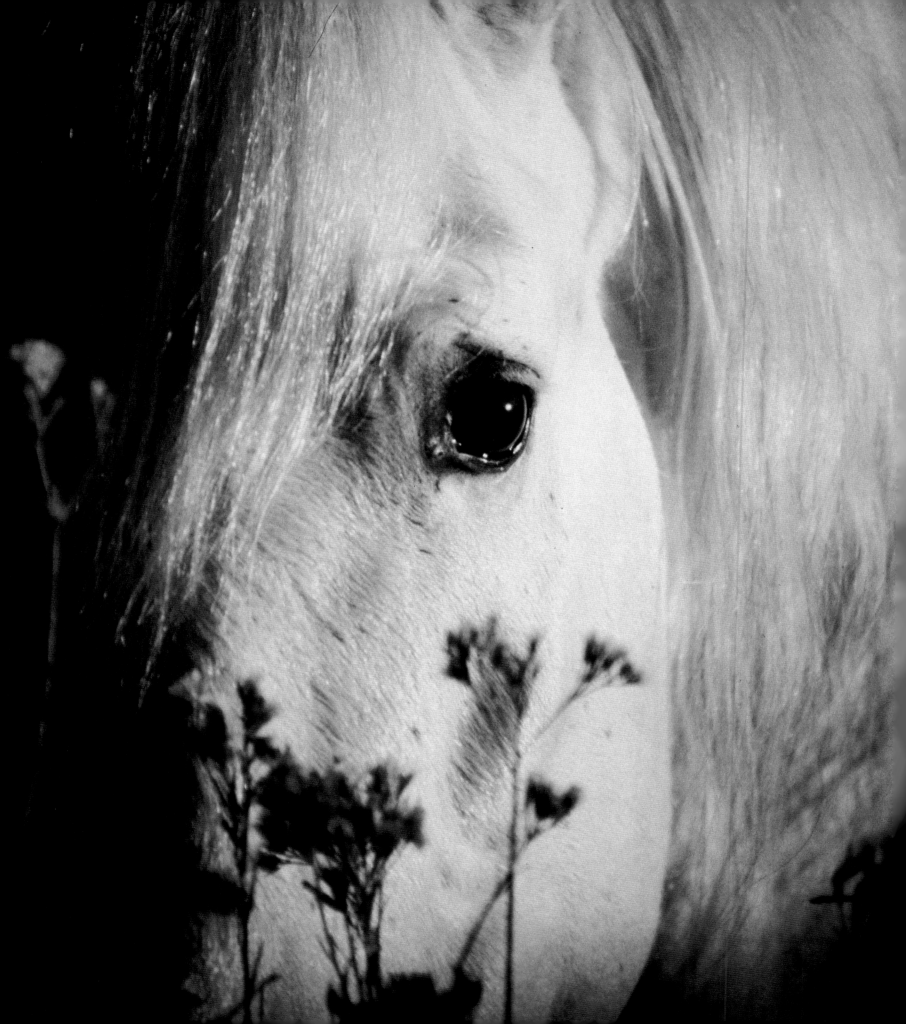

In this
snowy porcelain
form,
you find me
timid and courageous,
docile and ungovernable,
hot-headed and phlegmatic,
teachable and obtuse.
Soy
el caballo
Andaluz.

Bravo's Song

141

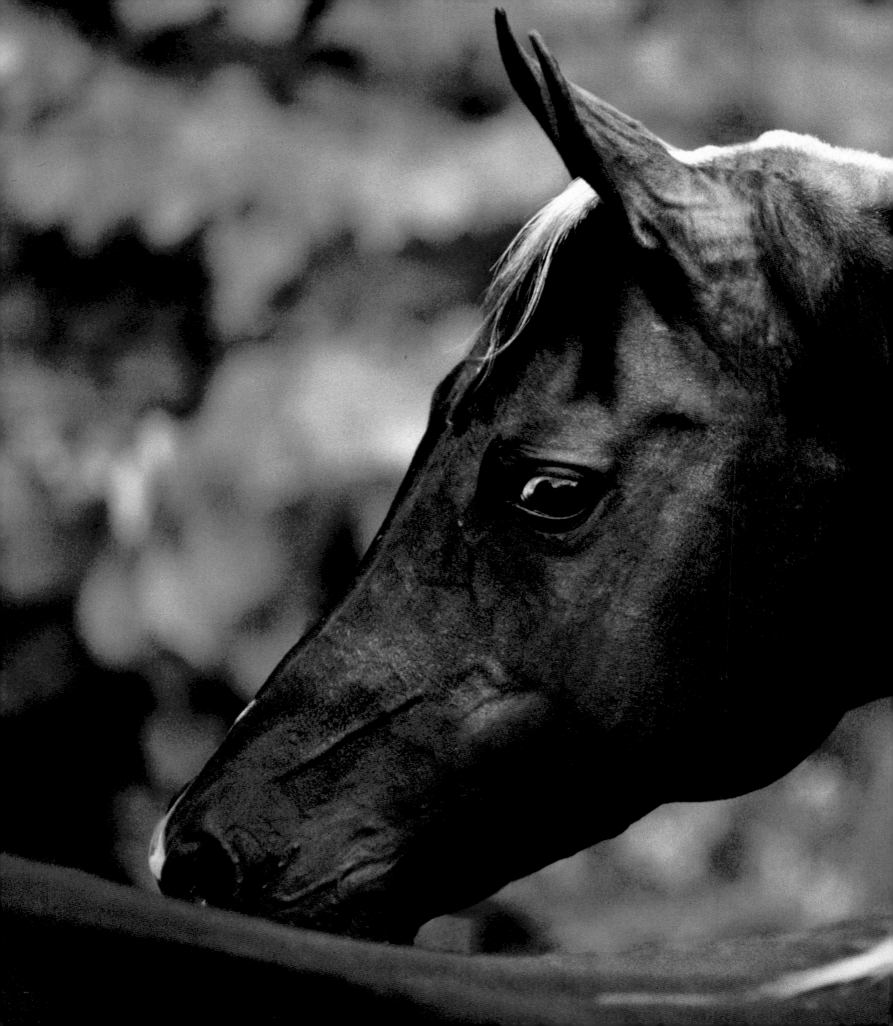

Prince Charmming

Charmed
Egyptian
prince,
my mantle
is even
more
exotic
than
the
coffer contents
of our
noble
Nile
breed.

143

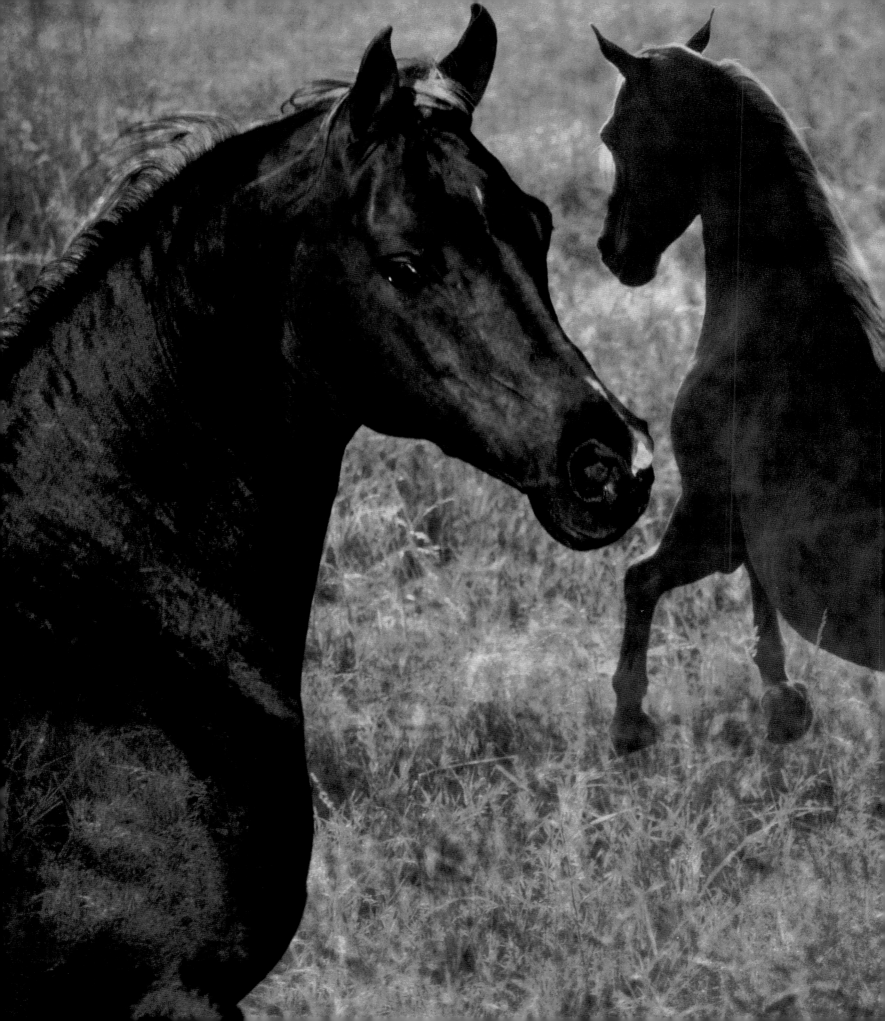

Swift

as Horus,

like

a lion in harness,

I pulled

Nefertiti's

chariot

to

the lead.

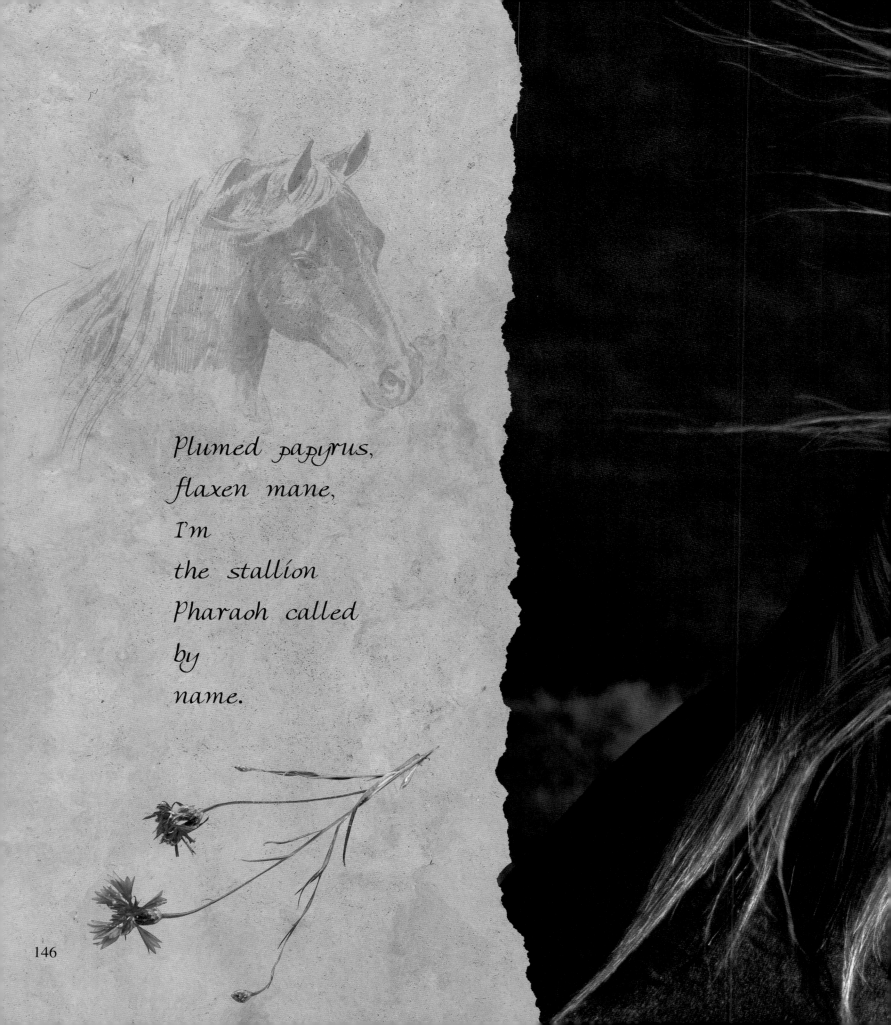

Plumed papyrus,
flaxen mane,
I'm
the stallion
Pharaoh called
by
name.

146

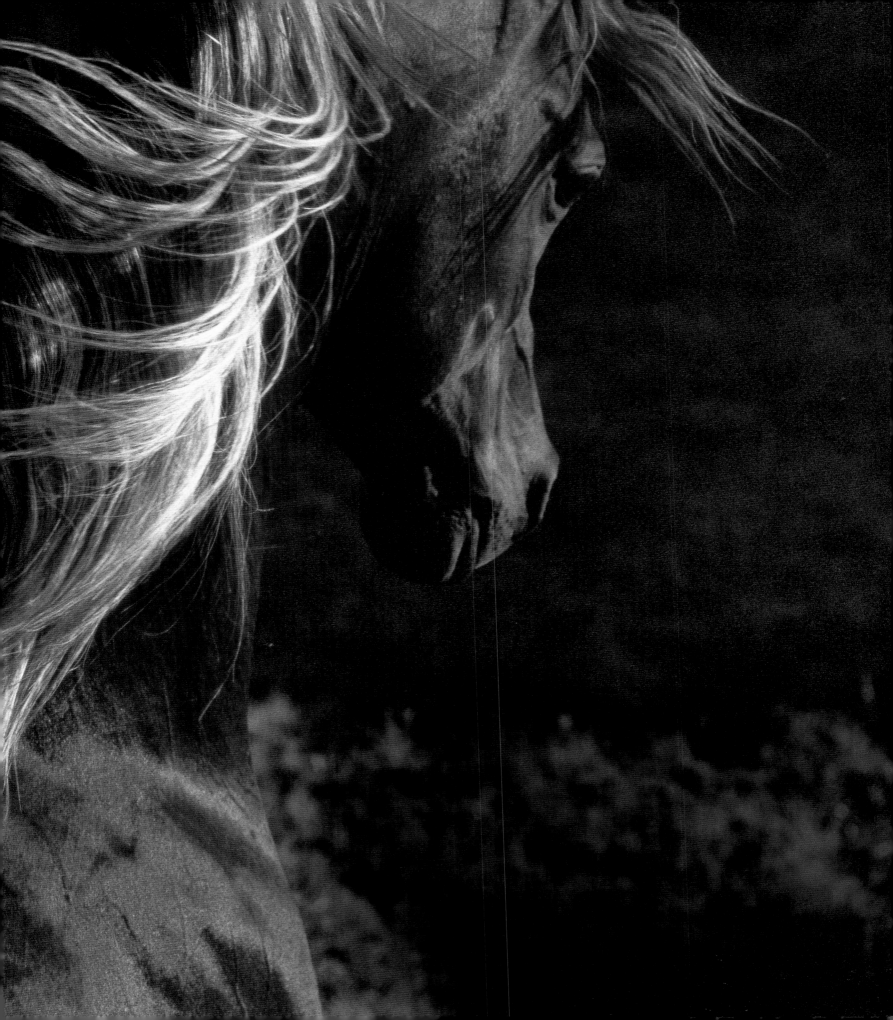

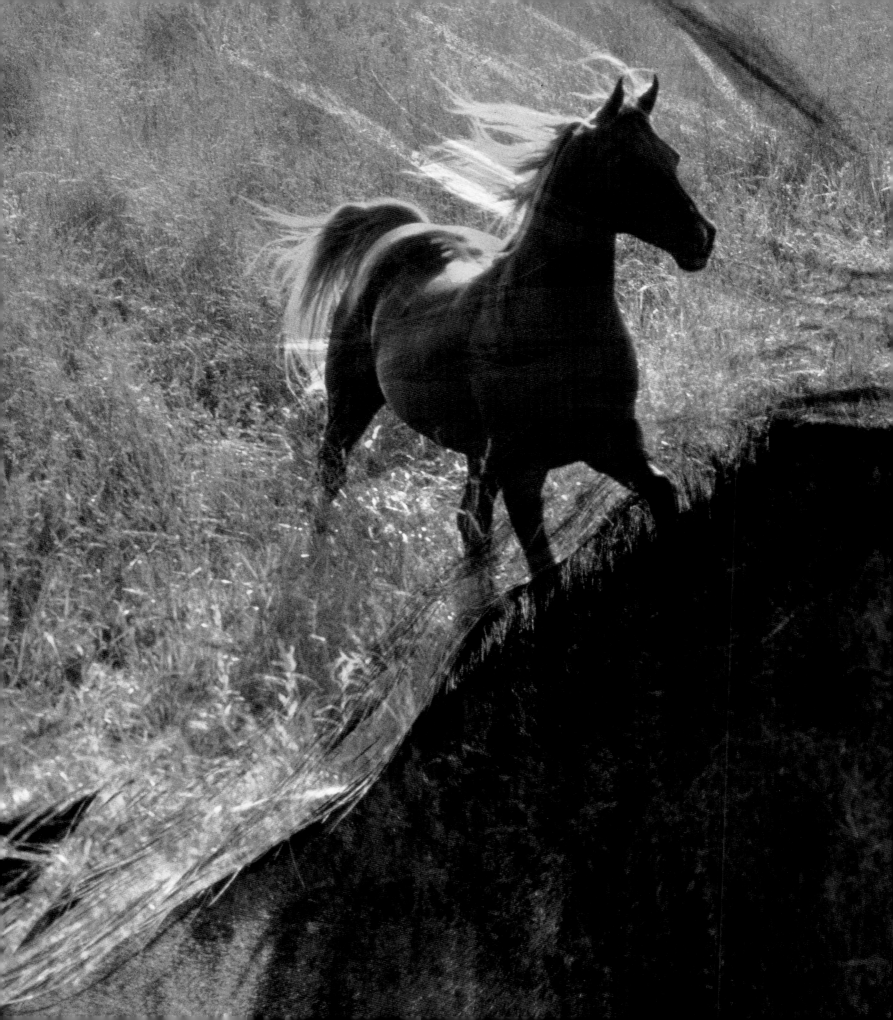

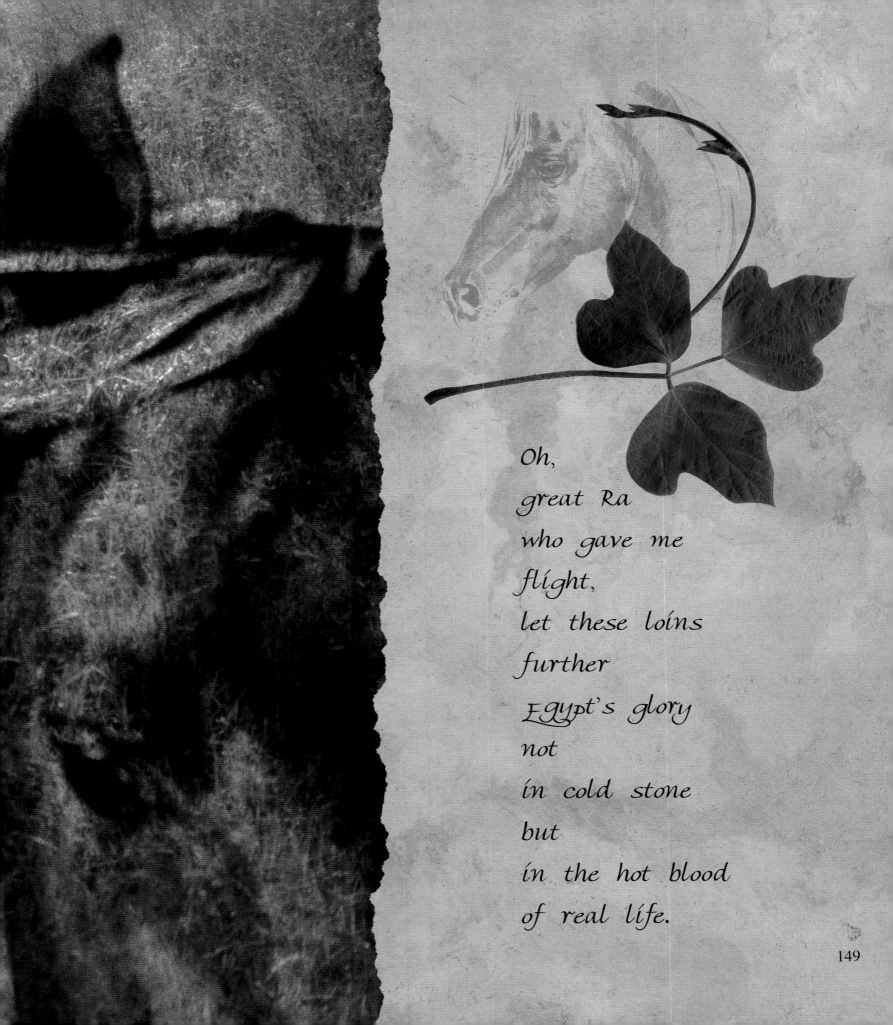

Oh,
great Ra
who gave me
flight,
let these loins
further
Egypt's glory
not
in cold stone
but
in the hot blood
of real life.

149

If
earth
were what
it once
was
to never be
again,
this sun-like gaze
would raise
Tutankhamen
from
his dark and stony
grave.

Prince Charmming's Song

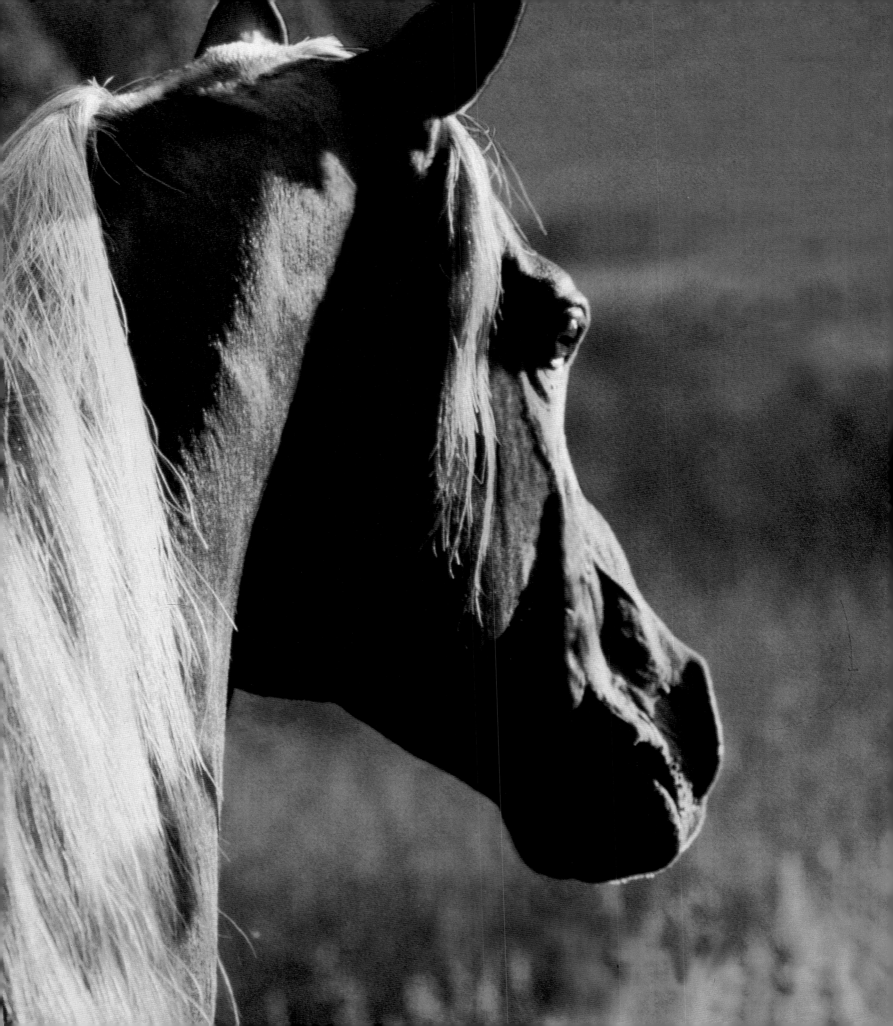

Frans

Through my mane and tail
the North wind
sings,
fanning ebony hairs
that wave like
feather'd wings.

152

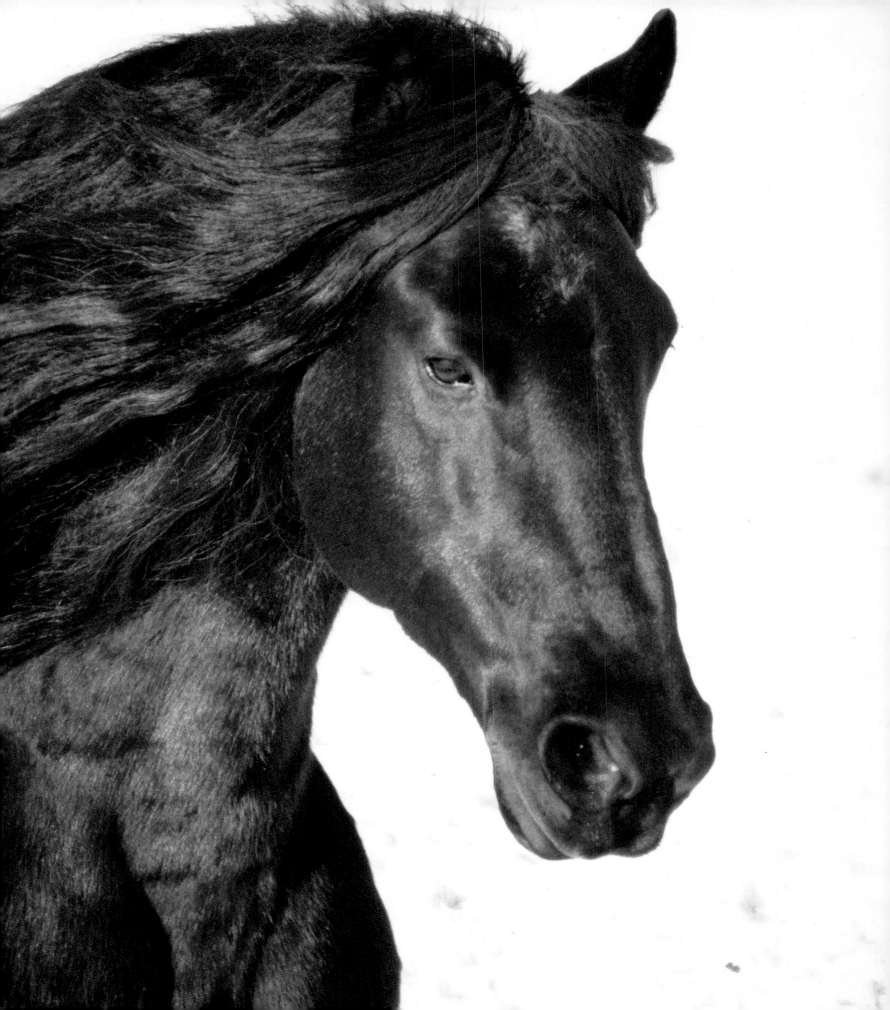

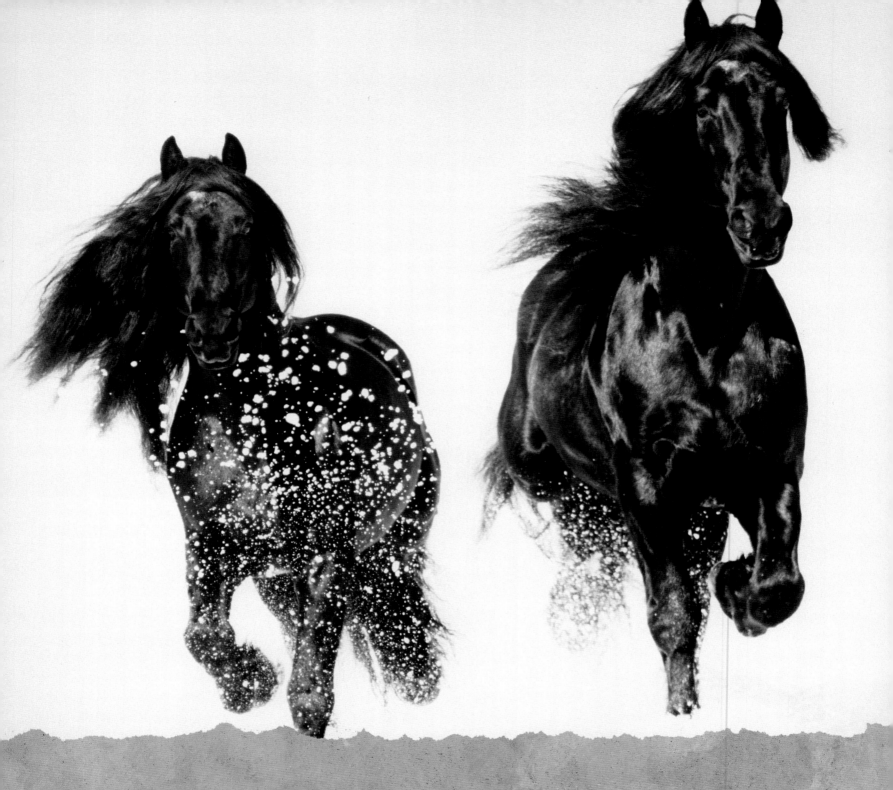

My rigid curved neck,
such as ancient sculptors
molded.
The interplay
of my muscles.

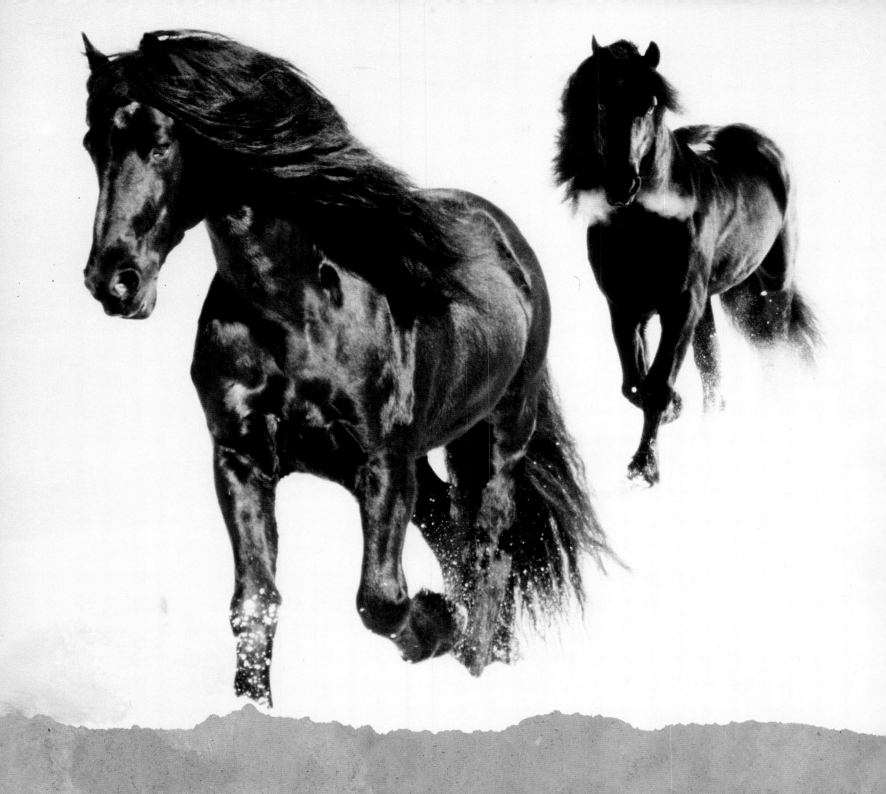

In each of my poses
I am a composite
of
all the equestrian statues
of history.

I am a thing
of
such bold beauty,
none will tire
of
looking at me
as long as
I display
myself
in my midnight
splendor.

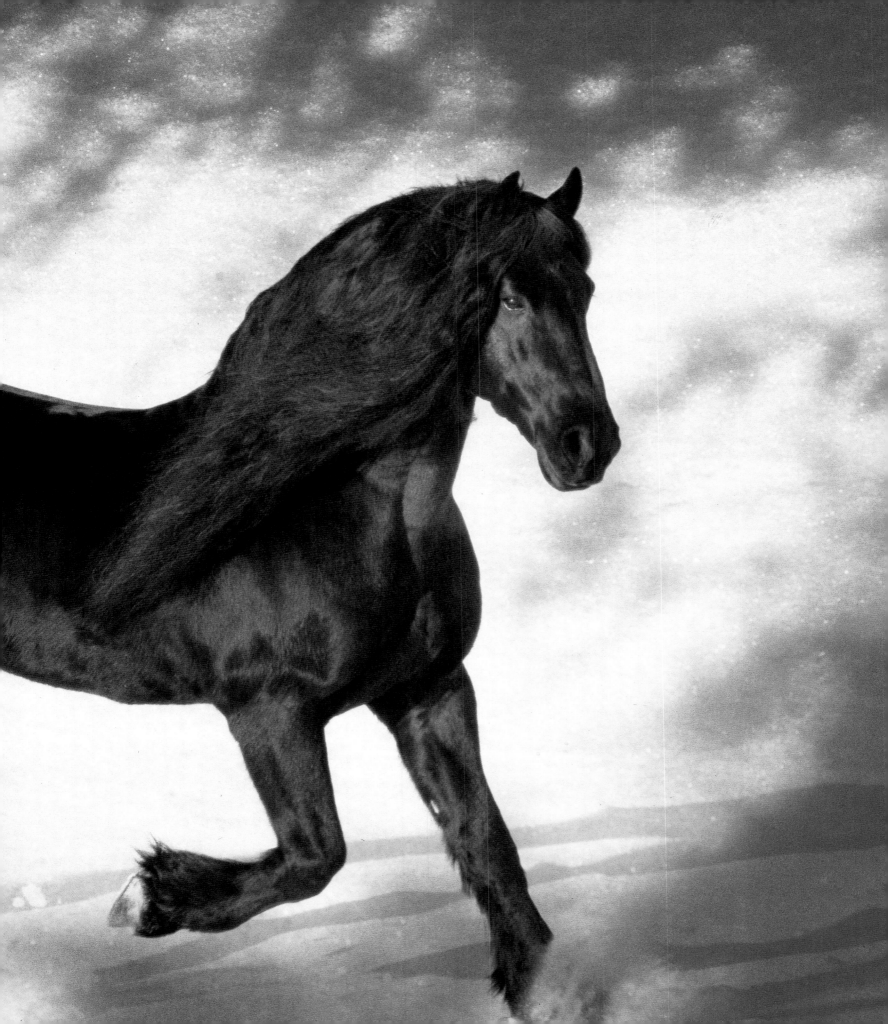

Cold land,
Friesland
from
whence
I sailed.
Wind-whipped
Viking masts,
wind-whipped
mane.
From
Hadrian's Wall
to
Crusaders' call,
I'm
the
standard bearer
of
victory
and fame.

159

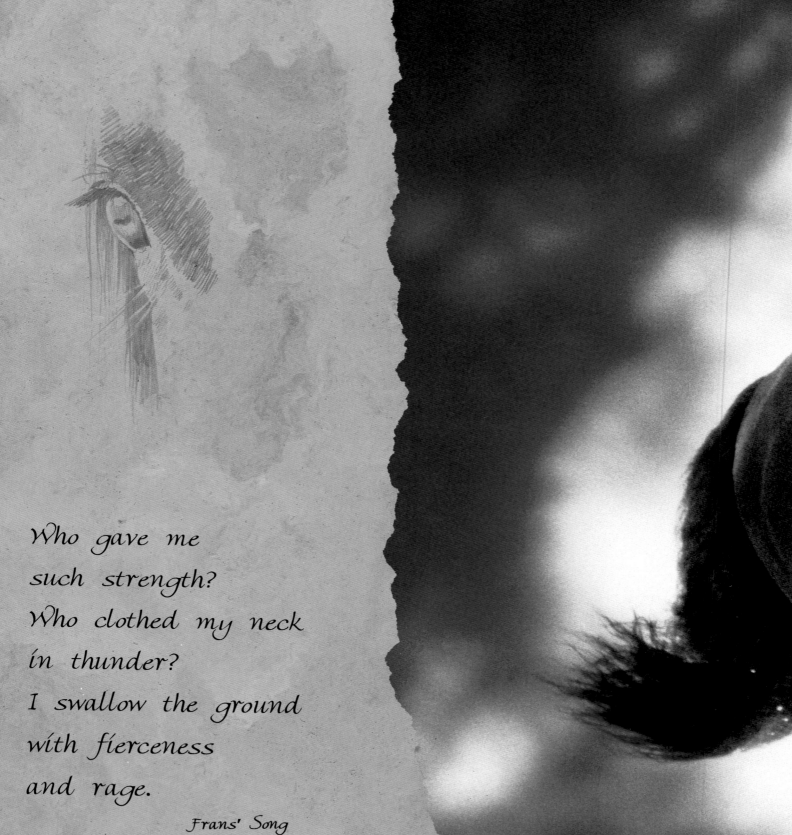

Who gave me
such strength?
Who clothed my neck
in thunder?
I swallow the ground
with fierceness
and rage.

Frans' Song

160

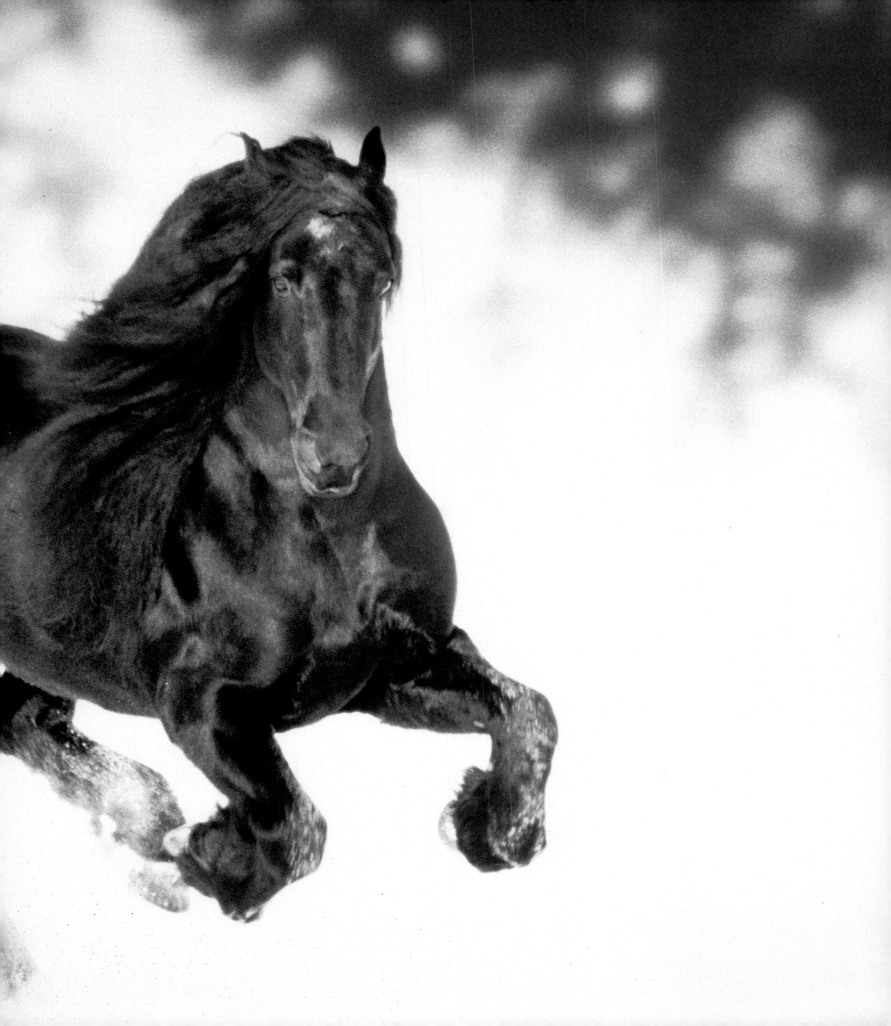

Tshockwave

Distant

Petra

listens

in stony silence

to my neigh.

And, oh

what a brisk

and joyous neigh

it is!

My very heart

leaps with

its

e c h o e d

answer.

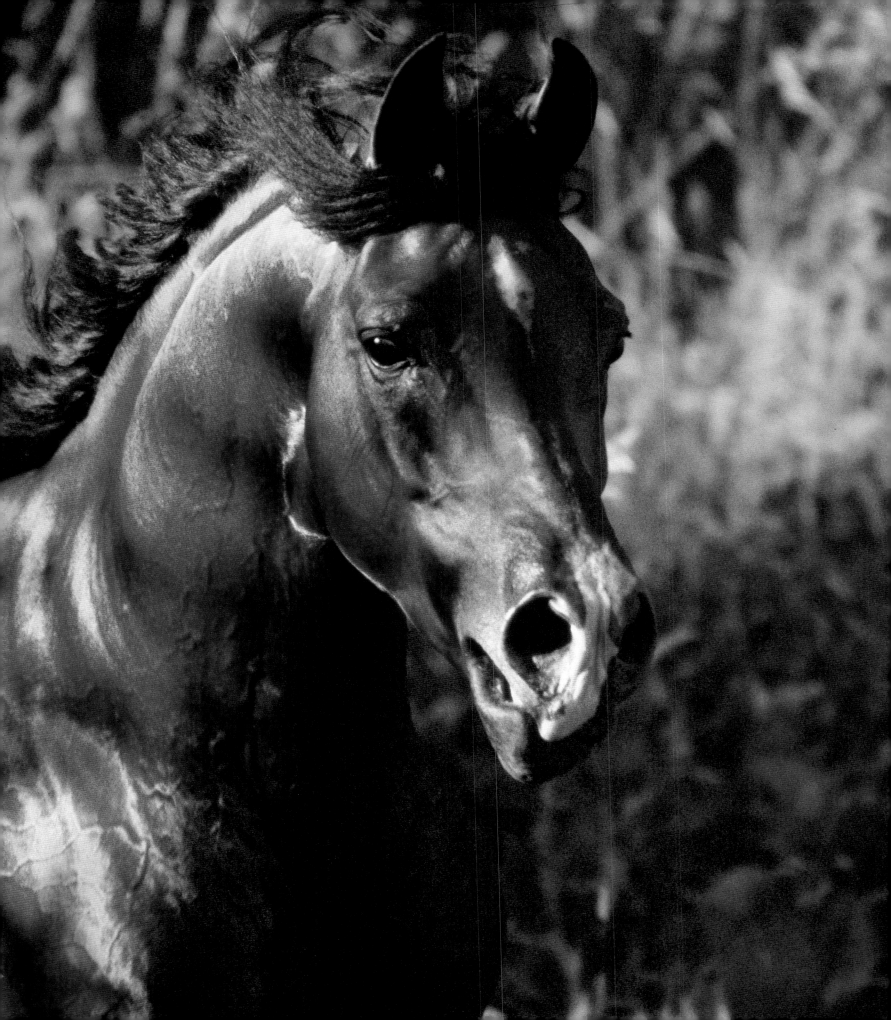

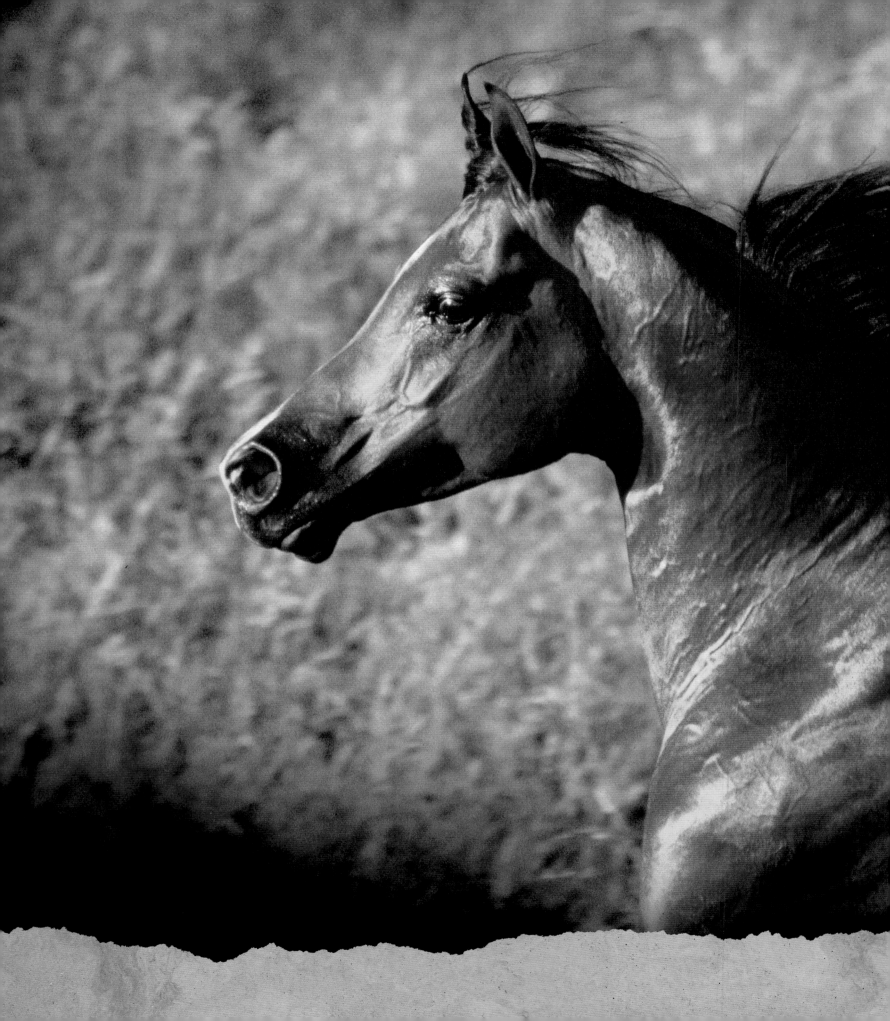

Fleeting on

in

the sunshine,

a speck

in

the gleam

on

galloping hooves,

my mane

in the wind,

out-flowing

as if

in

a Bedu

dream.

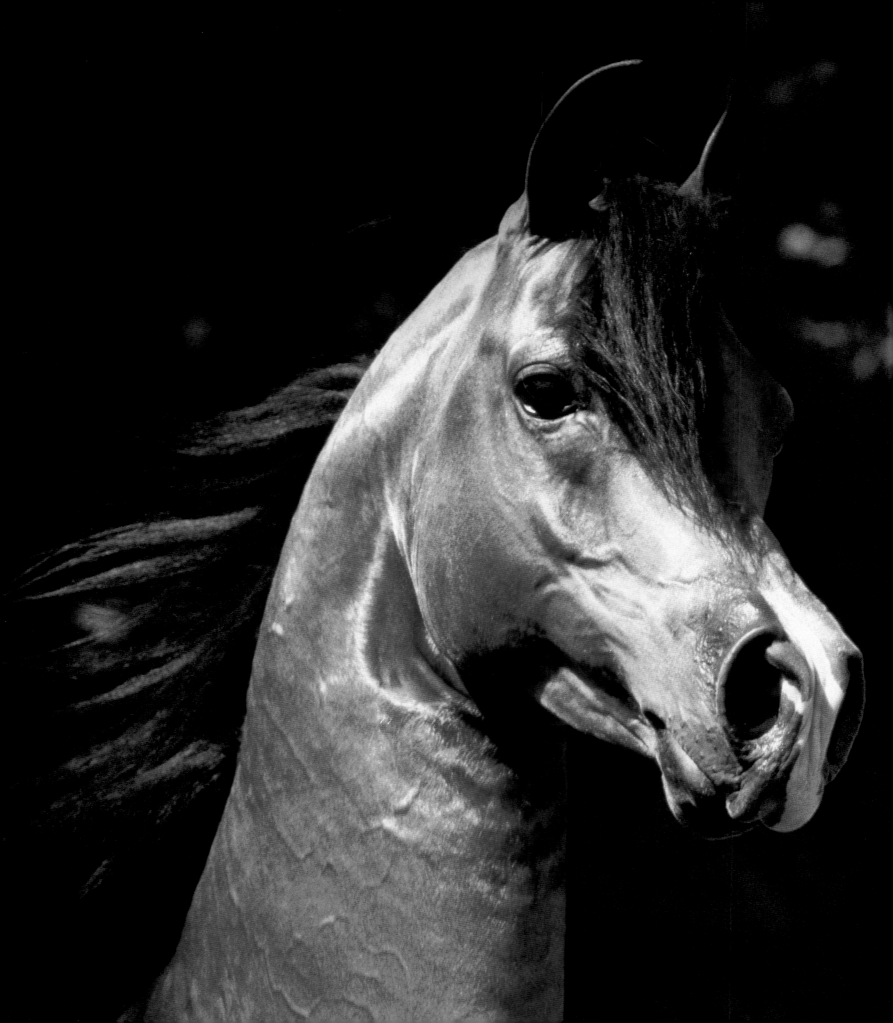

I am
the owner
of
the desert sphere,
Of
the seven stars
and
the solar year;
Of Ali's hand
and Aurens' brain,
Of Auda's heart
and
Feisal's strain.

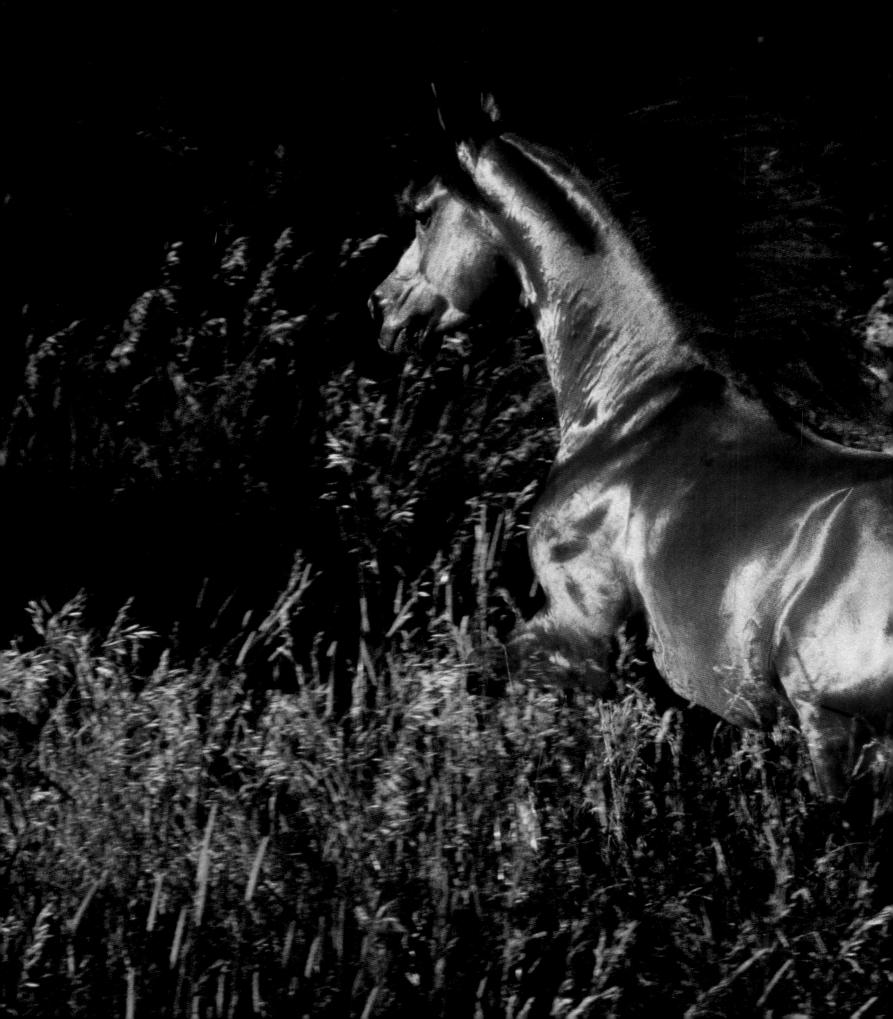

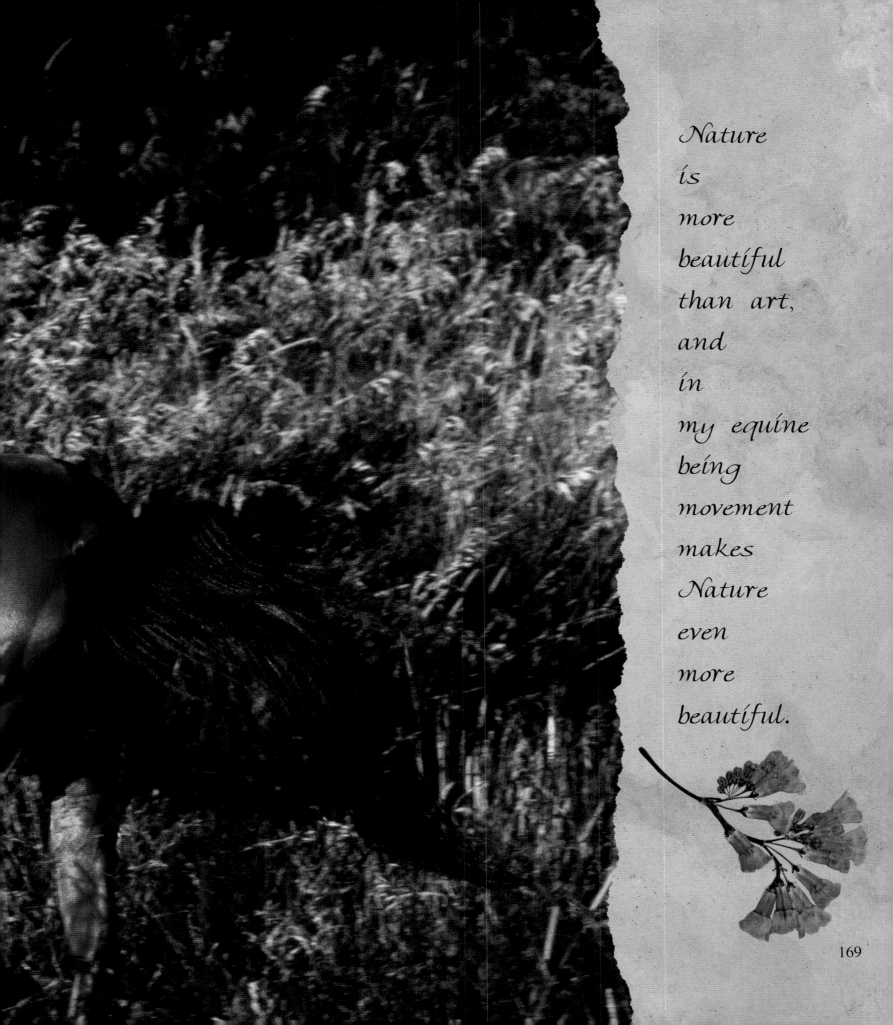

Nature
is
more
beautiful
than art,
and
in
my equine
being
movement
makes
Nature
even
more
beautiful.

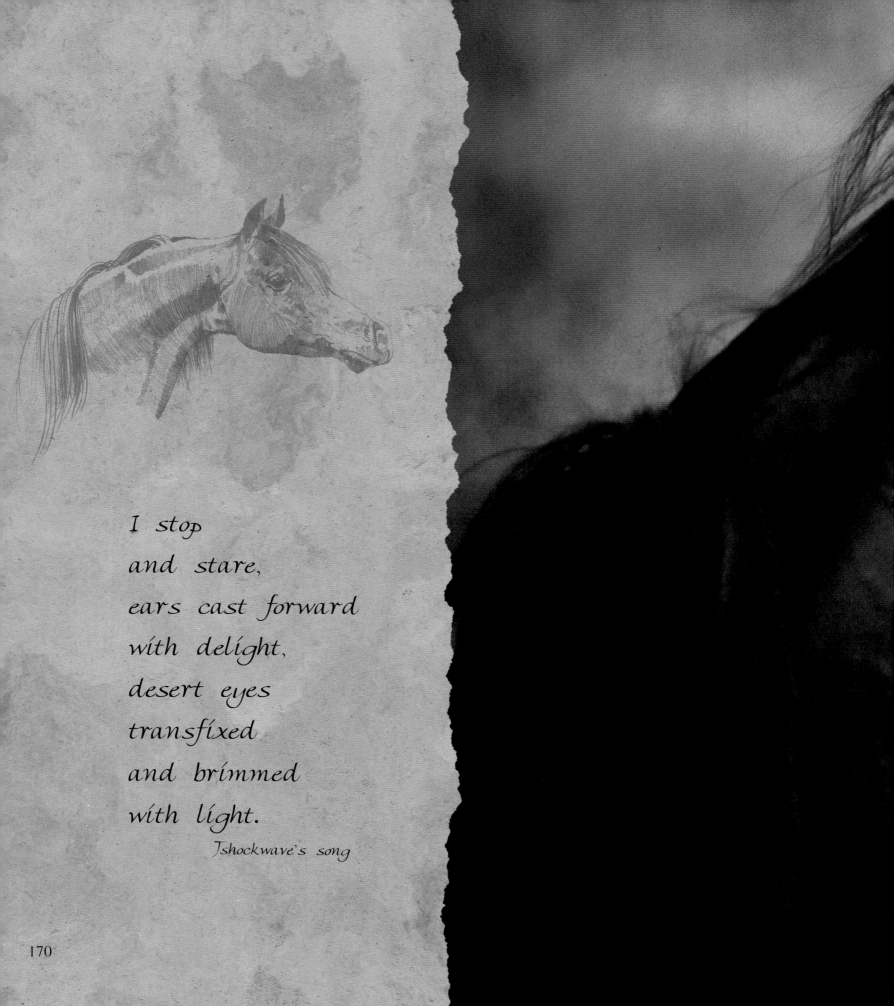

I stop
and stare,
ears cast forward
with delight,
desert eyes
transfixed
and brimmed
with light.

Tshockwave's song

Padrons Psyche

By reason of my elegance
I resemble
an image
painted in a palace,
though my reflection
is as
majestic
as the palace
itself.

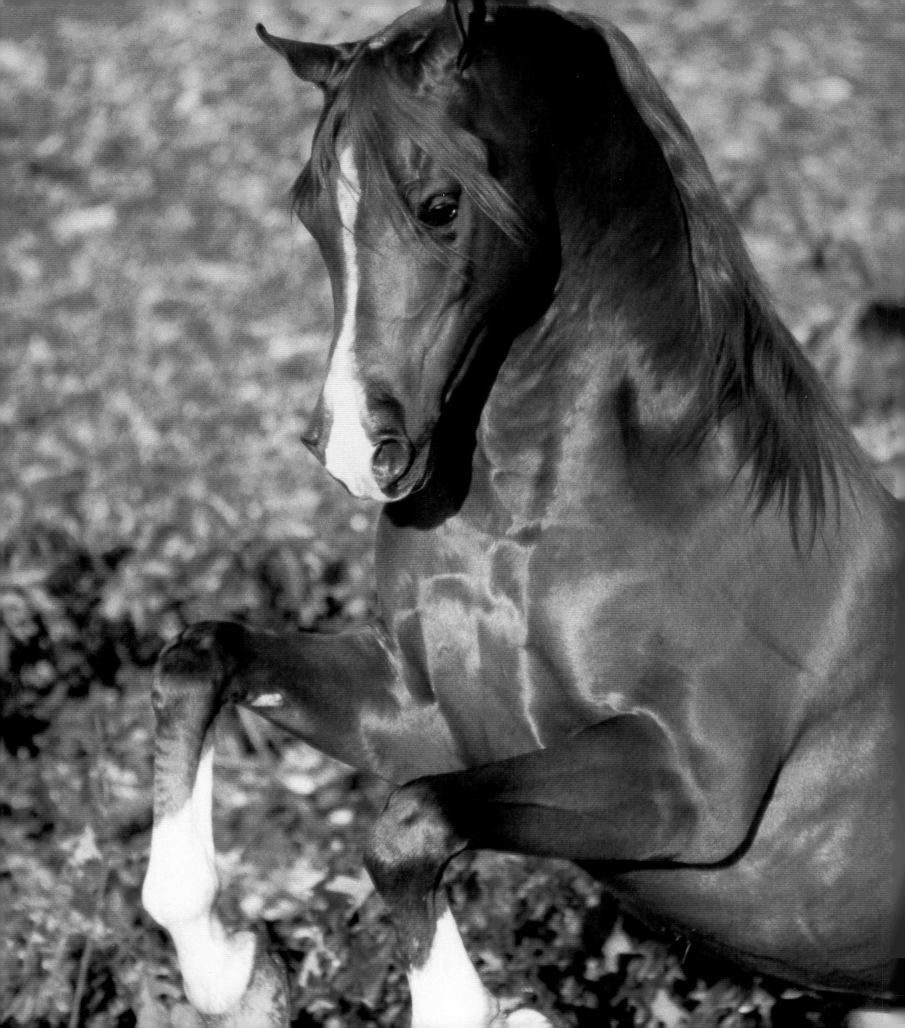

My ears uppríck'd,
my flowing mane
upon my compass'd crest
now stands erect.
My eye,
which scornfully
glisters like fire,
shows my hot courage
and my high desire.

175

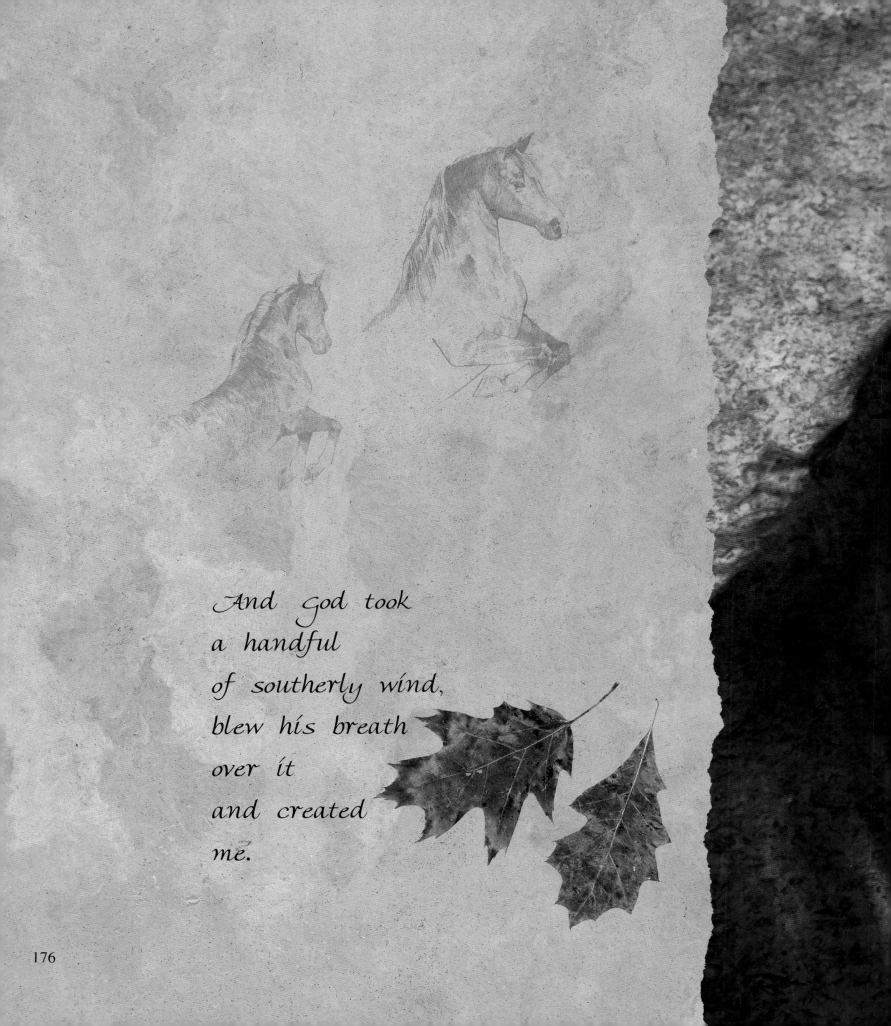

And God took
a handful
of southerly wind,
blew his breath
over it
and created
me.

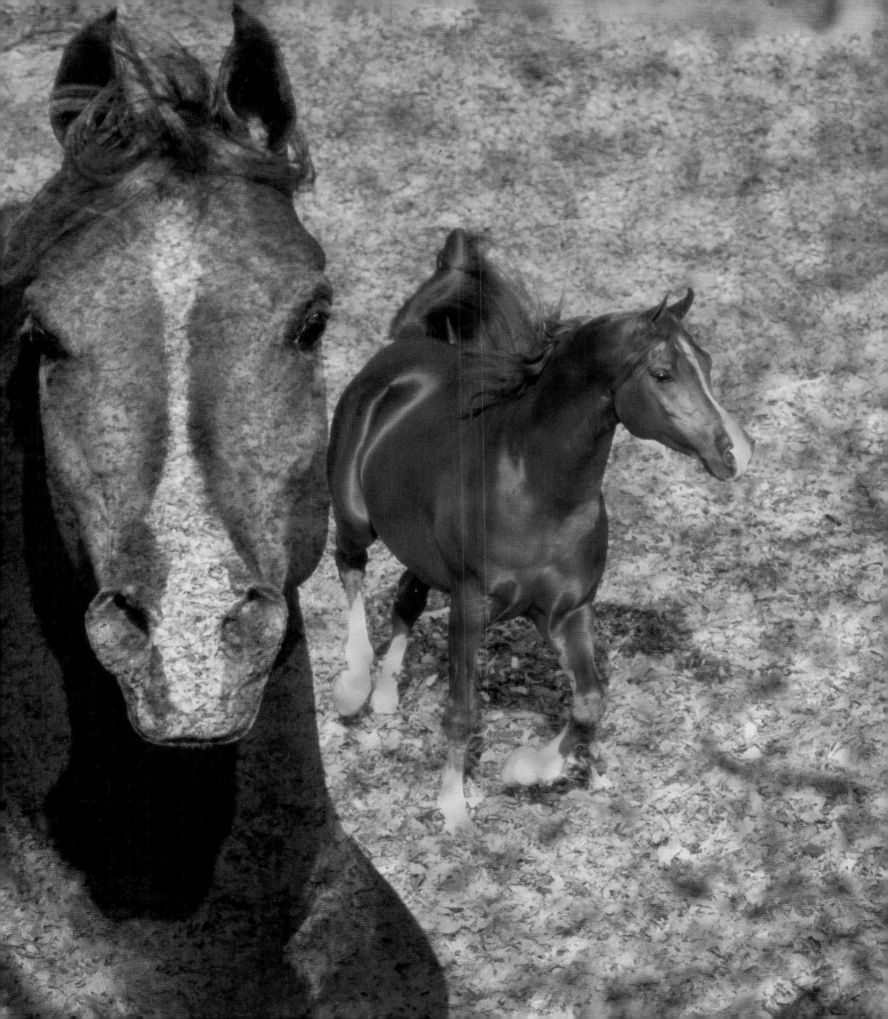

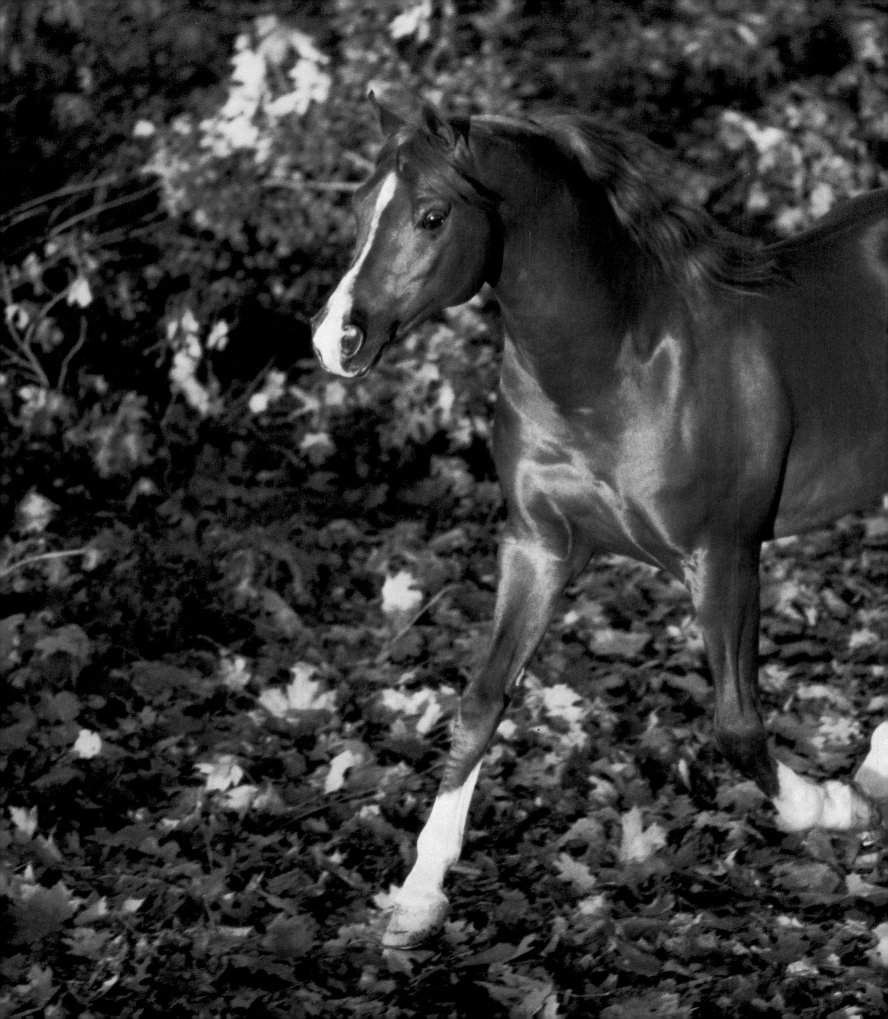

The flashing cascade
of my mane
the curving comet
of my tail,
have invested me
with housings
more resplendent
than even
autumn's brilliance.

179

O'er the horizon
the sun
flashes copper
on its
westward flight,
while blazing
the sinews
of my
desert might.

Padrons Psyche's Song

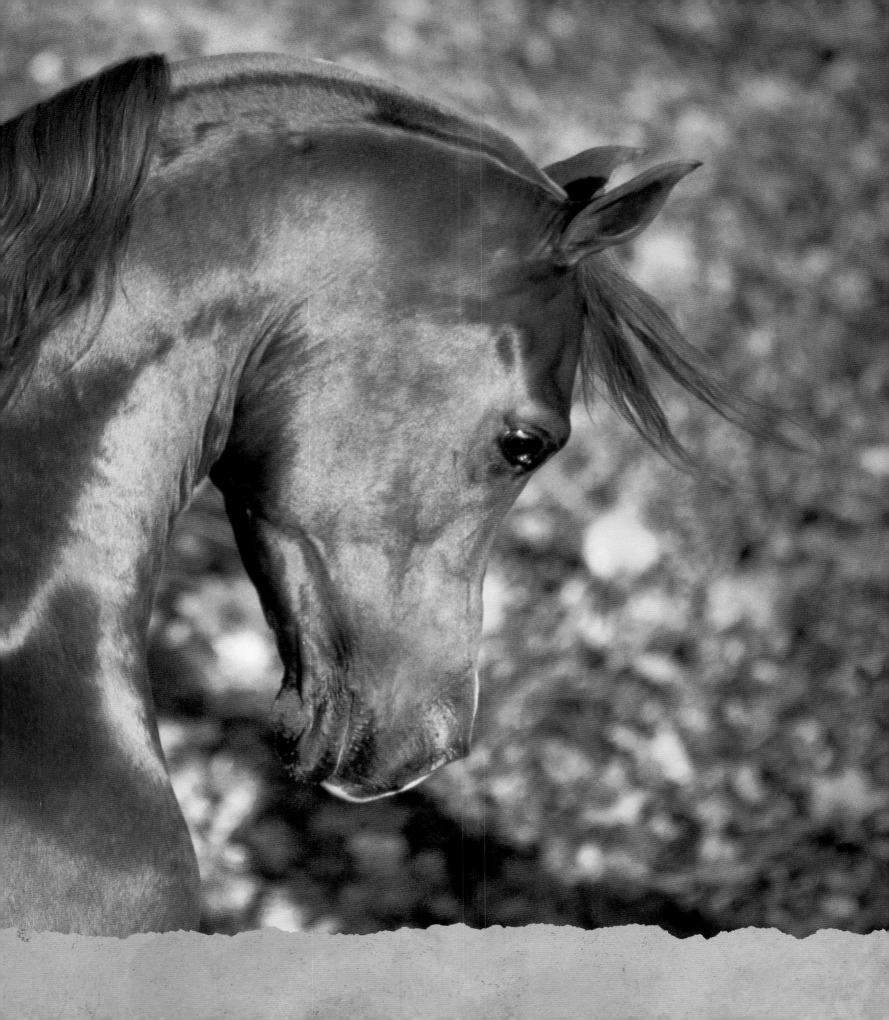

Barexi

Unblemished,

this

water-smooth

silver brilliance

beckons images

of cloudless desert skies,

of Nature's

gracious gifts.

These onyx orbs,

dark and cool

as

oasis pools,

shimmer

with

Rawashid ire.

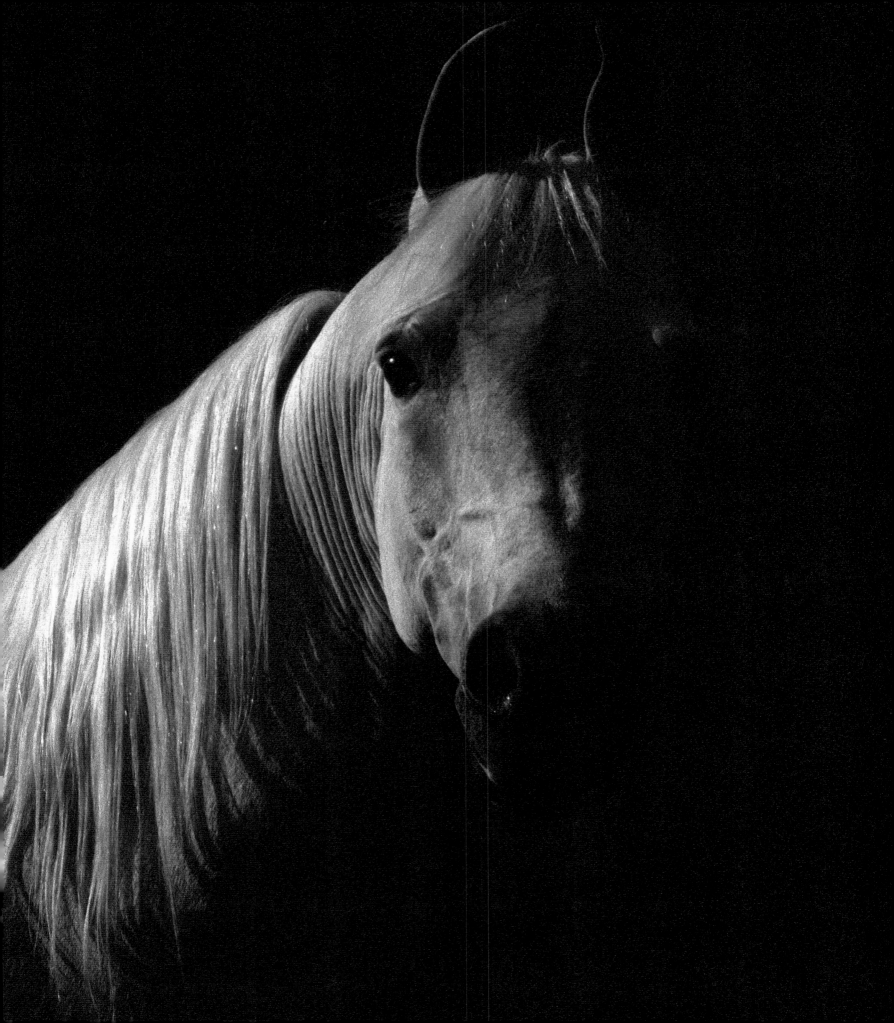

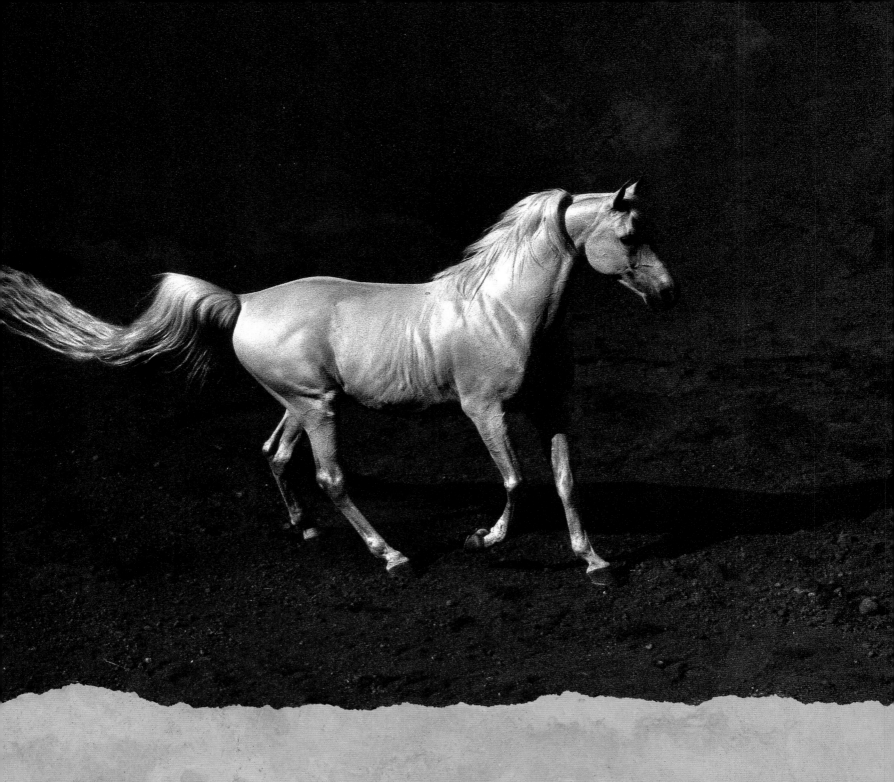

I am swift and strong
among the swift ones,
but it is
my flowing

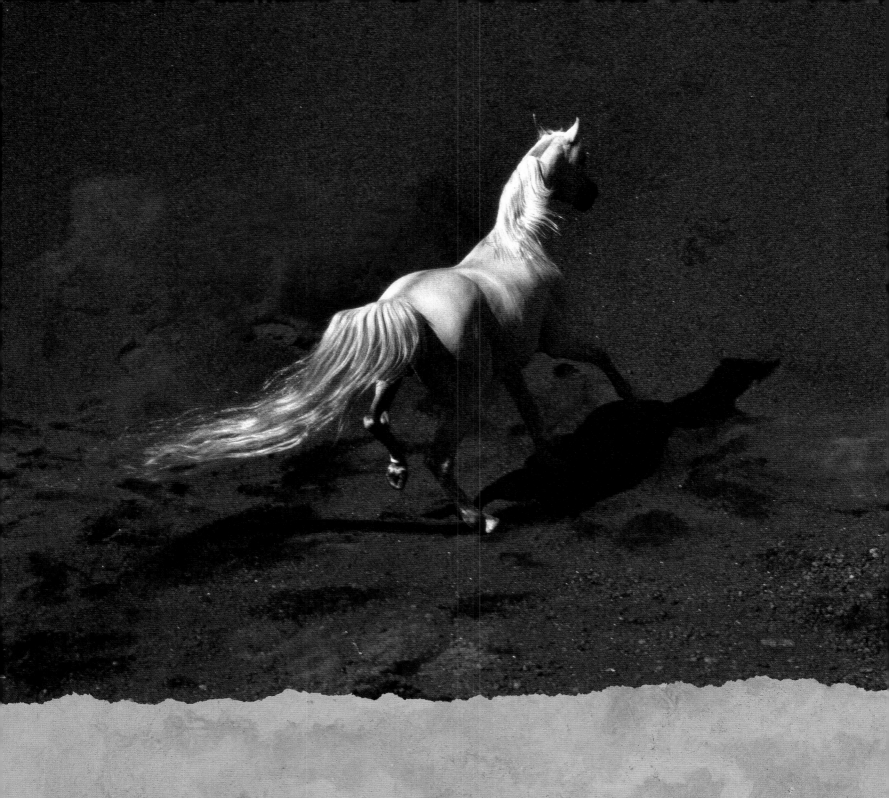

mane and tail
that mark me
chiefly from
afar.

Before the gods
that made the gods
had seen their sunrise
pass,
my whiteness
was hewn
of
the redrock
mass.

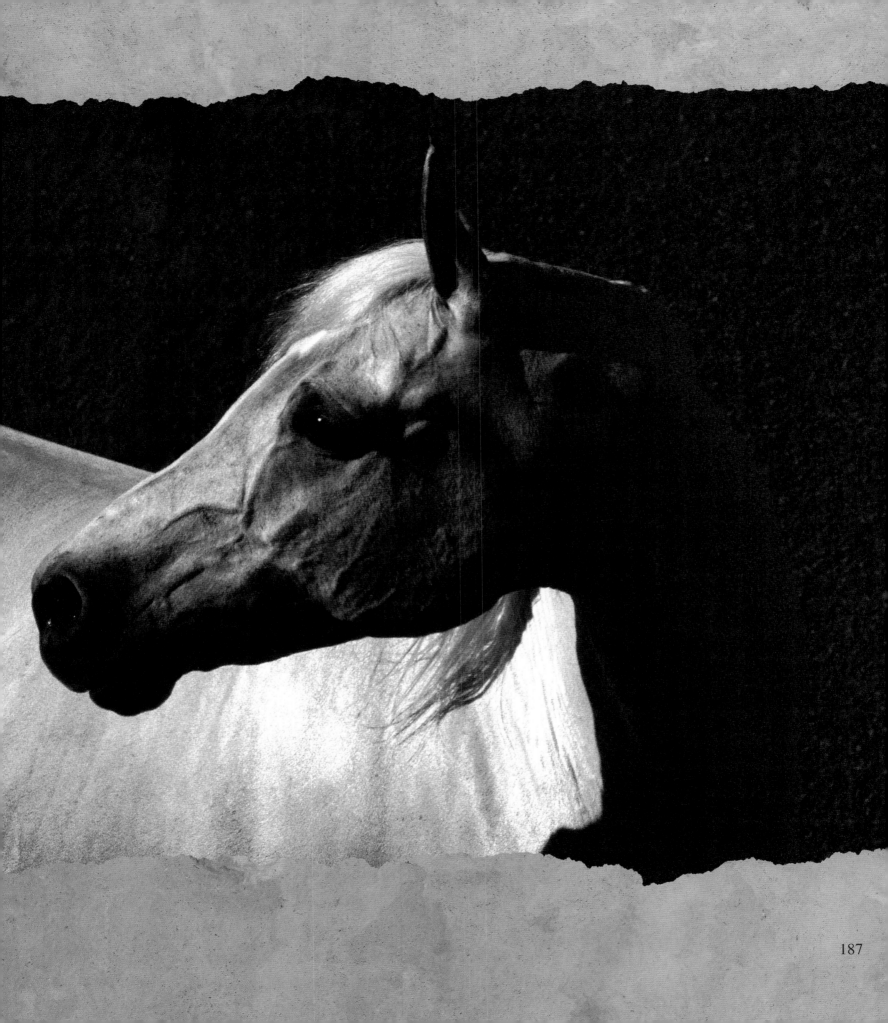

And forever streaming
above me,

caressing my arched-neck cool,

flows a mane of molten silver,

to fan the steady pulse

of my pinions,

their wonderful

fall

and

rise.

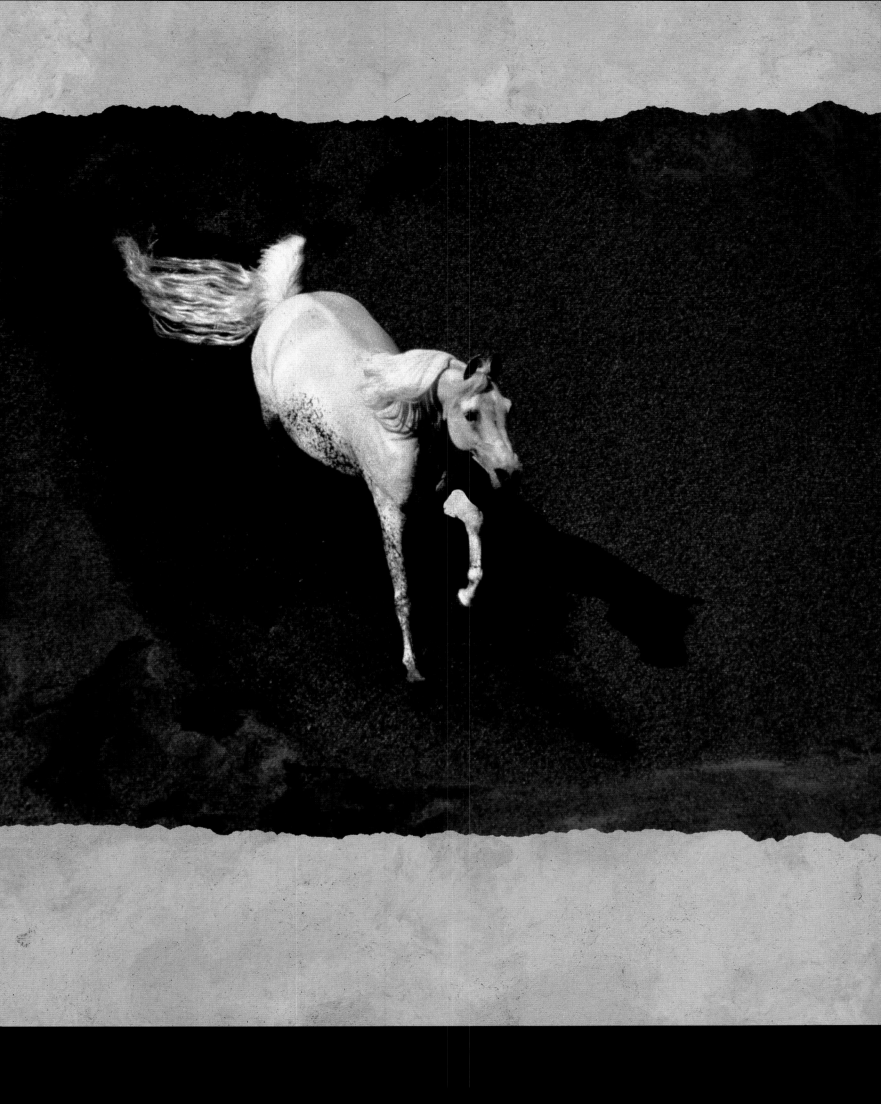

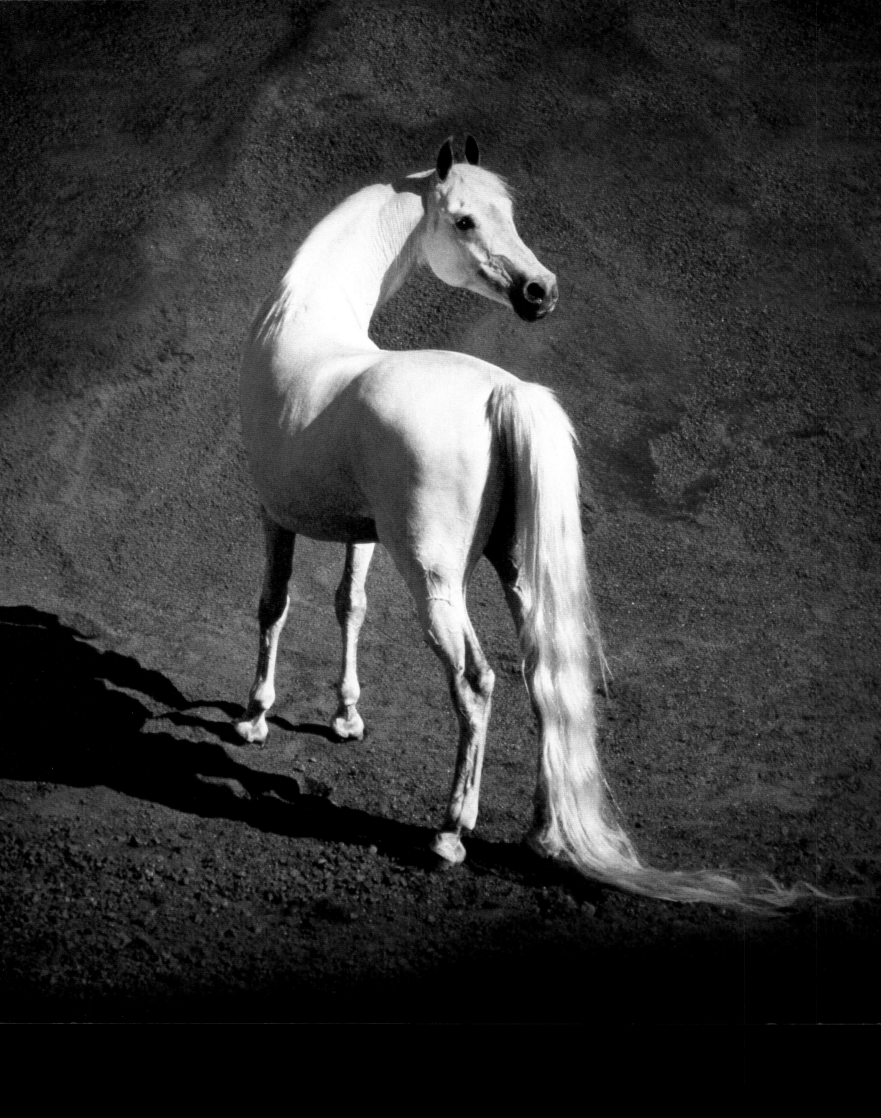

All shiny beautiful
and gentle of myself
I cross these savage sands,
unworthy
of my gracious pasterns.
My strutting tail
flows even to the ground,
and my mane was shed
by the loving nurture
of Mother Nature.

Barexi's Song

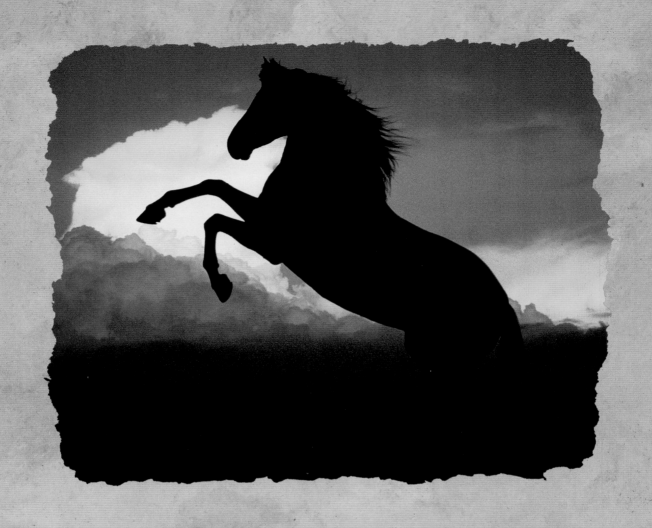

Wind, sand, moon and stars,
I rear aloft into the darkening heavens,
Galloping, galloping through silver galaxies,
Waiting, waiting, waiting, waiting, waiting,
Until and beyond midnight,
Waiting for the first ember-fringed cumulus,
Waiting to join all horses everywhere,
Waiting, waiting, waiting for the sun,
Waiting to once more come out to you...

REFLECTIONS

The Spanish horse has had an immeasurable significance in my life and influence on my work. Without question this animal, as it appears in the images in my books, is largely responsible for any success that I have enjoyed as an artist-photographer. Only non-existence could erase from memory that stunningly breathtaking image of Majestad, Andalusian white, knee-deep in a sea of blood-red poppies; or of Nevado, on the

beach at Puerto, "the silver runaway of Neptune's car, Racing, spray curled, like a wave before the wind." Or of Dejado, that midnight steed whose bold beauty would have been immortalized by Lorca in words or on canvas by Goya, had he lived in other times. Or of Vasallo, the embodiment of all the romantic chargers of history, the true stallion of a dream, back-lit by the setting summer sun, his "feathered mane" lifted like some luminous sail against the shadow of approaching night.

No one has written more sensitively about the Andalusian than that master of horsemanship, Alvaro Domecq Díez. In the Spanish foreword for one of my early horse books he commented:

"I would like to live longer to praise you, oh noble Spanish horse! I would like to stay here on the endless plain to admire you in your freedom, feeling with you the caress of the breeze.

"A thousand times I have thought that I am in love with you – oh, what madness! When God created man he used mud, but when it came to making you, the legend says that he used pure air. Some say that this is fantasy, but I doubt it. The air blows, dispels, moves away, but you are forever coming closer to me. When I stroke you, you follow me. When I kiss you, you gaze into my eyes. When I try to correct you, you understand. How is it possible that God made you so marvelous! As in the Apocalypses, you were and are the 'white horse,' the first vanquisher. . .

"I am jealous of you: so terribly jealous because so many humans have you on their minds, want to stroke you, want to love you and be yours in an instant. I am also jealous of the field from which you now neigh. The field where the poppies beg you to tread on them and where clover and grass are in continual dispute over which will be first touched by your mouth as you graze. With your name in the wind, you are King of the immense open spaces, with no limits and with no whiteness but the sun that envies you. Your image is the symbol of life and freedom. Your taut muscles are the proof of your strength; like strings on a guitar, they sing your music to the beat of your powerful canter.

"When I am thinking, I feel that you are also thinking, and when you think, I listen to you. I felt your heart beat days before you were foaled, before you were born to see the morning light and enlighten me.

"You are the passion in the life of riders that await you, that long for you, that dream of you.

"Before memory, why have you stirred such passion in me? Why are you the throne of kings and of all the mighty heroes of history? Why, being pure greatness, are you incapable of rejecting anyone, allowing the most humble to mount you and be your rider?

"You are ancient, and yet in my memory I see and delight in a foal running and playing games punctuated with cabrioles and levades. I look through my sleepy mind and your incredible agility awakens me. I see the blue glimmer of the heavens in your eyes, the steam rising from your skin. I feel the blasts of air from your nostrils, you, discharger of such energy. What joy, this vital fire that leaps as the reins are loosened on your neck! How many springs burst forth in your neigh, prodigious and without echo!

"At this moment I hear the familiar sound of my cantering horses. It arrives like a refrain, at first distant, but growing closer, like a wounded, uncontrollable guitar

that maintains its rhythm, a recurring sound, a bleeding falsetto voice of rhythmic sounds, a sharp sonata played by four hooves that all rise and touch together in D Major. This is the song of the gallop, unforgettable for him who has heard it."

While I was working with horses year after year all over the world, friends , including Alvaro Domecq, and new acquaintances continually expressed disbelief when I was asked to ride and I admitted that I had never learned to do so. My interest in horses had always been that of the artist or the scientific observer of their social behavior with the ground or a tree as a vantage point. It wasn't until I acquired a ranch near Sevilla that I learned to feel comfortable in the saddle and not on the ground when in the company of horses. My teacher was a handsome purebred Andalusian stallion that I kept as a model. It was Blanco, as he was simply called, and not one of my famous riding instructor friends in London, Calgary, New York, Jerez, or Louisville who taught me that sitting on a horse, whether standing or galloping across the country around the ranch, could be a totally pleasurable and unique experience. How many late afternoons we left the house when the July sun back-lit the countryside in gold and silver, with the bee eaters gliding and purring overhead, not to return until night had fallen, and Blanco's mane, lifted lightly by a breeze, flashed silver under the moon as a bull raised his head to roar from the Domecq ranch across the road.

As the years have passed, I have photographed Andalusians under difficult and trying conditions. Long afternoons have been spent in the marshes, on the dunes, and in spring fields of flowers, with free-running horses who behaved again and again almost as though they had seen the storyboard for the book's photographs. Many of those stallions are now dead. Hopefully, their beauty will continue to dazzle the viewer as long as the books in which they appear exist.

For all of my attraction to Andalusian horses, the desire to photograph them would have gone unfulfilled had it not been for a very select and relatively small group of breeders of Iberian horses. Behind those Andalusian breeders' names in my mind are projected brilliantly dramatic images of Spanish stallions, most often on the great ranches where fighting bulls are bred between Sevilla, Málaga, Algeciras, Cádiz, Huelva and Córdoba. How could I ever forget those modern Babiecas as they bravely responded to their riders' commands, charging through fields of red poppies which were stampeded by Lorca's "black bulls of pain" while in the distance the sun was starkly reflected from some elegant ranch house's "white walls of Spain." Those visions kaleidoscope my memory as do the names of those breeders of horses, of bulls, or of both. Among the ranches that were the stamping grounds of my youth were: Miura, Guardiola, Terry, Cárdenas, Lazo, Belmonte, Urquijo, Nuñez, Pablo Romero, Domecq, Salvatierra, Osborne, Tassara, Camerá, Moreno de la Cova, and Concha y Sierra. How fortunate I was. Those were the most wonderful of days for a young man who loved like life itself–because they were his life–Spanish horses and bulls.

In my own country there is only one name among Andalusian horse breeders which to me represents the respect for Spanish history and tradition, the herd size, the year after year dedication, the emphasis on functionality, and the scrupulousness in breeding that I found at the best ranches listed at the end of the previous paragraph. Not merely content with a large herd of the finest imported brood mares serviced by a spectacular group of imported and home-bred stallions, Rafael and Maritza Parra have sought the world's premier trainers and instructors to show and share with their fellow Americans the working capabilities of the Andalusian horse. It should be sufficient to say that year after year they brought that maestro of maestros of classical dressage in its most passionate, aesthetic, and classical form, Nuno Oliviera, to their home in San Antonio, Texas. There, not only did the maestro instruct the Parra children and trainers, but Rafael and Maritza, who are the epitome of generosity, "shared" Nuno Oliviera in the public dressage clinics that they organized. For all of these reasons and more, Andalusians de la Parra is singular among breeders of Iberian horses.

ANDALUSIANS DE LA PARRA

How grateful we should be to life for those things that bring happiness, that make us smile, that touch us to the core with their beauty, that bring peace and fulfillment. There are places that inspire these feelings in me: the Sevilla Cathedral's Giralda tower silhouetted against the moon which glides a bright blue summer sky particular only to nights in Andalusia; the Kenyan dawn beaming through the flaps of my tent beyond which the thatch of an umbrella acacia patterns the rising sun. There are animals that provide perhaps deeper feelings: Africano, the brave bull that I raised from birth to maturity, roaring, black neck muscle swollen, horns a silver crescent in the midday sun, having just beaten another bull in battle, as he runs toward me, a victory ribbon of coagulated red hanging from the wound on his side, to stop and gently rub the sweaty dust from his cheek onto my bare knee; or my Basenji and old friend Kizzy sitting on the stone hearth in California or the brick hearth in Spain, staring into the fire for visions of her Egyptian or Congo past.

And, of course, among the animals are horses: Majestad under the moon, his silver whiteness matching that of the dunes that we were crossing in the Coto Doñana as overhead flamingos in formation flew the night which was filled with the bugling of red deer stags in rut; or of Narok, her shoulder black as the stormy pre-dawn sky, as I leaned against it to keep warm, smelling the sweet smell of a horse nourished on fresh grass, while upstream a lion roared twice as my Maasai friend and I were about to saddle up the mares and set out in search of Cape Buffalo.

But more important are the people in my life, my family and friends. And of my friends, the Parra family are an endless source of joy and true happiness whether I am in their presence or they are in my thoughts.

It seems very long ago that our paths crossed for the first time in Sevilla, Spain. It must be almost twenty years ago, a quarter of a lifetime. But when I close my eyes and reflect upon that day, it comes back with great clarity.

Our friend Paco Lazo introduced us. The immediate recollections that I have of Rafael and Maritza are their eyes. First, both of them not only communicated as directly with their eyes as with their words, but the physical makeup and life behind those eyes were equally appealing. Rafael's friendly but dark piercing gaze had the intensity that is emitted from the orbs of that bird of the most acute vision, the peregrine falcon. Thus when I learned that Dr. Parra is not only a neurosurgeon but one of great note, it did not come as a surprise. His eyes transmit such intense concentration that if my brain had to be looked into for surgery, I would hope Dr. Parra would be on hand to do the operation. However, with a blink Rafael's eyes can sparkle with delightful mischievousness.

Maritza's eyes in color are the brightest blue imaginable, blue distilled to its purest intensity. I cannot envision a more dazzling collection of blue eyes anywhere as those that were found last year at the Spanish horse exhibition in Sevilla, when Maritza had lunch with Bo Derek and Daryl Hannah. Anyhow, I could not keep from staring at Maritza Parra's eyes, just as I had stared at Bo's eyes the first time we met, for in both cases it was like looking into the clarity and richness of rare gems.

After Paco Lazo had introduced us at the Club Pineda, I remember walking slowly from the grandstands with Rafael and Maritza. Those were the days when every third person you passed at Pineda was an acquaintance or recognizable because of his or her place in the Spanish horse world. Rivalries were strong, not only among individual horse breeders, but also between regions, especially between those of Sevilla and Jerez de la Frontera. It takes no effort to recall Rafael standing in front of a box to scrutinize a horse that had earlier captured his attention in the show ring. There was such intensity in his gaze that it seemed nothing else existed in his field of vision except the animal before us. I can see him with his blue blazer, a red carnation in its lapel, as he shifted slightly from one leg to the other to get a better look at the stallion, his hand raised to his face, thumb on one side of his chin, index finger on the opposite cheek as if to steady the lenses of his brilliant, dark eyes.

Year after year, at great expense and effort, Rafael and Maritza returned to Spain to search for the most distinguished Spanish and Portuguese horses with the most prized bloodlines to import to their ranch, Andalusians de la Parra in San Antonio. These efforts have been complicated not only by the ongoing test and

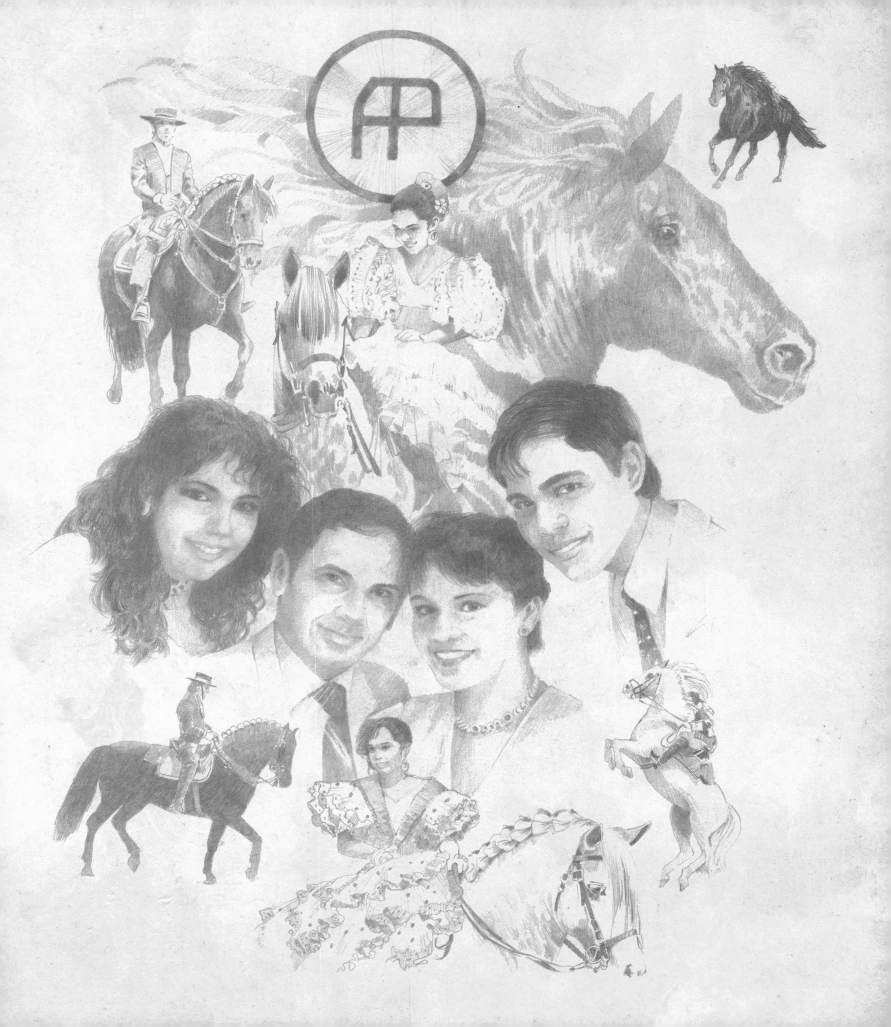

quarantine that are required for equine entry into this country because of the presence of the tick fever called piroplasmosis, but because of an outbreak of African equine fever that for years and until recently almost halted shipments of Andalusian horses beyond Spain's borders.

Not long ago the Parras experienced near tragedy when importing a group of horses from Sevilla. Only their love for the animals, their tenacity and ingenuity gave this story a happy ending. Rafael and Maritza had purchased three animals from their friend Paco Lazo. In Spain the horses had tested negative for piroplasmosis. However, upon arrival in New York two of them again showed negative, but the third, a beautiful six-year-old stallion named Pasajero (Passenger), tested positive. The next day, though, all of the horses were mistakenly loaded on a truck destined for San Antonio. When the error was realized, the Department of Agriculture issued an all-states bulletin and the truck was stopped and Pasajero was returned to New York. A Department of Agriculture veterinarian then phoned Maritza to tell her that if the horse wasn't on a plane bound for a foreign country in forty-eight hours, Pasajero would have to be put down.

Frantically the Parras phoned air cargo companies, but none would fly the horse out of New York. Finally Maritza remembered a Federal Express magazine ad she had seen that boasted: "We fly anything." She called Federal Express only to be told, "We don't fly horses." She then phoned her lawyer, who assured her that if she could find the magazine ad, there was a good chance of getting Pasajero on a Federal Express flight. Immediately family and friends gathered in the Parras' garage where, after looking through stacks of old magazines, they found the ad. Maritza alerted her lawyer. The lawyer phoned Federal Express. And the next day Pasajero was in a wooden crate on a Federal Express plane bound for Miami, where he would make a connecting flight to Costa Rica. Today, Pasajero is alive and well in Costa Rica where, as a breeding stallion, he has made a considerable contribution to Spanish horses in that country.

Maritza and Rafael often returned to Spain and Portugal to take courses that would qualify them as show ring judges of Iberian horses. Not long ago I was with Maritza in Sevilla when she had just returned from a judging seminar in Jerez de la Frontera. This program was organized by the Ministry of Defense and by the Spanish Military Stud in Jerez. It consisted of three days of classroom instruction and two days of actually qualifying stallions and mares, certifying them as breeding stock that would be accepted by the Spanish Registry. Both Rafael and Maritza are prepared to judge Andalusians at shows and to approve stock for breeding; however, they did not spend years and go to great expense learning to judge Iberian horses so that they could scrutinize them in the show ring. Their sole interest in judging has been to become more adept at evaluating the horses they breed at Andalusians de la Parra.

In these pages the word "family" will appear with regularity, for the Parras are family in the true sense of the word. And with Rafael and Maritza, family doesn't stop with that which is immediate. Maritza's sister Consuelo, her husband, Alberto, and their children, Francisco, Camilo, and Maria, also live in San Antonio, where, because of the Parras, their lives are also centered around horses — to be exact, one horse, a silver-gray stallion with abundant mane and tail, called Faruk. When I was last in San Antonio and visited with Consuelo and Alberto at their home, I asked Consuelo if she might give me some insights, starting with their Colombian background and childhood, into Maritza's great affection for the Spanish horses and this is what she told me:

"We spent our childhood in a small rural town where the legacy of our ancestors had considerable repercussions on Colombia's national history. Our father has always had a great passion for history, as has our mother for tradition. Their example would greatly influence our own interests in life, such as my porcelain painting, suited to the styles and traditions of the Andalusian, and Maritza's desire to uphold the purity of the Andalusian bloodline by staying true to those characteristics developed by natural selection.

"Our ranch's main focus was the breeding of fine cattle; therefore, our horses were trained for use as cutting horses. There was, however, a beautiful white horse with which we shared many great memories. Not only would he take us around the fields, exploring every

little corner of the ranch, but he would also stand patiently as we braided his mane.

"Another important part of our childhood was the equestrian lessons that we took at the military stud farm. There one could find the best and most beautiful horses of the entire region. Thanks to this, we were able to witness, at close range, horses that were very well trained in various different disciplines, in spite of the fact that our own interests wavered between admiration for the horses and youthful diversion.

"Recently, our parents celebrated their fiftieth wedding anniversary. Due to this my son has become interested in the historical literature of the region. In his research he discovered a book that successfully tied together much of our love for horses with the lives of our ancestors. At the start of the nineteenth century, 'El Libertador,' Simón Bolívar, arrived at our paternal family hacienda, which thereafter united him and our family in personal friendship. His troops, having been diminished by the inhospitable weather and topography of the region, were subsequently reinforced by our great-grandfather who contributed five hundred of his best horses to the revolutionary army so that they could continue. With this force, El Libertador was finally able to move onward into Boyacá where he successfully overcame his foe in the battle for independence. This battle marked the dawn of a new era for our country as it did for Venezuela, Ecuador, Peru, and Bolivia.

"When my father saw his granddaughter Maritza riding sidesaddle on Primoroso, he was overjoyed. He commented, 'She looks a great deal like your great-grandmother. She was a petite woman with a perfect posture when it came to horseback riding.' The woman of whom he spoke always took great pride in personally training the finest horses of the hacienda.

"The horse and its movement have always allowed me, through my ceramics, to participate in a very specific manner in the atmosphere that surrounds the world of the Parra family. With every fountain and tile that I have painted, at their house or ranch, I have been better able to describe the training and purity of the breed.

"This fascination with horses has also affected the lives of my immediate family to the point that our house in San Antonio, having been once absorbed in the world of international diplomacy thanks to my husband, now partly revolves around the patio where our own Andalusian, Faruk, is the central figure. The bar shares a window with the stable that allows Faruk to be an integral part of our social life. The bar's counter is made up of a series of hand-painted tiles that depict the history of the horse through the ages, from the caverns of Altamira right up to the modern horses, those ridden by Rafael and Maritza."

Several years ago I had flown to San Antonio to photograph the Parras' magnificent black stallion Dejado. (By coincidence, ten years earlier, I had been with Rafael in Sevilla when Dejado had been led from his stall to parade and prance before us at the Club Pineda. No sooner was he back in his box than Rafael softly said, "I have to have that horse!") As my assistants and I approached the Parras' home, I began to feel connections with my own life. The green scrub and low twisted oak trees were not unlike familiar patterns of the African bush, especially in the low reaches of the Loita hills, and among these trees grazed small Texas deer in considerable numbers. If we slightly squinted our eyes the deer easily became impala. Then the automatic gates were opening into the extensive grounds of Andalusians de la Parra. Here were not only more African-like trees and deer, but ahead and to the left was a large pond, the banks of which were scattered with dozens of Egyptian geese. So as not to feel too far from Africa at Cañada Grande, my ranch in Spain, I keep Egyptian geese and horned guinea fowl.

Above the honking of the geese came another sound familiar to Cañada Grande — that of a peacock, as behind Rafael and Maritza's spacious white house several peafowl paraded. In the late afternoon light their tail feathers were illuminated green, blue, and bronze by the golden rays that slipped through the trees overhead. But the best connection with my life away from America was yet to come. Behind the house was a riding ring which was adjacent to the stable that contained Spanish horses as fiery and beautiful and noble and majestic and long-maned and highly trained as any of the animals I had seen during half a lifetime of attending the Sevilla *feria* and the Jerez *feria* and spending years on the great horse and bull ranches around Sevilla. It was at that moment, as we stood in

the fading light admiring the stallions, that I looked at Maritza and Rafael with an expression that didn't need a spoken word. Their ever-so-perceptive and sensitive eyes surely read what my smile communicated: It is all here, all of the things I love, and if that weren't enough, I am in your company, and who could wish for more than that at this precise moment.

The following morning, we stood in the shade of the weeping willow trees, each planted by Rafael himself, which bring coolness to the perimeter of the outdoor riding ring. Working the stallions in the arena were Paco and Mauro Alamilla, who years before, as small boys, had arrived at Andalusians de la Parra. Seeing the horse put through the paces, I reflected on the greats of the Iberian equestrian world who had also passaged or piaffed their mounts on this same sand. Year after year this had been the training arena for Nuno Oliviera, the undisputed master of dressage in its aesthetic form, which seems lighter and more natural than the more machine-like approach seen in competition dressage. Today, João Oliviera, the late maestro's son, continues his father's work at Andalusians de la Parra. These same sands had also felt and been marked by the hooves of stallions guided by another father and son who are also legends in their own lifetimes: Alvaro Domecq Díez and Alvaro Domecq Romero. Alvaro, the father, was one of the all-time great rejoneadors, or gentlemen bullfighters on horseback, and is not only famous in Spain as a breeder of fine horses and bulls but as a literary figure. Alvaro, the son, followed in his father's footsteps as a rejoneador. But Alvarito's dream was to create a school of equestrian art in Jerez de la Frontera where Spanish classical horsemanship could be showcased and at which the versatility of the Andalusian horse would be displayed and nurtured. Under the greatest difficulties, Alvaro Domecq Romero persisted with his idea of establishing a riding school at Jerez that would be as respected as the Spanish Riding School of Vienna, the Sumur of France, and the Portuguese School of Equestrian Art in Lisbon. Year after year he continued forward, never losing sight of his goal, until, not long ago, the school was moved to a magnificent building, where it enjoys government sponsorship, and was inaugurated by the King of Spain to become the Royal

Riding School of Andalusian Equestrian Art. At the inauguration of the school, as King Juan Carlos spoke, I looked around at other faces that beamed from the front-row seats that side the ring: Miguel Angel and Carmen Cárdenas, Dn. Alvaro, the father, Mercedes González — and next to Paco and Mari Tere Lazo were Rafael and Maritza Parra, who had flown from Texas for the happening.

The smiles on the Parras' faces, which showed the pride they felt for their friend Alvaro Domecq, are unforgettable, as were their expressions of satisfaction when a white stallion that they had given the school began to dance between the pillars as the music of de Falla accompanied the horse's steps and the king and queen of Spain lifted their hands in applause.

As I have already mentioned, Dejado was the reason that I had brought my cameras the first time to Andalusians de la Parra. For the following three or four days our sessions with him began a half hour before the sun rose. In the afternoon we shot from several hours before sunset until it was dark. Our afternoon shoots were done at Bulverde, the Parras' 220-acre ranch just outside of San Antonio. Fall had enriched the late afternoon grass with every possible shade of yellow, gold, and ocher, which, when photographed with back lighting, spectacularly set off Dejado's midnight blackness. In every way Dejado represented all that is beautiful and good in the Spanish horse. He had the attitude: "If you want to do it again, let's do it again, and if you want to do the same thing once more, it will be easier than the first time."

At Bulverde I recall going for a long walk with both Maritzas, my assistants, and Paco and Mauro, who took us to a wide streambed, then dry, that borders one of the pastures. This was a wild area, home to deer, rattlesnakes, and domestic peacocks gone wild. As we walked along, I experienced another Parra phenomenon which is not common in current American society — and that was the relationship between the Maritzas, mother and daughter. This was an expression of affection and unity that I had seen and would continue to see whenever I visited the Parras. Mother and daughter, when they were strolling as we were then or when they had left the group to look for something that was needed for one of the shoots, would appear deep in

conversation, either holding hands or one with the arm around the other.

Last fall I again visited San Antonio and Bulverde, this time to photograph the gray stallion Boticario, for this book. It was then that Maritza (daughter) showed me a colt that she had raised from birth, and I asked her about her feelings for Spanish horses in general and what they have meant to her life. As her dark eyes flashed and she spoke, I stretched out on a horse blanket in a field of bluebonnets that for some reason had blossomed in fall instead of spring.

"My passion for horses seems a very natural thing to me," she began. "Horses exist in the majority of my memories as I look back through my life. Like the light of the dawn, this drive was present throughout my formative years. Early in life this love manifested itself in my creative efforts.

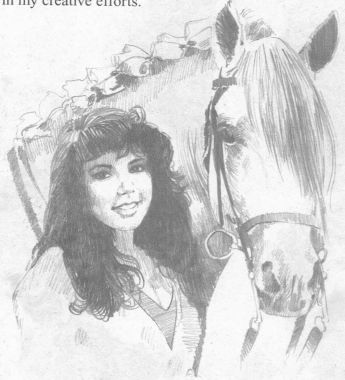

"I became very familiar with the section on horse references at my local library. When beginning to draw, I endlessly sought perfection in attempting to capture that ideal image on paper. In kindergarten I crafted a ceramic flowerpot with a relief of a horse's profile on the side as a gift for my mother and father. They always appreciated the presents created by our own hands. I enjoy watching a horse at liberty. I have stood in the center of a field full of mares. They will behave in several predictable ways. First they will investigate the stranger in their midst while pretending to continue grazing nonchalantly. Then they approach, certain leaders among the herd first, and are inevitably followed by others. Suddenly one is in the heart of an ocean of horses, attempting to satisfy each individual curiosity. Touch and interaction reveal the wealth of their distinct personalities.

"Most evenings I have visited, ridden, washed, and brushed the horses for hours at a time. Those evening hours were long and graying, but they were always worthwhile.

"In the early days of my formal training in Classical Dressage I spent considerable time with Maestro Nuno Oliviera in Portugal. In my life I have had no want of good, forward-looking figures of authority. The enduring effect those times have had on my personality has been dramatic. This extends into the development of my taste in music. After a full day of riding and training, the gathering of international riders in the Maestro's office would await us. The office was adorned with mementos from the press, friendly pictures and writings from his alumni and those who esteemed him in the equine community. Most of these were framed and covered the walls entirely, even reaching the floor. That small building was a haven and a refuge for the horse lover. It was customary for the maestro to play operas from records daily. I remember *Norma* by Bellini because I heard it so often. Where else would I have had this experience? And how could I ever forget the Maestro's words to my brother and to me:

" 'Often, horses do not give the best of themselves because they feel that the rider is not seeking a pleasurable sensation but is simply using aids and following the rules.

" 'Without lightness, everything the horse does is unnatural. Lightness is a necessary requirement for reaching that state of grace which is indispensable in art.

" 'Training a horse is not only gaining his submission, as it is often said. It is also making sure that the horse takes pleasure in doing everything that is asked of him.

" 'In life, when two living beings are giving of their

201

best in order to fulfill themselves, something marvelous happens. So it is in art — in all the art forms; the artist must be able to give the best of himself.

" 'When the lesson is over, the horse must have retained confidence and should return to the stable with a body which has been exercised with intelligence and affection.'

"The furnishings in the office were comfortable and specifically designed to accommodate conversationalists around a focal point. Each evening brought something new and valuable.

"I've always enjoyed the aspect of informing people who are curious about the horses. After exhibitions, far from home, I have explained the details of what Primoroso and I do to an impressive variety of people who come to see the shows.

"When the sky grows dark I remain, in an effort to exhaust everybody's questions, because I feel it is the only way to do my job right, or to thoroughly serve my purpose. Afterward, I end up exhausted, but happy and accomplished as well."

I then asked Maritza to tell me about the colt Capricho that she had raised:

"Caprichosa was the horse of which I had always dreamed, she continued. "She was beautiful, kind, and strong. During the first summer of our acquaintance, all of our time was spent together. Our friendship had become so strong that when vacation had ended and I returned to school, she practically refused to eat until we were together.

"We learned a lot from one another. I, how to ride and interact with her, and she, how to respond in kind. She was my teacher as well as my student. Together, we shared her first experiences of motherhood. My brother and I waited patiently for the new foal's arrival. We would place sleeping bags upon the hay bales or the burlap sacks full of bedding in the stables, and drift in and out of sleep throughout the night. She never seemed to mind. In fact, I believe she enjoyed the company.

"She was a wonderful mother, as gentle with the new baby as she was with her overexcited human family. For me, she was the first horse I was ever able to call a friend. Years later, our family decided to move all of the mares to the ranch, keeping only the stallions at home. I missed Caprichosa very much, but we saw each other virtually every weekend. She always greeted me warmly, although I began traveling for longer periods of time. Whenever I returned, I had only to go into the pasture, call 'Capri!,' and she would approach.

"Over the years my brother and I began riding only the stallions, one of which eventually became a most enduring friend. Primoroso has been the horse with which I have learned the most. With him, I have been able to share with people all that the world of Spanish horses encompasses.

"We had been trying unsuccessfully to get a colt by Primoroso, when my mother decided that he and Caprichosa would make a perfect match. Their combined attributes of strength and tenderness made us feel that they might bear the ideal Andalusian. In May of that year, our family had gathered for a Mother's Day celebration when we received an unexpected call from the ranch. After a complicated pregnancy, Caprichosa had undergone the traumatic delivery of a healthy colt. She, however, did not survive.

"The impact of that phone call on my mother was profound. The sadness and grief that we saw in her as she received the tragic news was a testament to her love for horses greater than any words can express. Despite our mourning, we were relieved to hear that her foal had survived.

"The entire family immediately mobilized to care for the newborn orphan. My father, my brother, and our trainers, Paco and Mauro, went to bring the foal home. My mother, Aunt Consuelo, and I went to find goat's milk for our little nursling. The baby arrived in the back of a station wagon, wet and frail. After preparing a stall and carefully placing him inside, we let the foal rest.

"Later, we started to help him in his tentative attempts to stand, worried that he may have suffered some damage during his difficult birth. In our hurry to prepare everything, I had forgotten to check if it was a colt or a filly. I was exhilarated when I saw that it was a colt. I was so overwhelmed I started crying. I would never see Caprichosa again, but after years of waiting for the perfect heir to Primoroso, I finally had him. In memory of her, we named him Capricho.

"For two weeks I slept in the stall with my little orphan. The first night I slept in the hay with him and

fed him every two hours. I awoke with him sound asleep by my side. The second night, I placed a small foldout bed in his stall. I had to remove it soon after because while I had gone to the tack room to get his formula, Capricho jumped on top of the rickety bed. He had become upset that I had left him alone. At least I was sure that he was healthy and alert. I solved the problem by replacing the bed with a hammock that hung diagonally from one corner of the stall to the other.

"During that time, Capricho came to believe that I was his mother. I only left his side to get his formula and to shower. I passed the time reading books, most of which he returned to me half chewed up. My hair also suffered the same fate. When we went out to play, he never strayed far. He would get very upset if I walked out of his reach. He ran whenever I ran and had no problem using me as a pillow, or vice versa.

"Today, Capricho is still at home, and is growing into a strong, beautiful stallion. I can see both Caprichosa and Primoroso in him and I know we already have a bond much stronger than friendship."

Following one of our shoots at Bulverde with Boticario, we would all return to San Antonio and the Parras' spacious white house, set among the African-like trees and the deer and the Egyptian geese and the peacocks and the Andalusian stallions. The interior of the home seems to project the openness, the generosity — here of space — that are found in its inhabitants. The living room has a ceiling that is tall enough to accommodate a forest-sized ficus tree that sits next to the fireplace. The photographs that are displayed among a collection of Spanish porcelain are mostly family portraits. Off the living room is a room where we often gathered and its walls are adorned with very large, framed silk scarves decorated with equestrian motifs. As we sat and talked and laughed, I thought how other voices, those of the Domecqs, the Lazos, and the Olivieras, had sounded in this room. Joáo Oliviera I have known for some time, so, not long ago, reflecting on the Parras and their home, I had asked him if he had experienced similar feelings:

"Years ago, Rafael and Luz Maritza came to Portugal to my father's place, with the desire that their children learn the finer points of classical equitation. This was the start of a deep and lasting friendship. My father had the greatest respect for both Rafael and Maritza as people and as breeders. He surely appreciated and supported their sincere efforts to bring to America the finest Iberian horses.

"They were tireless in their search for horses that reflect the true beauty and courage of the breed. My father, Nuno, at times would be with them in this quest. Their relationship, however, did not end here. Soon they invited him to visit their beautiful ranch in San Antonio, Texas. This was not only to give the family further instructions in dressage but also to bring to others my father's gift.

"Long after my father passed on they continued this tradition with me taking his place. For me it isn't only work that takes me to San Antonio but also the chance to relax and share in the daily life of these wonderful people who have the great capacity to share with others the wonderful things in their lives," concluded Joáo.

After a visit with the Parras, I would return to California and in the summer find myself again in Spain. And being in Spain meant visits to Paco Lazo's ranch, Lerena. A favorite place for conversation at Lerena is the cement bench just outside of the imposing walls that surround the house. The bench is next to two green wooden doors that stand over twelve feet high, and which were once the doors to the city of Carmona. Seldom would Paco and I sit on that cool, hard bench without speaking of the Parra family. On one occasion I remember him commenting:

"All of us Spanish breeders are grateful to Rafael and Maritza for having so vigorously pursued their goal of bringing to America recognition of all of the wondrous characteristics that comprise the Spanish horse.

"My family and I have spent so many memorable happy moments together at their house in San Antonio and at ours in Sevilla, always absorbed in discussions about horses and the equestrian arts. But also I am reminded of other qualities I admire in the Parras, like the time that Rafael fought a young fighting heifer at Jaime Guardiola's ranch and was so violently tossed that he fractured his hand. It was a frightening moment and oh, how the audience shouted with joy and amazement at seeing an American who fought with the ease and grace of an Andalusian. And if that weren't frightening

enough, their daughter Maritza, superb rider that she is, while helping with the ranch chores by cutting bulls in the fields on horseback, was unfortunate enough to have one of them charge her, causing her to fall and to fracture her pelvis. I remember how she bravely picked herself up off of the ground, just as her father had done, dusting herself off as I began to laugh, convinced by her smile that she hadn't been injured."

Mixed with those same memories of Paco Lazo and the spanish countryside are the visits that Rafael and Maritza made to my ranch, Cañada Grande. There we would walk the golden sand paths of the garden or sit in the house, its walls decorated with artifacts from my trips to Kenya, while the Egyptian geese, guinea fowl, and peacocks called outside. Then I would show Rafael and Maritza the photographs or the layout for a new book or give them a progress report on my almost twenty-year study of equine primitive social behavior. These studies in the Camargue with the semi-wild horses that roam the marshy delta of the Rhone River would not have been possible had it not been for a group of horse lovers who for years have funded that project. At almost its inception, Rafael and Maritza joined James A. Michener, William Shatner, Deedie Wrigley, and Martha and Henry du Pont in patronizing my fieldwork that began with the book *Such Is the Real Nature of Horses*. Without the support of these dedicated equine enthusiasts, it would have been impossible to continue firsthand observation in Africa of Common and Grévey's zebra. So the time we spent at Cañada Grande was filled with talk—mostly about horses.

Once, a few weeks after Rafael and Maritza had been at the ranch, several carloads of visitors drove up the long drive that passes beneath a purple canopy of cherry trees and leads to the house. There had been a bullfight in the nearby pueblo of Campofrío and the stars of the afternoon had been Antonio and Luis Domecq who, like their grandfather Alvaro Domecq Díez and uncle Alvaro Domecq Romero, perform in the classical tradition from horseback. So that evening three generations of Domecqs sat sipping sherry and sampling tapas in the garden. It was as the moon rose higher in the branches of the oak trees, and somewhere out in the darkness my stud bull, Rabinato, lifted his head to roar, that Don Alvaro, Alvarito, and I spoke of our friends Rafael and Maritza Parra.

"Thanks to the beautiful world of the Andalusian horse," said Alvarito, "Maribel and I long ago had the fortune of meeting Rafael and Maritza. San Antonio is a city that I remember so fondly. It almost seems as if I live there just as I live in Jerez, my native city. Here I have horses; in San Antonio at the Parras' I have horses. Here I have a house, and in San Antonio I have a house: Maritza and Rafael's house where they take me in and give me so much affection that I feel as if I were in my own home. There I awake in the morning and, like here in Jerez, the horses at the Parras' are near. Andalusian horses, strong horses, temperamental horses with long, flowing manes, thick tails and majestic movements, all of which have earned them their reputation as the best horse for dressage, for the 'picadero,' and for carrying a king on a day of triumph.

"One of the many lovely horses that Rafael and Maritza owned they were gracious enough to donate to the Royal Andalusian School of Equestrian Art, because they know that the school is my lifelong dream and labor. Now that white gift stallion from the Parras' 'piaffes' every day for the further enrichment of the Royal School."

Dn. Alvaro (the father) then reminded me that some years before he had journeyed to San Antonio to consult with Rafael about some suspected medical problems. Upon returning to Spain and his ranch, Los Alburejos, he wrote a note which I once came across in a scrapbook in the library at Andalusians de la Parra.

"My dear friends Maritza and Rafael,

"I am once again on my horse in the Andalusian countryside and being here only serves to strengthen the feelings of gratitude that I owe you.

"I have been an honored guest in your home, blessed by your affection and your company. Maritza, in her great mission as a guardian angel, who has always guided my steps and opened so many doors full of science and love for me. Rafael, being the conductor of this wondrous symphony of human and scientific values, in order that he may bestow tranquility upon those friends crossing the border of old age, and who contemplate with great insight that which has been and that which is, forever filled with longing for the

restless steed of youth, while always being full of vivid emotions.

"Here I am in my beloved countryside, and I am tempted to dismount and pick its brilliant flowers to give them to you, Maritza, so that you may continue being what you are, the grand lady that brings life and love to the halls of your home.

"You have given me peace here, by the confidence you have offered me, and although the human spine has become crooked with age, this can not be said of my desire to be your friend, worthy or not, but striving always to be faithful, as you have been with me.

"May the Lord always be with you, he who can fill your lives with all the happiness that I wish for you and your children during this coming Christmas as it draws near, renewing our faith and our hope.

Un abrazo,

Alvaro Domecq Díez"

In recalling other moments that I have lived with the Parra family, memory takes me back to the International Andalusian Horse Show in 1991 at Fort Worth, Texas. This was the first time I was to see the Parra family mobilized and in the process of not only showing their horses, but going through the preparations to ready stallions and riders for the exhibition of Spanish Equestrian Art that has made them famous in American equine circles. Their countless exhibitions all over this country are the reason that Andalusians de la Parra is considered the breeder of Spanish horses that has done more to promote these animals than anyone else in the United States.

And at Fort Worth, when I say family effort I mean Rafael and Maritza and Maritza's mother and father, who had recently come in from Colombia, and her sister Consuelo with her husband, Alberto, and their children, Francisco, Camilo, and Maria, along with Rafael Alberto and his sister Maritza and Paco and Mauro. Directed by Maritza (mother) this team of Paco and Mauro and the younger Parras braided manes and tails which they also adorned with intricately woven ribbons so that by the time the riders and horses were ready to perform they were as finely costumed and groomed as the most stunning young men and women in any Spanish or Portuguese fair or bullring.

In the stands for the Parras' performance was Charles Osborne, who had been a longtime close friend of Nuno Oliviera. As I sat with Charles through one of the performances, he told me:

"I began receiving instruction from Nuno Oliviera in the summer of 1971 and continued my training during three additional summers. To those sessions I added work at Oliviera clinics held on the East Coast of this country. By the time of my second trip to Portugal, Nuno and I had become fast friends, due not only to our mutual love of horses but also to a great and common interest in Italian grand opera.

"In the early '80s I received a telephone call from Rafael and Maritza Parra, inviting me to visit their home and discuss the possibility of organizing a clinic for Nuno there, a plan they had previously discussed with Nuno when they and their two children were in Portugal.

"Of course, that request delighted me, and soon afterward my wife, Esther, and I were deeply involved in the organization of the clinic, which was held in the autumn of 1982 and proved to be a huge success. Others followed in subsequent years as often as Nuno's busy schedule would permit.

"My wife and I were received by Maritza and Rafael from the very first as if we were lifelong friends. We were completely enveloped by that remarkable Parra hospitality: we were guests in their home and at their table; we were included in family activities; we shared many wonderful conversations. For us, Maritza and Rafael are generosity and grace personified. You meet them as strangers; you leave them as friends.

"A great debt is owed to the Parra family for providing this area of our country the opportunity to witness the expert training technique of Nuno Oliviera, perhaps the last truly great master of what he called 'Equestrian Art.' He felt it was his moral duty to pass on to others what he had learned in his lifetime. Maritza and Rafael made that possible for those of us who wanted to learn."

The success of that show in Fort Worth was largely due to the efforts of Holly Van Borst, who has been my friend for years and whose dedication to the Andalusian

breed and integrity are beyond reproach. Holly has had a long association with Rafael and Maritza Parra of which she recently wrote to me:

"The first time I went to Jerez to see the Real Escuela Andaluza del Arte Ecuestre perform, I was overcome with the beauty of the horses. Their ability to perform seemingly effortlessly airs and High School movements that prior to that I had seen only in books. I was taken by one individual stallion who was doing a piaffe between the pillars, and whose balance and cadenced rhythm seemed sheer perfection. Not for a minute or two, but during the entire performance! It was later called to my attention that this horse was purchased by the Parras, who had donated him to the Domecq school. This was the quality of individual the Parras chose for their breeding program — one who was not only beautiful, but who was also capable mentally and physically of being schooled to the highest degree of collection.

"For as long as I have known about the Andalusian breed, and in every country I have walked, the Parras' footsteps have been everywhere. I believe them to be the most positive energy behind the breed in the United States. They are an inspiration and are truly rare in their love for both horse and humanity."

The fact that Boticario de la Parra, who is one of the protagonists of this book, was judged champion stallion at those Andalusian nationals was not only a joy to all of Rafael and Maritza's friends. It also indicated the success of their dedication and their breeding program when one considers that the judges of the event were Iberian horse experts Guilherme Borba of Portugal and Luis Ramos of Spain. Later I asked Holly, who is also a trainer and had a fine eye for Iberian horseflesh, what she really thought of Boticario. This was her response:

"I fell in love with Boticario de la Parra, who exuded both power and elegance. He was undeniably Spanish in type; his large intelligent eye that expressed a willing and kind soul, his perfect head and arched neck that flowed into a lovely, strong back and beautifully proportioned, powerful hindquarters. His legs were strong and clean, and he seemed to float with every suspended trot stride, which was forward and straight. I have heard it said many times that there is no such thing

as a perfect horse. I would now have to debate that statement while observing this harmonious, enchanted creature. I studied him carefully, but could not find fault. He was the epitome of the Spanish horse."

The exhibition of Iberian horsemanship that was given at Fort Worth was attended by hundreds of spectators while at the Belmont track in New York, over 250,000 people were captivated by the spectacular demonstration of Andalusians de la Parra. Angel Cordero, jockey, winner of the Kentucky Derby, almost missed his race because he was so engrossed in shooting a video of the Parras' performance. The prince of movement, Rudolf Nureyev, returned to see the riders of the Andalusians de la Parra perform for four consecutive days and as if that weren't enough, after each exhibition day he followed the riders back to the stables to personally question them about the movements of their "dancing" Spanish stallions. Andalusians de la Parra have also given exhibitions at the Kentucky Horse Park and in Illinois at one of the largest horse shows in the United States. As goodwill ambassadors, this outstanding family and its stallions have traveled to Oklahoma, Nevada, California, and throughout Texas to offer performances for charity events while promoting the Andalusian horse.

Since I have not attended any of the exhibitions given by Andalusians de la Parra except in Fort Worth, I will rely on several firsthand accounts to describe the tremendous effect that Rafael Alberto, Maritza, Paco and Mauro, and the Parra stallions have had on their audience. Tom Mannos, the respected announcer at the Belmont track, has been witness to Andalusians de la Parra in action. When I asked him for a recollection from his point of view in the Belmont announcer's booth, he responded:

"The Belmont Horse Fair was created in 1988 as a nine day celebration leading up to the running of the Belmont Stakes, the third part of Thoroughbred racing's Triple Crown. A special performance arena was built with seating for 4,000 spectators and placed behind the big Grandstand, so that spectators could, between races, look down from the windows and see the performances in the arena.

"The Horse Fair's concept was to show as many different breeds of horses as possible and give the public

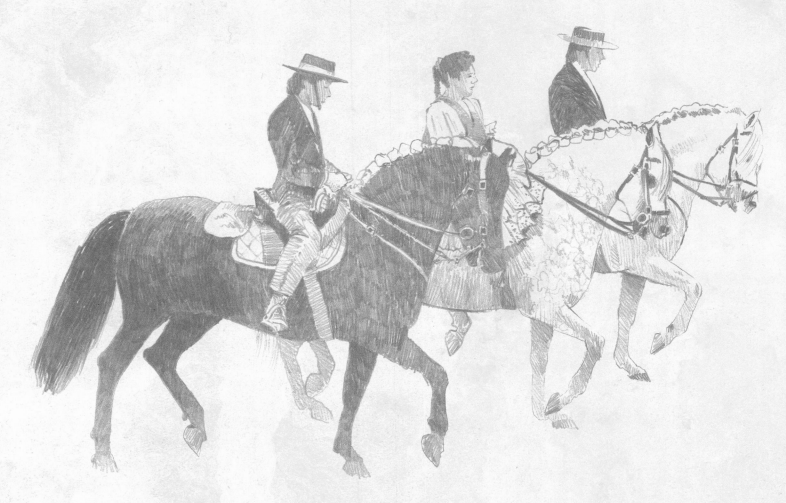

the opportunity to see these breeds in action in one setting. New York had never seen the Spanish horse, had never seen the regal presence of the Andalusians... and here were three of them, with authentic Iberian tack, ridden by riders dressed in beautiful costumes. The colorful flamenco dress of the Parras' daughter, Maritza, was spectacular and was greeted by loud applause from the audience. She was riding the gray stallion Primoroso II. Her brother, Rafael Alberto, rode the beautiful black Dejado and their trainer was on the white stallion Helicon II. You could actually sense that the audience knew this was going to be something unusual and special to see.

"As the announcer I had a very difficult time trying to read from a script fitted to their dressage performance and watch the performance; it was simply beautiful. Finally, I just dropped the script and followed the riders, doing a 'play-by-play' commentary of their movements.

"Their performances captured not only the general public in the arena but hundreds of people in the grandstands, who saw them on the television monitors and came to the windows to see more of them. The standing-room-only crowd included many Thoroughbred trainers who came to watch. The horses were showing not only the high-level dressage movements, like the Passage and Piaffe, but also 'Airs Above the Ground' movements, such as the very difficult Levade and Courbette. The Andalusian's training for the bullring was also demonstrated, showing its balance, grace, quickness, and courage.

"However, the audience wasn't satisfied after their performance; they wanted more. Hundreds of them came out of their seats and found Maritza behind the announcer's stand still sitting sidesaddle on her horse. They completely surrounded her to ask questions and pet Primoroso. They were touching him all over his body, a few even went under him. And that stallion just stood there, as if proudly realizing these were his new fans. It was at that time that I radioed for extra security to come down and help control the people.

"At their stabling area Mrs. Parra was another center of attraction, answering questions about the riders, horses, their saddles, and talking with horsemen and horsewomen about the breed she so dearly loves. The

crowd ranged from people who had never touched a live horse to veteran horse owners, nationally known celebrities, and world-famous jockeys. On one occasion I had to page Angel Cordero, who was videotaping the performances, to leave the arena and go back to the Jockey's Room to get ready for a race in which he was going to ride.

"After the Horse Fair was over, at a meeting to critique the event and plan for the 1989 Fair, there was unanimous agreement to invite the Andalusians de la Parra again. After all, they had just won over the very tough and blasé New York audience. As the song says: 'If you can make it there, you can make in anywhere.'"

Angel Cordero was so impressed with the Parras that he said if he won the Belmont Stakes that year, he wanted Maritza (daughter) to present him the winner's trophy. Cordero did win the race and Maritza did present the trophy.

Although many spectators at those exhibitions were deeply moved by the demonstration of Andalusian equestrian art, not more than a few would have their lives continue on with the Parras after the conclusion of the event. One who did is Dr. Barbara Panessa-Warren, a university professor from New York. In recalling her experience with the Parras, Barbara wrote me:

"After having attended each of the exhibitions of the Andalusians de la Parra at Belmont, my daughter and I were disappointed when the horse fair came to an end. The following August, I was at a scientific conference in San Antonio and I asked the Parras if my graduate student and I could come for a brief visit to their farm. They were very generous and suggested that they would come to the city to pick us up.

"I knew that I wanted to own one of these magnificent horses, but as a part-time college professor and research scientist I couldn't afford a trained stallion. Maritza seemed to read my mind and offered to show us the mares and older babies later that week. We drove out to their ranch in the hills surrounding San Antonio, and Mauro and Paco (the young men who worked with all of the horses) went into the field with lunge whips to bring the herd of Andalusians from the distant back pastures to where we could see them. On a perfect Texas day, with a turquoise blue sky and landscape blanketed in golden range grass, the mares appeared and eventually surrounded us. Maritza had brought her breeding book and she pointed out each of the brood mares and their lineage. For each yearling, two- and three-year-old she told us the dam and sire and explained the difference between Andalusian and Lusitano lines. Then we walked back to the mare barn and Maritza told us to wait and watch. At first everything was still. Then from all of the fields we saw mares and foals galloping toward us. Grays, bays, blacks and whites, were all around us. We were engulfed in a sea of glistening coats, ears, flying silver and black manes, long full tails held high, and classically sculpted heads with soft dark eyes. We were overwhelmed. Some forty horses had passed in front of us. One more beautiful than the next. We walked among them as each was led to a stall, each animal a work of art and a link with a history dating back to the Carthusian monks. This was the world of the Parras.

"The Parra family has not only kept alive the ancient tradition of breeding superior horses for classical horsemanship, but they also through their kindness, generosity, and warmth have shared their special philosophy of life with everyone who is lucky enough to know them. The grown children, Rafael Alberto and Maritza, have not only developed into superb horsemen and true ambassadors of the Classical Andalusian Horse, but they are also very special young people. They are both soft-spoken and extend their warmth and hospitality to everyone who comes to their home. When you realize how many people come to visit the Parras at any given time, it becomes apparent that these young people are not only very patient but extend themselves tremendously to bring their special kind of friendship and hospitality to so many outsiders. This is an extension of the example set over the years by their parents, Maritza and Rafael. Dr. Parra has a harrowing schedule as a neurosurgeon, and he is often called away from home to care for a patient or attend to an emergency at the hospital. He carries with him his concern for each of his patients, and in the years that I have been privileged to know this remarkable family, he has always extended himself to all who have needed him. This most often left him little time with his cherished horses. Maritza told me once of a time when Rafael had a particularly exhausting day in surgery and he came home wearing his surgical scrubs on (the

greenish-blue pajamas that are worn by doctors and nurses during a surgical procedure). He was exhausted, but seeing one of his stallions still tacked at the barn, he climbed aboard, still in his surgical scrubs, to take advantage of the last light before sunset. Just as he began to ride in the paddock behind the house, the phone rang. It was the hospital. A patient was in trouble. Maritza brought him the portable telephone, and still mounted on his stallion with the sun setting in the distance he carefully dictated the change in medication and treatment needed for this emergency.

"When you are a friend of the Parra family, you are drawn into a warm network of special people. I have been fortunate to get to know Maritza's parents and sister's family. Maritza's mother is a college professor like myself, and when I first met her there were so many things that I wanted to talk to her about... especially what it was like to be a mature woman professor at the University in Colombia? She is a tiny, pert older woman with a twinkle in her eye and a remarkably flexible intellect. I was determined to find a way to communicate, even though my two years of college Spanish had been eroded by many years of speaking and reading French, Italian, and German. My Spanish was crippled, and her English was minimal. However we could not let a mere language barrier interfere with sharing a friendship, so I spoke in French and she spoke in Spanish and Latin, and the children translated when our vocabulary and grammar brought us to a hopeless impasse. I think that we laughed more than we communicated. But this meticulously dressed, dignified lady projected such a warmth of personality and style that I can never forget her.

"There are so many things that I would like to say about the entire Parra family and their magnificent horses. But the most unique thing about them is that the deep family ties they share have brought them a grace of spirit and peace that is manifested to everyone who meets them as a special type of warm hospitality and sincerity. The Parras' love of their animals, their integrity as breeders and skill in genetics, has produced some of the finest Andalusian horses in North America. Each time I go to the stable to work with my Andalusian mare, Famosa, and I see her beautiful face, straight legs, and strong back, I am reminded of the Parras'

commitment to quality. I am lucky to own Famosa, but I am luckier to have known the Parras."

In these pages, we have heard friends praise the attributes of the Parra family. I recall Maritza having said that, in part, they made a life with horses because they felt that it would give their family a common, unifying interest. It is now obvious that this formula has achieved that purpose even beyond Rafael and Maritza's wildest expectations. With this in mind, I asked Rafael Alberto, who writes so extremely well that I have nicknamed him "the little Hemingway of San Antonio," to reflect on what his family's involvement with horses has meant to him:

"Humankind is blessed. We are allowed to coexist with one another over the span of our lifetimes. With particular individuals. With friends.

"I consider myself among the fortunate because I appreciate that which coincides with my lifetime. In the context of our world, people, animals, and structures are temporary. This brings to mind the seemingly countless generations of human beings who have lived and died with the purpose of ensuring the survival of their children. I am aware that my lineage extends to the very origin of my species. A very specific combination has brought me to this day in time, and has allowed me to be conscious of it. If this combination had not taken place, or had manifested itself in some other permutation, I would not know the difference, for I would not exist. I am thankful for this element of chance, or destiny, as the case may be.

"Life must never be taken for granted. It is an incomprehensible miracle that ourselves and others are here simultaneously, as sentient beings. We have the opportunity to share the time we find ourselves in.

"A horse is a companion to be appreciated. He is willing to give. He will gladly share your time with you. He becomes personally meaningful in your life. This is why I thrill to the sound of pounding hooves in close quarters. The experience is real. It is time well spent. It entails the view I have from above the horse's shoulders and neck. The sight of Dejado to my right inspires me as I conform my movements by eye, keeping parallel. When the forms of the other riders are obscured by the rider adjacent to me, I know we are aligned. Helicon II, beneath me, understands the effort

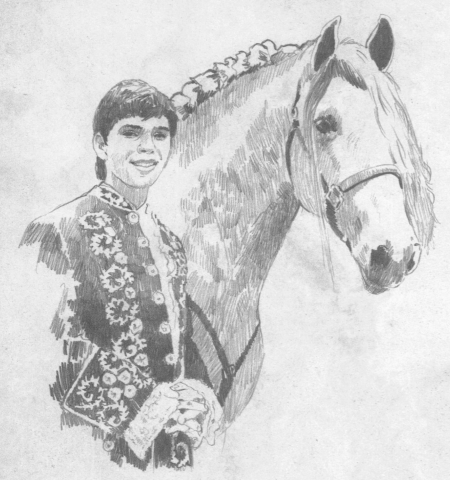

and assists in our common goal. I can feel the reins and their slight tension, separated in each hand. I become a mere component of a greater system. Balance, motion, and pressure are tools of the equestrian art form.

"One of my passions is the performance of the Courbette, an advanced movement based on the traditional air above the ground. I collect Helicon from a standstill. Moment by moment, as I issue the command, I am aware of the communication between us. It is as if we are one, thinking and acting with the same mind. When I decide to perform the maneuver, Helicon acts. I become unaware of the physical aid of rein and leg and slip into an automatic state of mind where the trigger is a thought. With this special communication, the stallion's huge neck rises into the position of a Levade. A sudden, abrupt moment later, we are airborne. The passage of time is arrested and slows into what will subsequently become a slow-motion visual and kinesthetic memory. This sensation has followed me into my dreams. Somehow, together we achieve success. Gratitude and satisfaction seem to emanate from the reintroduction of our combined

weight to the ground. This automatic mode lasts until the action is complete. I always say 'thank you' for the beauty of the horse's effort. Thus I am an aficionado raving about my activity as a skydiver would.

"Helicon is much more than a beast there simply to do my bidding. He is a true friend. Only he has heard my deepest secrets, and will never divulge them to another. Each horse and rider will have a distinct rapport. The animal can be befriended. Each is a valuable and interesting sensate individual.

"A precept governing my life is the belief that with practice, anything can be achieved. Practice, experience has taught me, is the most direct path between point A and point B.

"Since my introduction to horsemanship, I appreciate that my life has been greatly enhanced and enriched. I have been toughened by the seemingly endless hours of work. I have learned patience and how to relate to other living beings through this practice. I know that I am a far better man for the experience. I have learned to look at successful people and never attribute that success to luck. Success is created only by hard work, dedication, and perseverance. The lessons I have learned are numerous, many of which I could not or would not have learned any other way. People ask me, 'Have you ever fallen or been thrown from the saddle?' The question always strikes me as a humorous one. I have a distinct memory of my first day ever of unassisted riding. Near the age of six years, I clearly recall riding a Thoroughbred with an English saddle. I was mortified by the foreign sensation of the horse's walk. My balance was yet undeveloped. I was riding in a class of youngsters. It was a crash course for me as I knew nothing about riding at the time. My mount was cued by the other horses to trot when the command was given by the instructor. A moment later, the horse carefully came to a halt as I dangled from the left stirrup, completely upside down, crying my eyes out. I remained in that unique inverted position, awaiting my rescue, for what seemed an eternity. Despite the extreme humiliation I felt before my new peers, I was encouraged to get back into the saddle. Today I thank God that I did so. From that point, I felt things could not get much worse. A new day lay ahead. Since then, I have found myself catapulted into innumerable, sudden

trajectories to the ground. Each time, I regrouped and returned to the saddle. I eventually learned how to fall. In this way I escaped injury until the day I became confident enough to say to myself (with the exception of the unavoidable mishap, which has not yet occurred), 'No horse can throw me.' I had learned to lean back and ride it all out. This was not hubris, but experience and its resulting belief in my abilities.

"We've lived a lot since then, my sister, Maritza, and I. Always displaying the horses and our craft in their traditional light, we have known the inside of countless arenas and parade grounds and have come to know well the scrutiny of the public eye. We have smiled into the wide eyes of city people who are seeing and touching a horse for the first time. We have traveled to places previously unknown to us in our efforts to promote the Andalusian breed in the United States. Best of all have been the people we have been privileged to know, whom we would have met only through these equestrian arts.

"One such person is a man with whom I stayed while attending school in Sevilla over the course of a recent summer. He works the livestock on his ranch on horseback, and otherwise engages in falconry. He can easily relate to both people and animals. He lives as an inherent part of Nature. He may be the most sensible person I know. One day, I questioned his remarkable ability to follow a regimen of insulin injections, thinking that I would have a difficult time undergoing such treatment were I faced with the need. In response, he spoke to me of the importance of decisiveness in all areas of life. As I listened to his words, I realized that even while studying my undergraduate minor in philosophy, I had never heard a man make such sense of the world. It became clear to me then that mankind was intended by God to be close to Nature. There is nothing as striking as the sight of Paco sitting outside in the morning or the evening with a bird of prey on his falconry glove. If anyone can go beyond distant appreciation for nature and animals, it's Paco Lazo.

"This is just one particular instance of the overall benefit the common appreciation of horses and horsemanship has brought into our lives. The people we have met and who have taken an interest in us are diverse and valuable. As a law student, I have come to appreciate the valuable gift of a person's time, and have felt honored at its granting. As an equestrian, I have received more than this gift by having a greater exposure to the people of my time than I may have had otherwise. This, also, I do not take for granted.

"For all these great gifts, I am proud that I have had something to give in return. I am also pleased that, by the very essence of performance, I have been able to give to others on such a grand scale. The performances at Belmont Park in New York during the running of its leg of the Triple Crown were not only tremendously exciting, but very meaningful to me, as years of solitary and enduring training culminated in great public exposure. Times when our nervousness, on the part of both horses and riders, gradually mounted to almost

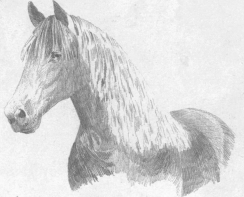

intolerable levels. At public performances, I have sensed Helicon's apprehension and instants of nervous noncompliance outside of the performance area. When the time finally arrives, he responds to his audience with perfect cooperation. It has become obvious to me that he is proud of himself. The stallion thrives in the center of attention. The audience applauds, and he responds in kind by endeavoring to provide the performance of his life. I often wonder, how could he have not been so spectacular during all the previous practice sessions? It is a phenomenon that I have come to expect from him, although I may not completely understand its reasons for being.

"Another high point of recent years has been our opening of the equestrian events at the Olympic Festival in San Antonio in 1993 on each of their four days. Becoming acquainted with so many other dedicated riders gave us an opportunity to compare notes and ideology on the subject of horsemanship. I also enjoyed

our invitations to perform at the Kentucky Horse Park in Lexington, because its goal is to educate those interested and inspired by this wonderful species.

"Exhibiting in the Capital Centre in Washington, D.C., during the Washington International Horse Show was a great thrill to me. I remember looking up in the 'nosebleed' sections of the arena and thinking the distance was so great that there could have been the mist of clouds obscuring their view. In the center of the great arena there was one of those four-sided screens which shows the camera angle views of the action on the arena floor. Even in my immediate state of concentration on the performance at hand, my peripheral vision would occasionally register the image from above. Maritza, riding Primoroso, and Mauro Alamilla, on Altivo, began to circle the center stage and performed the Levade. Immediately afterward, I took my position and performed a pair of Courbettes. He almost gave me more than I could handle, he was so inspired that night. I was very proud of him. The applause was sudden and dramatic. Only at that moment could I momentarily relax my concentration, which tends to be quite intense, and enjoy the response. We circled the area in a final salute, hats in our right hands, four reins in our left, before exiting the arena that night. We were called back in shortly to receive a special award, presented by another horseman who over time has become a true and proven friend of my fathers's and our family's. This was a great honor. Once again we saluted.

"We exited the arena into the cold and rainy D.C. night. Dejado steamed. The blue ribbons in Helicon's braided hair bled color onto his white mane and down his shoulder. The rain was refreshing as I had the opportunity to shed a tear of satisfaction that would not be noticed.

"Upon the recent passing of a family member, I asked a friend what image she had of heaven. The idea she conveyed was that of a great reunion where one would again share the company of those loved ones that had gone before. I immediately embraced this image, imagining those souls, human and otherwise, who have meant the most to me.

"In this ethereal moment I was surrounded by those who were dearest to me, those whose influences I had cherished most in life. My great-grandparents, a

grandfather, uncles and aunts, departed friends, equines, and even my late dog, Maverick, were there in their spiritual forms. I felt an indescribable happiness at seeing them after such a long, long time and remembered how much I loved and appreciated them all. Suddenly, I realized that I live this reality at the present. I am surrounded by the souls I love each day of my existence. How fortunate that I am surrounded by those companions I have now. I do not have to wait for them to be absent to truly appreciate them and cherish their influences and presence in my life. I am in a state similar to that image of heaven right now. I know this. I live it. And I will never take life for granted. For this state of realization I am eternally grateful for my lengthy and close association with the finest of living creatures — the human and the horse."

Rafael Alberto's words are a testimony to just what his parents' involvement with horses has brought to their children's lives.

In September of last year before returning to San Antonio to once again photograph Boticario, I first stopped in Austin to spend a couple of days with James A. Michener, my mentor and friend of more than thirty-five years. Going to Austin to see Jim last fall, I was filled with sadness, for he had recently lost his wife and my longtime friend, Mari.

During all of the years that I have known Jim, rarely have I seen him as happy as he was at the April *ferias* of Sevilla that we attended and about which he wrote with such perception and eloquence in our book *Iberia*. Now at eighty-eight years of age and on dialysis three times a week, it seemed that he would never again have that Sevilla experience. So when my assistant and I drove from Austin, destination San Antonio and Andalusians de la Parra, I began to formulate a plan that could bring the *feria* of Sevilla to Andalusians de la Parra. I knew that if anyone could stage that event in San Antonio, Maritza Parra was that person.

Early the following morning we set out for Bulverde to photograph Boticario one last time for this book. By some great luck, even though it was fall, recent heavy rains had promoted the untimely growth of a field of bluebonnets. A visit to Bulverde also meant lunch at Specht Store, a country store-restaurant founded in 1898. This right-out-of-the-old-west

building with its roof completely painted with the red, white, and blue of a Texas flag is one of the most traditional, charming, campy eating spots that I know in the world and it is no wonder that it is a favorite with the Parras' visiting European friends. It was over lunch that Maritza and I began to plan to soon re-create the Sevilla fair at Andalusians de la Parra. If the equine choreography that Maritza had arranged could mesmerize Rudolf Nureyev, causing him to return day after day to watch the Parras' dancing horses, I suspected that she could accomplish anything. If one of the Parra's dancing horses could draw applause from King Juan Carlos and Queen Sophia of Spain, who could question the spell that their stallions could cast on their home ground? And if the young riders of Andalusians de la Parra could so captivate Angel Cordero that he almost missed his horse at the Belmont starting gate, who could doubt the magic of their performance?

Thus, Boticario's beauty, we hope, will soon bring joy to a man of greatness, a greatness that touches anyone privileged to meet him, a greatness that comes not only from his literary epics but from his immense humanity—James A. Michener.

It has now been months since I was last in San Antonio, but the *feria* of Sevilla at Andalusians de la Parra has not been forgotten. Last Sunday I phoned Jim Michener, and I asked, "If Roger Bansemer and I come to Austin in July, are you up to going to the Parras' in San Antonio for flamenco, sherry, and a dazzling performance by a group of riders and Spanish stallions as fine as any that you have seen in Spain?"

"I don't see why not!" Jim firmly replied.

I can't wait to see the smile on James Michener's face as, with a glass of sherry in his hand, his eyes catch a first glimpse of a group of riders dressed in elegant fair costumes, mounted on the most magnificent Iberian stallions, coming out of the trees and toward the red-and-white-striped canvas caseta, where we sit under dozens of paper lanterns of the same colors. Leading this spectacular equestrian group will be Rafael on Boticario I. Behind him, riding sidesaddle, will be Luz Maritza on Altivo and Maritza on Primoroso. And following them Rafael Alberto will be on Helicon, Paco on Dejado, Mauro on Espartaco, with other riders in

formation on the stallions — Boticario II, Entendido, Esclavo, and Quisquilloso.

As this equine Spanish fantasy brought to life draws near, Boticario will step even higher to the beat of the flamenco singers and dancers that Rafael and Maritza have brought in for the event. When the riders reach James Michener (or Don Jaime as he will respectfully be called in Spanish that day), Rafael Alberto will remove his hat in honor of the man we all love so much, the man who loves Iberia with all his heart and who wrote *Iberia* for all the world.

James A. Michener will then slowly stand and raise his glass of sparkling sherry toward Rafael, Luz Maritza, Rafael Alberto, and Maritza Parra. His words will come slowly and deliberately in toast to this extraordinary family: "To you my friends! Viva la feria de Sevilla! Viva España! Viva San Antonio! Viva Andalusians de la Parra!"

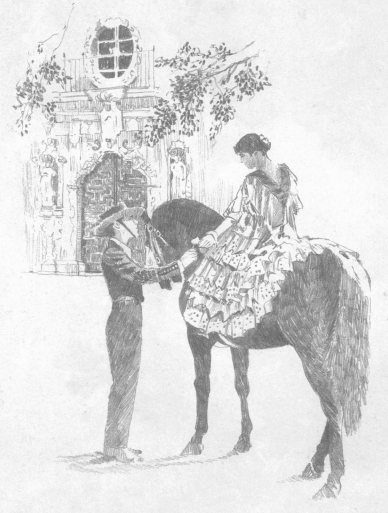

HISTORY OF THE ANDULUSIAN

by Valerie Hemingway

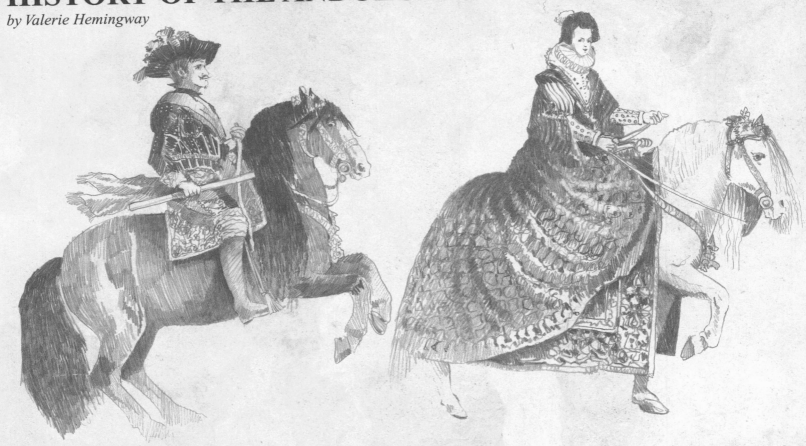

H orse of Trajan. Horse of Hadrian. Horse of the great El Cid. Throughout history the Andalusian has been prized by emperors and kings and has excelled as the steed of warriors. From the earliest times his noble bearing has been immortalized in bronze, his glory and fame celebrated by the poets, his distinctive physique captured on the canvases of master painters. An object of admiration and source of inspiration to horse lovers all over the world, the Andalusian is noted for its beauty and grace, bravery and intelligence, agility and docility.

The purebred Spanish horse was popular in the ancient world as a superior war-horse due to its strength and agility. Alexander the Great's Bucephalus is said to have been of Iberian origins. Julius Caesar wrote of the noble steed of Hispania in Commentarii de bello Gallico. Hannibal used Spanish horses in his invasion of Italy. While it is uncertain as to when the breed originated, evidence of weapons and harness has been uncovered in the Iberian Peninsula dating from the Bronze and Iron ages, and cave paintings indicate equine habitation at a much earlier time. Many theories exist regarding the origin of the Andalusian. Do they descend from the

Przewalski, the wild horse of Mongolia, or from the Tarpan, the wild horse of Eastern Europe which migrated from the north? Or did a horse of larger proportions migrate from the Orient, passing through Numidia and Libya? Some experts maintain that the primitive Sorraia horse, which evolved in central Portugal, is the main ancestor of both the Spanish and Portuguese horses. Claim is made that North African blood existing in the breed was introduced from the Barb horse, or Berber. Certainly the physical characteristics of these two breeds are similar. While there is no general agreement on the subject of the origin and classification of modern breeds, probably the whole of the Oriental light-legged group, including the Arab, Barb, and Turk, and indeed all the native races of Africa and Asia, are to be regarded as the descendants of one original Asiatic ancestor. Examination of the Berber and Andalusian horses supports the theory that the two breeds are very closely linked and clarifies the clear morphological differences existing between the Spanish horse and both the Berber and the Arabian. There are two distinct types of horses on the Iberian Peninsula: a small equine of prehistoric origin and of straight or

concave profile found in the northern regions, and a larger animal of convex or sub-convex profile found in the south. Today's Andalusian is a direct descendant of the latter.

The Andalusian head is quite distinct, larger than that of the Arabian, with a straight or convex profile. The forehead is very wide, with the eyes dark and kind. The ears are of a proportionate length and well-set. The nostrils are ample to allow tremendous air intake, and the muzzle is large enough to accommodate the large air passages. The neck is of proportionate length, well tied-in, and heavier than that of the Arab and Thoroughbred, yet elegant. In stallions, the crest is well-developed. The mane and tail are very long and thick; the shoulders, long and sloping with good muscle. Hindquarters are strong and lean with a rounded croup, and the tail is low-set. The chest is strong and broad with well-developed muscles; the back, strong and short-coupled. The legs of the Andalusian are usually sturdy, yet not coarse, clean-cut and elegant. As for color, most are grays, ranging from steel gray to pure white. Bays and blacks are also officially recognized colors.

It is surprising to note that the qualities so much admired in this extraordinary breed today are little changed from those of the Iberian horse of ancient times. It is documented that the Andalusian was handled and ridden by men at a much earlier date than any other horse. At the time of the Roman occupation of the Iberian Peninsula, the features of the Spanish horse were recognizable as those of the purebred horse of Spain today. The sub-convex facial profile, the strong arched neck, the rounded powerful body, and marked elevation in movement are quite clearly shown in horses depicted on Roman coinage and pottery of the period. The famous statue of the Roman Emperor Marcus Aurelius shows him astride a horse that could be an Andalusian of the 1990s.

Prior to the Roman invasion, Greek settlements were established in the Iberian Peninsula by 700 b.c. Homer and Xenophon both write of the Andalusian horse. Homer in the *Iliad* refers to Achilles' steeds, Xanthius and Balius, "swift as the wind, begotten by the seeds of Zephyr." And Xenophon tells us in *Hellenica*, "Then Dionysius's fifty Iberian horsemen spread out across the plain and galloping full tilt, hurled their javelins; if they were counter-attacked they retreated, turned and hurled their javelins again." We learn from Diodorus of Sicily that the Iberian soldiers, in the pay of the Carthaginians, fought in Sicily against the Greeks in the fifth century b.c., and when they went to Africa, and even to Sicily, they took with them their own horses or, if they had to leave their horses behind, they took their harness.

That the Romans recognized the superiority of the horse they found in the Iberian Peninsula is clearly documented by the Stoic philosopher Posidonius. After the Roman occupation, the next major foreign influence upon the Iberian Peninsula was the Moorish invasion and conquest early in the eighth century. In a.d. 711 Tariq ibn-Ziyad, a Berber, led his cavalry into Spain mounted on Barb horses. The Moors found the Spanish cavalry to be superior and more numerous than their own and as conquerors they quickly set about capturing the horses for their own use. The Moorish occupation of Spain lasted some eight hundred years but there is no evidence that during this time the Andalusian breed was significantly mixed with Arabian blood. Morphology points to the contrary, although there is a similarity between the Iberian horse and the Barb, and it is probable that these two breeds share a common origin.

During the Middle Ages the Spanish horse was famed thoughout Europe as a superior war-horse. Its physical abilities, together with its intelligence and courage, were recognized and used to improve other breeds. The role of the war-horse transformed as warfare methods changed. For a time a heavier, slower beast was needed to bear the weight of a mounted warrior in full armor, a task more suited to the heavier, cold-blooded breeds of the North. With the invention of gunpowder, cannon, and small firearms, the qualities of the Spanish horse—swiftness, obedience and bravery—were again in demand. In warfare the Spanish horse regained its superiority and was consistently chosen as the mount of kings and military commanders. It is recorded that William the Conqueror surveyed the battlefield of Hastings after the victorious Norman Conquest astride a Spanish horse, and that both Napoleon and Wellington led their armies to battle mounted upon Spanish steeds.

The Spanish stallions are unique in that they are fiery and proud while remaining docile and extremely

tractable. This seeming contradiction stems from the edict of King Ferdinand of Spain who enforced an old law that gentlemen must ride stallions. This edict resulted in the unseating of enough Spanish grandees to ensure the dedication of breeders to improving the temperament of their stock.

Not only was the Andalusian the premier war-horse of Europe, it was also used in Spain's successful conquests. After the Moors were expelled and Spain came into her own as conqueror of the New World, the Spanish horse again played a prominent part. The breed has often been called "The Great Colonizer." Spain established stock farms in the Caribbean and supplied horses to all colonizing countries. For hundreds of years, the Spanish horse was the representative of its kind in the Americas, and all New World breeds carry its blood.

During the Renaissance, interest in cultural and artistic pursuits increased. Equestrian academies were formed in the royal courts of Europe. Interest was taken in horsemanship as a refined activity, to be studied using an intellectual approach, and the same qualities that distinguished the Spanish horse in battle were now valued by the leisure rider. Military academies had been in existence in Europe for some time prior to the establishment of the first private equestrian academies attached to noble houses, notably those of Federico Grisone in 1532 and later of his pupil, Giovanni Pignatelli in Naples. The Neapolitan horse breed evolved from the Spanish. Following the institution of the riding academies, the art of horsemanship spread throughout Europe, where the Spanish breed was often favored as the mount of choice. In his equitation manual, *La Manège Real*, published in 1623 and still available today, the Neapolitan-trained French equestrian pioneer, Antoine Pluvinel, riding master to Louis X111, has engravings which clearly depict the Spanish horse. Another Frenchman, Jacques de Solleysel, Master of the Horse to the French Court at Versailles, wrote of the virtues of the Spanish horse:

"The Genettes have a wonderful active walk, a high trot, an admirable canter and an exceptionally fast racing gallop. In general they are not very big, but there are nowhere better bred horses. I have heard extraordinary tales of their courage."

In England the earliest classical Master of equitation was William Cavendish, Duke of Newcastle, who was a fervent admirer of the Spanish horse, which he invariably chose for his own use, declaring it to be the best for work in the manège. He wrote in 1667:

"If well chosen (the Spanish horse) is the noblest in the world, the most beautiful that can be. He is of great spirit and of great courage and docile; hath the proudest walk, the proudest trot and the best action in his trot, the loftiest gallop, and is the lovingest and gentlest horse, and fittest of all for a King in his day of triumph."

Newcastle was appointed riding master to the young prince who was later to become Charles II. We know from paintings of this period that both Charles I and Charles II favored the Iberian horse over all other breeds.

In the sixteenth century Spanish horses were used in the classical equestrian academies founded in Germany and Northern Europe and at this time in Austria the Imperial Spanish Riding School came into being. Originally founded in 1580, the Imperial stud in Lipizza used foundation stock of mares and stallions imported from Spain to create the Lipizzaner breed of horse used exclusively at the School. By 1735 the Spanish Riding School was established in the Winter Riding Hall in the center of Vienna. During the eighteenth century the Lipizzaner breed evolved with the introduction and mixing of Arab and Neapolitan strains, as well as a smattering of cold blood from Northern Europe. Over time, Spanish blood has been reintroduced into the Lipizzaners, to maintain their original qualities, and the School has continued on into the present day as a living monument to the art of classical equitation.

Classical equitation was also practiced in Spain and Portugal at this time. The riding style in Spain was called "a la gineta." The word "jinete" or "rider" derives from this term and the English name used for Spanish horses was Jennet, or Genette. The traditional Spanish style of riding was based on the rider's secure, deep seat and slightly bent leg, keeping the horse in a state of collection and roundness that emphasized his light, airy movements and agility in every maneuver, while allowing great forward movement and speed.

During the Baroque Era the Iberian horse's greatness peaked. His blood was used in the

establishment and improvement of other breeds. The warm-bloods of Germany, Holland, and Denmark, the Kladruber of Austria, the Cleveland Bay, and the Irish Connemara all have Iberian blood in their ancestry.

By the end of the eighteenth century, with the move toward social equality and a monied middle class, interest grew in a variety of new equestrian pursuits, especially hunting and horse racing, requiring breeds more suited for the newer sporting purposes. The significance of the role of the Spanish horse greatly diminished. Changing fashion in equestrian skills also brought about a lessening of interest in classical riding academies. However, in his native land one use for the Andalusian assured the continuation of the breed, that of mounted bullfighting, or rejoneo . Early hunting in Spain and Portugal involved wild boar and small bulls and their killing by javelins or lances. Mounted bullfighting was a logical progression. It has existed in various forms since Roman times, and man's admiration and envy for the power and potency of the bull itself can be dated back to Mithraic rites and to early Cretan culture. Ancient bloodlines of many of the best examples of the Andalusian horse in existence today can be traced back alongside those of the important fighting bulls.

The great families of Andalusia have continued breeding bulls and horses according to their ancient traditions, and the names of Concha y Sierra, Muira, Guardiola, Domecq, Camerá, and others are synonymous with the brave bulls and noble horses of Spain. On the great bull ranches purebred horses were originally used for working with the stock in the country. This work not only involved herding and separating but also the testing of immature brave bulls, and the pursuit of young animals for branding. The highly prized and jealously guarded bloodlines of the Andalusian horses have been preserved and continue to be shown proudly by their breeders as the symbol of nobility. They can be seen today splendidly parading in the ferias of Sevilla, Jerez, Córdoba, and Granada. The same horse that carried mighty leaders, generals, and kings on their proudest days continues to display all the magnificence of his honorable past. In the nineteenth century, in order to conserve the best horses for breeding, the government of

Spain placed an embargo on their export. For over one hundred years, the Andalusian was virtually unseen by the rest of the world. In the 1960s the export ban was lifted. Now the popularity of the Andalusian is once again on the rise. Horsemen have rediscovered the traits that made this the most sought-after equine in the world - the strength, agility, beauty, pride and docility. Although much equestrian competition in the twentieth century centers around show jumping and dressage, requiring an animal larger in stature and colder in temperament, purists have no doubt that the era of the classical art will return. In certain corners of the world, great Masters continue to keep this elegant and gracious art alive. The rounded elevations and lightness of the Classical School are still demonstrated with brilliance and artistry in the arena, and at the *Real Escuela de Arte Equestre in Jerez* where the form is practiced at its highest level, there is the greatest demand for the horse of Iberian blood, the Andalusian, or to call the breed by its official Spanish name, *Caballo de pura raza*, purebred Spanish horses.

In a recent book of Robert Vavra's, Alvaro Domecq pays tribute to the Spanish horse of today:

"It is my joy to be able once again to honor you, oh noble Spanish horse of my life! Because the history of my life has all been written on your back, oh Spanish horse of history! I still believe that you are the noblest of all animals, not conscious that your unlimited sensitivity delights life with the manner of walking that I taught you, though you were probably not even aware of my lessons. You are still my passion, you are still my life, whether you are playing freely on the plain or answering the call of my reins. I seem to hear a pleasing classical tune in your canter. I feel the immense pleasure of returning to life each day in your piaffe.

"I have spoken so much about you because you are not boastful, because horses with the majesty of your breed are difficult to describe. I am full of satisfaction to have lived all of these wonderful years so that my legs will still embrace those ribs of yours that are so full of force and energy.

"Dear Spanish horse, I shall never forget you. My last wish would be, after I am no longer here, to have the image of an angel on horseback near my grave."

BOTICARIO DE LA PARRA

How Velázquez and Goya and Rubens and Botticelli and Titian and Brueghel and Van Dyck and Benillure would have loved to have had Boticario De La Parra as an equine model. That thought passed my mind as I watched the young, darkly dappled stallion receive the honor of grand champion at the 1991 National Andalusian Horse Show at Fort Worth, Texas. Andalusian horses are known for their high elevation and their extremely showy movements; however, Boticario was almost without compare when it comes to evaluating his action. He comprises all the optimum qualities of a great Andalusian horse, and if the setting had not been Fort Worth, but Madrid or Sevilla or Jerez or Lisbon, he would have been equally worthy of the honor bestowed on him.

During the more than thirty years I have lived in Spain, dozens of Spanish stallions have captured my attention. Many of these I have sought and photographed when it was convenient and often when it wasn't. Boticario I would have journeyed great distances to record on film, and I actually did travel from California to Texas twice to focus my camera on his extremely elegant masculine beauty.

Since I did my first horse book *Equus*, I have crossed paths with scores of horse owners. Some I have never set eyes on after the first encounter. Others I see when it is comfortable to do so. But Rafael and Maritza Parra I would travel great distances to visit. The fact that this book is dedicated to the Parra family—taking into account that not that many books fill an author's lifetime—is an indication of my esteem for Rafael, Luz Maritza, Rafael Alberto, and Maritza.

To be able to photograph Boticario against an azure sea of Texas bluebonnets gave the same kind of creative rush that I received from photographing his ancestors galloping the almost solidly red-poppied pastures of Andalusia.

During one of our photo sessions in San Antonio, as the sky darkened and rain began to fall, Maritza and her daughter and I, along with the Colombian sculptor Celso Roman Campos, took refuge in the nearest vehicle. There, Maritza, her eyes sparkling and as bright as the purest sky blue–blue-blue and in contrast to the passing storm overhead, spoke to us of Boticario.

"There is nothing in the world as satisfactory as taking an idea and breathing life into it," Maritza told us. "To dream of the perfect horse; to study bloodlines, conformation elements, movements, personalities; to wait eleven months for the birth of the little creature sired by what you believe the best stallion and out of the best mare; to welcome a perfect package of qualities that makes that individual unique in the world.

"The little creature grows and matures, starts his training, and develops that athletic ability, beauty, lightness and brilliance of movement. Your sense of wonder increases as you witness coming into reality the promise you saw long before he was conceived.

"No emotion can match that of watching Boticario De La Parra come into an arena packed with admiring spectators, seeing him go through his paces of perfect classic dressage movements, working with great collection, engaging his whole body to do a great passage. So energetic, elegant, and light that he seems to barely touch the ground. A slow-motion pirouette

that makes you think of a ballet dancer, or a levade wherein he seems frozen in time.

"Boticario is the perfect example of the final goal we want to achieve. We know God gave him life, but we had the privilege of helping choose and develop the qualities that make him a great work of living art.

"Boticario was foaled in January 1983 at our ranch with the whole family in attendance. Now, twelve years later, he is the show horse who received standing ovations at the 1993 Olympic Festival, in Dallas, and in Washington, D.C.; the feature performer of exhibitions in New York, Chicago, Kansas, and Texas; the contender who consistently wins first place and 'best movements' every time he competes. A lion

full of energy and enthusiasm when you are riding him and a perfect teddy bear when you are next to him on the ground."

As the rain ended and the sun shone with post-storm spring intensity, we climbed onto the spectacular carpet of blue that spread out toward Boticario whose mane was now lifted and carried by the wind, like the distant dark storm clouds. Seeing him still and assured in all his bold macho being, one didn't have to use much imagination to realize why Hadrian and Trajan were so attracted to Spanish horses. This is the kind of Andalusian horse of which legends are made. Had he been born in another epoch, Boticario's name might have been written beside that of Babieca.

219

CH SANTANA LASS

CH Santana Lass—the only mare that appears in this book—is a legend in her lifetime. To be able to photograph her with her foal was a plus. As I watched this handsomely stunning American Saddlebred mare cavort in the field with her colt, I thought of other great athletes—human ones—who upon retirement may have similarly spent hours, far from the roar of the crowd, with their children or grandchildren in a park tennis court or sandlot.

The scene of Santana Lass grazing as her foal, almost hidden in tall reeds, suckled at her side made a lovely contrast to the mare as I had recently seen her in a video. In the film, she and her owner, Mary Gaylord, circled the ring during the American Royal Horse Show in a special tribute to the mare. As the band played, Santana Lass seemed to lift her hooves even higher—seemingly an impossibility—as the crowd offered her a final thundering ovation. A fitting compliment to one of the great American Saddlebred mares of all times.

"Redd Crabtree, my trainer, showed her when she was three and four," Mary told me. "I showed her in ladies' competition until 1990; then I showed her myself in open competition, against professional trainers. Her sensational speed, thrusting trot, and powerful rack made her a legitimate contender in the tough open championships."

The renowned Redd Crabtree of Simpsonville, Kentucky, purchased CH Santana Lass for Mary, as his client, shortly after she won her five-gaited class as a three-year-old in a spectacular performance. Under Redd's direction, the mare has left a trail of glory and blue ribbons wherever she goes—nine World's Championships and two Reserves, a remarkable record. The pedigree of CH Santana Lass suggests that her talent comes quite naturally. Her sire, Sultan's Santana, was 1981 World's Grand Champion Fine Harness; her dam, Miss Blarney, was sired by CH Irish American, the 1973 World's Champion Five-Gaited Stallion. Both sire and dam trace closely to Genius Bourbon King, a stallion noted for his great beauty. CH Santana Lass was foaled in 1982, bred and raised by Thomas Galbreath at Castle Hills Farm in Versailles, Kentucky. She was initially trained by Steve Joyce who showed her for the first time in the win that attracted Redd Crabtree's discerning eye.

By 1991, CH Santana Lass and Mary were seasoned and formidable contenders in open five-gaited competition—unbeaten in mare classes and championships at the Oklahoma Centennial, Midwest Charity, American Royal, and Indiana State Fair shows. They topped the mare stake at Louisville to win the World's Champion Five-Gaited Mare title, and were again Reserve in the World's Grand Championship. In the ladies-to-ride division, the mare's brilliance and beauty made her the queen in a division where judging is based on performance, manners, and quality.

Redd Crabtree offers his tribute to the winning combination: "Praised by all, criticized by none, one of history's handsomest mares of any breed. A mare who could execute five gaits equally perfectly and with such vigor, we were all breathless, admiring adorers. If a horse can be perfect, then Lass was perfection in beauty, conformation, and talent. Her attitude was 'I'll do more!'"

"Training Santana Lass for ten years was a gift only our Lord could grant. Every day of those years I knew we were part of a rare moment in time never to be repeated.

"Mary Gaylord and Santana Lass were one, the finest ladies team in the show world. Their place in American Saddlebred history is that of champion."

At the end of my second day photographing Santana Lass, I stood with her sensitive and devoted handler Tommie Blackburn, whose close communication with the mare was inspiring. As we watched her trotting away from us, her foal at her side, I sensed the excitement and expectation Mary Gaylord must feel,

anticipating the colt's future as well as the past of his extraordinarily famous and talented dam. At the moment, not far from Mary's home, which stood white and imposing under a red-gold Kentucky sky, we were surrounded by soft southern voices, human and otherwise. Far off, as a bobwhite called, it was not difficult at all to close one's eyes and go back in time "to when there was a land of cavaliers and cotton fields called the Old South. Here in this pretty world, gallantry took its last bow. Here was the last ever to be seen of knights and ladies fair. . . . Look for it only in a book, for it is no more than a dream remembered, a civilization gone with the wind."

EL GHAZI

It is often remarked that animal companions are reflections of their masters. If this were true of horses, it could be proven by the Arabian stallion El Ghazi and his owner, Kazu Ishikawa. Both are gentlemen in every sense of the word.

Upon first meeting Kazu at an Arabian Horse Trust dinner, I was impressed by his gracious and totally sincere manner; it was immediately apparent that here was a very special human being. Some years later as I stood in a pasture at Lasma East International Centre, near La Grange, Kentucky, and El Ghazi was presented to me, I knew that if gentlemen exist among equines, I was face-to-face with one.

Apart from El Ghazi's personal beauty and presence, what is so impressive about him is his extraordinary athletic ability and lovely movement. His natural action is almost singular among the Arabian horses I have known. He seems to trot as if trotting was the one thing he wanted to do more than anything in the world—not only do, but to elevate to a dream-like level of execution.

El Ghazi showed the world his trotting talent (along with proper form and ring presence) at the 1989 U.S. Nationals where he was named Reserve Champion English Pleasure. The 1995 Scottsdale All-Arabian Show gave him a chance to display his exuberance and joy of motion in Freestyle Liberty. Five judges found him outstanding in this competition and unanimously named him Champion.

This 15-hand bay stallion, marked with a white star and three white socks, was foaled in 1983 at Janow-Podlaski State Stud in Poland. His breeding is marked by the aristocracy of the Arabian horse world.

His sire, Aloes, a major progenitor of the Kuhailan-Haifi sire line, was named 1982 Polish National Champion Stallion and was noted worldwide for his siring of quality daughters. El Ghazi's dam, Elektra, was sired by Bandos PASB, a leading progenitor of the Skowronek sire line, and Elektra's dam Ellora is a treasure of Polish breeding, among her produce El Paso, 1976 U.S. National Champion Stallion.

El Ghazi's initial athletic triumphs were on the Polish racetracks where he ended his career with a decisive victory in the 1988 Bandola Stakes. Shortly after that win, El Ghazi was imported to the United States by Kazu's father, Mr. Ryohei Ishikawa.

At the top levels of the Arabian show world, El Ghazi is noted as the sire of two National winners, one in halter and one in English pleasure. At the 1995 Scottsdale show, where El Ghazi was named Champion Freestyle Liberty, his son demonstrated the athletic ability and versatility that comes with correct conformation by winning seven titles—four in dressage, three in hunter.

"I think El Ghazi is one of the most beautiful horses we have here," says Ruben Gaona, who handles the stallion. "He's also 'a real individualist'. El Ghazi can be *un poco asustón*. He likes to pretend he's spooky and skittish, perhaps as a way of handling his own high energy levels. Or perhaps he's fantasizing a little, pretending it's the old days and he's back on the racetrack in Poland."

When it's time for El Ghazi to come in after a morning paddock turn-out, he will treat Ruben's efforts to catch him as an invitation to play. Once he has been induced to come in, however, El Ghazi is

much more serene, says Ruben, and dotes on being handled. "He just has a lot of nervous energy. Once he's gotten it out of his system, he's actually very quiet and enjoys his bath. He loves to roll and usually is well-coated with mud by the time he comes in."

Never will I be able to see El Ghazi's images in this book without reflecting on his free-spirited owner, Kazu. I think of them both in motion, freed by their natures and free with nature. Whenever El Ghazi is released into a pasture, the scene will be transformed into an equine dream by his dream-like movement. While under the same bright sun and to nature's forceful rhythm, Kazu will also be moving, the epitome of grace under pressure as a great Pacific wave carries him forward with the force of a thousand

stallions. But for Kazu, there will only be one stallion waiting for him on land—El Ghazi.

Months after my time in Kentucky with El Ghazi, I received (by coincidence on my birthday) a book and card from Kazu. The sepia photograph on the card showed the small faraway figures of two surfers, boards under their arms, approaching the water. At the top of the card, in calligraphy, were the words "Why not?" When I opened the card, the written thought continued: "Do what you love to do."

This phrase could not be better exemplified than in the being of Kazu's stallion. For to see El Ghazi in motion is to see a stallion at liberty, doing what he wants to do so exceptionally well, and for the pure pleasure of doing it.

223

ALADA BASKIN

Alada Baskin is a true horse of the sun. I first saw his fiery copper countenance in 1993 at the Scottsdale Arabian Horse Show. Alada Baskin, among crowds of onlookers and brightly striped tents, conjured up a scene of stallions displayed at some Macedonian fair at which Alexander the Great might have been a spectator. As masses of people parted before Alada Baskin, he pranced forward, whirled, and stood statue-like so that anyone who loves beauty in horses might admire him.

That initial introduction, however, did little to prepare me for my next look at Alada Baskin at Rock Isle Arabians at Waconia, Minnesota, a farm owned by Georgene and Ward Holasek. With the greatest clarity, I remember the experience. I was high up on a ladder when in the distance, against the Minnesota green, a glimmer of golden copper, joined by the stallion's neigh, flashed the landscape and jarred the stillness of break of day. I could only lower my camera for a few seconds to marvel at the horse of the sun whose metallic brilliance gleamed ever closer.

Georgene Holasek is one of the brightest, most up-front horsewomen whose company I have ever enjoyed. That she is also a veterinarian was an added attraction for me. It seemed every word she spoke was well-thought-out, highly perceptive, and completely sincere. That she and her trainer Tammy Evans felt great admiration, pride, and respect for Alada Baskin could be read from their eyes.

After a search of several years for a special colt to use in her breeding program, Georgene found Alada Baskin quite by accident—or fate—while working at a training stable. "Love at first sight" characterizes her first impressions. "Just what I had been looking for. A beautiful head, long neck, great shoulder, long legs, excellent long quarters, and a fine trot—all with that extra charisma that only the great ones have," Georgene recalls.

"Lad" came to Rock Isle Arabians as a yearling, unsophisticated but full of promise. The show world soon turned that potential into reality. For Georgene, one of the most satisfying of Lad's show wins came at the Minnesota All-Arabian Show when Lad was only two and went Supreme Champion, winning over all ages and sexes. "He was the first horse into the ring for the Supreme and as each of his competitors came through the gate, he snorted and pranced and got higher and higher," Georgene recalls. "The judge couldn't take his eyes off him." Lad soon went on to pick up blues from Scottsdale and throughout the Midwest . At the National level, he has twice been U.S. National Reserve Champion Stallion, once at age four and again at age eight, the last win in a Top Ten that included three other past U.S. National Reserve Champion Stallions.

Alada Baskin is now recognized as the sire of nine National winners. Perhaps his finest moment as a sire came at the 1993 U.S. Nationals at Albuquerque when four sons were named Top Ten Futurity Colts and one of them moved on up to Reserve Champion, and two more offspring placed in amateur halter showing.

"The number one thing we see in the Alada Baskin foals is the wonderful shoulder and the excellent neck-set, along with his beautifully shaped neck and throatlatch," says Georgene. "Then the legs, those beautiful long legs. We see extremely pretty

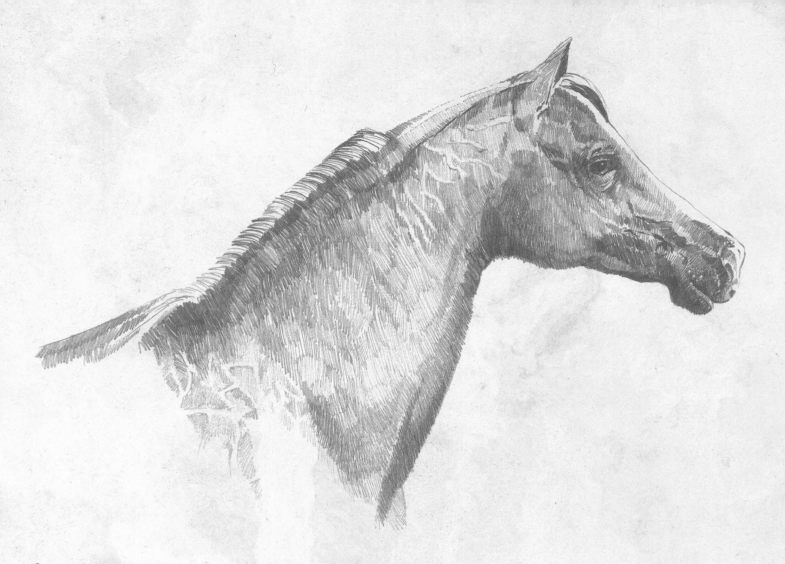

faces, fine ears, big eyes, and the most lovely eye sockets. And the bodies. Those little bodies are so smooth and level and the tummies are so tight they look like they've been on a conditioning program. Overall, the foals have the Lad look, the Lad personality."

Alada Baskin's sire, Aladdinn, contributed his unmistakable correctness and substance to the excellence of Alada Baskin, along with his name recognition: Aladdinn is noted as the sire of four U.S. National Champion Stallions and one National Champion Mare. Georgene credits Lad's dam, Launa Basketu, for the qualities she passed on to her son. "Launa Basketu is a great big mare, a dark bay, with a beautiful shoulder and a lot of leg. I'm sure Lad's long legs came from her. Her trot is much like that of a Saddlebred, her tail straight in the air, a trait she passed on to Lad. She's very athletic, her beautiful hocks contributing well to that ability.

"Lad is such a fine sire that I feel as if he and I are partners in a breeding program that has produced so many good individuals, who will bring joy and pride to their owners" Georgene continued. "Indeed, he has made a significant contribution to the Arabian breed. I enjoy the feeling that I am part of this contribution and feel honored just to own and share special moments with this horse."

Since the Holaseks also keep a sizable herd of Percherons that roam the woods of their extensive property, we frequently found ourselves photographing the most refined of Arabian stallions while encircled by a thundering herd of equine giants. They made the experience with Alada Baskin even more magical, for while the immense beasts of darkness literally rumbled the shadowed earth around us, Alada Baskin, the prince of the desert, remained calm, staring off into the distance and flaring his nostrils while he dazzled our eyes—a true stallion of the sun.

NORMANDO

After spending several days in Texas with Normando, I said to his owners Peter and Kelli Van Borst, "Can't we pack him up and send him to Spain? I'd like to have this horse on my ranch." What I found attractive in Normando, apart from his dappled masculine Spanish beauty, was a certain distance—a quietness and mystery that were a part of the charisma of Majestad, the Andalusian stallion who appeared in a number of my books. Majestad took a big piece of my heart with him when he died in Spain years ago.

Some summers before my photographic session with Normando, Peter and Kelli had been guests at Cañada Grande, my ranch near Sevilla, where hour after hour we talked of what we all love so much: horses. We also spent time with Alvaro Domecq Diéz and his son Alvaro Domecq Romero at their ranch, Los Alburejos, near Jerez. I especially recall a golden afternoon photographing Kelli in a green and white flamenco dress, riding behind Alvarito on one of his prized rejoneo stallions. Later we sat with numerous members of the Domecq family at a garden table, casually sipping sherry and sampling tapas, including Spanish omelette and mountain ham. As evening approached, one of Dn. Alvaro's fighting bulls began to roar in a nearby field carpeted in dark blue flowers—flowers that were exactly the same color as the Andalusian night sky. It was a special moment shared with special equestrian friends, Peter and Kelli and the Domecqs.

"My life with horses began in the south of Ireland when I was about ten," Peter Van Borst reminisced. "To me, in those days, Ireland was a great and wild and mysterious place, full of horse fairs, pony races, fox hunts, horse dealers, and the last of a long line of great horsemen. I spent much of my childhood—when I wasn't riding—listening to the stories the old men told about what seemed another age.

"Horses were never out of my life in the growing-up and young adult years. I worked horses with Gypsies and gentlemen and found no difference in the one desire we all shared: the horse. Horses and travel went together in my life—trying steeplechase riding (I was far too tall); working in an Irish film studio making period movies, many featuring horses; riding hunters in England; training polo ponies and jumpers; riding for the Olympic Committee in Germany; jousting in a medieval show for tourists at a castle in Wales; transporting circus horses to South America; riding high school horses in the Palermo in Buenos Aires; training and showing horses in a Japanese circus. I've traveled and trained and ridden, laughed, cried, been happy and sad all over the world, all with horses.

"My lifestyle suggests the way one can live and be a part of the history and excitement of real and special creatures. All my adventures were a long way from my ten-year-old year in Bantry Bay, Ireland, sitting on a wall, eyes as large as plates, watching a big dapple-grey stallion trotting down the market square, and wanting nothing more in the world than a few moments on his back.

"We first saw Normando as a young green horse at the ranch of Luis Gonzales Diaz in Mexico. In personality, he showed us a kind and affectionate

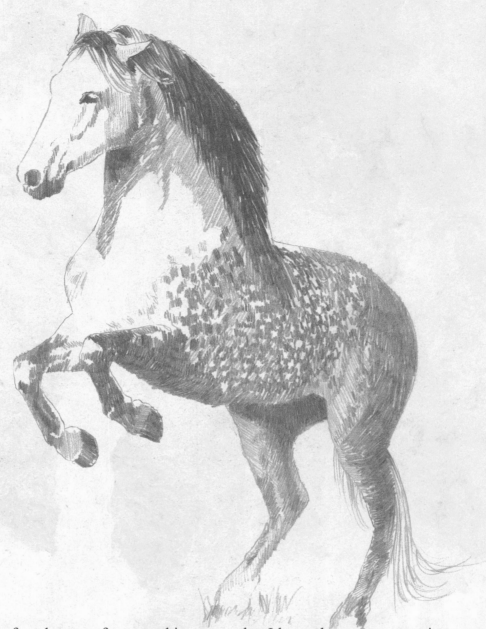

nature and a certain kind of exuberance for everything he did. That exuberance is now manifested in his skill and execution of the classical movements.

"Four years later, his exuberance still intact, his personality still developing into a very secure and trusting horse, he is doing exhibitions and fast becoming recognized as a very good high school horse. Most important of all, he has become part of our lives—a pleasure to ride and to watch at play—his elegance always abundant, his trust always obvious."

Normando's presence in a camera transported me on that magic carpet which horses provide to other places and different times. Though we were in Texas, the scene before the cameras could just as well have been Portuguese or Spanish. The equine photography that I have chosen attempts, in part, to create illusions. By zooming and focusing in on Normando's monochromatic beauty, the camera could eliminate distractions such as people and fences, allowing the viewer of the completed image to rejoice in the vision of a stallion running free. Normando then hopefully becomes like the stallions who freely roam and stampede our imaginations: *Le Cheval Nu*, or the naked horse, as one of my books was titled in its French edition.

During my last photo session with Normando, as the dappled stallion reared against a sunset filled with Maxfield Parrish clouds, much of Spain's splendor flashed in my memory, a glorious history that in part was due to the noble Andalusians like Normando.

CALLAWAY'S GOLD RUSH

Few horses can claim names that more aptly sum up their presence than does that of Callaway's Gold Rush. As the sun rose over a Kentucky field of clover and I looked into the darkness of my camera, a flash of red gold illuminated the image that was projected from the lens. High-stepping, nostrils flared, black tail flagging the wind, Callaway's Gold Rush flowed molten-gold across that sea of green, proudly blazing his way like a rush of lava into an emerald bay.

At one side of the field stood Betty and Bill Weldon and their trainer Redd Crabtree. Betty I have known for some years and have listened to and observed with admiration this outspoken, intelligent, well-traveled, leading force in the American Saddlebred world.

Once the sun had risen higher and the flame of Gold Rush's coat had been extinguished by the darkness of the stable, Betty spoke of her feelings for this American breed of horse—the Saddlebred.

"In addition to moving at the walk, trot, and gallop as most horses, the five-gaited Saddlebred has inherited the ability to learn two other ways of moving: the slow gait, a stepping pace; and the speedy syncopated rack," Betty related. "In these four-beat gaits, each of the horse's hooves contacts the ground separately, making for a smooth and comfortable ride.

"The American Saddlebred can trace its roots to the easy-gaited English pacers that came to North America in the 1600s. These hardy little horses throve and grew in the new environment and through selective breeding the Narragansett Pacer was developed. These horses are now 'extinct' in the United States—thousands were exported to the West Indies—but many Narragansett mares had been crossed with Thoroughbreds to produce a horse simply called 'the American horse.' These horses had the size and beauty of the Thoroughbred, but retained the ability to learn the smooth-riding gaits. They were used under saddle and in harness and were prized for a pleasant temperament, eagerness, strength, and stamina.

"These American horses carried Colonial cavalry to victory over the British at King's Mountain in South Carolina and, after the Revolution, carried their masters to the frontier of Kentucky. Continued crossing with Thoroughbreds produced quality horses called 'Kentucky Saddlers' known from coast to coast prior to the Civil War. The ancestors of Callaway's Gold Rush proudly served both sides in the Civil War and were especially effective in the Confederate cavalry. After this terrible strife, American Saddlebreds went to all parts of the country as soldiers returned to their homes. They could be seen on the bridle paths of Central Park in New York City and on the plains of Texas where they herded cattle.

"American Saddlebreds, because of their exceptional beauty and exciting, high-stepping action, began to dominate horse shows. As the automobile diminished the utility of horses, the Saddlebred was confined more and more to the show ring. Today, the American Saddlebred, in its highest state, is the ultimate show horse, a spectacle of grace and beauty and extreme athletic ability. The horse is successfully presented in combined training, dressage, endurance competition, carriage driving, and in western riding.

"Callaway's Gold Rush is a son of the great five-gaited champion CH Will Shriver; both were bred and

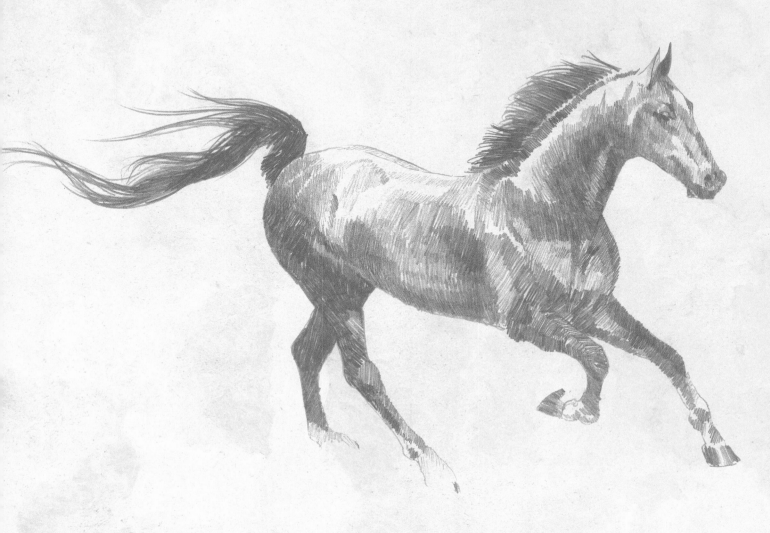

raised at Callaway Hills Farm, Jefferson City, Missouri. Will Shriver was not only a show horse—Five-Gaited World's Grand Champion of 1976—but a great sire until his death in 1991. His get include winners in all show divisions, including CH Callaway's New Look, the Five-Gaited World's Grand Champion of 1991 and 1992. Will Shriver made another significant contribution to the breed in that most of his get have retained the ability to slow-gait and rack correctly. The dam of Callaway's Gold Rush is CH Gold Treat, a top five-gaited mare of illustrious breeding.

"In the show ring, Callaway's Gold Rush is an outstanding performer for trainer Redd Crabtree (who also showed Will Shriver). Gold Rush is powerful and speedy, pure of gait, and has never-quit determination. On the other hand, he is gentle and has a wonderful and friendly personality. He has been used lightly at stud and his first get in training show exciting promise. Callaway's Gold Rush is truly a horse with a heritage of gold."

The following morning as I watched Gold Rush flash and gleam, posturing against his field of green, admired by Bill and Betty Weldon, I thought how equally proud Will Shriver would have been—if a horse can feel that kind of pride—in his flame-gold legacy. A legacy in which "could be found friendship without envy, and beauty without vanity. And in whose being, grace was laced by muscle and strength by gentleness confined."

DOMECQ

When I first saw Domecq's photograph in a horse magazine, I immediately identified with and felt a fraternity with this spectacular Peruvian Paso stallion of the flowing flaxen mane and burnished gold facade. In Spain, where I live, "Domecq" is one of the most prestigious of family names. Jerez, the sherry capital of the world is less than an hour from my ranch near Sevilla, and of the wineries producing sherry, Casa Domecq is without parallel. In Andalusia—actually in all of Spain—"Domecq" is also synonymous with fine horses and the bravest of fighting bulls.

The stallion had been named for my friend, the famed gentleman bullfighter from horseback, rejoneador Alvaro Domecq Romero. So it was that I looked forward to visiting Domecq's home, Barbara Windom's El Criadero La Estancia Alegre, a ranch near Santa Fe, New Mexico. Barbara is a petite, highly directed horsewoman who has an extremely clear vision of what sort of Peruvian Pasos she wishes to breed—those with an obvious accent on function.

One evening, following one of our shoots, Barbara and her partner, Victor, invited us into their spacious home of grand touches and charm. During dinner, Barbara spoke of Domecq's background, of her background as a horsewoman, and of her philosophy as a breeder. Also present that evening was noted Southwest photographer Barbara Van Cleve, whose father, Spike, had become my friend years before in Spain.

"When I was two," Barbara Windom told us, "my grandfather took me to the pony rides, the outcome being that I spent the best part of the next eighteen years on horseback. I rode in my first show at the age of six and was given my own horse at age ten. I spent all my after-school hours riding and before long I'd taught my horse (and me) how to jump. During the next years, I owned several hunters and jumpers and traveled the California show circuit. All I cared about was horses—until I met my husband. Then it was children and career for the next thirty years, and I had time only to dream of my 'lost' horses.

"Once the children were making their own lives and I had moved to Santa Fe, I thought about the possibility of owning a horse or two again. With the beautiful mountains and endless vistas and trails that beckoned, I sought a horse that would travel smoothly and efficiently. The Peruvian Paso fit that description. Before I could even begin to look for my dream horse, I was introduced to a neighbor who had several Peruvians.

"Curiosity about the breed led me to Peru, where I was fortunate enough to meet several breeders who are dedicated to carrying on the five-hundred-year-old traditions of the Peruvian horses. I visited many breeding farms near Lima and farther south, and I attended the Concurso Nacional. The importance of the gait, the temperament, and the *brio* was continually emphasized. I rode many horses, participated in a daylong trail ride (or *cabalgata*) through the mountains and valleys of green, and came away convinced that the Peruvian was the breed for me. I purchased three mares on that trip, a move that turned out to be just the beginning.

"Thirty horses later, I met Domecq. To me, he was the ideal horse, not only to ride in the beautiful

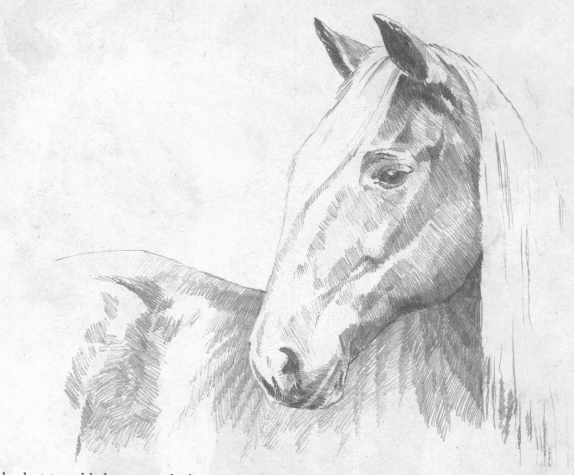

countryside, but to add the strength, beauty, and *brio* that we wanted in our breeding program. He is now sixteen and still going strong. He has very little *termino*, that strange paddling action of the front legs found only in Peruvian Pasos, but we intend to breed him to mares of such motion, which we hope will give us offspring with an appropriate amount.

"We know now Domecq passes on the 'Peruvian package'—gait, beauty, strength, and *brio*—to his get; all are fine representatives of the kind of horse we want to breed."

Domecq has done all his endurance racing with his original owner, Maurice Unger, and he achieved a first for the Peruvian Paso breed—that of certification as an endurance-race performance horse in the Endurance Horse Registry of America. To earn registration, a horse must satisfactorily complete three hundred endurance race miles in one year, all in races of fifty miles or longer. In each race, the horse and rider must finish in good and sound condition within a maximum elapsed time. The races challenge the

conformation and the inherent strength and stamina of each entry. Domecq has all those qualities in abundance and enhances them with tireless energy and the smoothest of rides. He has now completed more than six hundred fifty miles of endurance races and ranks nationally among the top ten stallions competing in Endurance Horse Registry of America-sanctioned endurance races. Domecq is owned in partnership with Raul del Solar and Maurice Ungar.

Early the next morning, I watched Domecq glide through a field shrouded in fog and gilded with frost, and it was not difficult to imagine how the Incas, at the onset of the Spanish Conquest, were awestruck by such a sight. As Domecq's luxurious mane rose and fell in the fog, I thought of my friend Alvaro riding his famous stallion Universo. At that moment, I felt very close to the Spain from which Domecq's ancestors had sailed over four hundred years ago to arrive in America where they helped to provide the foundation stock for this smoothest of the world's riding horses— the Peruvian Paso.

PADRONS MAHOGANY

To most photo-artists, eyes are the focus of the image, the connecting point between subject and viewer. But my first look into Padrons Mahogany's eyes was more than merely a connection between two beings, for in those dark pools set in his ever-so-refined head could be seen gazelle-like gentleness that in seconds could blaze with everything the word "stallion" signifies.

Mahogany's eyes are the embodiment of all the glorious Arabian horse eyes that statically glimmer from the world's masterpieces of desert equine art. The white of the eye, when it did show, was not quite white but tinged with rich sepia and tones of gold. His eyes are truly those of some charger right out of the Arabian Nights and will forever blaze in my memory when I recall beautiful horses.

That this son of Padron with his darkness accented by "the color of nutmeg and the heat of ginger" is in the custody of Linda Mehney made my visit to Grand Arabian Farms (Grand Rapids, Michigan) all the more attractive. I had met Linda, her husband, Dave, and their trainer, Joy Hatten, at the 1994 Scottsdale Arabian Show. Months later, I would be at the Mehneys' Michigan farm, where shortly after our first introduction, I fell under Mahogany's spell.

Of the horse breeders I have known, Linda is one of the brightest and best organized. Her blue eyes sparkled whenever she spoke of the dark mahogany stallion whose offspring—while I was photographing him—were claiming high honors in the show ring.

Padrons Mahogany won special recognition at the 1993 Scottsdale Arabian Show when his offspring unanimously won the Get of Sire class for him. The win gave the sire and his offspring a boost for the 1993 show year and the years following. By the end of 1994, Mahogany offspring had collected more than ninety halter championships and fifteen performance championships.

"The word "mahogany" when applied to wood is synonymous with strength, quality, and beauty," says Linda. "The meaning is of no less consequence when extolled for this outstanding stallion. As a great tree towers with majestic radiance, its beauty only relevant to the strength of the support below, the strength of Padrons Mahogany is not only his physical presence but, like the tree, his roots that support and enhance his character.

"Mahogany's roots draw from some of the most exquisite horses the Arabian breed has known. His sire, National Champion Padron, has left his mark far and wide with an established pattern of excellence in each foal, as attested by his dozens of National winners, both in halter and performance. Mahogany's dam, Hal Ane Versare, a halter winner, is a champion producer; three of her sons are National winners.

"Padrons Mahogany, a delightful creature in looks and personality, has the ability to stamp his special appeal on the next generation. First and lasting impressions of Mahogany and his offspring are type (with small tippy ears and large eyes in a cheerful expression), color (predominantly dark bays), motion (stylish and showy ways of moving), and personality (people-loving with attitudes that make them easy to live with and work with). The offspring win in the show ring and in the hearts of their breeders, owners and trainers."

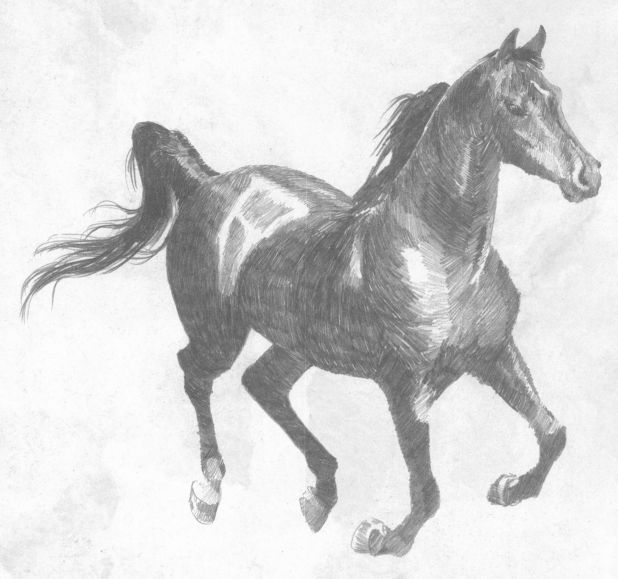

Joy Hatten has a very special bond with Mahogany, a relationship based on respect, understanding, and love. It was a pleasure to see them together, communicating in a way so admirable that I am still deeply touched by the recollection. "There's no kinder, more wonderful horse to work with," Joy told me. "He enjoys people. He greets me every morning when I walk over to his barn and of course he's always the first one fed. Mahogany spends much of his day looking out the large window of his stall, monitoring all the comings and goings of the farm. (We feel sure he'll never give up on the thought that the big brown UPS truck is bringing him mares, and he's forever hopeful.) After he's been worked, he knows I have apples and carrots for him, and he has his ways of reminding me of the treats he's due. One apple is never enough. Two to five apples are not enough. But you may be sure that whatever he wants, he gets."

Mahogany prancing across a green field starred yellow with dandelions. Mahogany, his eyes ignited by a passing mare. Mahogany, princely and proud, surveying his domain from a lime-green glade. At those moments, Shakespeare's wonderful lines seemed completely appropriate to describe the stallion in front of us:

"Look, what a horse should have he did not lack,
Save a proud rider on so proud a back."

CALEYNDAR

When I first heard of Caleyndar, I had the great desire not only to photograph him, but to know him, for he is the son of Cal-O-Bask, a stallion that was very close to me. "Caley," as both father and son are known, was owned by my great friend Patty Saccoman, and Patty's son Joe worked for years as my assistant in this country, France, Spain, and Kenya. Thus I was eager to learn if Caleyndar had the same slightly specked snow-white coat and large eyes of his sire and if he had Cal-O-Bask's character and self-esteem.

On the beach at Malibu, California, when I finally did meet Caley (the son), I found myself wondering if I were in the great outdoors or in a theater watching a new version of *The Black Stallion* now titled *The White Stallion*. For in front of us on the sand was a stallion as white as the clouds overhead. The person engaged to play with him was not actor Kelly Reno, but a young woman, Esta Bernstein, his owner. It was a true joy to watch Caley, completely free, as he ran and played with Esta along the tide line, seemingly to the same choreography between horse and human that moved so many people in Carroll Ballard's stunning film.

Esta ran and Caley ran after her. Esta feinted. Caley lunged and feinted. Esta stopped suddenly, having been engaged in a full-out sprint with Caley galloping behind her, spraying the air with sand. Esta whirled and rose up on her tiptoes while Caley reared and playfully pawed the air. This was not the usual human-horse relationship, but a bond between Esta and her white stallion that is seldom witnessed in the equine world.

One afternoon, as the sun drooped into the Pacific, flashing green as it disappeared, Esta told us how Caley came into her life: "After growing up with my father's racehorses, I found myself at age ten working as a trail guide at our local rental stables. This was not a paid job, but I could ride as often as I liked, sometimes up to twelve hours a day during the busy summer months. Family moves took us to Texas, Colorado, Connecticut, and California. In California, I was invited to join an acquaintance who was exercising an Arabian for a friend. I recalled the winning ways of the breed and knew I had to find an Arabian of my own.

"The first horse to find me was Caleyndar. Our initial encounter was magical and I knew he was 'the one.' His overwhelming presence and majesty were captivating; his gentleness and almost human intelligence, incredible. Because he was a stallion I had to make some decisions on the investment in him. I knew he would be my best friend, but was he capable of supporting himself? I did some research into the Arabian breeding business. The focus, I learned, had to be on extreme quality, not quantity. Personal visits to Caley's offspring confirmed that he, as a sire, could contribute to that focus. His disposition, movement, attitude, and conformation, as presented in his foals, resulted in numerous championships. The purchase was finalized and Caley will forever remain with me. I knew I had a stallion to rival all stallions, and Caley has since proven that through the quality of his offspring—Class A and Regional champions–who will be paving their way to National competition.

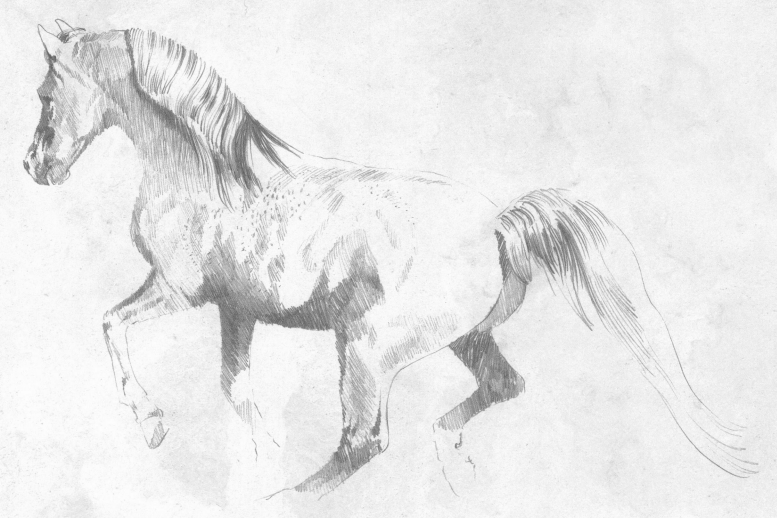

"The tales of Caley's great spirit, good cheer, and gentlemanly ways are many, but one story lets many sense his intelligence and understanding. One evening, Caley—no one knows quite how—got his braided tail caught in a metal gate, and we found him, his body distorted by the trap, in a narrow entrance to a stall. He could not be maneuvered so that he could be released. If he moved forward, the gate pulled his tail; if he moved backward, the gate hit him in his hindquarters. Caley, though frightened and upset, responded to the trainer, a relatively new person in his life. She asked him not to move, released his lead rope, and crawled between his back legs to unbraid his long, long tail. While she worked in this very vulnerable position, Caley stood quietly and gently nuzzled her, showing his trust and patience and his understanding that she was helping him out of his predicament.

"As a first-time Arabian owner, I know the special relationship I have with Caley is rare. If more owners would take the time to allow their horse's personalities and affection to emerge, the breeding business would be more selective and the cherished traits of the Arabian horse would be carefully preserved."

On our last shoot, when the sun had disappeared and the water was shimmering in coral, rose, gold, and violet iridescence, Caley trotted unusually far out into the surf where he seemed truly "a horse of the waves that even the sea might not conquer." Finally, he galloped toward shore, practically curtained by beads of golden spray. At that moment, an immense breaker crashed in a thousand platinum explosions behind him as he seemed to bring alive Roy Campbell's words and became one of "the silver runaways of Neptune's car, racing, Spray curled, like a wave before the wind."

ELESSAR

Elessar's image through my camera lens gave me the impression of having focused on a steed from a Gothic story, an impression reinforced by the blonde, blue-eyed, delicate beauty of his owner, Tiny Rubenstein. I first saw Tiny in a photograph in which she, wearing a long dress and carrying a basket of flowers, might have been the heroine from a romance novel.

Elessar I had also first seen in a photograph and, zeroing in on his abundant mane and tail playing in the wind and his handsome Morgan features, I immediately wanted to photograph him.

The days that my crew and I were at Shadowfax Farm in Upstate New York were some of the most delightful days spent doing this book. Tiny and her husband, Jeff, entertained us in their "house of windows" that commands a spectacular view from which we even experienced a summer storm in full thrust. While the storm raged outside, we learned more about Elessar and about Tiny's interest in horses.

"The motto of Shadowfax Farm—'Live the fantasy'—is embodied in Rohan Elessar—the beautiful black stallion, his wonderful mane flowing, his nostrils flared, keeping a watchful eye on his herd," Tiny told us. "I first saw him at a farm in Ohio where I bought a mare in foal to Elessar. As soon as the foal (TDR Shadowfax Nick) was born, I knew I must own his sire. By then, he'd been sold to a farm in North Carolina. At first the owners weren't interested in selling him, but several months later they changed their minds and in 1988 Elessar arrived at our farm. He'd had very little training and was extremely insecure. I decided it would not be prudent to try to make him into a show horse; rather, I would just appreciate him for what he is—a beautiful stallion. So Elessar leads a life of leisure, looking beautiful and keeping track of his mares.

"The lineage of Elessar, a 'Lippitt Morgan,' traces back to Figure, the founding sire of the Morgan breed. The Lippitts have the highest concentration of Figure's blood and their conformation, sturdiness, and versatility closely resemble those of Figure.

"I love these 'old-time' Morgans," Tiny continued, "and I breed them for the same reason that I breed Andalusians: I need a versatile sport horse, one that can do dressage, carriage-driving, fox-hunting, or trail-riding, or any other discipline that might cross my mind. I also want a beautiful horse and, most of all, a horse that can be my friend. These horses have it all, and more. A good sense of humor is essential to owning Morgans. They are so smart—they'll out-think you every time—and training them is a challenge. In daily living, they'll not only outsmart you, they'll seem to laugh at you for thinking you had outsmarted them.

"I have learned over the years to never take myself too seriously, a lesson taught to me by my Morgans. My first Morgan, Taj, was immensely talented, but he never gave me the security of knowing whether I would come out of dressage competition feeling good about my ride or cringing in embarrassment. He had a way of deflating my ego, should I start to get a little full of myself. He taught me a lot—most of all to laugh!

"The Morgans crave affection, and they always want to be the center of attention. I can't just close the barn door and walk away. They have me well trained

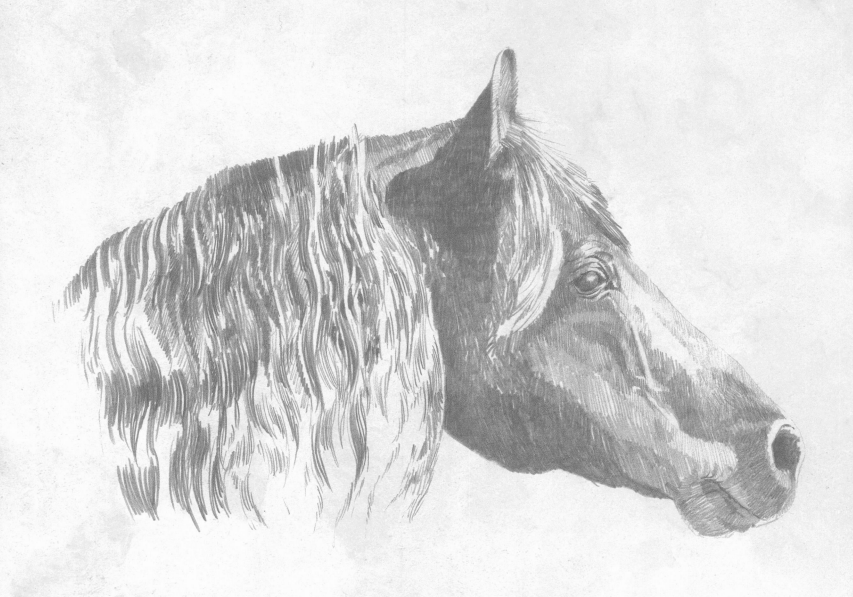

to come and visit with each one, giving each a little scratch. When a visitor comes to the barn, the horses are very vocal, demanding that the new person come to greet them.

"Live the fantasy," Tiny reiterated. "The Morgans are a part of my fantasy. Their beauty and free spirits have stolen my heart and captured my soul."

The field of spring flowers where we photographed Elessar provided a fitting setting for this proud horse whose breed had played such an important part in American history. As the black stallion galloped away, his mane lashed the heavily fragrant June air while a spray of petals, like brilliant confetti, was left in his wake. Elessar's path across the flower-filled field was as clearly marked as were the paths of other of Figure's descendants in American history. At that moment, the words of Elessar's song came on the wind and mixed with the words from the song of a legendary stallion, now deceased, that had appeared in another of my books. The two stallions' songs fused and chorused in one long trumpeting voice:

"Figure was his name. Justin Morgan was his name. Morgan horse is my name! Justin Morgan had a horse like me, Praised from Vermont to Tennessee. America had a horse like me, like me, like me. Custer had a horse like me. So did Stonewall, Sheridan, Lee. America from my muscle grew. We grew together, grew. Justin Morgan had a horse like me, like me, like me."

MARK OF FAME

Anyone who has learned how and why Leslie Marchelli acquired Mark Of Fame cannot help but be touched to the core. What can be more tragic than the loss of a small child and what could be more inspirational and moving than offering a living tribute to that child in the form of a beautiful young stallion? Mark Of Fame's story has all the elements of Greek legend.

Thus it was with special interest that I drove to Santa Ynez, California, in early March to photograph a horse whose spirit had been coupled with that of a young boy. Of less significance, Mark Of Fame was the last horse photographed for this book, in an odyssey of more than 35,000 miles on which my assistants and I had embarked in March 1994. These travels allowed us to journey to parts of my own country that had previously been foreign to me. Sevilla, Madrid, London, and Nairobi have been part of my experience for years. Prior to this book, Fort Wayne, Syracuse, Minneapolis, and Grand Rapids were so remote that it seemed that I would never know them except in word and picture. So it was that horses and good luck provided travels that are now part of the rich mosaic of my memory.

Our time with Mark Of Fame added him to a privileged list of special equine experiences. Not only is he a special horse unified with the spirit of a small boy, but he gave of himself again and again during our sessions. Apart from his own personal charisma and beauty, one could not help but have special feeling for him after hearing Leslie Marchelli's story.

"I grew up with a deep love for horses," Leslie recounts. "In Southern California, I was totally at peace as I rode alone through the meadows and streams of Fairbanks Ranch at Rancho Santa Fe, California, a property owned in part by my father.

"I truly feel fortunate, being blessed with four beautiful children, all of whom loved horses. Life seemed so perfect until disaster struck. My third child, Weston, just past three years of age, was killed in an automobile accident—the saddest day of my life. I knew life would never be quite the same without my dear little son.

"Picking up the pieces was not easy; however, I knew I must do so for the sake of my three other children, Nicole, Grant, and Clint. I felt compelled to do something special to honor Weston, and because he had a special love of nature and especially horses, I decided to create a horse business in his memory. Within a month I began a search for a special colt. I asked the very talented and accomplished trainer Mike Neal to find a colt that had all the quality, correctness, refinement, presence, and pedigree needed to be a National Champion one day and then to go on and be a great sire. A tall order, I realized, but after several months Mike found a wonderful four-month-old colt named Mark Of Fame.

"The first time I looked into the colt's eyes, I knew there was something very special, almost heavenly, about him and that I had to have him. He strutted around with his tail straight over his back, his head held high in the air, as if to say 'Look at me!' What a special day this would be in my memory. I wanted to honor Weston with greatness, and Mark Of Fame had greatness written all over his face. As a youngster, he collected many halter

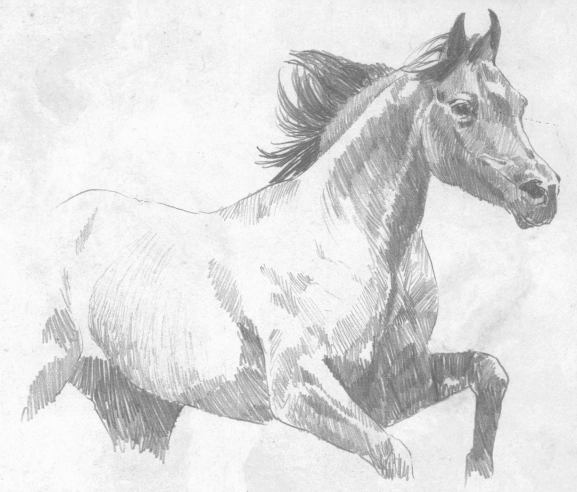

championships; then in 1994 he was named Scottsdale Top Ten Colts of 1991, Canadian National Reserve Champion Futurity Colt, and U.S. Top Ten Futurity Colt. I couldn't be happier. To top that all off, Mark Of Fame's first foal (sired when he was a two-year-old) was born—an exquisite filly named Markessa Rose. She was purchased by the accomplished equine photographer Javan Schaller.

"For 1995, Mark Of Fame has sired three exceptional foals, all of which are show quality. One is a filly out of a Nariadni daughter owned by Taylor Ranch, with an exotic head and perfect conformation. Another is Mark Of Fame's first son (out of a Negatraz daughter), and the third is a gorgeous filly, out of a Muscat granddaughter. If these four foals are an indication of Mark Of Fame's siring ability, then I feel he is going to be a great sire as well as a great show horse. For 1996, we are expecting several spectacular foals out of such great mares as Kaiyete, dam of National Champion Mare Fames Fax. Mike Neal feels Mark Of Fame will one day soon follow in the footsteps of his great sire, Fame VF, and be a National Champion Stallion.

"Weston truly loved every living thing and every living thing loved him. Children, adults, and animals were drawn to him as if he were a magnet. I am reminded of the grace of his spirit each day through the beauty and spirit of Mark Of Fame. I believe God bestows some special gifts, and I feel that Mark Of Fame was such a gift to me."

Mark Of Fame—what a fitting, filling, and fortunate way to end the photography section of this book. The fields of Santa Ynez were rich in green because of the unusually heavy rains this year. Against the lush background, as if flung joyously from an inspired painter's palette, were the vibrant gold splashes of California poppies, the purple of lupine, and the yellow of sprays of dainty wild mustard. With Mark Of Fame the protagonist of this scene, it appeared that Nature had distilled all the elements of spring and rebirth into the glorious panorama before us. It was then not too difficult to imagine, as the young stallion lunged and trotted and spun and cantered and jumped, that the spirit of a boy, joying in the freedom of play, was somehow directing his every movement.

NEGATRAZ

Negatraz I had appreciated and admired in photographs long before I was honored with his actual presence. This delicately refined stallion, son of the great Bask, I had come to know over the years through equine magazines sent to me in Spain. As much as I was attracted to the Andalusian horse at that time, with its wide chest, long Velázquez face, and thick neck, I found of equal appeal—at the other end of the equine spectrum—the refined beauty of the Arabian horse. Much of that beauty seemed to be captured in each of the photographic images I saw of Negatraz.

Some years later when I met Loyal McMillan who, with her husband, Jack, is the owner of Meadow Wood Farms at Snohomish, Washington, and of Negatraz, I found a kindred spirit, for Loyal loves not only horses but all animals. Though I knew that the McMillans also raised llamas, nothing could have prepared me for the vast number and variety of animals that graze the green, green pastures of Meadow Wood Farms. As we drove through the ranch gates, I almost felt we were entering the Serengeti in terms of the numbers of animals that appeared along the roadside. There were over four hundred llamas. There were camels and zebras and miniature donkeys and kangaroos. If Dr. Doolittle had stepped out from behind a tree, I would not have been surprised. But the pride of Meadow Wood is its Polish Arabians and the star of the farm is, without a doubt, Negatraz.

Negatraz came to Meadow Wood in December 1989—a special Christmas gift from Jack to Loyal—to become the farm's senior sire. He has carried off the assignment well, bringing the influence of the Ofir sire line (through his sire Bask) to the superb Polish mares there. Negatraz first stood at stud at Patterson Arabians, Sisters, Oregon, where he was bred, and now has five Meadow Wood foal crops on the ground. At age 24, he looks and acts like a horse half his age, always portraying the Bask look and motion as beautifully blended with the refinement and beauty of his dam Negotka, she of the Skowronek sire line.

Although Negatraz had only a brief career in halter showing (including a championship in the Ohio State Futurity), his sons and daughters add to his sire recognition with each show season. At the National level, Negatraz claims twenty-plus National winners, both halter and performance. In volume, more than five hundred foals are registered to him, making him one of the most significant sires in the breed.

"Negatraz sires a great deal of beauty, particularly in the eyes and ears, and he transmits an excellent topline, along with a wonderful disposition," says Loyal McMillan. "Beyond all his achievements as a superstar of the breed, Negatraz is a very special companion animal to Jack and me. He came from such a loving home and is very affectionate. He responds so much to our caring, and that's important to us. Even if he weren't beautiful and a superb sire, we would still love him." Happily he is all that and more.

Gail Deuel, the manager of Meadow Wood Farms, and I discovered that we have a remote Spanish connection. Almost twenty-five years before our meeting, Gail's daughter Natalie had received one of my children's books from her grandmother, then living in Sevilla. As I was impressed by the physical beauty of Meadow Wood, I was also impressed by Gail Deuel

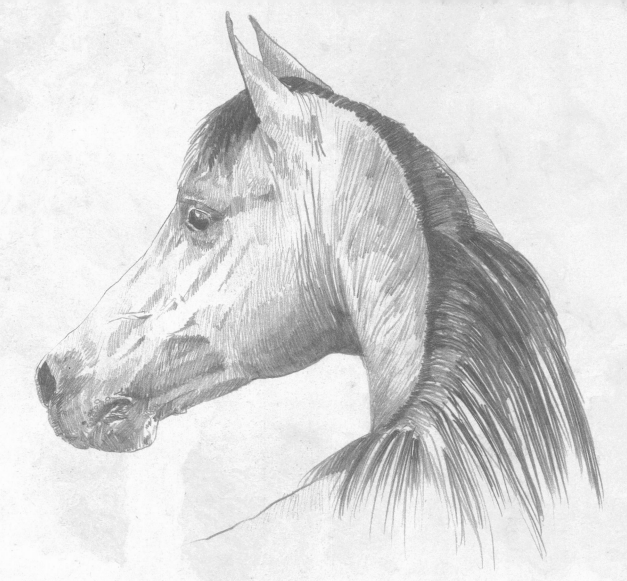

as an equine professional who also sports a keen sense of humor.

"Negatraz is a very easy horse to work with," Gail notes. "He loves showing off for guests, often not allowing himself to be caught until he's sure that everyone has had a good look."

Negatraz has always made the world look, and keep on looking, since he was foaled February 2, 1971, on the Ohio farm of Dick and Kay Patterson. The bay colt, marked almost exactly like Bask, was the result of long and careful planning. After the Patterson mare Negotka was Reserve Champion Mare at Scottsdale in 1970, she was booked to Bask, then already well on his way to becoming one of the most influential Arabian stallions in modern history. Bask was noted as 1964 U.S. National Champion Stallion, 1965 U.S. National Champion Park and 1967 U.S. National Reserve Champion Formal Driving and

Formal Combination. This newly foaled son of Bask (who would add much to Bask's already evident significance as a breeding stallion) was bold and showy and full of himself as soon as he could stand. The Pattersons realized that their long and careful planning of his breeding had paid off, and they named him after his his eminent grandsires, Witraz and Negatiw.

When Negatraz came to Meadow Wood, Elke Koehn, in whose care he had been for years, accompanied him to Washington and stayed on with him at the McMillans' farm. It was touching to see this grand old stallion surrounded by such love and care and to know that he is still passing on his Polish beauty to the Arabian foal crop of 1996 . With what pride those colts and fillies can claim their heritage—grandget of Bask and, as if that weren't enough, sired by the dream-like and legendary Negatraz.

241

BRAVO

You'll really like him," my friend and Andalusian authority Holly Van Borst told me of Bravo. "He'll remind you of the Terry horses, the true Carthusians." "Terry" is the most prestigious name among breeders of Andalusian horses in Spain, and the Carthusian monks nurtured and preserved the purest strain of these animals. When I first saw Bravo at the Andalusian Nationals in 1991 at Fort Worth, I was indeed reminded of the Terry stallions that I had spent considerable time with on the beach at Puerto de Santa Mariá when I was working on the book *Equus*.

Just as pleasing as that connection between Bravo and some of my favorite stallions from the past was meeting his owners, Ed and Donna Klopfer. The Klopfers are enamored of Andalusian horses and Spanish tradition, and Bravo is clearly the focus of most of their attention and equine conversation.

Years after that first meeting, I would spend delightful days with Ed and Donna and Bravo at their Rancho Vistoso while I was doing the photographs for this book. Their natural and spacious Santa Fe-style home with its large windows offered views so majestic that I was immediately reminded of the views from my tent in East Africa. The Klopfers' home was the setting for many over-lunch conversations about the Spanish horses that mean so much to them and to me.

From the Klopfers I learned that Bravo, son of the legendary Legionario III, Grand Champion of Spain in 1965, has a threefold job description at the ranch. First of all, he is a breeding stallion; he and the Rancho Vistoso mares have produced impressive offspring. Second, he's a public relations horse, helping to promote the Andalusian breed in New Mexico and, third, he's Ed's special friend.

"Bravo is the kind of horse that comes along once in a lifetime," Ed related. "He has a real presence and, whether he is in the dressage ring, in the Tournament of Roses Parade, or putting on a demonstration at the Volvo World Cup, he demands the attention of everyone. People do not forget him. In the show ring his handsome appearance and his movements always create a stir. He is intelligent, mischievous, graceful, and extremely athletic. He loves to show off, and occasionally has a mind of his own. Riding him is always fun and often a challenge.

"Donna and I bought Bravo in 1979," Ed continued. "He was a star performer then, having been trained to fourth level dressage, and we kept him on the show circuit. Even competing against the Warmbloods (who dominate dressage today), he scored high enough to be invited to the USDF Nationals. Bravo's training and ability prompted me to begin dressage lessons and my skills have improved considerably. I owe this to Bravo.

"In the future, we'll focus on freestyle riding to music at shows. Bravo is at his best when he's allowed to 'ham it up' with flying changes, half-passes, and passage. Bravo is my pal and my teacher. No one could want more in a horse!"

When I photographed Bravo in October, the chamisa brush was in bloom in New Mexico, and it provided a brilliant setting against which to photograph this white Andalusian of the flashing mane and tail, a sight that caused Ed Klopfer's

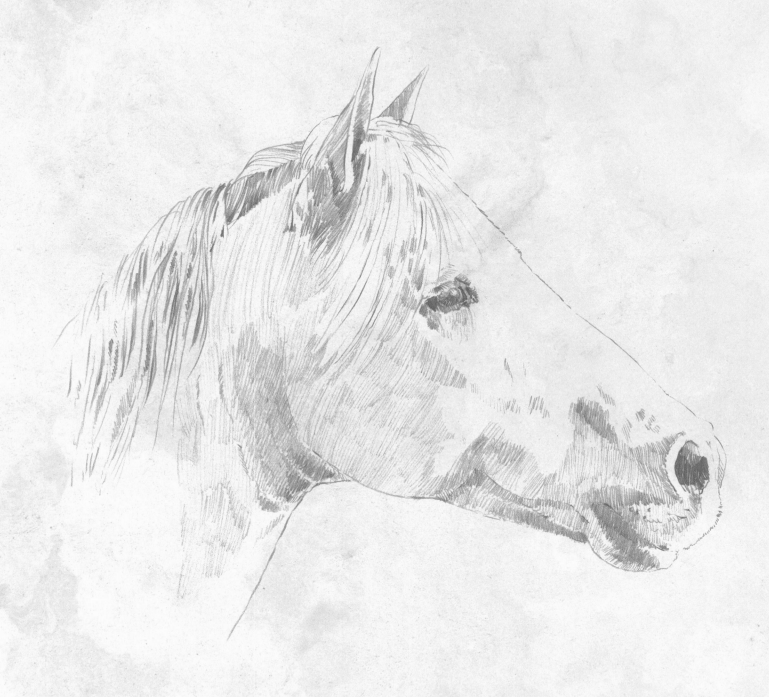

normally sparkling eyes to sparkle even brighter. He and Donna have joined friends who have special places in my heart, friends who have fortunately crossed my path because of horses like Bravo. I will never be able to think of this white Andalusian stallion, so proudly full of himself, without remembering the last stanza of his song which appears in this book:

"In this snowy porcelain form, You find me timid and courageous, docile and ungovernable, hotheaded and phlegmatic, teachable and obtuse. Soy el caballo Andaluz."

PRINCE CHARMMING

Prince Charmming's color alone attracted my attention for I had never photographed a horse with his particularly striking attributes—a rich chocolate-bronze body set off by flaxen mane and tail. But in all honesty, his classic Egyptian beauty alone would have caused me to attempt to bring him together with my camera.

If charm(m)ing is part of her horse's name, it could also apply to Joy Gildersleeve. Our time at Five Oaks Farm included some of the most fun-filled days spent on this book. And if I were to think of the dream production team, it would include Joy's husband, Bill Hinson, and her father, Ben. Also, my visit to Five Oaks had special meaning that was rooted in childhood. In those wonderfully innocent and pure times before television, The Great Gildersleeve was one of my family's favorite radio shows. To meet a "jolly" family of the same name provided me almost as big a thrill as when in a diner in rural Pennsylvania James Michener introduced me to the man who had invented Monopoly, or later when I met the person who had come up with the idea for that orange and vanilla delight, the 50/50 ice cream bar.

Prince Charmming epitomizes the Egyptian type that finds an audience in any eyes of aesthetic sensitivity. And the fact that he passes his color on to his get makes him a sought-after stallion for those who seek the equine exotic.

Over one of the many meals that Joy's mother, LaVelle, prepared for us, we heard how the charmed Egyptian prince came to Five Oaks Farm. "I don't think I'll ever forget the night I first actually saw Prince Charmming," Joy recalled for us. "My husband Bill and I waited for the van that was bringing the stallion cross-country to us. There is always some sense of anticipation whenever a new horse is coming in, but this evening I was particularly curious. Two days prior, the owner of the transport company had called to let us know that Prince was traveling well. Then he asked, 'Lady, have you seen this horse in person yet?' When I replied that I had not, he said, 'Well, I have to tell you he is absolutely gorgeous!' Good news to me, as I figured that this gentleman had probably seen about a zillion horses in his line of work.

"When the van finally arrived, I rushed out to peek in the small side window. The light was dim, but I could see part of Prince's neck—polished ebony with an overlay of ivory. I thought perhaps my eyes were playing tricks on me at that late hour; he could not possibly be that dark and yet have such a light mane and tail. But he was. Now out of the trailer standing in front of me loudly announcing his arrival was one of the most exotic and regal horses I had ever seen. I turned to Bill and noted that the horse seemed to regard himself as 'King' Charmming. And I quietly noted to myself that childhood fantasies can come true.

"As I was growing up, books were my main means of indulging myself in my passion for horses, including one book that described a dark-bodied horse with a silver mane and tail. Thoughts of the way this horse might look were so intriguing that the image was indelibly imprinted on my mind. For years I felt that such a beauty probably existed only in books or in my imagination, but in the 1970s I finally saw a dark liver

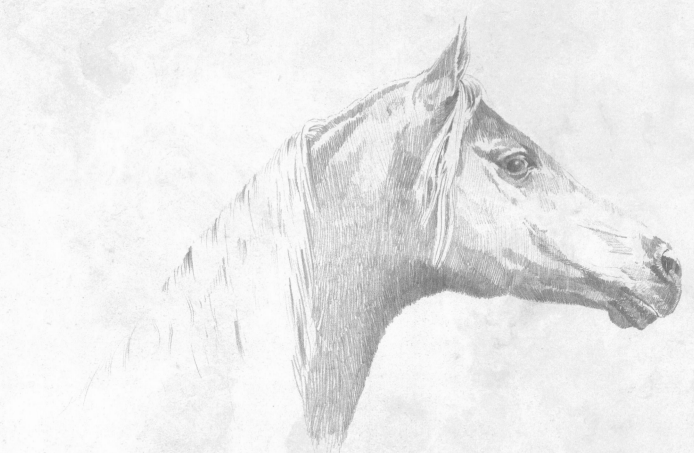

Arabian stallion with a light flaxen mane and tail. A rare color combination I learned, but I somehow knew I was destined to own one.

"Some years later, when my husband and I decided to develop an Arabian breeding program, we knew we wanted pretty heads, proper conformation, and the characteristic Arabian carriage and charisma. Quality, rather than quantity, became most important to us. We also knew our program should have a focus that would make it unique. I recalled the visual appeal of the dark liver/flaxen Arabians I had seen, and we embarked on a search for breeding stock. After some experimentation with a number of stallions, we felt we had to ensure the coloring (along with other desirable qualities we wanted) through owning a stallion prepotent for his coloring. Through my searches, I learned of Prince Charmming, a straight Egyptian stallion living the good life on the West Coast with a couple who lovingly cared for him. Transfer to our ownership was not immediate. Several years later, when Prince was made available to us, we still had seen him only on videotape, and we were not fully prepared for the impact of viewing him in person.

"Of all the dark liver/flaxen horses I have known, Prince has the greatest color contrast. Also, he is a well-made horse with fine features, large expressive eyes, good conformation, and a tractable disposition. Fortunately, he has some prepotency for these traits, and he has sired excellent foals, some of which are champions. His unique look is a magnet that constantly attracts people to Five Oaks, and each day he reminds us of the Spanish proverb: 'A horse is worth more than riches.'"

One evening as I watched Prince Charmming pronk and posture against a landscape of tall back-lit grass, behind which kudzu vines frosted green even the highest reaches of the forest, it did not take much imagination to transport oneself from South Carolina to the faraway banks of the Nile. There the same kind of Egyptian beauty had dazzled pharaohs and stirred artists to preserve it inside those great triangles of stone—those monuments to Egypt—that are justifiably listed among the wonders of the world. Prince Charmming is a living monument to all that is desirable in the stallions of the Nile, a beauty that is so traditionally Egyptian that it seems to have stepped out of a museum.

FRANS

I was unfamiliar enough with Friesian horses to have questioned if one would fit into the fabric of this book. In hindsight, what a mistake it would have been to have finished these pages without the presence of Frans. Perhaps one of the most powerful images to come from half a lifetime of photographing equines is the one of Frans on page 161 of this book. If I were to envision a black unicorn, it would have to be this horse with a dark mother-of-pearl horn on his head, set off by his bold midnight beauty.

Frans and his owners, Carolyn and Johnny Sharp of Midnight Valley Farms at Fort Collins, Colorado, provided me with the opportunity that I have always desired but had not been able to fulfill: to photograph a black horse against a background of snow. Even though black on white touched my imagination and the combination of an ebony stallion and snow would have been striking on its own, nothing could have prepared me for the true magnificence of Frans, the stereotype of all the romantic and massive horses of medieval times and legend. What knight, astride such a splendid mount, could fail to save his fair lady? If Frans's physical appearance weren't enough, here was a horse who seemed almost trained for the camera. Actually, I had first been introduced to Friesians, as have many other moviegoers, with the film *Ladyhawke*.

Over hot tea and brownies at Carolyn's dining-room table, she told my assistants and me of her quest for the outstanding features she had found in Frans.

"We became interested in breeding Friesians in 1987 and began searching for a breeding stallion," Carolyn related. "The Dutch registry *Het Friese Paard Stamboek* is the only worldwide registry for purebred Friesian horses; only fifty-six qualified stallions are recognized, eleven of which are in North America. Our search seemed futile, but one day in 1988 we received a call from a friend saying that a stallion in Holland was for sale. Not even knowing which stallion, we flew to Holland to see the prospect. Frans was the most beautiful horse we had ever seen, a horse of presence and power, spirit, and a lovely, cheerful personality. We were enchanted by him—and by his owner, Auke Frankena—and decided we couldn't live without him. He arrived at our farm two days before Christmas—the most wonderful Christmas present ever!

"We feel so blessed to have Frans in our lives and as the sire of the foals we are breeding. We have a lovely band of *ster* mares (only twenty-five percent of the mares reach the level), and our foals carry the unmistakable stamp of their sire—a beautiful head, lovely action, and the most incredible personality.

"We show our Friesians in harness and under saddle, our main goal being to produce extraordinary dressage horses. Frans is very competitive in dressage and his offspring are following in his footsteps. We want to breed horses that rival the quality of the Dutch Friesians—Friesians the Dutch would want in their own barns, horses that are valuable additions to anyone's breeding or show barn, as well as treasured family companions.

"Frans is the most lovable horse in the world. Even though he is a breeding stallion, he is very gentle, patient, and kind. He can be playful and a hardheaded Dutchman at times, but he never loses his sense of humor. He's tolerant and quick to forgive and

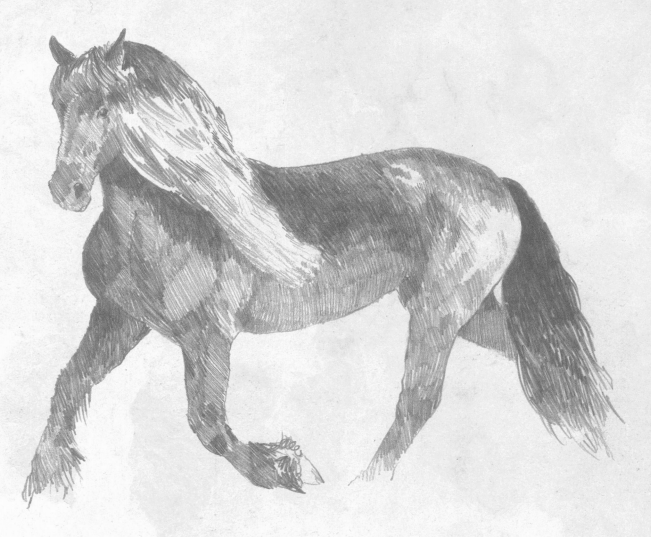

has shown us much about strength and dignity. He moves with the grace and natural rhythm characteristic of the Friesian breed, his thick mane, tail, and feathers accentuating his motion. Our lives would be less than complete without him."

In my years of photography, I have avoided using artificial light. However, since Frans is such a mystically magical horse, I had the idea, apart from portraying him running free through fields of snow, of trying a studio setup with him, using fog machines and tungsten lamps. We worked very hard on that daylong photographic session. A background was created and two highly professional studio technicians were brought in especially for the event. During the long hours of the shoot, Frans behaved like a super model, barely shifting his imposing body within the restrictive confines of the set. He allowed the lights and reflectors and gels to be placed inches from his face and stood completely still while a hose hanging from the ceiling clouded him in fog.

So much effort and patience went into that shoot that, even with my aversion to the use of artificial light, I thought that it might work. But work it did not. The images that came from the shoot were attractive but appeared slick and unnatural when compared with the pictures of Frans galloping or standing still, lit by the natural light of midday or by the orange glow of sunset. After the studio attempt, we watched Frans behave as horses have naturally behaved since the beginning of time, galloping against a background planned and created by nature. This experience confirmed feelings that have been with me beyond memory and which served as the title of one of my books: I love nature more.

TSHOCKWAVE

There are beautiful horses and there are beautiful horses, just as there are beautiful humans and there are beautiful humans. And while physical beauty in either may cause passersby to stop and stare, there is some mysterious element that makes some kinds of beauty more photogenic than others, so much so that what is appealing to the eye becomes even more so on film. The most photogenic human I have ever photographed is Bo Derek. No matter where the camera was—angle had no priority—her beauty remained constant. And not only did the beauty remain constant through the lens, but that same allure was evident on film. If Bo is the ultimate photogenic human, Ivanhoe Tshockwave is an equine counterpart.

What a delight it was to follow his movements through a pasture of green-going-to-yellow seedheads in a Minnesota setting. Tshockwave has that special quality, that innate ability to stop in just the right place, hold the pose for exactly the right amount of time, and angle his flights through the field so that he always showed just enough of himself to the camera. In truth, he was the photographer's dream. And he is such a proud horse. Several of the images in this book capture him as he seemed to lance a whinny not only to our immediate surroundings, but to the entire world, announcing the presence of a stallion who, even without a voice, could not escape notice.

Owner Pat Kennedy's involvement with Tshockwave is inter-generational in nature. She told me this story: "After I returned from the 1993 U.S. Nationals at Albuquerque, I reflected on the wins of the offspring of VS Blue Danube, a stallion I had the good fortune to own since the early 1980s. My first look at Blue Danube's gorgeous head and his huge dark luminous eyes and I was completely taken by an unknown horse. He had taken possession of my heart. I had to own him and eventually did. In the joy of ownership, I made grand plans to show him at the U.S. Nationals that year."

Pat Kennedy's dream did not become reality, for Blue Danube was stricken by an extreme case of founder. However, through the expertise of Burney Chapman, a farrier who specializes in the development of special shoes for founder victims, along with Pat's tenacity and Blue Danube's indomitable spirit and heart, the stallion survived. The condition meant his show career was over and that he would have to make his name in the breed through his offspring. This he did at Steeplechase Arabians, Barrington, Illinois.

"In 1993, I recalled the pride of watching the Blue Danube sons and daughters winning at Albuquerque—three of them Top Tens in halter. A few months earlier, at the Canadian Nationals, one of his offspring won two National Championships," Pat continued. "After all the suffering Blue Danube and I endured together, he finally received special recognition as a sire. After his death, I could only wish he were still alive, so I could continue breeding horses of his quality. If I could just have a Blue Danube son, I thought—one that could take his place, one who possessed his kindness, beauty, personality, star quality, correctness, athletic ability, and, most important, an attitude and a willingness to please.

"My reveries were interrupted by the ringing of the phone. As if I had tuned in to someone else's thoughts, I heard a voice say, `You don't know me, but

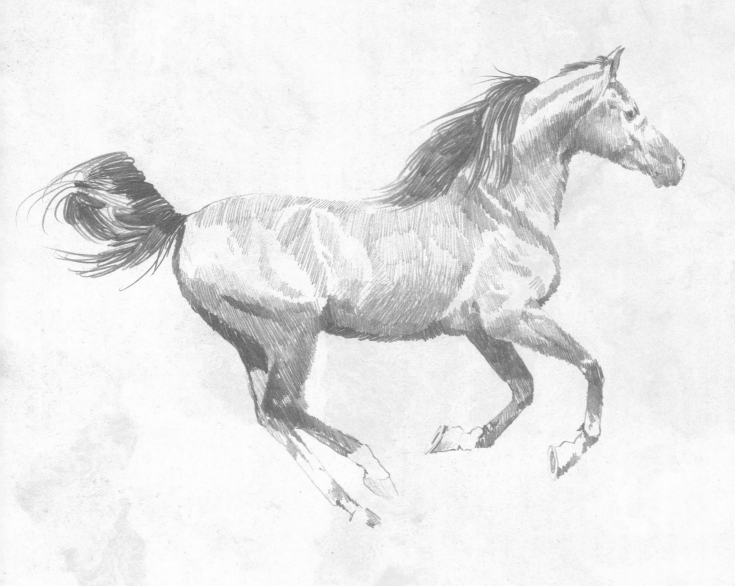

I have a five-year-old son of Blue Danube that I am considering selling.' Burney Mulder of Hawk View Farms had acquired Tshockwave as a yearling. No, he had not been gelded. Yes, he was bay, big, and beautiful. I had to see for myself. I drove to Michigan the very next day. The moment I saw Tshockwave, I knew I was going to own him. And I did.

"Tshockwave had never been used for breeding, so I knew I would have the pleasure of seeing his very first foal. So here I am, starting all over again with a new stallion, hoping he will fulfill the legacy passed on to him from his sire and my friend VS Blue Danube."

While the cameras were being stored after the last shoot with Tshockwave, I turned toward the field where he still stood. Shade patterns cast from leaves overhead dappled his coat in circles of red-gold, brilliant metallic flashes that could as easily have come from a treasure chest, the spoils of a sultan's dream. Oh, how Munnings or Stubbs or Sorolla would have loved to have painted you, Ivanhoe Tshockwave.

PADRONS PSYCHE

Opulence is what I think of when I envision Padrons Psyche, for his eyes are of the deepest onyx and his coat is as brilliant as are the most treasured metals of the world. To be able to photograph him against a backdrop of Indian-summer leaves that lent even more richness to his presence was indeed a treat.

Joe and Cathy Zehr, Psyche's owners, I had first met in Scottsdale, Arizona, at the all-Arabian show, where we soon learned that aside from horses, we share other interests. Since I am forever between Africa, Europe, and North America, I consider myself part Gypsy. (Actually I once spent much of several years traveling with a band of Hungarian circus Gypsies in Spain.) And because of the time the Zehrs spend on the road, I felt they must share my supposed Romany blood.

Although I had written about Psyche in one of my recent books, I had never seen him "in the flesh," so as the plane neared Fort Wayne, Indiana, I was eager to make the firsthand acquaintance of this popular Arabian stallion. His name alone intrigued me. Psyche—what exotically mysterious equine awaited us somewhere in the blazing red, yellow, and orange landscape that grew closer as the aircraft descended?

During the time I photographed each horse in this book, at least one evening was spent with the owners of the animals that prance these pages. So when I had a meal with Joe and Cathy Zehr—apart from helping them plan a safari to East Africa—I wanted to learn more about the stallion who now dominates so much of their lives: Padrons Psyche.

"Our introduction to Arabians and our meeting Psyche occurred at an Arabian horse event in 1991," Joe told me. "We just couldn't stop looking at Psyche, I remember. His natural charisma and beauty and the way he affected the many people at the event impressed Cathy and me. Later, as we watched his offspring bring in win after win, we realized that here was a young stallion that began to prove himself as a sire at age three or four. By age three, he'd already shown the world the stuff he himself was made of by going 1991 U.S. National Reserve Champion Stallion, one of only three three-year-olds to be so honored in the history of U.S. Nationals."

Early in 1994, when Psyche became available, the Zehrs bought him and a fifteen-acre farm which they named La Cabreah Arabians near Fort Wayne. They already owned quality Arabian mares, so they had the basic starter set for an Arabian breeding program. An international venture, as it turned out. Cathy and Joe's first effort in expanding the Psyche sphere of influence was that of working with European and Brazilian agencies to handle frozen semen in those countries. Later, they attended European and Australian shows, using those events as promotional efforts for Psyche. In Europe, they leased seven top mares, established them on a farm in Holland, and bred them to Psyche via frozen semen as a further effort to capitalize on the European interest in Psyche.

In pedigree, Psyche encompasses a wide range of countries of origin. His sire Padron (Scottsdale Champion Stallion and Canadian and U.S. National Champion Stallion) was bred in Holland, sired by Patron, a stallion of Egyptian, Polish, and Crabbet lines who was bred at Tersk Stud in the former USSR, and he is out of a mare bred in Belgium of mostly Crabbet lines. Psyche's dam Kilika traces to Tersk bloodlines with Polish and Egyptian overtones.

"At home, Psyche relates well to all those around him and is especially gentle and understanding of a one-year-old who loves to pet him," Cathy related. "Yet

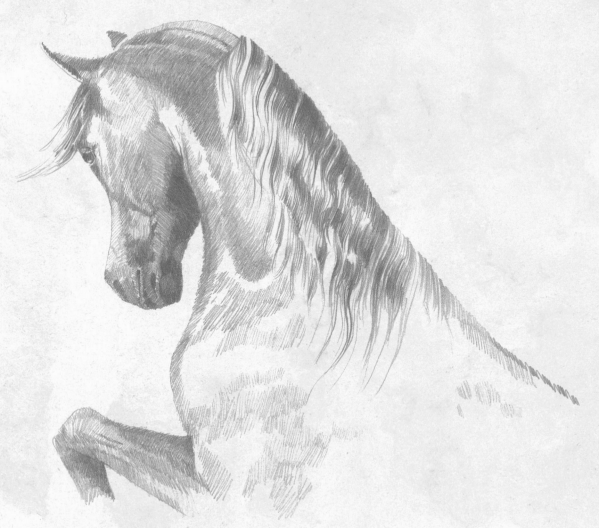

when he wants his meals or his carrot treat, he's insistent in letting us know what he believes to be his due."

"Within twenty-four hours of moving into his new stall here at the farm, Psyche had us trained to the idea that he's due a carrot each time we walk by his window," Joe added. "At a party during the 1994 Scottsdale show, Psyche showed his ability to respond to any situation. He carefully threaded his way through a crowd of people, many of whom were petting him and loving him, and he was all gentleness. But once he got into the presentation ring, he was up on his hind legs and showing the world all the presence and charisma we associate with Arabian stallions. A changed personality within a few moments."

Ten Psyche sons and daughters competed at the 1995 Scottsdale All- Arabian Show, presenting a constant display of the prepotency of their sire.

Psyche's son GA Hal Psyche captured two of the show's highest honors—Reserve Senior Champion Stallion and Reserve Grand Champion Stallion—and others placed in the demanding competition for which Scottsdale is known in the show world.

During the last evening I spent photographing Psyche, there came a moment in which, to me, he lived up to his name. Far off, a grey stallion, distant but visible, called. Psyche listened, stopped before a curtain of fall leaves set aflame by the setting sun, and stared toward the rival stallion. And for an instant the sun ignited his eyes so that from their seemingly immense darkness shone two fiery, almost fluorescent, spheres, as bright as a lion's eyes as they collect reflected light in the African night. Fortunately, those images were caught on film, though there was not space to use them in this book. They do prove, however, that the mysteriously beautiful animal that is momentarily captured in them is worthy of his name.

BAREXI

If ever there was a stallion of a dream, it is Barexi. Few times in the past thirty years have I focused my camera on a stallion that is a composite of all the romantic beauty of the Arabian horse. I only wish that Barexi had been around for Alec Guinness to ride in his role as Prince Feisal in the film *Lawrence of Arabia*.

As I photographed this truly fairy tale-like stallion in a setting of red volcanic sand, it did not take much imagination to transport my mind from Santa Fe to Petra, where this proud horse of the desert would have been carved into the red stone as a way of preserving his magnificence.

An evening spent at the home of Sally Rodgers and Max Coll let me feel totally at home, as we enjoyed a Mexican meal while sitting on a floor covered by Oriental cushions in a spacious room of natural wood decorated with Native American rugs and artifacts. Presiding over this colorful scene, Sally sat in a chair covered with an exotic fabric. Dozing in her lap was her Vietnamese potbellied pig, Abner, who reminded me of one of the warthogs rooting around the tents at Peter Beard's Hog Ranch near Nairobi.

"I can't remember the first time I rode a horse any more than I can remember my first steps or my first words," Sally began the story of her life with horses. "Childhood summers on the family ranch in Oklahoma meant being surrounded by every possible kind of farm animal. And horses. These were working horses and the ranch rule was a simple one for adults too busy with farm work for riding lessons, but a frustrating rule for a horse-happy little girl: If you can catch it, bridle it, and get on its back, you can ride it. Before I was big enough to catch a horse, however, I had to make do with my first solo mount—an extremely patient dairy cow. With her help, I was able to corral and catch the first in a long line of teachers—teachers who taught me some of the greatest lessons horses teach people: patience, how to communicate without words, patience, how to pay attention, patience, how to truly listen. But especially honesty—what honesty really is and the value of its practice—a value that has nothing to do with human economics. And patience.

"Like many of my generation, I first came to know Arabians through books. The first picture, the first descriptions were enough for me to know that the Arabian would someday be an important part of my life. I virtually memorized the Arabian horse magazines of the 1960s and will never forget the early photos of the Polish stallion Bask. Even in black and white photos, I could sense him as an individual and that sense became an ideal. I dreamed that one day I would own an Arabian stallion who could tell me, by his look, who he was.

"For the next twenty years or so, I bred my mares to stallions that I hoped would help to create my own special Arabian—until I came to the conclusion that it made sense to buy my own stallion. A very big step and a very scary commitment. Because I am a compulsive sort, the search was long—from small backyard farms to the big farms of the day—always looking for something I couldn't quite describe, but knowing that I'd recognize the right one. At Nichols-DeLongpré Arabians in California, Don DeLongpré brought out an unshown, untried—even unadvertised—three-year-old colt named Barexi.

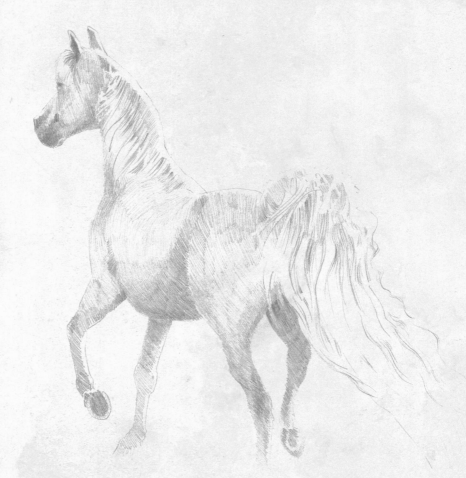

A lack of record in the show ring and breeding shed didn't recommend a major financial and breeding commitment. But then I saw him explode in a quite small viewing area, his neck arching, tail flowing, and showing an amazing amount of motion in a small space. When the stimulation stopped, he became quiet and attentive. His ability to turn on and turn off told me a lot about who he was. And his beauty—just drop-dead gorgeous. This could be the one. But still, coming from a background where a beautiful horse wasn't worth his grain if he wasn't also a useful companion and partner, I had to be sure Barexi's mind and heart matched his flawless exterior. I walked by his stall for one last look before I left the farm, and in that moment, he owned me.

"Years later, it's gratifying beyond my original fantasy to walk the barn aisle and see the faces of his sons and daughters as they turn to me, all wearing that same kind, trusting look that says, `What shall we do today?' He gives all his foals his sweetness, his willingness to be a partner.

"A disfiguring injury ended Barexi's show career, a career marked by halter championships, so Barexi had to prove himself as a breeding stallion the hard way—through his Sun Mountain-bred foals. And there he has excelled: Every one that we have bred is a champion in both halter and performance.

"Santa Fe, Barexi's home, is in an ancient land and is called `the city different.' It is fitting, after all, that Barexi, a horse of ancient lineage, lives in an ancient land and has come to be known as `the Santa Fe stallion.' Even though Barexi's story has a lot of real-life tragedy in it, his enduring spirit has written the happy ending. And when he puts his head close to mine and we share each other's breath, I know that Barexi is my horse of a lifetime in a lifetime of horses."

As Barexi dashed forward, his tail trailing him like a stream of desert clouds, or pirouetted, or stopped to listen or to breathe messages carried on the wind—messages intelligible to his ears and nostrils, but too remote for our human sensors—my camera captured him in poses that lacked only a lion to make him the subject of Delacroix's series of paintings in which an African cat and a white stallion are the protagonists. Barexi's image truly demonstrates that "a thing of beauty is a joy forever."

ACKNOWLEDGEMENTS

If I were asked to list the number of books that Rick Fabares and I have done together, I would be stuck for an answer. It simply seems that we have always been together for the final production stages of book after

book after book. Perhaps Rick's creative efforts with these projects are so indispensable, I can't imagine how any of my books would have been done without him.

Almost twenty years ago when I first started doing photographic coffee-table books, I naively sent the original 35mm transparencies to the color separators. It was then that Rick Fabares came into my life, for I realized how irresponsible it was to let original transparencies out of a bank vault. The problem, however, was to find someone who could make 4x5 duplicate transparencies which, when used for color separations, would be indistinguishable from the original 35mm film.

Anyway, Rick not only made perfect duplicates from my originals but he added his own personal artistic sensitivity to the reproduction of those images. Rick had originally been a graphic artist, and fortunately his creativity benefited my work — or I should say "our" work. Not satisfied with a first result, Rick usually goes through time-consuming multiple proof processes before he produces an image that satisfies his very critical, artistic eye.

Without Rick's presence in my personal and professional life, I would experience a considerable vacuum. Rick's wife, Becky, and his children, Sanders, Jade, and Hannah have also enlightened my existence. And even if I haven't seen Rick in weeks, I know I can hear his voice whenever I'm in San Diego by simply waiting until Friday and tuning in to his late-night radio jazz show when he changes film and enlarger for tapes and a microphone to become Rick Fabares, disk jockey. But no matter where I am or where Rick is, he is one of my few really close and loyal friends and for that I will always be grateful.

Years ago Kent Rump, who by training and desire is a graphic designer, had to turn me down when I asked him to assist on a photographic shoot. He had a full-time job and was unable to help me photograph a black girl with a cheetah for my cat book.

However, when it came time to start work on this book, Kent was fortunately free, and he accompanied me for over a year while "the horses of the sun" were photographed. Without Kent's sense of responsibility, his attention to every detail, his creative eye, and his straight forward nature, there is no way that I would have accomplished the artistic goals that I had set for these pages. Each time I look at this book, I am grateful for the past year and a half that Kent and I have worked together.

Indirectly, because of James Michener, Roger Bansemer's splendidly perceptive drawings are found in this book. Jim had invited Roger and me to speak at a seminar at his creative writing program for graduate students at the University of Texas at Austin. I was immediately impressed upon seeing Roger's drawings and paintings on display there in his books, *Southern Shores*, *At Waters Edge* and *The Art of Hot Air Ballooning*. I also noted that Roger's work had received high critical acclaim from Walter Cronkite, from *Good Morning America*, and from Malcolm Forbes.

Though this is the first time Roger has drawn equines, the reader can easily see that his highly sensitive and talented eyes are capable of rendering horse images as fine as any done with pencil on paper. On the computer Roger also generously worked long hours inputting the text for this book, and I hope that it won't be too long before I can make my first visit to his studio at 2352 Alligator Creek Lane in Clearwater, Florida.

Gemma Giannini was recommended to me by my good friend Mary Daniels. Ten of the horses in this book were photographed with Gemma's assistance. Certainly our travels were made entertaining and less stressful because of Gemma's sense of fun and her concern for her friends. When I reflect on the past year, those memories are made more pleasant because of Gemma's presence in them.

Janey Parkinson is not only a fine writer and editor but one of my most positive, loyal, and supportive friends. Janey's advice has always been sound, her sense of humor is an unfailing source of happiness, and her company at Osaka Joe's Restaurant, followed by a trip to the Yogurt Mill, would be missed very much if I were not privileged with it. Let it be enough to say that like our late friend Deedie Wrigley Hancock, Janey is an endangered species, for she is a lady in every sense of the word.

Valerie Hemingway has been of immeasurable assistance with this project. Her advice, editing, encouragement, and the history of the Andalusian horse that she has provided for these pages will contribute to any success that this book might enjoy. To Valerie I will always be grateful.

Paul Blackwell lent his photographic expertise to this project and joined me on three shoots, and he has my thanks, as does Pete West, who also accompanied me as an assistant. We could not have accomplished the section of this book that was shot on the sands and in the waters of the Pacific Ocean, had it not been for the immeasurable effort that was made by Jay Vavra and Wes Toller.

Bonita Walker I thank for having typed much of this manuscript. My good friend John Dixon has contributed his talent to this book as he has done with so many of my other projects. Denise Hearst, Lynn Wright, and Nancy Walton have my gratitude for their sound advice. At Award Photo Imaging we counted on the help of Mike Scalon and Adam Dudek. Jimmy Chiarella and Digital Imaging of Southern California also contributed to important technical aspects of this project. In San Diego, I would like to thank Chroma-color for processing my film, and Graphic Media and Elsa Mellor for outputting the text for these pages.

The film that was used for the images in this book was mostly Ektachrome 400ASA pushed one stop. For their generous patronage I thank the Eastman Kodak Company of Rochester, New York. At Kodak we benefited from the direct assistance of Marianne Samenko and Thatcher Hogan.

Canon U.S.A., Inc., was also generous in their patronage of this project. The cameras and lenses used to capture the horses in these pages were all supplied by Canon. At Canon I would especially like to thank Dave Metz, and Chuck Westfall, as well as Joe Delora with whom I dealt directly.

Behzad Pakzad of South Sea International Press also has my gratitude for the care he gave to this project.

At William Morrow and Company I am eternally grateful to Al Marchioni as well as Larry Hughes. I also have the good fortune to have Toni Sciarra as my editor. Toni's assistant, Katharine Cluverius, was also of great help. At Morrow, I would also like to thank Richard Aquan, Barbara Levine, Karen Lumley, and Joan Amico.

Special thanks also go to Steve and Sherry Gaggero for sharing their beach with us. For their assistance, I would also like to thank Ted Wahler, Judi Lovell, Fred Sarver, David Priest, Barbara Chance, Carol Landry, Evelyn Westmoreland and Darlene La Madrid.

The owners of the horses in this book have my deepest gratitude for their patronage of my almost— twenty-year study of primitive equine social behavior. Hopefully this study will be published before long and make possible greater communication between equines and people, which will result in the better understanding and treatment of horses everywhere.

Ted Purpero has my gratitude for helping me keep fit. And for taking care of me in El Cajon, I thank Ron and Gale Vavra.

My deepest thanks go to the trainers and friends of the owners of the horses in this book who were often with us before sunrise and until after sunset. To help make possible the images that appear in these pages, the following people gave generously of their time, often under unfavorable conditions: Francisco and Mauro Almilla, John Fenton, Tommie Blackburn, Tom and Sabrina Reed, Meagan McReary, Bea Montgomery, Ruben Gaona, Anita Domeier, Carol Jones, Julia Domeck, Tammy Bach, Jerry Mills, Gerry Satchwell, Deddo Goldsmith, Tammy Evans, Redd and Casey Crabtree, Eduardo Peschiera, Victoria Diamond, Shawn Edwards, David Smith, Tom Juarez, Joy Hatten, Sally Oberpriller, Buck McGaffee, Linda Kellish, Ed Lelakowski, Jennifer Hyatt, Andy Minor, Jeff Ralph, Geoff Tucker, Bill Melendez, Scott Allmar, Gail Deuel, Natalie Jones, Elke Koehn, Yvonne Haagen, Lee Klopfer, Rex Hoffmeister, Ray Padilla, Dennis Johnson, Barbara Boesen, Ben and LaVelle Gildersleeve, Allen Green, Bill Hinson, Rob and Lori MacDougall, Loretta and Mark Melton, Cindy Spear, Viola Thomas, Linda Warren, Teressa Williams, Kristi Spath, Nikki Hartley, Noah Allison, Jennifer Nisbet, Margaret Schneider, Anne Clark, Bonnie Stevens, Sheri Casement, Jeff, Valerie, and Jerry Schall, Chuck Mathews, Al Lengacher, Cameron Bostick, Rose, Joe, and Linsay Alexa, Kathy, Mia, and Fara Richkind, Ruben and Joyce Pankey, Monique Swisher, Mark White, Rachael Rodgers, Martha Roy, Justin Convers, Lynda Taylor, Robert Haspel, Claudia Adams, Cindy West, George Baca, Cloyce Harrison, Patsy Bennett, Jyoti Parry, and Willow Adams.

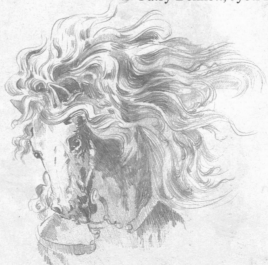

The bark paper (or amate) *that was photographed for the page backgrounds in this book, was handmade by Mexican Indians. The flowers, plants, butterflies, and feathers that appear on these pages, were gathered from the locations where each horse was photographed.*